The Guide to Managing Postproduction for Film, TV and Digital Distribution

The updated third edition of this popular book offers a clear and detailed overview of the postproduction process, showing readers how to manage each step in taking a film, TV or media project from production to final delivery, from scheduling and budgeting through editing, sound, visual effects and more.

Accessibly written for producers, post supervisors, filmmakers and students, and extensively updated to address current digital and file-based industry practices, *The Guide to Managing Postproduction for Film, TV and Digital Distribution* helps the reader to understand the new worlds of accessibility, deliverables, license requirements, legal considerations and acquisitions involved in postproduction, including the ins and outs of piracy management and archiving. This edition addresses the standards for theatrical and digital distribution, network, cable and pay TV, as well as spotlighting internet streaming and various delivery methods for specialty screenings, premium large format, and formats including 3D, virtual reality and augmented reality.

Susan J. Spohr has over 30 years' experience as an associate producer/postproduction supervisor. As a producer at Technicolor, Susan worked directly with both filmmakers and studios. She is credited on series, pilots, mini-series, features and more than 35 TV movies, and taught summer courses at USC School of Cinematic Arts.

Barbara Clark is former Executive Director of Technical Services at 20th Century Fox, where she was responsible for the creation of all international and domestic syndication versions for TV and feature product. She has worked in TV and feature film postproduction for 25 years.

Dawn Higginbotham is a writer and director of numerous award-winning short films, features and TV shows. Her short film *The Usual* was featured in the 2014 Emerging Filmmaker Showcase at the Cannes Film Festival. She also worked as a postproduction supervisor for Dolby Laboratories and Lucasfilm on films such as *Star Wars: Episodes I–III*, *Saving Private Ryan* and *Avatar*, among others. Dawn also oversaw business and creative affairs as Chief Creative Officer of Carl Laemmle Studios.

Kumari Bakhru, Director of Strategic Planning and Project Management for Walt Disney Studios Worldwide Motion Pictures Theatrical Distribution, works on bringing virtual reality, augmented reality, immersive cinema and interactive projects to theaters. She was selected to relocate to Singapore for two years to manage the development of digital cinema operations for the Asia-Pacific territory. Prior to Disney, Kumari worked in postproduction and distribution for KPBS, Warner Bros., Lucasfilm Ltd. and Dolby Laboratories. She earned her undergraduate degree from the University of California, Berkeley, and an MA in Film and Television from the University of California, Los Angeles. Kumari has been a guest speaker for the National Association of Broadcasters, the Producers Guild of America and at the USC School of Cinematic Arts.

The Guide to Managing Postproduction for Film, TV and Digital Distribution

Third edition

Susan J. Spohr
Barbara Clark
Dawn Higginbotham
Kumari Bakhru

Routledge
Taylor & Francis Group
NEW YORK AND LONDON

First published 2019
by Routledge
52 Vanderbilt Avenue, New York, NY 10017

and by Routledge
2 Park Square, Milton Park, Abingdon, Oxon, OX14 4RN

Routledge is an imprint of the Taylor & Francis Group, an informa business

© 2019 Taylor & Francis

The right of Susan J. Spohr, Barbara Clark, Dawn Higginbotham and Kumari Bakhru to be identified as authors of this work has been asserted by them in accordance with sections 77 and 78 of the Copyright, Designs and Patents Act 1988.

All rights reserved. No part of this book may be reprinted or reproduced or utilized in any form or by any electronic, mechanical, or other means, now known or hereafter invented, including photocopying and recording, or in any information storage or retrieval system, without permission in writing from the publishers.

Trademark notice: Product or corporate names may be trademarks or registered trademarks, and are used only for identification and explanation without intent to infringe.

Library of Congress Cataloging-in-Publication Data
A catalog record for this book has been requested

ISBN: 978-1-138-48277-7 (hbk)
ISBN: 978-1-138-48281-4 (pbk)
ISBN: 978-1-351-05674-8 (ebk)

Typeset in Bembo
by Newgen Publishing UK

Contents

	Acknowledgments	*vi*
	Introduction	1
1	Scheduling	15
2	Budgeting	30
3	Digital Workflow and the Film Laboratory	53
4	Dailies	87
5	Editorial	106
6	VFX	124
7	Sound	134
8	Mastering for Digital Cinema and Film Completion	169
9	Deliverables	204
10	Piracy	230
11	Acquisitions	237
12	Archiving	251
13	Legal	256
14	The Future	265
	Glossary	*272*
	Index	*292*

Acknowledgments

Since the second edition of our book, technology has changed the way we capture, edit and exhibit motion pictures and TV. We have also gained a venue, streaming, which requires a different set of deliverables. The shift from analog to digital has opened up a world of possibilities, with several paths to delivery, and with it come complex workflows, multiple digital formats and new rules. Each type of exhibition stream has become a specialty, and it has become increasingly difficult to become an expert in all things postproduction. This, the third edition to our book, would not have been complete without the following experts and facilities, who gave so generously of their time and knowledge. Sometimes, thank you just doesn't seem like enough.

FotoKem and its sister company Margarita Mix allowed us to call and visit anytime we had questions or needed a reference chart or guidance. They were kind enough to read chapters and provided additional material. We thank you all for your interest and help to "get it right". Our gratitude extends to our friends at FotoKem – Mark Van Horn, Andrew Oran, Tom Ennis, Bastien Minniti and Tom Vice; and at Margarita Mix, Veneta Butler and Brian Thornally.

We received invaluable guidance from our friends who are studio executives, facility owners, Academy Award winners and industry professionals:

> Graef Allen, Dolby Laboratories
> George Artope, Editor
> Stephanie Austin, Producer
> Becca Berry, Editor
> Rick Boggs, Founder and GM, Audio Eyes
> Sarah Borjorquez
> Monica Borne
> Marc Bovee
> Gary Chambers, since retired from Warner Bros. Sound
> Jenifer Camp Pine
> Annie Chang, VP Creative Technologies, Universal Pictures

Acknowledgments

Natalie Ebnet, Editor
Arnie Geher
Wes Irwin, Executive Director Postproduction, Fox 21 Television Studios
Justin Janowitz, Director of Photography
Jon Johnson, Supervising Sound Editor, King Soundworks
Craig Kuehne, VFX
Valerie Lettera-Spletzer
Dave Lockwood, VFX
David Christopher Loya, CEO, Renegade Lens
Howard Lukk, VP Engineering, Nitrate
Ed Premetz, Director Marketing and Sales, Captions Inc.
Vidya Prakash
Neil Rothschild
Phelicia Sperrazzo
Paul Springer
Narbeh Tartoussian

Special thanks to our publishers John Makowski and Simon Jacobs for their unending accommodations, assistance and encouragement throughout the process.

For many, many months our time was occupied with group sessions of updates, research and interviews. We are indebted to our families, David Orr, Louis Eales, Trillian Eales, William Gragg Higginbotham and Susan Higginbotham for supporting us, feeding us, helping to make charts and cheering us on. It would not have been possible without all your support, sacrifice and belief in our quest. We love you.

We would be remiss if we didn't mention the wonderful artwork and concept cover design William Gragg Higginbotham II so kindly created.

Thank you, thank you all.

Introduction

Welcome to the third edition of our book, where we introduce you to the wonderful, wacky, unpredictable, fun, funny and stressful world of film, TV and streaming. You'll love it and you'll curse it. But, ultimately, we hope to help you enjoy it as much as we do.

In this book we focus on the *postproduction* aspects of making movies, TV and streaming programs. Postproduction encompasses all steps that take place between production and final delivery. The person who manages this process is called a postproduction supervisor or associate producer. While the book is geared toward these positions, producers, line producers, and those just learning the business will also find this book essential.

Postproduction is a job that, if done well, can be both personally and financially rewarding. If done badly, it can be miserable (although you may still be rewarded financially – it's a funny business that way).

We have organized this book with the hope of making it clear and easy to follow. Let's just say that we tried to write a book that will help those who use it.

In this, the third edition of our book, we have made some changes and added some very useful new information. Advances have been made in our business of postproduction that you need to know.

You'll find the following changes and updates as you read through this edition.

Chapter 1: Scheduling

The general steps to postproduction don't change, but how you get there and what media you use are ever-evolving. We revised postproduction scheduling, and added information about data capture on the set and coordinating the path it takes to editorial. There are revisions to the postproduction scheduling timeline, and we discuss the communication and transition from production to postproduction, and the importance to having the editorial department and your post facility involved from the start of production.

Introduction

Chapter 2: Budgeting

Budgeting software has not changed much over the years and still includes sections for film and film laboratories; however, the actual materials and workflow are in constant flux. We include insights on how to change or adapt current budget forms to current-day postproduction needs. The new discussion continues with a section on how production and postproduction interface, how to read and understand "budget top sheets" and "cost-of-accounting sheets", the importance of knowing "the importance" of the line items in the budget, as well as confidentiality and understanding your place in the process.

Chapter 3: Digital Workflow

Digital workflow is a new chapter in postproduction. It is a general road map of how the data is packaged into files, how those files are changed, edited or shared, and what formats are used. In this chapter we investigate how to get from camera to theater using only computer files and the digital processes that have replaced photochemical steps. We discuss why it is best to assemble your postproduction team, and pick the tools and techniques you will use, before you shoot. We take you through the file formats you'll need to use from shooting camera raw through dailies, editorial, visual effects (VFX) and mastering. It's all about the files.

The film lab portion of this chapter is old-school, but many of the name director/producers still capture on film. Included in the discussion is film scanning as well as all the steps of how film is processed and printed, how to avoid and recognize film damage, aspect ratios, film formats, adding sound to prints, communication with the lab and schedule expectations.

Chapter 4: Dailies

During a production, rushes or dailies are the footage shot each day and rushed to the postproduction facility for transcoding, for you and your crew to view at the end of a day's shoot. It has also now become possible for filmmakers to screen dailies on set through their digital imaging technician (DIT). In this chapter we follow production to editorial: On set with the camera department and DIT, dropping dailies at your post facility, turning over camera reports and shot log sheets, digital dailies and film-to-digital dailies, framing charts and picture safe area, production audio recording tips, and road maps from production to deliverables. We discuss alternate delivery methods for dailies, including the Cloud, file transfer protocol (FTP) or third-party vendors and distributing screeners. We also discuss daily problems with "dailies" and how to troubleshoot issues once principal photography begins.

Chapter 5: Editorial

The editorial chapter discusses off-line and on-line editing, the roles of the editor and the assistant editor, off-line edit bay hardware and software, and additional items, such as furniture, needed to fill your editing suite. This chapter will discuss editorial procedures from receiving the off-line files delivered from your post facility once the raw data from set has been processed/transcoded and is ready to assemble, as well as the role of the assistant editor in assembling the takes onto the off-line edit timeline (i.e. rough assembly). It covers notes from set, given by the director, camera department, DIT, producers, associate producer or post-production supervisor, and everything from defects in camera, color adjustments, lighting, continuity or creative and production decisions. We explore the responsibilities of the associate producer and/or postproduction supervisor, and how and when to schedule screening time, as well as editor's logs, script supervisor's notes and managing the editorial process prior to the conform. We take a look at VFX, stock footage clips and aspect ratios and how they affect editing. Finally, we discuss the editor's cut, director's cut and producer's cut, temporary dubs, picture lock and edit decision lists (EDLs).

Chapter 6: VFX

VFX comprise a wide array of tools, techniques and file formats. This new chapter investigates the considerations for low budgets, preproduction planning and color space. In VFX, we look at common file formats: Open EXtended Range (EXR) and Digital Picture Exchange (DPX). We talk about color, 2D and 3D, and address the VFX pipeline from preproduction and previsualization to production, animation and compositing.

Chapter 7: Sound

Advances in technology have improved sound capture and design. In this chapter, new capture and delivery formats and terms are explained; details of the final sound track masters are outlined; and basic steps from capture through design, automatic dialogue replacement (ADR), the final mix, laugh tracks and foreign tracks are covered.

Chapter 8: Mastering for Digital Cinema

This is a new chapter that covers how to digitally finish your project for distribution. It details digital cinema packages (DCPs) for theatrical distribution, including compression, encryption and packaging; quality control (QC); how to

choose a mastering facility; MXF; E-Cinema; 3D; and gotchas or other problems. We also take a brief look at mastering for streaming, TV and home entertainment.

The film finish section of this chapter retains the original concept of finishing on film. Added is how to create a film print if you have shot on film and don't cut negative, or what you need to know when you have shot digitally and need to make a film negative.

The accessibility section is new and explains the necessity and good business choice of captioning and video description. It gives a little history on requirements, the different types of captions, who creates them, what materials are needed to complete the job and in what time frame, and how they are added to your movie.

Chapter 9: Deliverables

Due to the changes in technology, the delivery requirements have been updated. We checked with major studios and post experts to include the most current delivery elements, as well as how items are delivered. With the ever-expansive Cloud, file formats and data specs may change as technology progresses. Physical items like music cue sheets, timing sheets and script copies remain as standard delivery requirements.

Chapter 10: Piracy

A new and extremely important subject. This chapter outlines methods to protect your content at each step of postproduction – how piracy measures are applied, and simple actions you can take to avoid being a target of theft, even if you are the little guy. Protecting your assets is crucial, starting at dailies, as dailies can be transferred from production to postproduction using several different methods, all of which have their own piracy potential. Sending unprotected files or unsecured drives to the next facility or across the globe can be risky, so we talk about the importance and options of watermarking, encrypting and protecting your content. Watermarking and encryption are also relevant in combating piracy for theatrical exhibition, as is the use of key delivery messages (KDMs) for encrypted DCPs. While piracy is a difficult issue to combat, the film industry and the government are working on various initiatives to do whatever is possible in the global fight. We hope to help you to be aware of these potential dangers and to research the vendors you deal with, especially when it comes to your file and data transfer and storage.

Chapter 11: Acquisitions

Digital rejection and its causes are new to this chapter, as are tips on what changes need to be made before a distributor will accept delivery. Read this chapter and

learn the pitfalls before they trip you up, and avoid some very common mistakes that mean less money for the producers and even a canceled schedule.

Chapter 12: Archiving

There is a long list of materials to "save" – the same materials that the distributor will want to acquire. In the archiving chapter we discuss best practices for archiving your content from raw to various edits of your project, all the way to your deliverables. This includes raw dailies, completed feature or TV content, trailers, behind-the-scenes, and additional metadata. It also covers the safety of outputting your files at the highest resolution and storing them on the most reliable high-volume storage element, making several backup copies on Linear Tape-Open (LTO), data capture cards, SSD media and hard drives, and storing in various locations (never all in the same place). Digital file storage options change and hardware degrades, so we recommend migrating data every five years or less. Other options we discuss are to think about a film finish, turning your digital intermediate (DI) into film negative (film elements, YCMs, negatives and optical sound tracks stored in climate-controlled vaults is a solidly proven form of archiving), or to think about Cloud storage banks and other internet-based file storage. These Cloud banks are huge facilities in multiple undisclosed locations throughout the US and abroad. The materials are backed up multiple times, and major encryption is applied. We touch on the security issues that come with archiving (i.e. piracy) and troubleshooting these, as well as suggestions for researching all options and knowing the true costs of hard drive storage vs. Cloud vs. film print archiving.

Chapter 13: Legal

How do you know when you need to consult an attorney in postproduction? We give you guidelines, tips and even specific situations to help you make this decision. We have added current horror stories, also known as examples of what can go wrong, and ways to resolve these issues. We also encourage you to create a good working relationship with your attorney. So, even though this chapter appears at the end of the book, you may want to peruse it at the beginning of your project.

Chapter 14: The Future

In the conclusion of our book we explore the future of postproduction and how technology and security will drive most of the changes in the next few years. Industrywide vetting and testing of secure pipelines will become standard. Ultra high definition is on the way, along with cameras that will allow you to choose different points of focus after capture. Cloud-based companies are creating entertainment industry-specific services beyond long- and short-term storage. LED

Introduction

cinema screens that do not require a projector will be appearing on the scene. Venues with all-immersive multiscreen formats using a *three*-screen configuration by adding image to the sides of the theater will increase, as will premium large-format theaters with giant screens, premium sound systems and enhanced customer offerings to entice more audiences. Sound will further develop object-oriented sound, thereby projecting sound in a 360-degree bubble.

General Overview

In the scheduling and workflow chapters we've laid out the steps necessary to post a show and the order in which to complete those steps, along with the list of data files and how those files become the finished project. The subsequent chapters then explain each of the steps in detail.

Although digital post is the focus of our newest material and certainly of the current workflow, we felt it was important to retain film finish techniques. Some of the biggest names in directing and producing prefer to shoot film, and it is often the choice of student filmmakers. The film lab section of the workflow chapter, and the film completion section of the mastering chapter, will guide you through the film world. We also provide all of the steps required to deliver your product both domestically (in the US) and internationally. As you read, you will learn about budgets and how costs are calculated, what happens to film when it disappears into the chemical bowels of the film laboratory, how to manage workflow, how to plan and carry out cost-effective conform, color correction and titling sessions, and ultimately what goes into creating a DCP. There are numerous anecdotes throughout to help illustrate points and aid you in avoiding expensive and embarrassing mistakes. And sometimes just to entertain.

Figures I.1 to I.3 are a series of flowcharts to help illustrate the simplified paths that each method of postproduction will travel for film and digital, from DI to TV and streaming.

Figure I.1 Digital shoot to digital finish: Simplified workflow

```
┌─────────────┐    ┌──────────────────────┐    ┌──────────────────────────┐
│             │    │ Negative to film lab │    │ Film negative scanned    │
│ Film capture│───▶│ • Film processed     │───▶│ for Editorial            │
│             │    │ • Prep for scanning  │    │ • Negative sent to vault │
│             │    │                      │    │ • Data sent to Editor    │
└─────────────┘    └──────────────────────┘    └──────────────────────────┘
                                                           │
       ┌───────────────────────────────────────────────────┘
       ▼
┌──────────────────────┐    ┌──────────────────────────────┐
│ Editorial            │    │ DI                           │
│ • Locked picture     │───▶│ Scanned data to DI facility  │
│   files and data     │    │ • Conform data using pro-res │
│   sent to DI facility│    │   files as reference         │
│                      │    │ • Color correction           │
└──────────────────────┘    └──────────────────────────────┘
                                        │
       ┌────────────────────────────────┘
       ▼
┌──────────────────────┐    ┌──────────────────────┐    ┌──────────────────┐
│ DCDM                 │    │ DCP                  │    │                  │
│ • Theatrical master  │───▶│ • Add sound          │───▶│ Screen in theaters│
│                      │    │ • Subtitles          │    │                  │
│                      │    │ • Captions if needed │    │                  │
└──────────────────────┘    └──────────────────────┘    └──────────────────┘
```

Figure I.2 Film shoot through digital finish

```
   DI        →   Digital source  →   Mezzanine   →   Ancillary
                    master              files          markets,
                                                        OTTs

• Conform       • Titles          • Master file used  • Over the top
• Color correct • Sound             to create video for  markets
                • Captions          streaming or TV   • TV
                  (if necessary)                      • Streaming
                                                      • Airlines
                                                      • DVD
```

Figure I.3 Digital finish to streaming, TV or DVD from DI

Who Does What and for Whom?

Something else we've added is organizational charts of the various postproduction and show managers and crew. Figures I.4 and I.5 illustrate the reporting structure for these jobs. Bullet point lists highlighting the responsibilities of each position follow these. Note that there is a chart for TV/streaming and another

Introduction

```
                    ┌─────────────────────────┐
                    │ The Management and Crew │
                    └─────────────────────────┘
                                 │
                    ┌─────────────────────────┐
                    │  TV/Streaming Postproduction │
                    └─────────────────────────┘
         ┌──────────────┬──────────────┬──────────────┐
┌──────────────┐ ┌──────────────┐ ┌──────────────┐ ┌──────────────┐
│   Network    │ │Studio Executive│ │  Showrunner  │ │  Producer/   │
│  Executive   │ │  in Charge of  │ │ (may also be │ │  Co-Producer │
│              │ │ Postproduction │ │  head writer)│ │              │
└──────────────┘ └──────────────┘ └──────────────┘ └──────────────┘
                        │                │                │
                 ┌──────────────┐ ┌──────────────┐ ┌──────────────────┐
                 │Postproduction│ │   Directors  │ │Production Manager│
                 │  Supervisor/ │ │              │ │   Line Producer  │
                 │Assoc. Producer│ └──────────────┘ └──────────────────┘
                 └──────────────┘
                        │        ┌──────────────┐
                 ┌──────────────┐│    Editors   │
                 │Postproduction│└──────────────┘
                 │  Coordinator │
                 └──────────────┘
                        │
                 ┌──────────────┐
                 │Postproduction│
                 │   Assistant  │
                 └──────────────┘
                        │
                 ┌──────────────┐
                 │    Intern    │
                 └──────────────┘
```

Figure I.4 Streaming and TV management and crew flowchart

for features. The jobs are almost identical; however, in TV you will have multiple directors and editors, to keep up with the weekly episodes. This venue will have a showrunner who may or may not be the head writer and works in a similar position to a producer. Figure I.6 is an overview of the core postproduction crew that is responsible for creating and delivering the final project and necessary materials. There may be other jobs assigned to these positions, depending on the size of the project and the budget. But this should give you a fair idea of what you can expect to be assigned should you take one of these jobs.

The Management Team

Executive Producer/Co-Executive Producer
- Answers to the network or studio executive
- Is ultimately responsible for completion of the project

Figure I.5 Feature management and crew

- Concentrates on the business end of the project and assumes financial responsibility
- Usually has little time to offer input into technical issues
- May be the owner or head of the production company
- May have multiple shows in production simultaneously
- May be one of a number of executive producers working on the same show

Producer/Co-Producer
- Answers to the executive producer
- Works with attorneys to determine distribution license fees and contract details with distributors
- Has creative input

- Has budgetary authority
- Is a member of the project team from preproduction through delivery
- Works on one show at a time

Showrunner (TV/Streaming)
- Answers to the network executives
- Has creative control
- May be the head writer
- Director answers to showrunner
- Acts as script editor

Line Producer
- Is a production position that may interact with post personnel
- Answers to the executive producer and/or the producer
- Works closely with the production manager during principal photography
- Works on the budget and production schedule for principal photography and probably second unit
- Is a role that on smaller projects may be assumed by the production manager and listed as "line producer" in the credits
- Works on one show at a time

Production Manager
- Answers to the producer
- Is responsible for budgeting
- Is responsible for scheduling
- Supervises all day-to-day production-related activities
- Is on a project from preproduction through the end of principal photography
- Usually works on one series or movie at a time
- Is often a union position

Executive in Charge of Postproduction
- Is a studio or network executive
- Provides a list of studio or network delivery requirements
- Oversees creation of delivery materials
- Has little creative authority

Postproduction Supervisor/Associate Producer
- Answers to the producer and executive in charge of postproduction
- Manages all aspects of postproduction, including budgeting, scheduling, editing, sound, mixing and color correction

- Creates and delivers final elements to the distributor(s)
- May have some creative input

Postproduction Coordinator
- Answers to the postproduction supervisor and the producer
- Works closely with the editors
- Coordinates mountains of paperwork and all film/tape/audio materials
- Keeps track of stock footage and its paperwork
- Is a key source of communication during postproduction
- Keeps records for the postproduction department
- Manages movement of materials

Postproduction Assistant
- Answers to the postproduction supervisor
- Is general assistant to the postproduction supervisor
- Assists the editorial crew by filling in when the editorial assistant or production assistant is not available
- Helps to track down, and coordinates movement of, stock footage, special effects elements and other materials
- May be responsible for the boxing and inventory of delivery elements

Intern
- Answers to the postproduction supervisor and editorial staff
- Helps the postproduction staff wherever needed
- May be paid a token salary or work for college credits
- Is an entry-level position

The Postproduction Staff

This is the core group responsible for creating the final project elements including sound effects, music and VFX. These individuals work as a team to finish the project on time and on budget. They usually know each other and help each other in this group effort. We have included the director of photography (DP) and the digital imaging technician (DIT) in Figure I.6. These positions are not considered postproduction, but play a big part in getting the initial raw material to the core team.

Editor
- Answers to the producer and the director
- Is responsible for editing dailies and the editor's cut through picture lock
- Has extensive creative input
- May be a union position

Assistant Editor

- Answers to the editor and the director
- Is responsible for ingest and manages logs and dailies data, or film picture and track
- Catalogs and tracks all elements for the editor (i.e. negative, dailies data, sound, print dailies, stock footage, script notes and any other necessary materials)
- Stays on payroll through delivery to help box and catalog delivery materials
- May be one of a team of assistant editors on a project
- May be a union position

Sound Design Supervisor

- Answers to the producer, the director and the post supervisor
- Works closely with the editor
- Is responsible for supervising creation of the final sound elements that make the finished sound track

Figure I.6 Postproduction staff flowchart

Introduction

Sound Editor
- Works for the sound design supervisor
- Cuts the audio track to match picture, utilizing all the sound elements including effects, production audio and automated dialogue replacement
- Prepares the audio materials for the sound mix

Music Supervisor
- Answers to the producer, the composer and the post supervisor
- Coordinates the creation of the musical score
- Prepares the visual materials and cue timings for the composer
- Supervises music mixdown for the dub
- Coordinates materials for the sound mix
- Recommends and purchases prerecorded musical material
- May also act as music editor
- May be a union position

Music Editor
- Works for the composer and with the music supervisor
- Prepares and cuts the musical score and purchased musical cues
- Attends the music mixdown

Music Coordinator
- Works for the composer and the music supervisor
- Coordinates the purchase of prerecorded music cues
- Assists the composer with the duplication of sheet music and other administrative duties
- May also be the music supervisor

Visual Effects Supervisor
- Answers to the producer and the director
- Works with the picture editor and the postproduction supervisor
- Keeps detailed records of all components used in building VFX
- Creates the VFX budget
- Supervises the entire effects

How to Use This Book

Technology is moving ahead at a frantic pace. New file formats, new ways to send and receive data, additional settings on cameras to aid in capture, and new ways to reach audiences are all happening at once. With each advance comes a new acronym that is added to our vocabulary. It is enough to make an organized

post super-dizzy. Before you collapse, take a deep breath, steady your nerves and consult *The Guide*. If your situation is crazy and breaks new territory, our suggestions are designed to guide you in the right direction.

You can utilize this book in two ways. You can sit down and read it cover to cover. When you are done, you will know postproduction. You can also use this book as a reference to guide you through each phase of your job as needed.

We hope this literary effort gives you aid and comfort on your journey through the postproduction maze. The twists and turns can seem confusing, but with our help you can make it through to the end.

We have guided many features, TV movies, dramas, situation comedies and specials through these steps. Along the way, we made mistakes – some expensive, some just embarrassing. The information in this book is necessary for successful film and digital postproduction. There is humor in this book because we believe that to do this job, it is essential to keep the job in perspective. And keeping a sense of humor helps.

We recommend you stay organized, work hard and *above all, have fun!* This job demands hard work, so remembering to have fun can be the hard part.

CHAPTER 1

Scheduling

The dictionary defines schedule as:

1. a list of details
2. a list of times of recurring events; timetable
3. a timed plan for a project

All three of these definitions apply to postproduction scheduling. Production and postproduction scheduling are an art form. Primarily, you are expected to commit to paper a plan encompassing every single step of postproduction, from dailies to delivery. Each phase is dependent on the successful completion of the previous phase. Translation: Your schedule needs to be flexible, and you need to be very organized and possess patience.

Once you have mapped out your postproduction schedule and committed it to paper, it is distributed to the show's executive producers and producers, the studio, network executives and countless others. And, at any given moment, anything can (and usually will) happen to change your schedule. These interruptions can be caused by, but not limited to, bad weather, an actor's scheduling conflict, or adjustments from a studio or network executive. Any of these interruptions may cause a ripple effect through your entire schedule.

Knowing what you need ahead of time, and having strong communication with production at the start, will help with flexibility as issues come out of nowhere.

Creating a Production to Postproduction Schedule

In film and TV, scheduling is a timetable, and the success of a show relies heavily on time management. This includes managing, organizing, planning production processes, allocating assets and optimizing resources. It is highly recommended, depending on the complexity of your project, to include your postproduction facility in conversations at the start of production.

A postproduction supervisor can use details and information provided by production to create a postproduction timeline, request bids and build the

postproduction budget. An experienced and talented postproduction supervisor can save a production time, complications and money.

What will be your timetable? Ultimately, your release date or air date will determine your delivery date (or the delivery date the network/distributor has established). Often, the best way is to work back from the release or delivery date. If you don't deliver, your show doesn't air. It's that simple. If you don't have a delivery date, make one.

The areas that the post supervisor is responsible for scheduling are listed below. The time allotted for each phase of a show depends on the complexity of the project, whether it is shot on digital or film, your delivery requirements and intended platform, and whether it's a half-hour single-camera comedy or multi-camera sitcom, an hour-long episodic, a limited series, pay cable, digital streaming content or theatrical feature.

With the shift from film to digital, the workflow for longform cable and streaming productions has become more like theatricals. These programs have longer schedules and bigger budgets. In the end, production executives aim to have a richer, bigger show that will guarantee better ratings and higher accolades than your average series.

When posting a series for streaming or cable, a one-hour episodic, a half-hour sitcom or other special programming, many of the steps are the same and are completed in the same order. The time it takes to complete each step may vary. Some steps may not be necessary for every show.

Here is a list of the basic postproduction steps that you will go through to complete your project, and the general order in which these steps will happen. At the end of the chapter are samples of various production and postproduction schedules.

Always keep the distributor's delivery date foremost in your mind. It is usually tied to a distributor's theatrical marketing and release deadline or streaming or TV air date, and therefore unchangeable.

With the advent of digital workflow, the postproduction supervisor may be responsible for the supervision of the dailies materials' (data capture cards, SSD media and sound cards) delivery to the post facility for transcoding and delivery to the editor, and if transcoding is done on set, from the set to the editor. This is a timetable that is very important, and something the post supervisor may not have been responsible for in the past.

Elements of the Postproduction Schedule

1. Principal photography
2. Dailies
 a. Off-line editor
 b. Duplication for viewing

3. Second unit photography
4. Editor's cut
5. Director's cut
6. Producer's cut
7. Temporary on-line/temporary dub
8. Network or studio view
9. Picture lock
10. Film titles and graphics
11. VFX
12. Test screenings (theatrical feedback or focus groups)
13. Negative cut/conform/on-line edit
14. Spotting music and sound effects
15. ADR/looping
16. Scoring
17. Prelay/predub
18. Final audio mix
19. Creating foreign audio tracks
20. Delivery duplication/air masters
21. Delivery
 a. "Day and date" theatrical
 b. Video on demand (VOD) release
 c. Staggered release schedule
 d. Festival submission
22. Release date or air date/film festival screening

Principal Photography

The principal photography stage is when your primary footage is shot. There is a beginning date and an ending date. When scheduling postproduction for a feature or a TV project, you must know the first and last days of principal photography, whether a second unit shoot is planned, and the delivery date. Knowing the first day of principal photography and the date you must deliver your final master provides the parameters necessary to fill in the rest of the schedule.

For example, a half-hour multi-camera sitcom will rehearse several days and usually shoot one to two days per episode in front of a live audience. A half-hour single-camera sitcom is shot similarly to an hour-long episodic on a stage or on location. An hour-long episodic will typically shoot four to eight days per episode. A limited series could shoot approximately 25 to 40 days. These are rough estimates. The complexity of the show and the budget determine the exact number of shooting days per program. Situation comedies shoot more than one day when pre-shoots are scheduled. These are usually scenes that are shot ahead

of time, and then transferred and edited together to show to the live audience on the day of principal photography. This material could be used for playback on the set (on a TV monitor) or to show the audience key story points that are shot at another location.

You must be aware of the days of the week you are shooting and whether any Friday night or weekend post facility will be open for dailies processing. There will be extra charges for weekend work, and it is necessary to alert the post house as early as possible so they can staff accordingly. These additional charges may also affect your budget.

Dailies

Dailies are the footage that is shot each day. As suggested, make sure the data or footage has a path to the post facility at the end of each shoot day. The source material will be ingested into the editorial suite and dailies material will be created, and then delivered for viewing on the set or by executives.

By shooting on digital, you eliminate the laboratory and the film scanning process, although a transcode may still be necessary. Your clips/files can be uploaded to a backup hard drive and viewed in real time on set via playback or DIT monitor. But the material you shoot still constitutes dailies, and will still go to your postproduction facility for secure storage for your on-line editing later in the process (usually stored to a RAID, thunderbolt drive or LTO, or on the Cloud for easier access when filming on location).

Whether you are transcoding or processing digital dailies or you are transferring film dailies to digital, you will want to read the dailies chapter carefully. There are many details you will need to provide to your lab and/or post house before they can begin. This is in addition to scheduling those facilities.

Second Unit Photography

Second unit is a smaller skeleton crew, independent from principal photography, made up of either fewer members of the original crew or an entirely different group. Sometimes second unit material is shot simultaneously with the principal dailies, while at other times it is shot after principal photography has ended. Some shows even start shooting second unit material – establishing shots, inserts, clean plates for VFX etc. – at the beginning of their shooting schedule.

Second unit shoots are often shot MOS (without sound) or with wild sound (not meant to be matched to picture during the dailies transfer). Once shot, second unit dailies would be processed with the same workflow and procedure as the principal production, in terms of processing, scanning, transcoding, color timing, editing…

Editor's Cut

The off-line editor is responsible for creating the first-version editor's cut. This version is the foundation for the final show assembly or on-line/conform. Shots are assembled from dailies according to the blueprint provided by the script. Being familiar with all of the varying takes, the editor chooses the better takes of each scene. Once all the dailies are shot and delivered to the editing bay, the editor has one to two days for assembly of episodics and sitcoms, and no more than six days, per the Directors Guild of America (DGA), for limited series or projects that have a run time of more than an hour. Always refer to your DGA contracts, as these guidelines change often, and can vary depending on the circumstances of your project.

Director's Cut

Once the editor's cut is complete, the director screens the cut, then all changes made by the director become part of the director's cut. The director sets the pace of the show, shortening (tightening) and lengthening scenes as the director deems necessary. This cut shows the producers how the director envisioned the movie when it was shot. The director's cut goes to the production company, network executives and/or studio executives to view.

Unless the director invites them, it is illegal (per the DGA) for anyone other than the editorial staff to be in the cutting room before the director has finished. Breaking this rule can result in fines to the production company. Current DGA rules, noting the number of days for the director's cut and dependent on budget tier, allow eight to ten weeks for theatrical, one day with an additional day for changes for 30-minute shows, approximately 15 days for 90-minute programs, 20 days for 120-minute programs, and longer for features or limited series. If in doubt about the rules, call the DGA. Some directors are very strict about these rules, so exercise caution. Don't second-guess when making the schedule. Stick to the rules.

In TV, the director's job is officially done when shooting is completed and the director's cut has been delivered. Because of TV's fast pace, a new job is often waiting, and the director often leaves before the picture is locked. However, the director may supervise the ADR or looping session and the second unit shoot, as well as being present at the final audio mix. The director must be informed of when each step is scheduled to take place and where the sessions will be held. It is not incumbent upon the director to participate, but it is an option, depending on the director's availability.

Producer's Cut

Following the director, the producer creates a version of the project or program. This version may or may not incorporate part or all of the director's cut and any

other production footage. In feature films, the director may be heavily involved in this cut. Producers usually take two to five days to screen the director's cut and complete their version. The producer's cut will then go to the production company or studio executives or to the network to be screened. Even in a half-hour sitcom, several versions (called producer's cuts and labeled PC #1, 2, 3 etc.) may be created for executives and the network to view. We have seen seven and eight producer's cuts go out for a single show before everyone was satisfied. In one instance, four copies of each version were sent to the production company, and seven digital screeners were sent to the network executives. These costs can really add up.

Temporary music and effects may be incorporated into the producer's cut. VFX not created during production are often too expensive to make for the screening of a producer's cut, since they might not be used in the final version, so many times you may see a green screen or an unfinished effect, tracking dots, placeholders etc. With off-line editing, simple VFX, color correction, inserts and shot cleanup can be created quite easily by your off-line or on-line editor. Simple titles can be added to help round out the effect. These extras are traditionally saved for use on pilots and theatrical test screenings, as are temporary on-lines.

Temporary On-Line/Temporary Dub

The producers may decide to create a more completed version of the producer's cut, rather than simply making digital copies of the off-line version. They spruce up the cut with a conform to a temporary on-line with a temp music track.

These added steps are the exception to the rule and are often saved for use on pilots and/or features with anticipated foreign theatrical releases. This is an added expense that may not have been included in the budget at the start of the process. The money to do this may have to come from somewhere else in your budget.

Network/Studio View

Once the producer is satisfied with the producer's cut, this version is delivered, and everyone waits for the network or studio notes – usually two or more days later.

Picture Lock

After all the executive or network notes have been addressed, and final changes are made, your picture is considered "locked", meaning all of the changes to the edit have been done and approved. This stage is often referred to simply as picture lock.

Whether it is digitally created or film scanned to digital, you are now ready to conform from your off-line to your on-line edit. In a show that has been both shot and finished on film, you would order the negative cut to begin at this stage. Composers, sound editors and music editors will need to receive their materials as soon as possible to ensure everything is delivered on time to the sound mixer for the final mix.

Opticals/Film Titles and Graphics

Simple opticals can sometimes be incorporated in to the on-line session (fades and dissolves). More complicated effects need to be created by a VFX company or in an editing bay. Credits are tiered. If you are an independent, there may be software available that you can use. These may already be incorporated into the on-line data. For larger budgets, your post facility may be able to do simple text over black or action. Book a session before your on-line if your titles are not complicated; it may only take a few hours in an edit bay for title creation. Finally, special optical houses are available, if within your budget, to create special titles and roll-ups. This may take several weeks, depending on your needs.

VFX

VFX or added animation may need to start in preproduction. It is important to give these facilities a target date for when the media needs to be finished and dropped into your on-line.

Test Screenings

There are many types of screenings that as a post supervisor you may be responsible to deliver media to, such as:

- test audiences
- research screenings
- sneak previews
- advanced presentations
- focus groups

Test screenings are held for the purpose of measuring audience reactions to a story and its characters. They are also used to gage the target market for a film or pilot. In other words, do the audience laugh and cry where they are supposed to, and which age/gender group enjoys the movie most? The goal is to give the producers and marketing department information on how to best market the film and to whom, and if story changes need to be made. If changes are made,

the film may be tested again to see if the changes were effective. Creating the media and booking the screening room(s) are the two areas that may cost you time in your schedule.

Negative Cut/Conform/On-line Edit/DI

The film editor will provide the negative cutter with a completed work print. The negative cutter will ask for a negative cut list or negative conform list. Depending on the number of edits and the time to scan to digital for any additional work (VFX, color, titles etc.), this process can take several weeks for a feature. In the on-line (or "conform"), your show is assembled from your raw data using the EDL created by your editor. The EDL includes the in and out timecode from your source titles and opticals.

As soon as the picture is locked, you can go into on-line editing. In the on-line session, the picture is assembled from the uncompressed master source elements. Wait to do the on-line until the picture is locked. With TV schedules being what they can be, you rarely find yourself in an "ideal" situation. Where possible, you do not want to make changes once a project is picture locked, and especially not once it's on-lined. Assembling your show before the picture is locked is rarely an issue with sitcoms and episodics, because the format is so short you don't buy much time by rushing the on-line before the edit is completed. But limited series may fall prey to this piecemeal form of assembly. Often the on-line for these two- to four-hour shows gets rushed so that work files can be made for the sound and music editors, the special effects and graphics creators, and the composer. It could be one day of on-line for a 90-minute show. It's not always about the time it takes; it's about trying to get into the facility. These folks can then have the maximum amount of time to create their magic.

Answer Print for Film Finish

A film finish requires that you approve either the first trial/answer print or a proof print, depending on time and budget. A proof print, made from the color timings, is a slide show or filmstrip made up of one to three frames from each scene in the show. If a film print has not been scanned to a digital master for color-grading, a Hazeltine is one machine on which the color corrections are made. The first trial is the first full print viewed for corrections. Often the director or cinematographer attends. Whether you view a full answer print or a proof print, there will probably be adjustments to the color. If so, a second check print is struck, and the process is repeated for the corrected areas until you, the client, are satisfied. What you end up with is a scene-to-scene color-corrected print. The answer print is the final print.

Spotting Music and Sound Effects

During music and sound effects spotting, decisions are made regarding the placement of music cues and sound effects. The director, producer(s), editor and associate producer, along with the composer and sound designer, view the picture with timecode on either a rough digital file or via editing software to discuss the various music and effects cues and where they should be placed.

Your sound, music and effects editors, along with the composer, will all require work elements as soon as possible. It is always best to give them a locked picture for timing purposes. If this is not possible, give them timecode with placeholders for effects. Make sure they know when the final mix is scheduled so they will be able to meet the deadline. It may take an afternoon to do spotting, music and effects. It will take you a couple of weeks to complete the editorial and preparation of the mix, including preparation of the score. Make sure you allow enough time to complete these tasks.

ADR/Looping

ADR is also referred to as looping. Here dialogue is rerecorded after shooting is complete to replace unusable original production sound. An independent feature looping session will usually take one to two days for the loop group, two days for supporting actors, and one to two days for lead actors. A loop group, sometimes called a Walla group or an ADR group, is a collection of people hired to rerecord dialogue and background voices. For a special or episodic, one day should cover all participants. Looping is not normally done for a sitcom, since it is usually recorded live.

Scoring

The score is all the original music used in your film or TV series, and is written by a composer. Some composers score using electronic instrumentation. This is known as electronic scoring. They usually work out of their homes or in small studios. The director and producers sit with the composer several times during the postproduction process to evaluate and provide direction for the scoring. If the score is not produced electronically, you will need to book a scoring stage.

Some composers hire a group of musicians and record on actual sound stages (see the "scoring" section in the sound chapter). This type of scoring is more likely used today in big-budget theatrical or premium cable platforms, but most independent film and TV will use electronic scoring to save on time and budget. If you are using this method for a pilot, allow one day to record the music. Then

allow one day between the recording and the dubbing stage for the music editor to cut the music.

Your music supervisor will know how many sessions you will need to book. The musicians' union governs the length of time a musician can work without a break. Your music supervisor will help you, be sure you don't incur penalties.

Color Correction/Final Color-Grading

This is the final time you alter your picture before the credits are added. In color-grading, the picture is evened out on a shot-by-shot basis so the shots flow together with a planned consistency of hue and balance. Your director and DP may want to be (or may be contractually) involved.

For a 90-minute show, it should take about three days to do color correction. An independent short should take a day. For film color correction, see the film lab chapter. Color-grading a one-hour episodic may take one day. Sitcoms are generally not color-corrected. If necessary, a half-hour sitcom should take half the time of an episodic. For film, see the mastering and completion chapter.

Prelay/Predub

If your show includes a lot of sound effects, then your sound effects supervisor may recommend a prelay/predub. This is intended to make the actual dub go more smoothly and easily by reducing the number of individual effects cues the mixer has to control simultaneously. When working on a feature, your sound effects supervisor and your mixer should be able to complete this in one day.

Mix/Dub

This is one of the most time-consuming and creative events in the entire post-production process. The producers, director, composer, music supervisor, editor, sound effects supervisor and sound mixer go through the show scene by scene, making decisions about the placement of music and effects cues, and adjusting audio levels.

When all the separate dialogue, music and effects tracks are completed, they are mixed down onto an unused track (or tracks) of the multitrack element. These tracks become the master sound track or final mix, which is then laid back or dubbed onto the sound track of the master. This master sound track is also the element used to create an optical track in the case of a film finish project.

Schedule an entire day of sound dub for an episodic and a half-day for a sitcom. In Canada, in the US on some stages, and many times in independent filmmaking, dubbing involves one mixer, who mixes the sound sources one at a

time. Whichever method you use, the show opening will traditionally take the longest to dub.

If during the session you see that you are going to go over the time allotted, quietly notify the producer. If you need more time than originally budgeted, someone will need to determine if it is more cost-effective to rack up some overtime or add another day to the dub. These additional costs are probably outside of any package deal.

If your show is going to have a laugh track, be sure to schedule the time for your laugh session as early as possible. There are only a handful of laugh people around. They book up quickly during the TV season, and they don't come cheap.

Creating Foreign Tracks

It usually takes one day to create the audio for your foreign delivery requirements. It usually takes place the day after the dub.

Delivery/Air Masters

Delivery dubs are the final materials delivered to the network, the production company and the distributor. Some of these are closed-captioned and require special formatting. International delivery requirements will vary from network requirements.

If closed-captioning is required, you will do this either in a separate formatting session or at the time the dubs are made. See the section on closed-captioning in the completion chapter for more details.

Once your DI is created, you will then make your masters for each of your distribution outlets – theatrical, home entertainment etc. Here is where you will lay back the sound and add any foreign languages, text or titles. This may take a day or two, depending on what you need to make.

Delivery

At this point the distributor (network, foreign, cable etc.) actually accepts delivery of your show, meaning all of the delivery requirements have been met. Be sure you know whom you are expected to deliver to, their address or Cloud-based server, and the exact delivery date and time specified. We cannot stress enough how important it is that you know and understand your delivery requirements from the start of the project. Some of the elements may be pushed from the facility, and you should receive an acknowledgment that they have been received in good condition.

Air Date

Once your show has aired, many schedules include the air date and a reminder to get the overnight ratings the next morning. It's not required, but everyone will want them. Likewise, for a theatrical release, people are very interested in the box office for the opening weekend.

Summary

Successful delivery of your show depends on how organized you are and the order in which the steps in your postproduction process are completed. You may very well spend more time updating, reorganizing and agonizing over your postproduction schedule than you spend on any other part of your job. Any change in that schedule will cause a ripple effect throughout the entire process – including your budget. Good project management will help ensure that your ripple doesn't become a tidal wave.

It is important that each change to your schedule be incorporated, the affected steps adjusted, and everyone involved in your postproduction process issued with an updated schedule in a timely manner. When you are distributing updated schedules, be sure that you deliver them to all your contacts at your various postproduction facilities. It is also a good idea to point out, at least to the postproduction houses, what parts of your schedule have changed. Be sure to date each version of the postproduction schedule that you distribute.

Scheduling Samples

Figures 1.1 to 1.3 are excerpts from sample production and postproduction schedules. Use the schedule that best helps you organize and plan your show's postproduction schedule. While we look at postproduction as starting on the last day of principal, post should be involved from day one of production and through the daily process up to deliverables to have a smooth-running show.

Pre-Production	Approx. two weeks
Principle Photography	Approx. 18 to 30 days depending
Last day of Principal Photography	Insert date
Re-shoots / Pick Ups	Insert date
Begin Visual Effects	Insert date
Film Scanning Scanning film rolls (16mm, 35mm, 65mm) to a high-resolution, uncompressed digital format.	Allow two weeks
Rough Cut / Editor's Cut / Off-Line	Governed by the DGA, begins promptly after completion of principal photography.
Director's Cut	Governed by the DGA, Feature: ten weeks or one day in editorial for every two days in production, or whichever is longer. Low Budget Feature: six weeks or one day in editorial for every two days in production, or whichever is longer.
Producer's Cut	Allow at least one week from completion of director's cut.
Test Audience Screening / Previews	Dependent upon the show and its executives, for a large budget studio feature, this may take several months. For an independent low budget feature, this testing and re-editing process may take a week or less, if tests are done at all.
Re-edit / Re-cut	Insert date
Studio View	Insert date
Re-cut (Studio Exec Notes)	Insert date (if applicable)
Visual Effects completed & inserted	Effects may take two weeks to several months depending on complexity.
Picture Lock / Final Cut	Insert date
ADR/Looping	Allow 1-2 weeks
Foley	Allow 1-2 days
Scoring	Allow one week (one day for approximately 20 mins. of music)
Music	Insert date
M&E	Allow 1-3 days
Opening and End Credits	Allow 1-3 days
Color Correction / Color Grading	Allow 1-3 days
Final Sound Mix	Allow 3-7 days
EDL (Edit Decision List)	Allow 1 day
On-line / Final Conform to DI (using an EDL to create an Online Master)	Allow 1-3 days
If Film-Finish, Wetgate Negative (for archiving purposes)	Allow 1-3 days
If Digital Master, Layback (record conformed audio to digital master for non-theatrical distribution)	Allow 1-2 days
Quality Control	Allow 1 day
DCDM	Allow 1-2 days
DCPs (for theatrical distribution)	Allow 2-3 days for 150-500 DCPs depending upon postproduction facility.
Delivery / Access to Distributors	One day after approval of DI from DCP, depending upon the delivery requirements
Cast & Crew Screening	Insert date
Premiere / Film Festival	Insert date

*The timetables given are approximates, and may differ dependent on a project's delivery requirements.

Figure 1.1 Feature postproduction schedule

Show No.	Title	Dir.	Shoot Dates	Editor Cut	Dir. Cut	Studio/Net. View	Lock	On-Line	ADR	MX FX	Color Correct	Title	Mix	Del. Dubs	Avail. for Air	Air-date
101	RED PLANE	COKER	16-Nov to 28-Nov	1-Dec	8-Dec	20-Dec	21-Dec	21-Dec	8-Jan	22-Dec	29-Dec	10-Jan	15-Jan & 16-Jan	18-Jan	18-Jan	22-Jan
102	SOFT GAME	HARD	29-Nov to 7-Dec	12-Dec	14-Dec	22-Dec	28-Dec	28-Dec	4-Jan	29-Dec	8-Jan	8-Jan	11-Jan & 12-Jan	13-Jan	13-Jan	15-Jan
103	HELLO YOU	VAN	8-Dec to 18-Dec	20-Dec	22-Dec	8-Jan	16-Jan	15-Jan	24-Jan	16-Jan	22-Jan	24-Jan	26-Jan & 28-Jan	1-Feb	1-Feb	5-Feb
104	TOAD SONG	HADLE	8-Jan to 18-Jan	18-Jan	22-Jan	29-Jan	31-Jan	31-Jan	6-Feb	1-Feb	6-Feb	7-Feb	6-Feb & 9-Feb	10-Feb	10-Feb	12-Feb
105	HACK	LEE	17-Jan to 25-Jan	29-Jan	31-Jan	6-Feb	7-Feb	7-Feb	12-Feb	8-Feb	8-Feb	13-Feb	14-Feb & 15-Feb	16-Feb	16-Feb	19-Feb
106	JUST US	HARD	28-Jan to 6-Feb	8-Feb	9-Feb	12-Feb	14-Feb	14-Feb	20-Feb	16-Feb	16-Feb	22-Feb	21-Feb & 22-Feb	23-Feb	23-Feb	26-Feb
107	DO IT RIGHT	COKER	7-Feb to 15-Feb	21-Feb	21-Feb	1-Feb	4-Mar	4-Mar	11-Mar	5-Mar	6-Mar	11-Mar	12-Mar & 13-Mar	15-Mar	15-Mar	18-Mar

Figure 1.2 One-hour episodic schedule

EPISODE NUMBER	101	102	103
TRANSCODE TO OFF-LINE	2-Oct & 3-Oct	11-Oct & 12-Oct	18-Oct & 19-Oct
EDITOR'S CUT	4-Oct & 5-Oct	12-Oct & 13-Oct	20-Oct & 21-Oct
DIRECTOR'S CUT	6-Oct & 7-Oct	14-Oct & 15-Oct	22-Oct & 23-Oct
PRODUCER'S CUT #1	8-Oct	14-Oct	24-Oct & 25-Oct
PRODUCER'S CUT #2	9-Oct	15-Oct	26-Oct
STUDIO CUT	10-Oct & 11-Oct	16-Oct & 17-Oct	27-Oct & 28-Oct
TEMP ON-LINE	12-Oct & 13-Oct	20-Oct	29-Oct
DIALOGUE, M&E EDIT	4-Oct & 5-Oct	21-Oct	30-Oct
NETWORK CUT	14-Oct & 15-Oct	22-Oct	31-Oct
ON-LINE	16-Oct & 17-Oct	23-Oct	1-Nov
COLOR TIMING	18-Oct & 19-Oct	24-Oct & 25-Oct	2-Nov & 3-Nov
CONFORM	20-Oct	26-Oct	4-Nov & 5-Nov
TITLES	21-Oct	27-Oct	6-Nov & 7-Nov
FINAL AUDIO MIX	22-Oct	28-Oct	8-Nov & 9-Nov
LAYBACK	23-Oct	29-Oct	10-Nov & 11-Nov
DELIVER	24-Oct	30-Oct	12-Nov & 13-Nov
AIRDATE	TBD	TBD	TBD

Figure 1.3 Half-hour sitcom sample schedule

CHAPTER 2

Budgeting

Only an accountant or a line producer knows budgets well enough to attach human emotions like love and hate to them. They love the feelings of organization and confidence that come with having all your ducks in a row. Yet they hate the fact that no matter how good everything looks on paper, the first little hiccup can toss their budget right out the window, unless financial contingencies are factored in to cover the expected unexpected. In light of all this, a budget will be needed in the preparation stages of a production in order to secure the appropriate financing. Producers will expect you to create a budget before postproduction has started, then expect you to stick to it. This is why it is often suggested that postproduction be involved as early on as the prep of a film, in order to get bids specifically tailored to the production, from post facilities to colorists, VFX, sound etc., while the budget is being finalized.

Bidding vs. Estimates

Your first job will most likely be the creation of the postproduction budget. Your budget numbers would be derived from a postproduction facility or post house bid. A bid is a list of fees and expenses, with a final price at the bottom indicating the client's cost to have a job produced. Once agreed between the post house and producer, that final number is set in stone – barring any unforeseen situations like added VFX or a director changing their mind during production, which is where a "contingency" would come in handy. It is now your responsibility to produce the agreed-upon work for the agreed-upon price. An estimate is a list of fees and expenses with a final price at the bottom indicating what you *think* the job will cost to produce. It is different from a bid in that the final invoice total of the job may vary from the estimated total.

Keep in mind that if your job includes creating a budget, the producers may not give you an exact bottom-line figure, yet they will expect your budget to meet their expectations. You will be held to and benchmarked against this budget throughout the entire postproduction process.

It's helpful to ascertain whether the producer you're working with is more concerned with the product or with cost, and there are good reasons for both. In TV, if a choice has to be made between product quality and product cost, cost often wins out.

Line Items

A line item is part of an accounting method, listing systematically the production's expenditures by department. Each department's costs are given a separate line on the budget. Assembled during the preparation of a project, the line items assist the production team, who include the producer, production manager, line producer, auditor and post supervisor, in determining costs and expenses. While the software and structure have remained pretty much the same, the line items in a budget have had to adjust over the years to account for the evolving digital landscape. Budgeting has become more complex and precise. Now when preparing a budget, you must account for line items such as new technology and state incentive programs. It is also important to note that not all of these line items would automatically be included in budgeting software, which means you will need to add them in yourself. Most independent and low-budget filmmakers use the existing generic budgets and change the categories to match the technology and delivery elements for the specific project.

It would be impossible, and therefore wrong, to address exact dollar amounts and specific line items in generalizations. No one budget will fit every project. While a production budget needs to factor in the complexity of the shoot, the number of days, locations, travel costs, cast etc., a postproduction budget needs to consider the digital facility's services, QC, captioning, formatting, titling, the amount of VFX, specific sound requirements etc. You will have a more accurate budget if you work with production to establish their requirements as they relate to postproduction.

If you are working on a big-budget or studio show, a professional firm will provide auditors (the studio bookkeepers for each project) and budget software that is created for each individual studio. These are based on the studio's financial needs and the standards that it requires. Costs to do business vary from year to year. They depend on changing technology, labor, materials costs, digital cards, card readers and hard drives, stock prices (that's film stock, not your producer's NASDAQ or Dow portfolios) etc. They also vary depending upon the type of project. For example, a facility may be willing to help out a student or industrial film by giving them student prices. A large studio that brings a lot of volume can usually negotiate a better long-term package deal than an independent production that is only around for one or two projects and no guarantee of return

business. Commercial companies traditionally pay the highest rates – even rate card. In return, they are very demanding, high-pressure clients who require a lot of attention, a high level of service and short deadlines.

Negotiating

So, we know that being a student can bring lower rates. And we know that being a high-volume client can bring lower rates. There are also varying degrees of *lower rates*. Even if you don't have the neediness of a student or the power to bring with you lots of business, you can still negotiate. For example, you could offer all, or much, of your business on a particular project to one or two facilities. There's always room to negotiate, and there's an art to it.

Negotiating like this is called creating a package. A package rate should always be lower than the sum of all of its parts. In other words, if you add up the costs for each item separately, the total needs to be greater than your package rate. Now, whether that saving is 10%, 15% or more will depend largely on the scope of your project, the anticipated billing by the facility and your relationship to that facility. Are you a new client, or are you someone that is coming back as repeat business? If you have brought multiple shows into a facility, your rates will most likely reflect that relationship. Vendors have to be able to count on a certain amount of repeat business. If you are a new client, be sure to bid your job with several facilities. It is the only way to know if your package is a good deal, and it gives you real negotiating power and confidence.

Facilities never want to lose clients and will usually work with you, within reason, on rates and special deals.

Creating a Budget

The real secret of creating a budget is working through it in a step-by-step process, instead of trying to tackle it as one large single task. Show after show, year after year, you will do this, and you'll become a master almost without realizing it. The other secret is in the word "math". Math isn't your strong point, you say? No problem – get a calculator, it's the 21st century for Pete's sake. After that, it's really all just common sense and doing your homework.

It can be daunting to realize that you have to come up with a bottom-line number for a postproduction budget *and* be expected to stick with it, especially if this is your first attempt. Where do you even start? To help, we've provided a list of necessary tools and handy hints to get you started.

Getting Started

The following are six steps that will help you get the necessary information for creating a budget:

1. *Read and break down the script.* It will help to do your own breakdown of the script for editorial, VFX and special sound and picture needs that could potentially cause their cost to rise.
2. *Make sure you have an accurate list of all of your delivery requirements.* It is imperative that every area of postproduction is covered in the budget and in your cost-of-accounting form. Later in this chapter you will find a sample budget form (Figure 2.1) and a postproduction cost-of-accounting form (Figure 2.2) to help provide you with a checklist of the areas that must be covered. The sample budget form can be adapted for feature film, documentaries, half-hour comedies, episodics, docuseries or longform TV.
3. *Know the shoot dates, when the picture must lock, and the delivery date.* Try to determine if these dates are "drop-dead" or if there is some flexibility built in that you can use when negotiating with vendors. Armed with this information, combined with the list of all the areas you need to cover in your budget, you are ready to start soliciting realistic bids.
4. *Relationships.* Call the vendors you know, and your friends and colleagues. Being able to call in a favor or two and get a break here or there due to personal relationships may help you in negotiating your budget. Many larger production companies have deals and special rates already set up with various postproduction facilities around town. Be sure to check with your executives and producers before approaching houses to make deals on your own.
5. *Meet with the vendors to discuss your project.* Discuss with them any special needs or circumstances. These may include, but are not limited to, special effects and opticals, digital formats, film finish, framing issues, special title and graphics needs, delivery schedules, time constraints, and special voice-overs or narration. Don't try to fix it in post; better to have your editor and post supervisor talking with your facilities in preproduction, and not wait until you're locked into problems.
6. *Choose your facilities.* Some people like to do each step at a different facility that specializes in a particular area. Many larger facilities offer one-stop shopping. They can handle several or even all phases of your postproduction schedule. Usually you end up with one or two vendors doing all of the postproduction on a project. There are a variety of factors to consider in this step of choosing your facility. Sometimes price is the determining factor. Sometimes scheduling conflicts prohibit one facility from doing all of your work. And sometimes producers have promised certain parts, or your entire project, to a particular facility. A postproduction house is going to want as much of your business as they can get, and it is certainly easier on the entire postproduction process. To keep your elements safe, it is wise to limit the movement of your files or negative. The facility may be able to adjust or offer certain cost incentives to lure you into giving them a larger portion of your business. It's important to consider all of your options.

Budgeting

A Carefully Planned Nightmare

There once was an associate producer who did her dailies and on-line at one facility, sound at another facility, color correction at a third facility, and duplication at yet another house. Tracking the elements and making sure that everything had been moved from one facility to another for each session was almost a full-time job. And in tracking any problems that cropped up along the way, it was very time-consuming, and nearly impossible, to accurately determine where a problem had started and decide who should be fiscally responsible for any fixes. Schlepping from house to house at each stage, and trying to schedule work around the availability of several facilities and still make deadlines, was extremely taxing. Plus, a facility is going to be less inclined to work with you on costs or to bail you out in an emergency if they are getting only a small portion of the entire job.

Areas to Budget

The following is a list of production and postproduction areas that will need to be budgeted to complete a project.

Production

Although this is not part of the postproduction budget, you will interface with the production team and should be aware of the on-set workflow and prep for dailies. Some production managers appreciate the post supervisor's help in these areas.

- Data capture cards or SSD media will contain raw captured by the camera. The assistant cameraperson (AC) or camera crew is responsible for sending the original digital data to the post facility throughout the day or at day's end, if you are using a facility. If you are ingesting to a hard drive and multiple backups, the DIT will do this. Once the data capture card or SSD media is downloaded and backed up, the storage drive will be verified, and the data capture card or SSD media erased and reused. Therefore, you will need a few more data capture cards or SSD media than expected. AC, camera team or DIT will also check for dead pixels, dropouts, file corruption, color-grading and other technical issues on set during production.
- *Camera settings.* Meet with your production camera crew and DIT to verify how much data will be recorded. 8K capture may be overkill for your production. The reason this is crucial for budgeting is the time and money it will cost to unnecessarily convert files from a high data capture format to a format that you can work with, as well as quantity of storage, drives and file transfer time. Note that most theaters project in 2K, and TVs show content in mostly high definition (HD), while some high-end TVs can play high dynamic range (HDR) and ultra HD. Something else to keep in mind if you

shoot in HDR is that you can down-res to other versions; however, if you film in a lower resolution you cannot up-res.
- A DIT can save production money in post by catching issues on set, and by doing partial color timing.
 - DIT station
 - raw file storage
 - playback

Postproduction

The following are standard items that may be necessary to your budget. Keep in mind your final exhibition source and how your dailies are captured, as well as your schedule.

- Dailies
 - For digital data capture, the post house will transcode the raw data to a compressed format and save the compressed data to the off-line portable drive. The number of shoot days and hours of transcode will be the key to calculate this cost.
 - For film capture, the lab will need to process, prep for scanning (adding leader) and clean your negative. If the lab has a digital facility, they will then scan each of your dailies to the editorial hard drive for editing. If the lab does not provide a scanning service, a digital post house will give you a bid on this process.
- Nonlinear editorial bay/hardware/software
 - Computer and edit bay rentals
 - Avid/Final Cut Pro/Media Composer/etc.
 - Pro Tools or other editorial software
 - File transfer/transcode/compression/codec
 - Hard drives/data capture cards or SSD media/Cloud and data management
- Postproduction staff/labor
 - Postproduction supervisor/associate producer
 - Editors – this may be a union position
 - Assistant editor (vital to your dailies process – logging footage, creating a rough assembly, tracking effects – and will catch defects early in the process, allowing a quicker response) – also may be a union position
 - Color timer/color-grading (if not covered by your post house package)
 - Additional post house staff
- Titles and opticals
 - For independents, most of the opticals can be made in editorial; some must be created by a title and optical department or separate facility.
 - Film opticals can be created during the printing process, or if they are created separately must be bid out.

- VFX
 - Previz (previsualization/rough virtually created or animated versions of shots or sequences ahead of VFX production)
 - Clean plate (shot with same camera angle, setting and depth of field, as well as lighting and movement, but without characters or objects in the frame)
 - Compositing/green or blue screen/scaling
 - Compositing is the combining of visual elements from separate sources to create a single image that makes up a scene.
 - Green screen vs. blue screen depends on the color of the subject's wardrobe or of the object in focus. Most times you will not use green screen if wardrobe is green, unless you're trying to give the appearance of something floating or missing from a shot, since that image will be masked out.
 - Scaling is the adjusting of the size of an image or character without affecting the background or environment. So if you need to shrink, let's say, a wizard to the size of a hobbit, you would scale the wizard down within the environment around him.
 - Rotoscoping (assists in removing an object or character and replacing it with another)
 - Projection mapping (special AR, wrapping and blending the image so that it can be superimposed on a target surface area in 3D displays, visuals and projection; for example, you can create a city in 2D and map it onto any surface, creating a 3D effect)
 - Raw capture file transfer
 - Open EXR (file format using HDR, offering a wider range of brightness values in a scene or image, used primarily for VFX and the Academy Color Encoding System (ACES))
- Stock shots/royalties (you may have to pay transfer fees to use the data, so figure that in as well)
- Sound design, sound mix, looping, sound effects and final layback
- Music composition, scoring, music editor and licensing
- Postproduction and lab
 - On-line editorial/final layback
 - Master/picture MXF files (ProRes/MPEG-2/JPEG 2000/MOV)
 - Mezzanine files (H.264 codec – compressed master file)
 - Sound files (AIFF/.wav/MP3)
 - Versioning (subtitle, dub, closed caption, watermark, censorship etc.)
 - Internegatives and prints
- Negative cut for film finish or film out
- Test screenings
- Delivery elements

- Digital master deliverables
- DCP
- Archiving
- Duplication

Understanding Costs and Bids

The vendor will usually give you cost estimates over the phone, and follow up with a hard copy of their proposed package a day or so later. A verbal estimate allows you to start on your budget right away. If you have never done a budget, ask your auditor for a blank postproduction budget. You can then break down the costs as you get them and negotiate your rates.

Figure 2.1 is the top sheet for our sample budget form. The line item numbers 3700, 3800, 4000, 4400, 4600, 4700, 4800, 4900, 5000, 5100, 5200, 5300 and 5400 are designated to specific areas of postproduction. Some of these assignments are broken down further on the sample accounting form (Figure 2.2). These are the line items you must concentrate on when you break down your costs. Please note that each company may have a similar or different budget form and its own system of line item numbers. The ones we use here are for reference and explanation in this book only. Also, there are a number of budgeting software programs (EP Movie Magic, Hot Budget, Gorilla etc.) available that can be purchased off the shelf or online. These come as generic industry-specific budget spreadsheets and cost-accounting ledgers. If you're working on a studio production, they will have their own dedicated software.

As your bids come back (or as they are provided to you by your company), it will be easier for you to fill in the figures. There are several ways to fill in a budget (but we recommend pencil... just kidding). Costs can be broken down in a number of ways. It may not be easy at first glance to know whether you have been offered a good deal. Be sure you understand the bids and all the steps it takes to complete the project. Don't be afraid to ask questions!

Not understanding will catch up with you. Someone, usually an executive, will want you to explain a cost, and you'll look inept and unqualified if you cannot. Understanding what is included in the bids and the vendor's listed line items, workflow and labor costs will also help you stand your ground with the producer.

We don't say things like this to put you on the defensive. We have been in these situations once or twice in our careers, and we're hoping to make your way a little easier by pointing out some of the simple traps we all can get ourselves into.

When the vendor's bid comes back to you, first break it down into the individual components. Facilities like to give package deals. They should represent a better rate for the client and more profit for the facility by locking in a guaranteed amount of work. However, these bids can be harder to dissect.

Package deals will not give a specific rate for individual items like digital master or LTO or DCP, or a per-hour rate for, say, on-line editorial or layback. Without an idea of what you will be paying per each digital upload or transcode per hour, it's very difficult to compare bids. In this case we recommend calling the facility that gave you the package deal and asking what the rate would be if you needed one hour of editorial, or an additional DCP, or an extra hour's color timing session… and what you will pay if you exceed the allotted package estimate. This will give you a better idea of what the rate is outside the package.

Knowing what steps will be necessary to complete the job will also help. Whether you need to make elements for theatrical delivery or material for TV and streaming, talk to the postproduction facility about what elements will be needed and next steps for the intended distribution platform.

Further research will reveal that each of these elements will need to be inspected and QC'd. If you are exhibiting digitally, you will need to create a DCP, which may need to be loaded to a special CRU drive, which also needs to be packaged with special cables and other materials when shipped to exhibition. Make sure these items are included in your original bid. Does your bid include labor charges? Those will need to be factored in, so make sure you get these figures.

As you can see, there are a lot of details to some projects. It will benefit you to take the time and learn what is needed to get your job done. Feel free to ask questions and check with experts to create a more accurate budget.

Purchase Orders

A purchase order (PO) is the written record of items purchased or rented and the per-unit cost applied to those items. Some studios use work orders in place of POs. At the very least you have to have a way of tracking purchases.

If we convince you of nothing else throughout this entire book, we hope to be able to impress upon you how vital POs will be when it is time to reconcile the moneys you authorized to be spent on the postproduction of your project.

Actual POs will vary widely in design and form. But they will all contain the same facts. There will be a place to record the vendor to whom you are issuing the PO, what is being ordered, the quantity, the price per unit, and the total dollar amount. Be sure to date all of your POs. Each PO will carry its own number. This is your tracking system. Some vendors will require that you provide a PO. So, even if you don't set up a system from the start, you will need to be prepared to issue some POs during the postproduction process.

Create a PO book, log or spreadsheet to track each PO number when it is assigned. It will be helpful to note some general information about who that PO number went to and what the PO was for.

Often, production accounting will want a regular tally of your PO totals so they can create their budget-to-date and cost-to-complete reports for the

producers. These reports tell the producers how much money has been spent to date and provide an estimate of how much it will cost to complete the project.

PO instructions should also include specific information about the service ordered. For example, if a PO is made for dailies, make sure it names who the dailies are for and how they are to be made.

If you are posting a series, each episode needs to have its own separate PO numbering system and set of POs. This allows you to quickly and accurately track work for each episode.

When approving invoices and costs, it is convenient to have a hard copy of each PO to attach to the actual paperwork, to back up the work that was done.

Non-Disclosure

Before diving into the detail area of postproduction, we are going to make an important note about protocol. If you are a postproduction supervisor on a project and have the honor of viewing the complete budget for your show (with the summary top sheet attached), behave accordingly. Do not repeat the figures you have seen or the bottom line to anyone. These numbers are privileged information, and the fact that they have been shown to you means that you are respected and trusted. Do not risk your job or your reputation by sharing this information. We have written this book with the humor and lightheartedness that is needed in this crazy business, but this advice is not a joke and is given in all seriousness.

If you have seen the budget, you will probably be required to attend the weekly budget meetings. The producer, auditor, production manager and postproduction supervisor are brought together to review how much has been spent to date and how the estimates are holding up. As the postproduction supervisor, you will be asked for details relating to moneys spent and estimates of costs to be incurred going forward. These meetings are not meant to put you in the hot seat but to review what's been spent and what is expected to be spent in the future. Keep your POs up to date and an eye on the schedule, and you will do fine.

A Sample Budget

Figure 2.1 shows what the cover page of a project budget, called the top sheet, may look like. This is an accounting of each area that may be included in the budget. The top sheet will contain the final amounts budgeted for the entire project, including development, preproduction, production and postproduction. On this sheet, the page number for each item refers to the page in the full budget where the line item is located. These items are called the account and detail areas. A total budget for a project can include many pages.

Figure 2.2 is a sample page from an actual cost-of-accounting form. This shows the line item breakdowns of the subaccounts in detail. This is where you

Budgeting

PRODUCTION TITLE – MY PRODUCTION BUDGET PRODUCERS: S. Spohr, B. Clark, K. Bakhru

SHOOT: Number of Principal Photography Days DIRECTOR: D. Higginbotham

UNION: SAG-AFTRA DIRECTOR OF PHOTOGRAPHY: D. Orr

Acct#	Category Description	Page	Total
1100	WRITER, SCENARIO & STORY RIGHTS		0
1200	PRODUCER UNIT		0
1300	DIRECTOR UNIT		0
1400	PRINCIPAL CAST		0
1500	SUPPORTING CAST		0
1600	ATL TRAVEL AND LIVING EXPENSES		0
1800	FRINGE BENEFITS		0
TOTAL ABOVE-THE-LINE		$	0
2000	PRODUCTION STAFF		0
2100	EXTRA TALENT / BACKGROUND ARTISTS		0
2200	CAMERA		0
2300	DIT / DIGITAL IMAGING TECHNICIAN		0
2400	PRODUCTION SOUND		0
2500	GRIP / SET OPERATIONS		0
2600	ELECTRICAL / SET LIGHTING		0
2700	LOCATION & EXPENSES		0
2800	ART DEPARTMENT		0
2900	SET CONSTRUCTION		0
3000	SET DRESSING		0
3100	PROPS		0
3200	WARDROBE		0
3300	MAKEUP / HAIR		0
3500	TRANSPORTATION		0
3600	PICTURE VEHICLES / ACTION PROPS		0
3700	FILM & DIGITAL LAB PRODUCTION		0
3800	DATA CAPTURE CARDS / STOCK		0
3900	SECOND UNIT / VR		0
4000	DAILIES / HMU TESTS		0
4100	BTL TRAVEL AND LIVING EXPENSES		
TOTAL PRODUCTION		$	0
4400	VISUAL EFFECTS		
TOTAL VISUAL EFFECTS		$	0
4600	PICTURE EDITORIAL		0
4700	MUSIC		0
4800	SOUND DESIGNER		0
4900	MASTERING (FILM or DIGITAL LAB)		0
5000	TITLES / ARTIST		0
5100	VERSIONING / LOCALIZATION		0
5200	MISCELLANEOUS POSTPRODUCTION		0
5300	STOCK FOOTAGE		0
5400	FRINGE BENEFITS POSTPRODUCTION		0
TOTAL POST PRODUCTION		$	0
6500	PUBLICITY/STILLS		0
6600	PRODUCTION INSURANCE		0
6700	PUBLICITY / STILLS		0
6800	GENERAL EXPENSE		0
7400	FRINGE BENEFITS – OTHER		0
TOTAL OTHER		$	0

Acct#	Category Description	Page	Total
	Total Above-the-Line		
	Total Below-the-Line		
	Total Above and Below-the-Line		
	Contingency 10%		
	Bond 3%		
	Grand Total		

Figure 2.1 Sample top sheet budget form

list each cost separately, and their account totals go into the "total" column on the cover page under their respective account numbers.

The following is an item-by-item description of each postproduction line item in the sample budget. For weekly shows you will have a new budget for

Acct#	Description	Page#	Total
4600	OFFLINE PICTURE EDITORIAL		
4601 - 4602	EDITOR and ASSISTANT EDITOR		
4603	APPRENTICE EDITOR		
4604	EDITING BAY and EQUIPMENT RENTAL		
4700	MUSIC		
4701	MUSIC SUPERVISOR		
4702 - 4704	COMPOSER / MUSICIANS / PERFORMERS		
4705	ORCHESTRA		
4706	MUSIC LICENSING		
4800	POSTPRODUCTION SOUND		
4801	SOUND EDITOR / SOUND EDITING / SOUND DESIGN		
4802	SOUND MIXER		
4803 - 4804	ADR / FOLEY		
4805 - 4807	FINAL SOUND LAYBACK / DUBBING / FOREIGN M&E		
4900	MASTERING		
4901	FINAL CONFORM		
4902	DIGITAL INTERMEDIATE		
4903	DCDM		
4905	DIGITAL MASTER		
TOTAL FOR 4000			
5000	MAIN TITLES-ARTWORK / MOTION GRAPHICS DESIGN		
5001	END TITLES-ARTWORK		
5100	VERSIONING / LOCALIZATION		
5101-5102	SUBTITLES & LOCAL TITLES		
5200	MISCELLANEOUS POSTPRODUCTION		
5201	POST HOUSE STAFF		
	COLOR TIMER / MACHINE ROOM TECH / ONLINE EDITOR / ARCHIVIST		
	DIGITAL CINEMA TECHNICIAN		
	DAILIES TECHNICIAN		
	VFX PRODUCTION MANAGER / COORDINATOR		
	QC (QUALITY CONTROL)		
5202	ADDTIONAL EQUIPMENT / SOFTWARE PURCHASES		
5203	MASTERS / STOCK / STORAGE / TRANSFER / SHIPPING		
	SATELLITE / CLOUD BACK-UP / STORAGE & TRANSFER / TERABYTE RAID DRIVES		
	DCPs / CRU DRIVES		
	LTO		
5300	STOCK FOOTAGE		
TOTAL FOR 5000			

Figure 2.2 Cost-of-accounting form

each episode. For feature or 90-minute programming, there will be one budget for the entire completion process of that show.

We can't stress enough the importance of applying a dollar amount to line items that you know will be required by production. If you aren't sure where to start, start at the end with deliverables and work your way back. Where will your content be exhibited (theatrical, TV, streaming, Blu-ray/DVD, on film or digital)? This will help you with scheduling and budgeting.

Also, be aware that on a production budget an auditor will include fringes (such as additional fees like taxes, insurance, union, add-ons, kit rental etc.) for different departments, and a 10% contingency (for those unexpected or forgotten costs); an independent production company may be required to put up a 3% bond (not James Bond) and a bondable line producer.

Cost-of-Accounting Form Breakdown

3700 Postproduction Facility (aka Film and Digital Lab)

This section is where you will put all of your costs for items such as your film finish or film-out postproduction facility, or post house expenses and raw production materials.

If you are the postproduction supervisor and there is not a separate line item in the budget for your salary, put one in here.

3800 Data Capture Cards/Stock

Previously this would be where you would list your tape or film raw stock. These days you'll most likely be including costs for digital capture cards for picture and sound cards.

3900 Second Unit/VR

Usually under the DGA umbrella, second unit includes additional photography, VFX, stunts, and other items such as VR, AR and 3D stereoscopic.

4000 Dailies/Hair and Makeup Tests

This represents the actual dailies data processed by the post house. These are created by the post house, normally with rough picture and sound married, and provided to the director and the designated key production team, by either digital copy, screening disk or secure internet transfer. In relation to film, this figure is based on an equation of roughly 80% of daily average film shot multiplied by the per-foot developing rate. Normally, film print dailies come in around 60% of this total. If you are not ordering print dailies, be aware there is a postproduction facility charge for prepping and cleaning film for scanning to digital dailies. Any special handling charges will be included here.

Burned-in timecode is created as well, in a second master, while the dailies are being synced. These burned-in numbers are permanently displayed, referencing the timecode of a clip as you play it back. This is useful and necessary in editing for marrying picture and sound, tracking shots, noting adjustments, reshoots etc.

To arrive at an estimated cost for creating each day's dailies, calculate shoot days by the number of digital screeners or upload time to the Cloud, plus the costs of stock and duplications that you will be making. Your transfer house will include these totals in their dailies transfer/transcode bid. Remember to add monies if you are doubling up dailies footage or shooting several cameras every day.

In general, a postproduction supervisor will not need to budget for the film stock, data capture cards or SSD media required for dailies production. Because we have experience with the lab, the production manager may ask you to help with the estimate. For an episodic or sitcom there may be a different director for each episode; therefore, you will want to allow for a change in shooting styles, lighting etc. Some directors will use more data capture cards or SSD media than others. Young or inexperienced directors may tend to shoot more takes or add more shots (and choose more circled takes). Also, the more cameras that are rolling, the more data capture cards or SSD media drive space you'll need. You will also need to think about external hard drives for data storage, i.e. a terabyte hard drive or Thunderbolt RAID drive for a single-camera shoot, plus an additional drive of the same size for backup.

4400 VFX/Photographic Effects and Inserts

Keep a separate accounting for any special effects, animation, plates or inserts you will shoot or create. VFX budgets have a way of growing exponentially at the blink of an eye. Go to the VFX experts, show them your script, and get their best bids at the start of a project. Unless you have a lot of experience in this area, do not try to guess these costs on your own.

4601–4602 Editor and Assistant Editor

The editor and assistant editor will have a standard rate, and it will usually be a union-mandated wage or higher – whether or not you are crewing a union show. If yours is a nonunion show, the editor and assistant editor may not insist on strict adherence to the union-mandated hours, but you should expect to pay extra for weekends and sixth and seventh days. Either you or the production manager may be responsible for negotiating the editor's and assistant editor's rates.

How long the editor stays with a project depends on the project and the producer. Sometimes, for an episodic or longform TV program, the editor is let go once the picture locks. The lower-paid assistant editor is often kept on the

payroll until the picture is delivered. Some producers will bring the editor back for the audio dub. Check with your producer before committing the editor's schedule to paper.

4603 Apprentice Editors

On a union shoot, there is a set rate for this position. Otherwise, this position is usually paid the same rate as a runner or production assistant. Apprentice editors are brought on staff when the project has a very tight schedule and there is a large volume of dailies. In TV, they are usually kept on staff until the director has viewed the editor's cut. In features, they work through delivery. It is rare that apprentice editors are employed on episodics or sitcoms. Sometimes when an episodic has a tight postproduction schedule and employs two editors and one assistant editor, an apprentice editor will be brought on to assist the assistant. They still may be required to perform duties such as pickups and deliveries.

4604 Editing Bay and Equipment Rental

Your assistant editor will provide you with a list of necessary supplies prior to the start of production. This could include the following editing suites, furniture, computer hardware, monitors, software and file-sharing services:

- Rental of off-line editing bay/editing suite
 - An isolated, quiet space – it could be a bay or bays in the post facility, or an office room rental.
 - Episodics or larger studio projects may have multiple editors working in various bays.
- Monitors
- Editing keyboards
- PC or Mac
 - Must have enough bandwidth to handle larger gigabyte-size files during ingest, file transfer, encoding, transcoding and/or rendering of data and adjustments.
 - The number of bytes (amount of storage) you will need for the duration of your project will depend on the complexity of the project, the data to be stored and the image resolution.
- Editorial storage external terabyte Thunderbolt hard drives or RAID drives
- Editing software packages such as Adobe Premiere Pro, Final Cut Pro, Avid etc.
- Additional software could include Pro Tools, Creative Cloud apps, After Effects, Audition, Photoshop, Illustrator, Media Encoder, minimal FX software, even basic software like Word, Excel, Acrobat etc.

- Cloud and FTP file-sharing access (each of these allows the transfer and sharing of data across the internet, using different protocols)
- Edit suite furniture including table(s), couch, ergonomic chairs, mini fridge etc.
- Headphones

4700 Music Editor and Assistant/Music and Effects (M&E)

Occasionally this shows up as a line item under the music section of your budget. The music editor and assistant will charge a standard rate for the number of weeks involved. Find out what additional rate will apply should you go beyond the initial contracted time. The price you pay for the music editor will usually include an assistant, but not always, so check. The editor and assistant may elect to be responsible for their own union costs. You will still need to budget for all applicable taxes, such as payroll and pension. There should be no unexpected expenses here unless you have large delays or a rush situation that requires the editor to hire an additional assistant to meet the accelerated deadline.

4701 Music Supervisor

Low-budget features may not be able to afford a music supervisor, but if you can budget for this position it will make your life exponentially easier, since they coordinate all music aspects of a project, including assisting with licensing.

4702 Composer

Often the composer will charge a package price. If not, break down the fees in the sections that follow. Your music supervisor can help you with these costs (see item 4701).

- In some instances, your composer will hand off the completion of smaller pieces of the score to a less expensive music writer or an orchestrator. The composer writes the first part, or the underlying theme, and the orchestrator will complete the piece. Some composer packages include these costs. If not, they need to be listed separately in this area. This may be a union position with set union wages.
- A copyist transcribes the musical score for each instrument.

4703 Musicians – Score or Prescore

If your composer needs to hire musicians, these costs will be outside his or her original package deal. You will have to pay these musicians, their union benefits and any applicable payroll taxes. If the composition is complicated, there is usually a prescore or rehearsal session prior to recording. This would be rare for TV.

4704 Singers/Performers

The Screen Actors Guild (SAG) monitors this position, and you will be charged for all applicable union benefits and payroll taxes.

4705 Orchestra

- The orchestra contractor is a union orchestra member who watches after the union rules and tracks the musicians' hours and breaks. This individual will handle all of the union paperwork and provide packets of signed W-2s, I-9s and contracts for the session.
- Studio time on a scoring stage will need to be coordinated if you are going to have an orchestral score. Make sure it is also in your budget. Don't forget to add in the mixdown time after the scoring session if your mixdown is being done at the same location as you are scoring. Remember to add in digital storage costs to the session fees.
- Cartage or instrument rental will be needed if your composer writes an orchestral score and the musicians hired need to rent their musical instruments, if they do not own them, or if they pay to have them moved from storage to the session (cartage). Those charges would be added here. You may not know these numbers until the actual scoring session.

4706 Music Rights and Licenses

There are two sides to every song: A sync license and a master use license. A sync license allows a music user to use a specified piece of music for a motion picture, TV production, video or advertising commercial. A master use license is used in getting permission to use a specified recording of a song. For instance, if you intend to use a specific recording of a song by its original artist or band, you need a master use license and a sync license. If you intend to have another artist or band perform a version of the same song, and you only need the lyrics, then you simply need the sync license. Some shows budget money to purchase already existing music. You can purchase the rights for the lyrics and hire an actor/singer to sing or play the tune, or you may purchase the master use license to use the original recording. You may incur additional costs for uses in foreign markets. Put all related costs here – and they can be costly.

4800 Postproduction Sound

These budget items will include any effects, sweetening (sound design), looping or mixing. Sometimes this number comes as a package flat rate. The company doing your final sound can help you estimate these costs to arrive at a reasonable figure. We have provided line items to help you list these costs separately, should that be required. This will become especially necessary if you are posting in a foreign country.

4801 Sound Editor/M&E

Sound editing and sound effects are usually a package deal with the sound design company. The sound design company employs people and their services on behalf of its clients. The salaries for any sound employees are usually covered in the package price. If you are doing the postproduction in a foreign country, you may have to pay a separate rate to the effects editor and assistant effects editor, plus any additional costs for using effects that are not contained in their existing library. In this instance, these positions are on your payroll and you must pay pension, health and welfare, and all applicable taxes (these would be considered fringes).

4802 Sound Mixer

The sound mixer can at times be confused with the sound editor, but you need to make sure there are separate line items reflecting each position, as they handle different steps of the sound process. Generally, the sound mixer is included in the dubbing package and works at the dubbing stage, but that may not be the case if traveling out of the country. They are responsible for your final mix.

4803–4804 ADR/Looping/Foley

Looping or ADR (i.e. automated dialogue replacement) is exactly what it sounds like. When a piece of dialogue is missed on set during production, or may not be clear, or may need to be replaced due to other reasons, ADR or looping is recorded and later conformed to the original audio track.

A foley artist recreates sound in a postproduction facility. Utilizing the tools and props available to them and their creativity, they can recreate the clopping of horse hooves by using a couple of shoes on a small mound of dirt. While audio is recorded during production, there may be a sound that isn't clear or needs to be highlighted or enriched: This is where a foley artist would come in. Foley and ADR tend to show up in the same line item, but they are different jobs handled by different crew, and at times even different facilities, so you should account for both positions in your budget. You will need them.

The sound effects company may include foley artists in your foley package. If that is the case, don't add that payroll here. This area holds your sound or stage facility package costs. Your package should include three days of foley for a low-budget feature.

4805 Final Sound Layback and Export

Once you've created your final sound mix, you will have a final, finished mixed audio .wav file. The costs here will come with the time it takes to export and marry this audio file to the picture during the final layback (see the sound chapter for more details).

Budgeting

4806 Dubbing

This area will include any effects, sweetening or mixing for additional versions. Sometimes this number comes as a flat rate. But to list costs separately, add three days for a longform TV program (or whatever dubbing time is appropriate for your project), any extra equipment or stock or storage required, the looping stage and the sound effects company's bid, temp dub, predub, and final 24-track mix. Include any mixdowns to six-track, Open Media Framework (OMF), Advanced Authoring Format (AAF), QuickTime (QT) etc., and any music elements for delivery requirements. The company doing your sound transfer can help you estimate these costs and arrive at a reasonable figure.

4807 Foreign Delivery Requirements

Refer to your delivery requirements, but any additional sound tracks, such as foreign fill M&E, as well as dubbing, subtitling, closed-captioning, territory-specified censorship, duplication and standard conversions, will cost extra and must be budgeted. Whether that cost is picked up by the production company or by your foreign distributor, it is good to keep these foreign costs separate. Then, if the studio calls for an audit of your budget (not an uncommon occurrence), these costs won't get mixed in with the domestic expenses. Don't forget to ask about mastering charges for foreign theatrical materials. You'll have to allot money for this as well.

4900–4906 Mastering

This would be a package deal through your digital postproduction facility, and would include final conform, digital cinema distribution master (DCDM), digital master and DI. Something to keep in mind: You may accrue additional costs if you run past your allotted time for color correction, and if your raw dailies aren't staged or VFX are not completed in time for your final conform session (for more information on mastering and digital intermediate, see the mastering chapter).

5000–5001 Titles/Artist/Opticals

For feature shows, graphics are created independently from the rest of the production process. A graphic design or effects department within your post facility or an independent company will create these elements. Look to your postproduction facility or post house contact for guidance. Remember to determine as early as possible if your titles will require creation by a specialty company. Titles that require work at a specified graphics facility are going to cost a lot more than ones built in your on-line session; those additional costs should be included here. You will usually need to keep your textless backgrounds after the titles and opticals

are created to fulfill your foreign delivery requirements. If you are creating a film finish project, consult with the film laboratory concerning your opticals.

Episodics will require that a main title be created. This can be expensive. Longform often have the graphics department at their on-line facility create the main titles. This should be included in your titling hourly rate and will be much less costly.

5100 Versioning and Localization

This would include localization and versioning for main titles, subtitling, dubbing, and texted and textless content for foreign markets, as well as transcription and closed-captioning. Most indie filmmakers will not need to be concerned about this very specialized foreign delivery item, as most likely foreign distributors will oversee this; however, it is something you should be aware of (see localization in the sound chapter for more information).

Check your foreign delivery requirements. Usually they will call for a continuity script. The continuity person will require a MOV/MPEG/QT file with visible timecode and a final script. The continuity person usually charges by the hour for feature productions. Add the script duplication and digital dubbing costs to get your total.

5200 Miscellaneous Postproduction

This area of the postproduction budget and accounting cost form would consist of additional post house staff, services, travel, meals, insurance, taxes, and other miscellaneous costs accrued during postproduction that you may not be thinking of.

5201 Additional Postproduction Staff

This subsection might include staff that are hired for a short term, or if you are posting out of the country where each step is separate and perhaps not covered by a package deal. The additional personnel could include but is not limited to:

- postproduction supervisor assistant or additional editorial assistant
- freelance color timer – if you are trying to do this yourself
- machine room technician, on-line editor or archivist – again, if you are trying to do this outside a post facility
- VFX production manager/coordinator – this is money well spent if you hire someone who knows their workflow

A few things to note: If the DP and director expect to supervise the entire color correction process, this could add additional time. Posting in high resolution (4K,

8K, HDR etc.) could also add additional costs to this area. If you are required to deliver multiple versions on your project, check with your post facility regarding the most cost-effective way to create these elements.

5203 Masters/Stock/Storage/Transfer/Shipping

- DCP duplication
- DCP theatrical distribution on CRUs in shipping cases or specialized boxes
- Key generation (KDMs)
- LTO
- Copyright dubs
- Required deliverables for over-the-top content (OTTs)
- Hard drives
- Film finish or film-out negative and print for archiving
- Film finish or film-out will require picture leader. You'll need to purchase pre-picture countdown (academy leader) and picture start leader for a feature.
- Shipping raw data or processed film from location to the post house, and processed dailies back to set, will require a runner or messenger service. Even if the post facility offers to arrange the daily pickup and delivery of content, they will charge costs back to production. Also, if filming outside the country, you'll need a customs broker for shipment of content. Include these costs here. (An alternate method of shipment of content is via file transfer.)

Prior to the start of production, get a list of supplies from your assistant editor. Use POs to track expenditures, as this section will balloon very quickly, and you will need to be able to trace where the money has gone.

5300 Stock Footage Use License

Add to this section fees for the purchase of stock footage (royalties or licensing) and costs to upload, transfer, edit and color time the stock footage shots to match picture. Itemize these costs as specifically as you can so you can justify them later should there be an audit. If you have already listed these costs in the film lab/postproduction section, do not duplicate them here.

There are royalty-free sites where you can license stock footage. You want to be cautious with this. Just as with music, it is recommended to purchase an all-rights usage license across all platforms, not a license limited to online usage or festival rights, since a sales company or distributor will need to know that you own the film outright and there are no surprise additional costs. You'll also want to make sure that you do your research and verify that the footage is cleared and that there is a clear chain of ownership or "chain of title".

5400 Fringe Benefits – Postproduction

Get these figures from your accounting department or auditor. Items in this section will include payroll taxes, pension costs, health and welfare insurance, and any rental or kit fees paid to crew members who are authorized to use their own supplies.

A Few Additional Budget Tips

For dailies transfer, data capture cards or SSD media, base your estimate on the number of shooting days, hours and number of shots expected, adding for any extra takes or unplanned shots.

For hard drive rental or purchase estimates, remember that backup drives must be used simultaneously in preserving copies of digital masters while on set during production. Cloning of the digital masters is also an option in post, but it is highly recommended that backups be recorded on set, and that the post house archive the backups or clones.

Confirm data files and codec before production to avoid additional transfer costs. The capture format must be compatible with the editing system (i.e. codec, conversion etc.); if not, it could cause time delays and cost more money, thus raising your budget. We cannot stress enough that the camera team, editor and postproduction supervisor must coordinate at the start of the project to ensure a smooth and timely transition.

While episodic or comedy TV may have a similar workflow, it is a unique format requiring additional cameras, rotating directors and editors, and short schedules. All of this will use up more data capture cards or SSD media, hard drive space and additional editorial workstations. It is always best to err on the side of caution and talk to your producer before production so that no misunderstandings occur.

Music licensing or stock footage can be expensive. Know your delivery market, territory and the length needed to satisfy your final delivery. Negotiating after the fact will likely cost you more money. For more information on licensing, see the legal chapter.

If you have any doubts or questions about costs, pick up the phone and call someone. Your post house, title/VFX company or lab can help you estimate costs based on the type of project you are budgeting. They want you to succeed and return with another project.

Summary

It will seem that everything costs more and takes longer than expected. Unfortunately, there is no secret formula to accurately estimate costs. It is not

ethical to advise you to "pad" your budget for unforeseen costs, but we can urge you to add monies for all the delivery materials required, and a few additional items like duplication or a few more hours of a sound mix, because you will use them. If this is your first budget, you will rely heavily on your postproduction facilities and department supervisors to help guide you. It will get easier, and you will be more accurate with experience. Understanding the director's vision, doing several of the same type of project, involving the postproduction facility at the start, and working with a bondable line producer will go a long way toward getting your budget in the ballpark.

A completion bond is a guarantee – a written contract stating that a feature film will be finished and delivered on schedule and as budgeted. Bondable line producers and an experienced production manager and DP will ensure that there is an experienced team overseeing the production. Completion bond fees are put into the production part of the budget.

The information in this chapter is meant to be used as a guide. Equations, when noted, are tools with which to estimate your "best guess". Many variables affect the bottom line. Keep a detailed log of POs and amounts and reasons why extra things are needed or become necessary. Always be able to back yourself up when the producers or auditors start questioning costs. You are spending someone else's money, and your purchases should all be backed up with authorization, paperwork, POs and memos. The more paper flying around, the less explaining you'll have to do.

If you've come to the last page of this chapter and still have some areas in which you are unclear, pick up the phone and call an experienced line producer or postproduction supervisor. Get references from your auditor or the post facility for people working on projects similar to yours. Your auditor may be a good accountant, but postproduction is a specialty. And unless the auditor concentrates on feature or TV as their sole business, they may not know all of the intricacies of postproduction. Just remember to do your homework, go with your gut, and question things that don't seem right.

CHAPTER

3

Digital Workflow and the Film Laboratory

It's all about the files…

Workflow is the sequence of processes by which work is completed. Digital workflows in the entertainment industry automate the flow of tasks and activities, reducing the time the process takes to complete, as well as eliminating potential errors. Workflow automation makes processes more efficient, compliant and agile.

Digital Workflow

In the old days (aka the last edition of this book), the majority of movies and TV shows were shot on film and, in the case of movie theaters, distributed on film. Film is tangible and analog, and must be assembled in a particular order. In analog technology, a wave is recorded or used in its original form. So, for example, in an analog tape recorder, a signal is taken straight from the microphone and laid onto tape. In digital technology, the analog wave is sampled at some interval, and then turned into numbers that are stored in the digital device.

Currently the majority of projects are captured digitally and remain as digital files throughout distribution. The data can be captured in several different file formats. It is then reduced in size for ease of editorial. VFX effects are created, and then all the pieces are recombined to create a final storyline. VFX rarely use the raw material for their work. They will get an uncompressed image sequence such as EXR or DPX. Once the picture is locked, the data can then be saved in many different file formats, depending upon the distribution medium. This can become very complex, and you may have to make a chart to keep track of the data, where it is and what stage of completion it is in.

Here's a list of things to keep in mind before you start.

- Understand the custody of your data. It will be shared with editors and facilities, and will flow through many people's hands.

- Track protocols and *don't ever delete your content* until you have verified it's been backed up several times.
- Set up your color pipeline in preproduction. (This cannot be overstated, as this often dictates the look of the film, and people often fall in love with dailies.)
- Plan your entire workflow in preproduction.
 - Test your workflow before any rush scheduling starts.
 - Build in extra time to make sure your files can be delivered from transcoding dailies to editorial, to delivery of network dailies, and to other facilities if necessary.
- Coordinate naming conventions between your editor, digital facility, VFX and any other vendor that will need material.
- If your show is VFX-heavy, make sure to review your post schedule with the VFX company to confirm that the work can be finished on time. Waiting for VFX and other files is very frustrating and can be nerve-racking; it will hold up your production line and increase your budget.

Find trusted vendors for your entire production before you shoot anything. Learn enough to be dangerous, and when in doubt find experts you trust to ask. It might be a good idea to run a piece of footage (e.g. a hair and makeup test) through your entire pipeline as a test to see where things get hung up. Where was the ball dropped and by whom, or was it a particular technology? It's better to catch it now, before you are in a time crunch.

To keep it as simple as possible, we have broken down the files into the following categories:

1. Digital capture/camera files. The picture and sound are recorded. Sound is usually recorded on a memory sound card. The picture file is specific for each particular camera type.
2. Dailies archiving. Storing raw dailies data on a dedicated hard drive, RAID or server, or in the Cloud.
3. Editing data. Editorial and viewing dailies have been transcoded to the proper format per the predefined specifications.
4. VFX. Using either original camera data or computer-generated images.
5. Final sound files. Added to the elements needed for mastering.
6. Mastering. Putting all the pieces together into a final storyline, with the highest resolution and the proper content, container and codec.
7. Distribution. Creating several different elements for multiple distribution venues.
8. Archiving. The files kept for final delivery – usually archived to LTO tape in some type or storage vault, but possibly in the Cloud.

We will follow the files through the workflow process and how they may change with each step. It is important to explain the makeup of the files before we start. A common misconception is regarding wrappers vs. containers. What's a wrapper vs. a container? A wrapper or codec is what your content is made of: It's a flavor, like QT. A container is the bucket your content is housed in: For example, MXF.

The files themselves are broken down into:

- Content. What is in the files, i.e. action, sound or other material.
- Container. Also known as a format, and usually represented by a file extension. It "contains" the various components of images, sound and metadata, and is able to play back or "distribute" that data.
- Codec. A method for encoding and decoding data, and more specifically a protocol for compressing data. It is often confused with the container; however, they work together to play and compress the data content.

As a postproduction supervisor you may not have to use these terms. However, it's good to know, especially if the show is very detailed and technical.

To help you follow the files, we created a handy-dandy chart (Figure 3.1).

Dailies Capture/Camera Files

Big blockbuster effects features might start to chart their production data files long before live-action production begins. Often the creation of complicated

Figure 3.1 Digital file workflow

computer-generated effects begins in preproduction, and the data will need tracking. This is not the usual workflow sequence, and therefore we are going to begin at the beginning with capturing dailies on the set.

The director has a team that helps capture the visual style of the project. The DP is in charge of the camera and the capture of the data. In addition to the DP, there is a very important new member of this team, and that person is responsible for managing all the data the DP captures. This new team member is a digital imaging technician, which has been shortened to the unfortunate acronym DIT. Together these three people coordinate the camera settings, signal integrity and image manipulation, which includes color, to ensure the highest-quality data. File-raw camera files come in a variety of file types; it all depends on the camera you are using. ARRI cameras will have ARI file name. ARRI shoots an image sequence, whereas Red shoots file per shot. Red camera files still have a unique extension: R3D. Panasonic also have their own. In a multi-camera shoot, pick a predominant camera and use that file type as much as you can. Your dominant camera should dictate the color space you use.

The camera captures data and saves that information on a data capture card or SSD media. The card or SSD media must be formatted before use, and this is done by the AC. A bit of caution here: If you have a data capture card or drive that has data stored on it from a previous capture, the material will be erased if the card or drive is reformatted. It's best to start with cards or drives that have been cleared of any data. The dailies data is referred to as raw files, implying that it is not edited. We heard a story about a DIT who accidently recorded over some footage. The DIT removed the data capture card from the camera and inadvertently stuffed it into his shirt pocket. Forgetting about it, he thought it was an extra card and put it back in the camera without backing the footage up. The entire morning's shoot on that camera was lost. The lesson here is back up, back up, back up. Have a protocol whereby you can confirm when each camera roll has been backed up in at least two locations.

Dailies Archiving

Store the original camera data on a dedicated hard drive, a RAID or a server.

Once the data has been captured, the data capture card or SSD media is downloaded by the DIT into a RAID – a "redundant array of independent disks", or dedicated hard drives, that are on a mobile cart on the set. The cart is called…wait for it… a DIT cart. We do not recommend production erase their cards until they have the media backed up in multiple locations, and in many cases not until the LTO or Cloud archive is confirmed. Then the card is erased and used again. Before the data is erased, it is viewed by the team, and the shoot continues. The playback monitor will also need to be calibrated. The DIT, or sometimes your post facility, will support calibration on set and be responsible

for this adjustment. The standard color space measurement for digital cinema is DCI-P3 (a range of color signal for a particular device or monitor), and for TV/streaming the color space is Rec. 709. Most on-set monitors are in Rec. 709 color space, and this gives the DP and his team a definite idea of how the final show will look on screen. The DP will assign a lookup table (LUT) to the daily footage, which will be used as a starting point for color-grading, as well as a color decision list (CDL), a format for the exchange of basic color-grading information between equipment and software from different manufacturers. These values will be added to the metadata for the day's dailies.

Once the raw data is reviewed and the metadata added, the dailies are transcoded to a file format for editorial. The file is then uploaded to a hard drive, or more often sent digitally to the cutting room via Aspera or proprietary software. Because the editorial suite is unable to send and manipulate the large amount of raw data each day, the transcoded data is reduced in size or compressed during the transcoding. To achieve this, the number of pixels is reduced. This leaves the original data unchanged (uncompressed) and saved on the RAID, LTO or Cloud storage. The compressed editorial material is now small enough to edit and send via secure internet. Editorial file formats may be AVI, QT, MOV, MP4 or MXF, depending upon the editing software. Dailies can be stored in MXF format. Before you wipe a drive, make sure your imagery is transferred and your files are validated.

Editing Data

Ingest dailies and temporary effects data that has been reduced in file size.

Using editing software, the dailies data is "ingested" onto the editor's hard drive. The editor syncs the action and sound, and distributes the dailies. This may be done by sending the data via secure internet. If you are working on a studio project this will be the norm, and a priority server or service will be provided through the studio. If your project is independent, you may use Dropbox or another secure data-sharing site. The data file may be QT, MOV, MP4 or another standard file type. These services may also be used to send and receive temporary music, stock shots, titles or effects files.

VFX

Use either dailies or computer-generated images.

Once the picture is locked, the editor will send the VFX team a disk (or data via secure internet) of the sections surrounding the required effects. These will be rough mock-ups of what is intended, what precedes the effect, and what shot follows the effect. These visuals will be for reference only, and will be in a standard compressed data file type listed above. Using the visual and the metadata provided by the editor, including the LUTs and CDLs, the VFX team will access the raw files and ingest the data with additional footage, so that they have a handle on

each side of the cut. VFX editors will create the effects a layer at a time, using the original raw and computer manipulation. If the effect is completely computer-generated, only the editorial reference is used and no raw footage is needed. VFX data is very large and complex; these files are considered HDR files. Cameras now capture enough range to be HDR-ready. The final VFX data will most likely be an EXR or DPX file. However, each VFX facility uses different software, and the production editor needs to confer with the effects house as to what type of files will be created, EXR or DPX. Make sure that your VFX mattes are "clean" of any visual anomalies before being viewed by your director. Directors can be picky that way.

Once the final effect(s) are viewed and approved, the editor will receive a compressed standard file to drop into the editorial cut. It is very important that these files represent the final VFX shots in metadata. The shot name and other specifics have to match in order for the conform to be automated. The locked editorial master (also called an off-line master), including the new effects and possibly titles, is saved as an AAF file. This information will have all the metadata (i.e. takes, lengths of shots etc.) necessary for the completion of the on-line or final visual master. This is sent to the on-line or mastering facility.

Mastering

Put all the pieces together into a final storyline with the highest resolution.

The on-line/mastering facility will receive a list of materials needed to create a final visual master from the editor, and the delivery materials list from the post-production supervisor. Media management at the facility will assemble the raw daily files, the HDR Open EXR files from VFX, and any additional material like locals or dates included in the storyline, usually EXR. Using the data from the AAF, they will find and pull each clip onto a storage area network, (high-speed and high-capacity data storage). The scenes can now be laid down in order. Sometimes the editor or the post supervisor will be present, but more often than not the post facility turns over conform check QT files, and the editorial team will confirm that the conform matches the original cut. If the file names are not consistent, or there are questions or problems with the data, it will need to be resolved quickly. The postproduction supervisor and/or the editor will then approve the final version as it plays back against the editor's guide. Most people wait to do color correction after their VFX shots come in, but sometimes your schedule doesn't allow for that; that's where the post supervisor helps keep everyone abreast of the latest schedule, so you can turn around those last VFX shots quickly while color correction is going on.

With the on-line approved, color correction is applied scene by scene, using the LUTs and CDLs. This gets way more complicated and advanced with power windows, secondary color and plug-ins. If you need more info, ask an expert. The DP may be present during the color process. Once approved by the postproduction

Figure 3.2 Ancillary markets workflow

supervisor and/or the editor, the final DI master will be a DPX/EXR, a 2K or 4K file sequence. This is a clean color-corrected picture master without sound or titles. (See the mastering chapter for more detailed information.)

Distribution

Create several different elements for multiple distribution venues (see Figure 3.2).

A DI is the first step to create delivery materials. Sound, titles and other elements will have to be added.

Media management at the facility will have assembled the sound .wav files and titles or credits. These, along with any subtitles or alternate language files, are staged and inserted as required into the digital source master (DSM), which will be an uncompressed DPX or EXR file, and/or the DCDM, which are TIFF files. Again, the postproduction supervisor or editor needs to approve the master with audio and titles before any further delivery materials are made. If your project is to play for audiences in a theater, a DCDM may be the only material you will need. However, if your delivery is for TV, or for streaming media content delivered over the internet (also called OTTs – for example Amazon, Hulu, Netflix and YouTube), you will need to make additional elements.

If you are delivering to OTTs, you will create a mezzanine or ProRes file that will be your delivery element. The format for these types of deliveries is MPEG-2. In-flight entertainment files are files for airlines and hotels that can be included in this group. These types of files are usually delivered via a secure internet protocol like Aspera, GlobalData or SmartJog.

Archiving

Make sure you archive! You can use LTO tapes, J2K for theatrical, and MXF for everything else. They can be stored physically or in the Cloud. Digital distribution broadcast files are usually MPEG-2 or ProRes 422. It's a good idea to make two copies of your LTO tapes: One for safekeeping, and the other for production purposes. You can generally derive all your deliverables from these files.

A note on frame rates: Make sure you are aware of your frame rates. Ask an expert, and have your final frame rates confirmed. Frame rate changes can be costly.

Digital cinema: 24 frames per second (fps)
Print masters: 23.98 fps
Sound stems: 23.98 fps

Wrap-up

A good postproduction supervisor keeps everyone updated with the latest schedule and any changes. They keep the entire production and executives abreast of workflow and DI milestones. They communicate when studio or executive reviews take place, and give updates on color timing and all deadlines. They also track budget and ensure the project stays within the confines of the agreed parameters.

Facilities often complain about clients using the wrong workflows, file types and naming conventions. Figure out what you need in advance. Confirm and coordinate with editorial, VFX and the post facility, and keep everyone on the same page.

Food for Thought

With all the fancy flavors that you can create your media in, it's worth taking a moment to contemplate your files. It's tempting to pour your money into a fancy top-of-the-line proprietary file type, and yes, HDR in its many flavors is becoming more prevalent. It's worth asking yourself: How will most people see my movie? If the answer is their iPhone or a flat-screen TV, you might want to consider prioritizing your home entertainment Rec. 709 grade. Will you be showing in the theatrical space? How much time, effort and money are you willing to spend on a DCP? Be careful of specialty brands and their HD formats: If you are using them as your hero and deriving all your deliverables from them, you may run into transition issues in the home entertainment space. It's always great to cater to the newest technology, but how large is that market? How many people will see it that way? A hero is the master that all your other deliverables will be derived from. Make sure you choose your hero wisely. This can be a difficult and a costly decision for a filmmaker.

The Film Laboratory

The film laboratory is one of the few remaining technical areas in moving pictures that has changed very little and still manages to exist. Students, independent filmmakers and a handful of well-known directors continue to shoot film. Film has a specific feel and look that filmmakers desire, as well as the image

quality. Studios have gravitated to digital delivery for multiple reasons, including cost savings in the elimination of release prints and the shipping of these prints, but some still require delivery of a film negative to archive in the salt mines, even if the project is captured digitally. When a filmmaker chooses to shoot film, most of the time the daily negative is scanned and stored for delivery to the distributor. The data from the scan is used to create all the final elements and delivery materials. Sometimes a cut negative is required, or the creatives have decided to make film prints. So without a doubt, film is still being shot and processed. Less is being printed, and a very small market is being projected. However small the chances are that you will supervise a negative film finish, it is important to provide the necessary steps.

Film is processed in pretty much the same way as it was in the silent-movie days. Film itself has improved, but film processing has remained relatively unchanged. (There are issues causing change in film labs, such as Environmental Protection Agency regulations regarding harmful chemicals in the air and water. But for our purposes, we'll let those issues remain the headaches of the lab folks themselves.)

Film Formats

Motion picture negative is available in 8mm, 16mm, 35mm and 65mm formats, and is shot either normal Academy aperture or Super (except for 65/70mm, which is handled completely differently from the others). The difference in aperture refers to the part of the film frame that is exposed. In the Super format, Super 8mm and Super 16mm are their own film formats and have perforations (sprocket holes or "perfs") down one side only. With Super 35mm, the entire film frame is exposed from perforation to perforation. When normal Academy framing is used, one edge of the frame is left unexposed. This area is reserved for the sound track if you are making a composite print, and is otherwise left blank.

Two-, Three- and Four-Perf Film

Thirty-five-millimeter film can be shot as two-perf, three-perf or four-perf. This refers to the number of perforations or sprocket holes per frame of picture along the sides of the film. Two-perf has two sprocket holes on each side of the film frame, three-perf has three sprocket holes on each side of each film frame, while four-perf has... well, you get the idea. Some independents choose to shoot three-perf instead of the standard four-perf. This gives a 25% smaller image area, but allows 25% more frames of picture out of the same amount of film. This equals a 25% saving in raw film stock costs. The technology is finally here that allows three-perf film edge code information to be encoded and decoded accurately for ease in negative cutting. If you aren't saving enough money on film stock, you can shoot two-perf and save even more. A new and confusing way to

save money! The slightly reduced image size results from shooting a new frame every second or third perf instead of every fourth perf. Two-perf is not widely used, three-perf is rarely used, and large-name features that still shoot film have opted to shoot large-format or 65mm film negative. This gives the filmmaker more picture information when creating effects.

Aspect Ratio

The aspect ratio refers to the ratio of width to height of your pictures. Either the camera used for shooting or the projector the film is shown on determines it. Features are most often 1.85:1, also known as "flat"; other formats are 1.66:1 and 2.35:1. Features shot in 2.35:1 are called scope or anamorphic pictures.

The photographed aperture and aspect ratio can be different from the projected aperture. The aspect ratio represents how you want the exposed area of the film framed when it is projected or transferred. The key to framing is to find the proper center of the frame. Be sure you know at what aspect ratio your film is being shot so you can inform the transfer house. The Super 35mm image exposes the film frame from perforation to perforation. Therefore, the center of the image is the center of the film frame. Normal Academy aperture leaves an edge for a sound track, so the center is offset from the center of the film frame. The transfer house must be informed of this so they can compensate for this offset when setting up the film for transfer; otherwise the center of your picture may be off. It sounds confusing because it is. Just make sure your transfer house is clear on the intended projection aperture and image center. Often it is not possible to tell just by looking at the image on the telecine.

Figure 3.3 shows the sizes and relationships of various aspect ratios.

Negative Processing Path

When your film is dropped at the laboratory, it is logged and scheduled for processing. The PO, any written instructions and camera reports are reviewed for any special processing or prep instructions. Special instructions are included in the processing write-up. Once the film is developed, it goes to negative assembly, where the camera rolls are spliced into lab rolls. Thirty-five-millimeter film is built into approximately 1000-foot or 2000-foot rolls. Sixteen-millimeter film is built into approximately 1200-foot rolls. The film is spliced in camera roll order. Leader is added to the film rolls. If any punching is required, it is done in negative assembly. (See "Inform the Laboratory" in this chapter on more on punching film.) The film is then cleaned, placed in plastic bags, and put into boxes or cans. Camera reports either go into each individual box or are gathered and taped as a group to the inside of the top of the first box.

The cost for developing and preparing your film for transfer is always calculated per foot. The lab keep an accurate daily count of the amount of film for each

Figure 3.3 Aspect ratios

project they process. If you need a daily footage count for budget purposes, the lab will have that information each morning.

When receiving film print dailies, a negative report is available from the lab. If you are transferring to electronic dailies, negative reports from the lab will not exist (unless you're having the dailies printed). The lab will note anything they can easily see during the develop-and-prep process. Obvious damage such as perf damage, torn film, edge fogging or severe scratches will be reported in the morning to the client. Subtler damage will not be noticed until the film is looked at, and that doesn't happen until the telecine transfer.

Figure 3.4 shows these steps in a flowchart form.

Processing Dailies

When you are shooting film, there are some important issues to set up with the laboratory before you deliver film to process on that first day of shooting.

Laboratory Processing Schedule

Know what time the lab starts processing film for overnight dailies. Most labs have cut the developing to two shifts a day, usually starting at midnight and processing to 1 p.m. Also, be aware of the weekend and holiday processing schedules. Be aware that most labs do not process film on Saturday nights or Sundays. Labs that process color and black-and-white film usually process color film overnight and black-and-white film during the day. But, for a premium fee, most labs will open for a client that needs special off-hour services. Labs also offer

Figure 3.4 Processing negative and film dailies

daylight developing services. Film can be developed in a few hours during the day for an extra charge. This charge is usually a flat fee plus your normal costs of developing on a per-foot basis.

Sixty-five-millimeter negative is not always processed every day. If this is part of your shooting schedule, have a meeting with the lab regarding the days you're shooting 65mm and what the turnaround need will be.

Scheduling Film Processing

Let the laboratory supervisor know when you will be delivering film and when you need to have it processed (and printed, in the case of film dailies). Make sure your timetable is realistic. It may be that you will have to "break off" film before shooting is completed each day to give the laboratory enough time to process your negative for your telecine transfer session or to make prints for screening or cutting.

Traditionally, the turnaround for developing, cleaning and prepping for telecine transfer is three to six hours, depending on the amount of film you are turning in and the lab's workload. This estimation is based on approximately 5000 to 6000 feet of 35mm film that does not require special handling by the lab. If you have a 1 a.m. transfer/scanning scheduled, you may need to take a portion of your film in for processing by 7 p.m. or 8 p.m. to assure on-time delivery of your film to the transfer house. Any special processing needs, such as push-stop developing, will slow down the film developing process.

Push processing (sometimes called "force" processing) requires special handling. When the cinematographer asks that film be "pushed" or "forced", the lab must slow down the transport speed of the negative through the developer, increasing the negative exposure. Because this process requires an equipment speed change in the lab, this film is generally developed at the end of the night or the processing run. Push processing is one example of special handling that may be requested by the cinematographer that will slow down the turnaround of your dailies from the laboratory.

If you are shooting film and then scanning, it is advisable to print and screen a roll or two from the first day's shoot and any special set up, e.g. change of cameras, special effects on set etc. Screening will reveal whether or not there are film or camera issues that need to be addressed. Often these issues are not seen on the digital transfer. The lab will provide a screening room for this purpose, usually free of charge, but you have to schedule it and make sure the prints will be ready at that time. If you are going to print dailies every day, you need to reserve the screening room in blocks of time in advance. Most labs will have daily prints ready by noon.

Inform the Laboratory

Tell the lab what the processed film will be used for, such as film dailies or scanning. When processing negative for telecine transfer, make sure the lab

supervisor understands that you are doing a dailies transfer, and that you will need the film cleaned and prepped before it is picked up from the lab. Prepping film for transfer means winding the film onto a core, adding leader, splicing camera rolls together to make 1000-foot rolls (or as close to 1000 feet as possible), and punching the first frame of picture. The punch is usually made on a frame with a key number, just before the close of the clapper on the slate, well before usable action. The punch identifies the 00 frame; it will serve to establish the starting point for timecode during the transfer, and can be reverified by the Keykode at that very frame. Punching puts a hole punch in your film at head, head and tail, or circled takes, depending on your instructions. This is a guide for dailies transfer and negative cutter (if you are cutting negative). The punch becomes your reference, which all references back to the Keykode.

Special Handling

A special laboratory process is classified as any process that is not within the normal instruction of "develop negative normal and make a daily print (or prep for telecine)". Special processes require individual handling and personal attention to get them right. *Therefore, if you are going to order a special treatment in the film laboratory when your film is processed or printed, read this section.*

On occasion the DP, director or producer will want to see a take on a roll printed in daily print form, but the negative needs to be intact. Printed circled takes are cut out of the negative and put together to form daily rolls, interrupting the edge code numbers. If your goal is to keep the negative uncut with continuous edge code, you will ask the lab to make a "dummy roll". In the not-so-long-ago past this was called paper to paper sections, due to the little torn pieces of paper that marked the beginning and end of each take to be printed within the roll of negative. It seems the little pieces of paper would get stuck in the printing machines and wreak havoc with the negative and the machine. Talk about a paper jam. Not wanting to damage negative and spend the day picking out paper fibers from the printing machine, they now print with the dummy roll system. The negative assembly department of the lab will make a cue list of footages, head to tail of the takes on a roll that need to be printed. The printer (the person actually working the printing machine) will then get the cue list and the negative, print stock and leader. They will create a roll to match the cue list with print stock and blank leader spliced together. The blank leader matches the footages of the takes that are *not* printed. The printer will then line up the negative and the dummy roll, and expose the required takes on the print stock. Once processed, the blank leader can be removed by the editor or positive assembly, or left as is. Although this process poses no risk to the negative, it is a very labor-intensive process that comes with a price. Most labs will charge the regular printing price per foot and an additional surcharge per circled take printed. Depending upon how long the

roll is vs. how many takes are printed, it may be more cost-effective to print an entire roll. We will let you do the math.

DPs are very special people; the world is framed slightly differently for them than for most people. They are creative, and express themselves in a visual medium. This is the very reason they are hired to shoot a project. To achieve this visual perfection, they must search out *all* the ways possible to manipulate film, through lighting, diffusion, gels, cameras, film stocks and film processing. Once a "look" is decided upon for a project, the way to achieve that look is their responsibility, and it takes team effort and participation to create it. Often it is the laboratory that will counsel a DP through the technical maze of special processes available to arrive at a systematic approach to achieving the look they want for their film. Whether included in the approach or not, the film laboratory must be informed of every special film stock and special process necessary to the final result.

Not all laboratories do all things. Before you embark upon the biggest, most expensive creative process you have ever dreamed of accomplishing, talk to the people who can help you: The film laboratory and the raw stock supplier. Just because you have a deal at a "big" laboratory doesn't mean they process all types of film, or process all types of film every day.

For example, 16mm is not always processed every day of the week, and neither is black-and-white film stock. Both of these negative stocks were once staples of Hollywood. Most TV shows and documentaries were shot in 16mm, and at one time black-and-white was the color of the day. But today these stocks are not as popular as they once were. Color film took the world by storm, and 16mm has been elbowed over by HD and the superior quality of grain and aspect ratio of 35mm. Although most of the major laboratories still process both, the quantities in which they are used are low, and the processing baths are limited to certain days or specific hours.

Smaller laboratories may specialize in these film stocks, and therefore the processing is more frequent. You also need to know if you are going to cut negative. If you plan to shoot both black-and-white and color stocks, you need to ask the experts how to achieve the look you want, because black-and-white stock does not splice or cut together with color negative stock.

Color reversal stock was once used in the news business. A news crew could go into the field, shoot live footage for a story, return to the office, process the film, and project it in time for the five o'clock news; creating a print was not necessary. Today the news crews use digital. Reversal stock has certain visual properties that have become popular with cinematographers trying to obtain the cutting-edge look, but not every laboratory processes reversal stocks. If you have a lab agreement with a motion picture laboratory, talk to them about your needs and stock choices. What they can do is create a package deal to include processes that they do not cover but will subcontract out for your situation. The agreement will be custom tailored to your project.

Other special needs include a process called bleach bypass, skip bleach or silver retention. Most laboratories will do this for the DP with the signed consent that it does not have a guaranteed result. The process involves the negative skipping a chemical bath, thereby achieving a high amount of contrast. The negative from multiple projects usually travels with other projects in the film chain, but because this is irregular and involves skipping baths, this film will have to travel alone at the end of the day's film run. So heads-up that this roll of dailies will be running a little later than usual. Sometimes producers don't want to chance their negative stock being processed in an unusual and possibly unstable method. They will then suggest to bleach bypass the prints instead, depending upon the creative use of the look. There may be other ways to achieve the same end result, by digitally enhancing the negative and re-outputting this to film. Another method could be to create interpositives and internegatives from bypass negatives or reversal stocks and cut these new stable negatives into the rest of the regular action negative.

The list of special treatments does not end here. There are many more tricks a DP can employ to dazzle the audience. However, all of these processes take time, planning, and often more money. Anything that takes special attention will cost a little more and must be scheduled well in advance. Don't confuse the laboratory with verbal or spur-of-the-moment instructions. You take a chance that the negative will either be processed incorrectly or not processed at all, until you are contacted by a supervisor sometime at their convenience. Talk to the laboratory and raw stock supplier; they will suggest testing and methods that are best for your project. Most of all, take the time to research it before you shoot.

Flashing – It's Not What You Might Think

This is a term used to describe another one of the many artistic treatments you can apply to film. Just as the name implies, the stock is flashed or exposed to light, with or without a filter. It can be flashed either before or after exposure through the camera and prior to processing. Again, the laboratory will flash for you; however, they must have specific instructions, and you must give them ample time to arrange for this "no-guarantee-of-results" treatment.

Camera and Makeup Tests

Schedule camera and makeup tests in advance. If you are shooting camera or makeup tests before initial photography begins, make sure the lab supervisor is aware of this and knows when your film is being shot and delivered to the laboratory. The operations manager at the laboratory will need to know if you are testing different film stocks so they can be assembled and marked in a usable fashion for review later. Often, a camera test involves such a small amount of film that (in lab terms) the lab may waive the process charge, especially if they are scheduled to process all of your daily footage. Similarly, the transfer house may

agree to schedule a viewing of your camera test in a telecine bay or screening room if they will be transferring your dailies. Freebies vary on a situation-by-situation basis, often depending on the amount of business a client does at a facility, how much the facility wants to woo the client, or the facility's relationship with the client.

Film Cans, Bags, Cores and Blank Camera Reports

Film cans, bags and cores come from the laboratory. The laboratory that is processing your film will provide you, free of charge, with cores, film cans, film bags and blank camera reports for your shoot. These can normally be provided by the lab the same day they are requested. The lab will need to know how many you need, whether you'll shoot 400-foot, 1000-foot or 2000-foot loads, and if you're shooting 16mm or 35mm film. Some labs preprint the camera reports with the production company name and project title.

Color-Correcting Dailies

If you are going to make film print dailies, the negative will be given an overall correction by the dailies colorist. Usually the DP will have specific timing instructions. For example, the dream sequence is all blue, or it's shot day for night, or lighten the hero scenes, etc. The "new norm" for film is "scan once". Low-budget and student filmmakers usually opt to have the facility create the initial high-resolution (2K–4K) scan, and the show's editor will sync and make color corrections. Shows with larger budgets will have the facility scan the film, make editorial files, sync the sound to these files, and deliver this data to the editorial suite via a secured internet delivery system or on a drive.

Film Damage

To learn to effectively handle film damage problems, you must first learn to recognize when a problem is really a problem, be able to ascertain how serious the problem (if there is one) really is, and know how to choose the best approach to solving that problem and moving on with your project.

To aid you in this process, the following 13 film damage scenarios will be discussed in detail, followed by our advice on how to recover and move forward. Unfortunately, the news will not be all good. However, it should give you enough confidence to help you find answers and provide solutions to those that need them.

1. Perforation/edge tears
2. Camera scratches – from both the gate and foreign bodies
3. Fogging/light leaks
4. Film loaded in reverse

5. Double exposure
6. Camera running off-speed
7. Skiving
8. Water damage
9. Density shifts/breathing and HMIs
10. X-ray damage
11. Laboratory errors
12. Stock damage
13. Film weave

Production is a race: The shooting schedule must be finished; script changes, camera coverage, license guarantees, limited locations, and actor's schedules are all delicately balanced on these two little details, time and money. The last thing a filmmaker wants to hear is that the film that represents the day's work has been damaged.

Film damage ranges from the minor and inconsequential to the absolutely devastating. This section was written to inform the filmmaker of common types of damage, possible causes, terms used to describe them, and some suggestions of how to correct a problem, if it can be corrected at all.

Film manufacturers and laboratories have extensive knowledge and experience with film damage; they even employ experts to assess film problems. When you encounter film damage, it is best to discuss questions or repair suggestions with these experts. First, the exact location of the damage must be identified (e.g. edge code, foot and frames on the negative). Then the negative may have to be printed to obtain a proper visual assessment. During dailies processing and printing, the laboratory will make note of any fogging, tears, scratches or other problems they encounter. The lab representative will then call the producer, DP or other production representative with a brief report and suggestions to help determine your next step.

A word of caution: Insurance. In preproduction and while creating your budget, it might be tempting to bypass this expense. However, it could be the costliest decision you ever make.

Perforation/Edge Tears

The little square holes on the edges of the film are called perforations, or perfs for short. Most often the perfs, the holes on the edge of the film, are torn due to stress from improper threading of the camera. As the camera gears begin to drive the film through the gate and onto the take-up roll, pressure is put on the film to unwind and rewind onto the take-up roll. If the perfs are off, just a little, or the thread is not correct, or the edge of the film has a little nick, the perfs become stressed and eventually break. This might also be referred to as

edge tears. Developing mangled film or torn perfs is the single biggest problem the lab sees. If the film has just a one perf tear, it may break the film chain in developing, allowing the negative to remain in the bath longer than necessary – thus overdeveloping and further damaging the negative, and perhaps damaging the negative that it was spliced to. If in production the camera really jams, then the film becomes creased, torn and unusable in that area. To avoid a negative film jam in developing, the lab feel for tears or crumbled film in the darkroom as they wind it onto rewinds. If there is an area of damage, it is cut out of the roll. The damaged part is discarded, and the rest of the negative is patched or taped back together and processed. Sometimes the patch is inadvertently left on the negative prior to printing, or residue might be left from this patch, and it will be visible on the print. Both the residue and the patch can be removed, usually with no further damage. It is not advisable to cut the perf-damaged negative into your final cut negative. The lab would probably reject cut negative that would be a danger to itself or other negative.

Scratches

This is the biggest everyday occurrence. Every project will have some type of film scratch. They can range from barely visible to unusable footage.

Camera scratches. These are the most common type of negative scratch. The gate area has a claw mechanism that may get out of alignment and cause the claw to drag or pull against the negative scratching it. The magazine that holds the film may not be loaded correctly, or there might be a little rough edge rubbing against the negative, causing a negative scratch.

Dirt is also a very large factor here. During shooting in the desert or at the beach, sand and debris may get into the camera or magazine while the gate is being loaded or cleaned. The dirt rubs against the film, causing a scratch. This type of scratch is easy to identify: It's usually straight, with a buildup of emulsion at the end of the scratch where the film was scraped up.

Gate clean-outs are good, because even though they sometimes initiate debris which causes a scratch, they usually disperse the offending matter and end the problem. While the gate is open, the camera operator feels around to make sure there is no buildup of film shavings or emulsion, blows air into the crevices and resets the negative. But a scratched film is not usable, right?

Before you panic, first determine that the negative is actually scratched, not just the daily print you ran with your crew. The laboratory will help you determine the damage and offer suggestions on repairs. Now that you have scratched film and it's a take you absolutely have to use in your project, what do you do?

First thing is getting the lab involved and asking for advice. If it's a cell scratch – damage to the base side of the film, not the emulsion side with all the layers – then it's possible that it can be printed on a wetgate printer, and the wet

solution will fill in the scratch and hide it on the prints. If it's on the emulsion side, there isn't any solution that will help. The options left are to blow up the shot to reposition the scratch out of frame, reshoot, recut or digitally fix.

Handling scratches. These occur as the term implies, through *handling*. The negative is handled in processing, transfer and negative cutting. They are identified and treated in the same way that camera scratches are. Usually the negative is inspected, and if it is determined that a wetgate solution will help, a wet print is made. If it looks good, cut the negative into your project. All release prints that are made from your original are made wet, so the scratches will be filled in each time your negative is printed.

Fogging/Light Leaks

Film is a light-sensitive material and must be loaded, unloaded and processed in the dark. If the camera door is left open, even just the smallest crack, or if the thread-up/recan to or from the camera is not done in darkness, a darkroom or a changing bag, it is possible that your film will become "fogged".

Negative fog. It will be apparent both in your telecine and on your prints. The light will leave a "fog", or flash of light, on the negative that is nearest to the light exposure, usually one edge of the roll. The fog may disappear at a camera clean-out, which means the camera door was minutely ajar and then closed tightly after the clean-out. The fogged film cannot be fixed. Reshooting is recommended if you cannot work around the fogged shots. Any digital fixes will be very costly.

Print fog. Thousands of feet of film are printed in the film laboratory each night. With this amount of material being processed, it is possible that during the printing process the print will be accidentally fogged. It's usually at the tail of the roll, and sometimes the tail is not completely printed – "printed short". This is just a printing error, and no harm has been done to your negative. The lab will reprint this roll at no charge.

Film Loaded in Reverse

Usually film loaded improperly is an error, but on a rare occasion it is done to achieve a particular look. The effect you will have from negative loaded with the base layer out rather than down, making the film upside down and backward, will be a severely underexposed red-and-black image. If this is the look your DP wants, please do a test before getting on the set. The most common reason film is exposed "backward" is that it was left tails out. Consider that the negative is loaded in the camera and only a portion is exposed. The camera loader breaks the exposed film off and sends it to the lab. The unexposed leftover is wound out onto a core and put in a can with tape around it. The unexposed negative "short end" is now tails out. This may happen on your shoot, or more often it happens when purchasing short ends. Short ends are recanned negative stock left over

from a previous film shoot: It is recanned and sold in an aftermarket. Suppose that your camera loader, not knowing the roll is this way, loads the recanned film into the camera. This might not sound like an issue, but consider the Keykode is now descending. In telecine, a barcode reader on the right-side edge of the film captures the Keykode. If the Keykode is now reversed, the reader won't be able to read it; additionally, it is now in descending order, rather than the numerical ascending order. This means someone has to make note of the Keykode by hand when it comes time for cutting. If you are exposing the film for look or reverse action, be advised that everything comes with a price.

Double Exposure

Once in a lifetime, a camera loader will forget to label an exposed roll and accidentally reload it into the camera and reexpose it. This is unfixable. What you will see on a print made from the double-exposed negative will be both scenes shot on top of one another: One image will be right side up, and the other... upside down. If this is what you intended, the better way to achieve a double exposure would be to shoot both scenes separately and have them digitally put together by your post house.

Camera Running Off-Speed

If you are trying to shoot a certain effect, you might run the camera at high or slow speed. If you are shooting for normal action and the camera is running at other than 24 fps, you will have sound sync problems. Strange things do happen, although they may be rare. There has been only one time we have had the crystal in the camera off calibration and the camera ran at an off-speed. This was only apparent after trying to sync dailies. It took all morning to figure out the problem before we changed the camera. The sound editor altered the audio in post, and we were back in sync – we were lucky. Should this happen to you, you have two choices: Alter your sound or reshoot. The lab suggests that on the first day of production the first AC should slate both the head and the tail of the first few takes. If the camera is running off-speed, it will be apparent. It has happened that the camera was running at 23.95 fps, and on short takes it appeared in sync. Three days later, on a long scene, the film drifted out of sync. This is difficult and costly to fix.

Skiving

Several times throughout the day the first AC, or the DP, will open the camera gate, take a look inside, blow out the gate with canned air, and sometimes feel the gate area. They then rethread the negative and close the camera. They are checking for dirt, lint and skiving. Skiving is little hairlike strands of film that are being shaved off the edge of the negative as it goes through the camera. This is

due to improper threading or something wrong with the gate. Upon observing this the camera operator will clean out the gate, rethread and check again later. If the skiving continues, the little shavings will wind into the film and thus become stuck. Some of the skiving will come off in the developing bath; however, much of it will remain embedded in the film. It will be evident in telecine and on the prints. If you pay to have the negative rewashed, it may come loose; you might also have a film technician take the main offending pieces off by hand. This hand cleaning could be costly, and you still might have a little mark left behind where the skiving was embedded. If you are going to master digitally, a little electronic dirt removal should hide or remove the worst of the problem. Printing for a theatrical release and can't live with it? Do a digital fix and film-out from electronic media to fix the problem; otherwise, reshoot.

Water Damage

If you are shooting near water, there is a danger of the camera and/or your negative taking a swim. Film labs see this on occasion, and yes, they do snicker and roll their eyes. Just remember it wasn't them on that leaky boat; they have no idea what happened. If your camera or exposed negative does go in the drink, keep the negative wet. Let's be perfectly clear: Keep it submerged in water, in a bucket, in a plastic bag or in an ice chest – just keep it from drying out. If the wet film begins to dry, it will stick to itself, and when it is unwound it will pull apart, removing some of the layers. Deliver the fully submerged roll(s) to the lab in water, and they will process it. Because it is now considered contaminated, this will be the last negative they will process that day. It has to go in by itself at the end of the bath. This is to protect the other negatives from any contamination it might leave in the bath. What will it look like? It might warp or curl, causing the image to look out of focus near the edges when printed or telecined. It might have water spots, which may be removed by hand with a special solvent. It might look pretty good. If the warping is minimal and there is no further damage, it might be usable. We recommend you try your best to save it. Reshooting is always costly.

Use caution and pay the insurance rather than have a fatal accident trying to recover a sinking camera or film. Note: This also applies if the film gets wet from melted snow and ice.

Density Shifts (Light Shifts)/Breathing and HMIs

HMIs are a type of halogen light used to light up sets. Ninety-nine percent of the time, an HMI won't represent any threat to your film. However, there are a few things that can cause the gas in the bulb of the HMI to pulse at a slower/faster than the normal rate of 60 Hz. Electricity has a normal pulse, which causes all electrical machines to have a natural rhythm. This rhythm is so slight that

the human eye does not perceive it. The electrical rhythm of the HMI has been timed to sync with the camera's shutter opening and closing.

If, however, the rhythm is interrupted or changed – e.g. if the gas tube of the HMI fails, there is a change of electrical frequency or the ballast (the bulb's electrical regulator) fails – the pulse or rhythm will change. The pulse of the electricity surging and ebbing will be very evident as it is photographed in sequence on the motion picture negative. Negative exposed with this light pulse is not usable. Telecine or print from this type of damaged negative will seem to be lighter and gradually darker, and then lighter again – hence the term breathing.

What to do? Well, it really depends on the shot you intend to use. If it's an entire scene with coverage, and it all contains breathing, you won't be able to cut it together, because you can never smooth out the breathing to look even. If the negative is scanned, there is software that may improve the density shift, frame by frame. So, if you are shooting film and finishing digitally, you might save the day. However, no color correction or special printing can fix the *film*. If you have a shot that is a single, stand-alone shot, and the breathing is very slight, and it cuts away to another scene, you might get away with it. If you are not delivering digitally, we recommend you reshoot or cut around the material.

X-Ray Damage

Yikes! This is possibly the worst news, next to your camera falling into the ocean or the lead actor leaving your movie before it's finished. It's an awful sinking feeling, and unfortunately many filmmakers have experienced this fate. The reason this news is *so* bad is that it affects not just one shot, location or roll, or even one day, but an entire shipment of film, and the affected film is unusable. It could happen to unexposed film (raw stock) or exposed unprocessed film (prior to sending it to the lab). If the negative has been processed, there is no further threat of damage by x-ray.

What does x-ray/radioactive damage look like, and how does it differ from the breathing of HMIs? It looks similar to fog: There is a point of contact, and the film will have a lighter/brighter-looking exposure toward the side of the film that has had the greatest contact.

HMIs have a breathing rhythm that affects the entire frame, not a visual point of contact. X-ray damage is distinct and usually on one side of the frame that has a foggy or bright area fanning out across the frame. The lab will be able to determine whether the damage occurred before or after exposure by evaluating the wind of the film. As the film is wound around a core, the wind is small, and as the film takes up, the wind gradually becomes larger and larger. If the film was damaged prior to exposure in the camera, the breathing, or rhythm, of the damage will be less or longer between the points of contact on the first scenes shot, because the first part of the raw stock was on the largest part of the wind. If

the damage was after exposure, it will be less evident or longer between points of contact on the last scenes shot, because the film is left tails out from the camera, and the tail is the largest part of the wind. This would only be true if the film was not rewound after x-ray damage and prior to camera exposure, which may happen on a rare occasion when using short ends.

You will not know that you have radioactive or x-ray damage until the film is processed and either projected or transferred to tape. The laboratory will advise you to print part of a roll and view the negative in a telecine bay to evaluate the damage. Any damage that is there is not reversible. This becomes an insurance claim.

Laboratory Errors

Once in a great while the film laboratory will create accidental damage. Sometimes it's inconsequential, and then on rare occasions it's an insurance claim. Because damaged prints can be replaced and reprinted, we will only explore damage to the original camera negative.

Torn or ripped negative. There is more than one type of physical negative damage. Sometimes a perf will have a weakened edge and rip or tear, as in the perforation tear explanation above. Another type of negative tear that can be very costly can happen once a negative is conformed. When the negative is conformed, it is physically cut. Hot splicing then reinforces these cuts. This fuses the pieces of negative together permanently, without being evident to the viewing audience.

Hot splices are durable, strong and made to withstand the tension of printing. However, occasionally Murphy's Law takes effect and one of these splices comes apart on a printing machine and your negative is in trouble. The damage can range from a corner of the spliced frame folding back upon itself to the negative ripping in half.

A folded frame can be removed, and the show can be pulled up one frame without a sync problem. But if you're on the other edge of the damage spectrum, and your film has ripped in half, one solution is to replace the damaged film with alternate takes. Using alternate takes can make up for additional loss of frames on each side of the splice.

The other alternative is digital repairs. This entails hours/days of artistry by a film restoration specialist. First the damaged negative is scanned into a computer, and then it is digitally hand-painted frame by frame to replace the missing picture information and then output back to film. The new negative is cut into the show, spliced, retimed and printed. This makes a beautiful fix, and if it is done properly, no one will be able to easily tell the difference between the fix and the original. Digital fixes impact not only your budget but your schedule as well.

If neither of these fixes is an option, another alternative might be to output film from a digital master made before the damage occurred – such as a dailies

transfer master. One last suggestion would be to make a duplicate negative from an existing interpositive, or a dupe from a print. The latter is a last resort, as the inserted piece will be difficult to time and the grain will be evident, but your project will be fixed.

Chemical issues. Soup stop or developing stop are not lab-friendly words. In the lab, film runs through the laboratory processing in a long chain spliced together end to end, project to project, traveling together through many processing chemical baths and dryers. If this chain of film must be stopped during processing, the negative may remain in the chemical baths too long, causing irreversible damage. Perforation tears, splices breaking apart, machine malfunctions or human error could cause the "stop". Most of the time, film that sits in the developing bath too long is unusable. Even if there is an image, it will have processed unevenly, with light and dark areas evident where the film was wrapped around rollers in the bath. Your only choices are to use another take or another camera roll, or to reshoot the ruined footage.

Streaking. Streaking is the term for chemical stains. These are usually seen on prints, but on rare occasions you can spot them on the negative. A faulty lab squeegee, splashing or chemical problems cause this streaking. Often rewashing the negative will remove the stains. Sometimes film has to be spotted or cleaned by hand.

Debris. Debris left on the negative is usually the result of static cling or friction that builds up from running the negative back and forth through the telecine. On very rare occasions, debris is left on the negative due to dirty cleaning or processing solution in the lab. Either way, recleaning may take care of the problem. If the negative is handled through cutting or telecine, the dirt will become embedded, and it will be very difficult to remove. It will have to be removed by hand and may leave a mark or impression where the debris was stuck to the film. Removing dirt by hand is time-consuming and expensive.

Sometimes debris is found to be the result of a stock defect (see stock damage, below). The only way to correct this problem is to reshoot, correct digitally and reoutput to film, or use a dirt removal system on your digital masters.

Wet wrap. Wet wrap is a term used to describe what happens when a wet spot is left on the film and it is then wound up around a core. The wet area sticks to the film it is wrapped around. As the film is unwound, the wet spot might tear apart, or a layer of the film may be removed. However, sometimes the only damage is a faint watermark, which may be removed by hand cleaning or digital repair. This type of damage does not happen very often.

Stock Damage

Occasionally we hear about raw stock damage. This is raw stock purchased from the manufacturer that has built-in damage. This is very rare and sometimes

difficult to detect. Most of the time the damage is debris that is manufactured into the base of the film. It looks like lots of black dirt, and yet it doesn't clean off. If you have a dirt problem that doesn't go away with the usual cleaning techniques, have the lab and the manufacturer inspect the negative. They will give you a diagnosis and suggest how to resolve the problem. *Very* rarely, negative stock may have what are called pressure marks or even tape splices within rolls. If it is a stock problem, you are left with the same old suggestions: Reshoot, recut or digitally fix. If the manufacturer is at fault, you will probably get free raw stock in an amount equal to the damaged stock. Now you remember why you bought that insurance.

Short ends. Many low-budget filmmakers have no choice but to shoot with recans or short ends. This is leftover raw stock from a production that has sold back excess film to a film broker. The film manufacturers will not buy back excess film or the short ends left over from a larger roll; they sell fresh from the factory only. Short ends or recans are usually in good condition and not very old, but the broker can't always guarantee quality. When buying film this way, it would be in your best interest to do what is called a snip test. The laboratory will test a few rolls, either free or at a very nominal cost.

The test will tell you the density of the negative and where it should read according to the manufacturer. This will give you an indication of whether its quality is worthy of your creative endeavors. The stock will also have a stock number that can be tracked through the manufacturer that will tell you the date it was made, indicating how old the negative is. You will want to do everything possible to ensure that the negative you are using is in good condition and is not damaged (x-ray damage applies here, too) prior to your use. Snip tests are not necessary on purchases of fresh stock from the manufacturer.

Film Weave

Another common film problem is weave. Weave manifests itself as side-to-side movement of the entire film frame. The movement will be readily apparent in the frame area if the matte is removed from the projector while you are viewing a daily print. Some amount of motion is always present when a film element is played, and a minor amount is acceptable. The severity is going to be the issue. Movement is especially problematic if you are using the shot as a background (backplate) for effects.

Stock problems such as shrinkage can be the culprit. There may also have been a problem inside the camera and the film was weaving as the images were being photographed. There are de-flicker filters in most editing and color correction software that can improve or reduce the effect of the weave. However, this is an electronic fix, which will only help your project if you are delivering digitally or if you record the fixes digitally and then reoutput to film. If the shake is so severe that the frames are blurred, a reshoot is in order.

We Just Meant to Inform, Not Frighten

The above has been a very long and scary list of bad and ugly things that can happen to your negative. Your best course of action is to do everything you can to protect yourself from having any damage happen in the first place. That said, should you have film damage, have the damage that does occur professionally diagnosed before you have a complete mental and financial breakdown. Finally, we recommend that you not consider foregoing production insurance as a way to cut costs, and make sure you shoot enough coverage to back yourself up if you do lose shots.

This information is not intended to keep you up at night (that's your producer's job). It's simply meant to educate you about some of the problems that can occur, and ways to avoid or minimize the impact to your project and keep you going to the end of your movie. Keep everything we tell you in perspective. Forewarned is forearmed, nothing more. Now, go out and shoot some film!

Creating Other Negatives and Prints

If your show is going to have a film finish, once the show has been locked and opticals are complete the negative is cut (see the negative cut section in the completion chapter). Creation of a color-corrected print is done from the negative at the film lab. First you will need to approve a proof print. The proof print is a slide show of one to three frames of each scene from the roll. Often, the director or cinematographer attends this "screening". A color timer will adjust and smooth out the color and density. Once this is approved, the lab will move on to a "first trial print". In the sound section we talk about making a check print to run with the sound element to make sure the sound is in sync before you make a print with sound. Once sync has been established, an optical sound track negative is struck. It is then sent to the lab for processing and leadered to match your negative. It is at this time you are ready to make the first print with sound. It might be your "answer print" with all the final color corrections. The colorist may have to adjust the color and one or two first trials may have to be made before your answer print is final.

If, after you have approved the color correction of your negative, theatrical release prints are required, you need to protect your original negative. This is done by making a copy of your negative and using the copy to make any additional prints from. This copy is called an interpositive (IP). An interpositive is an intermediate positive picture element made on special film stock. From the IP other negatives, called internegatives (IN), can be struck. (Once the initial IN has been struck, a check print is made to check the overall color.) Sometimes several INs are made and the release prints are made from these. This eliminates the need to go back and reuse the original negative again and again for printing, thus preserving the original negative's quality. To clarify, an IP is made from the

original negative; then an IN is created, and the release prints are made from the IN and an optical track. Laboratories make IPs sometime during the daytime once all of their dailies footage has been processed. If an order calls for an IP, an IN (dupe neg) and a check print to be made, don't expect all of these elements to be ready the next day. The IP will be turned around in one day, and the next day the dupe will be made, if the IP passes QC within the lab. Depending upon the traffic in the laboratory, the check print might be ready the same day as the dupe, but most likely the day after.

Be sure to order elements made from your original negative with the wetgate process. In wetgate printing, as the film travels through the printing gate it is exposed to a liquid solution that works to mask minus density marks and spots. These imperfections manifest as dirt or minor scratches on the negative. If successful, this wetgate process will make it seem that these imperfections have "disappeared". Due to the softer emulsions of the negative stocks, embedded dirt and handling marks are not uncommon in cut negative. The wetgate process, when printing, will temporarily remove these minus density spots that show up white on the screen.

Should your original cut negative become damaged, new sections of IN can be created from the IP and spliced into your original cut negative element. The replacement section will be two generations away from your original element.

Consider the risk each time you use your original cut negative. While the equipment you run your film on in telecine and printing is gentle on your negative, human error or mechanical troubles could result in a scratch to your negative, and once your negative has been damaged that section is rendered useless. Often a wetgate print or other restoration method can be used to create a usable piece of film to replace the damaged area, but there is no way to repair your negative. Should damage occur and you have to replace the shot with another piece of negative, make sure your negative cutter has compensated for any frames that may have been lost.

Acetate vs. Estar

If you need a repeated shot, or need to cut new duplicate negative into your original negative, you must order an "acetate" dupe. This is very important. Estar negative stock and acetate film stock cannot be spliced together: They are two different kinds of stock. Acetate splices are cemented together; Estar has to be sonic spliced (melted together) or the splice will break apart. Most laboratories will make Estar dupes unless otherwise requested, so it is up to you to request the correct film stock.

Adding Sound

Prior to 2004 the process for applying sound to a print was a multistep process that involved additional developing and chemical applications. The separate developing baths were not environmentally friendly and often resulted in

overspray or "application splash" that ruined the sound on the print. Once the LED red light reader was created, these "silver tracks" as they were called were phased out, saving money and helping to save the environment.

Cyan and High Magenta Sound Tracks

Cyan tracks are exposed directly on to the cyan layer of the color print. High magenta tracks use both a silver redevelopment of the application track plus filters which print the track on the magenta layer of the film. This allows the high magenta track to be read with both white light and red LED readers.

This is achieved by shinning tungsten light (white light reader) through the track area. The tracks require the use of a high-intensity LED red light reader. The high magenta tracks require a higher density on the optical sound track negative and must be made specifically to manufacture this type of print; they are not interchangeable with silver redeveloped tracks.

Knowing what type of tracks you are making and where on the film frame they are placed will help if you need to solve an issue. Your main concern is what type of sound is required by your delivery requirements – most often Dolby Digital and the SR for backup – and what it takes to put that on the prints. Your sound facility will shoot the optical sound track negative; the lab will process it and leader the head and tail for printing, and then with an order they will print it.

Figures 3.5 and 3.6 illustrate the various optical tracks and their placement on the film frame.

Creating YCMs

In the 1930s, Technicolor Corporation developed a process called the Technicolor process to print color motion pictures.

Figure 3.5 SDDS and DTS track placement on 35mm film

Digital Workflow and the Film Laboratory

Figure 3.6 Optical track placement on 35mm film

A light source recording the image was projected through a lens into a split prism cube. This cube divided up the image into green and minus green components. These components were refracted into three separate negative film stocks. One stock received the green information, one stock the red information, and one stock (blue-sensitive with a red-coated emulsion) the blue information. Then light was emitted through the three layers of exposed negative combined and printed onto a fourth piece of negative, yielding a full color positive element. This three-strip process was used for motion picture capture throughout the 1930s and 1940s.

Today the YCMs starts at three separate film strips. Each film strip represents a black-and-white interpretation of one of the colors: Red, green or blue. Then dye is applied to the film to bring out the colors. Due to the technical nature of each separation and the thickness of the gelatins where the images are recorded, red dye cannot be used in the dye process for coating the red separations. So the opposite of red, or cyan, is used. For the same reasons, magenta dye is used for green, and yellow for blue. Thus, we have our three-color separation (yellow/cyan/magenta) that, when combined, makes our color image.

The "clear" filmstrip used to initially create these dye-coated separations is actually a piece of black-and-white negative photographically exposed to a silver positive image. This process adds contrast and richness to the final color negative. Thus, we have our YCM (yellow/cyan/magenta) silver separation master positives.

What Are YCM Masters?

So, what are YCM masters? YCM silver separation master positives are black-and-white records that represent each of the three-color layers present in the emulsion of color negative film.

Why Create YCM Masters?

Because the vegetable dyes used in the emulsion of color film break down (fade) over time. In black-and-white film, the metal silver is used when making the image. As a metal (rather than the organic vegetable dye), silver doesn't fade. If you are finishing digitally, you may be required to create a YCM master from a laser recorder, aka digital to film-out. YCMs are extremely robust and can be printed with perfect color, even if vaulted for hundreds of years.

What Is the Process?

A color negative is printed to YCM master positive stock three times. On each pass, different filters are used, representing different color dye layers. The result is a set of YCM masters. To check the integrity of the YCM masters, they are immediately printed back to a single piece of new color negative stock (run three times, once with each record). The resulting *recombined internegative* is then printed and screened. Anomalies in the masters can be clearly spotted in screening. The color separations can also be made digitally with the three prints, as outlined above, and recombined digitally, allowing each element to be minutely adjusted for perfect alignment.

Archivally speaking, the YCM masters can be similarly recombined in the future (as many times as necessary) to recreate the original color content of the original negative, long after it has faded past the point of being printable – which is estimated to be 400 years, give or take a few decades. Thus, they preserve the cleanest, truest representation of the images that were originally captured when the movie was shot.

Is the Result Always Positive?

Is the image on YCM masters a negative image or a positive image? Depending on the source material, YCM masters can be either positive or negative. Most commonly, though, YCM masters are created from original cut camera negative. Consequently, they are usually positives.

The newest film for creating YCM silver separation provides improved sharpness and grain highlights for more consistent results and better colors.

But what if I didn't shoot film? There are a couple of processes to choose from to create YCMs from a digital element. One process is called sequential exposure: The digital material is ingested into a recorder; the computer finds and shoots each frame three times on a single strip of black-and-white film through an RGB (red, green, blue) color wheel; the film is processed and then printed. Another process uses a laser recorder to expose each color spectrum separately on high-quality black-and-white Kodak film. The three separations are developed and then combined to make a print, which is ideally approved by the director. A film element is the safest and longest-lasting archival element you can create to store your digital masters.

When Are YCMs Needed?

YCMs are the only known guarantee that the film you shoot today can be reprinted and shown in its original beauty long after the original negative has begun to fade with age or suffered damage from handling or misuse.

This is very important to studios and filmmakers around the world, who have come to realize what a valuable asset their project can be to them. Even just a few years ago, most people had no idea that the demand for product would be so intense and widespread. With the growth of cable channels, streaming and DVD/Blu-ray rental markets virtually around the world, it seems there is a constant need for more and more product. Due to its long archive shelf life, it's a common delivery requirement.

Aside from the commercial arguments for protecting these assets, there is the social importance of maintaining a record of our cultural heritage. Movies have always represented a window into our past (and sometimes our future). Generations now feel they know and understand generations past simply by watching the movies that were made about them and by them. Many feel we have a moral obligation to preserve this information for generations to come – a sort of moving picture history of humankind.

It is encouraging to us in the industry who share this belief and passion about our moving picture history that the trend of once again creating YCMs, solely for the purpose of archiving this product, seems to have found a home in our industry.

Shipping Exposed Negative

In response to the September 11, 2001 airline tragedies, new and increased scanning procedures have been put into place by both the US Postal Service and the airline industry. These new procedures put negatives at risk of fogging and exposure.

For safety, all commercial airlines x-ray their cargo. Carry-on luggage and luggage checked in at the gate/curb all go through x-ray inspection. Most overnight couriers, however, do not x-ray their cargo.

In the past, airport x-ray equipment had little or no effect on unprocessed film. The new higher-intensity scanners have been tested and shown to have the potential to fog both unprocessed color and black-and-white film. Processed film appears unaffected.

The US Postal Service has installed electron beam scanners for use in sterilizing items sent through the mail. This technology will fully expose undeveloped film as if it had been exposed to sunlight. It is rumored that this equipment may even cause damage to exposed film, prints and DVDs. Because it is still unclear how extensively this equipment is used, it is best to err on the side of caution until more information is available.

Carry-on bags used to be considered safer from damage due to radiation. The x-ray used is lower-intensity. However, in some instances airports may be supplementing these checkpoints with higher-intensity machines that will fog unprocessed film. In most cases, no additional warnings are being posted.

We have also seen damage due to radioactive isotopes being shipped alongside unprocessed negative. This renders the same result: Useless film.

You will not know that you have radioactive or x-ray damage until the film is processed and either projected or transferred to tape. The laboratory will advise you to print part of a roll and view it in a telecine bay to evaluate the damage. This type of damage is irreversible and becomes an insurance claim.

The following tips are offered to help you safeguard your film:

- Make sure there is no unprocessed film in your checked baggage.
- Send your film via a cargo carrier or expediter that will certify that your film will not be x-rayed. Most airfreight shipping services use their own aircraft and do not employ x-ray scanning of customers' packages on domestic routes. However, you should verify this information before sending your film.
- Goods shipped as freight on passenger airlines are subject to high-intensity x-ray scanning.
- Try to purchase your film locally to your shoot, and process locally before shipping if possible.

One last reminder: X-ray or isotopes will not harm processed film print or processed negative. The photo chemicals have been stopped in the processing and will no longer react.

Summary

Most film laboratories offer a variety of services. They develop your film and prepare it for transfer, create prints, and repair damaged film. Some have departments where they can create your film effects and titles, blow-ups and repositions digitally and film them out. To fully understand and appreciate the work that goes on at the film laboratory, take a tour. Your salesperson or laboratory supervisor will be glad to arrange one for you.

Footage Conversions

Someone will always be asking you to convert your film footage into run time. For your convenience, Figure 3.7 is a film footage guide that provides an exact conversion for both 35mm and 16mm film.

SECONDS	35mm FOOTAGE	16mm FOOTAGE	MINUTES	35mm FOOTAGE	16mm FOOTAGE
1	1.5	3/5	1	90	36
2	3	1 1/5	2	180	72
3	4.5	1 4/5	3	270	108
4	6	2 2/5	4	360	144
5	7.5	3	5	450	180
6	9	3 2/5	6	540	216
7	10.5	4 1/5	7	630	252
8	12	4 4/5	8	720	288
9	13.5	5 2/5	9	810	324
10	15	6	10	900	360
11	16.5	6 2/5	11	990	396
12	18	7 1/5	12	1080	432
13	19.5	7 4/5	13	1170	468
14	21	8 2/5	14	1260	504
15	22.5	9	15	1350	540
16	24	9 2/5	16	1440	576
17	25.5	10 1/5	17	1530	612
18	27	10 4/5	18	1620	648
19	28.5	11 2/5	19	1710	684
20	30	12	20	1800	720
21	31.5	12 3/5	21	1890	756
22	33	13 1/5	22	1980	792
23	34.5	13 4/5	23	2070	828
24	36	14 2/5	24	2160	864
25	37.5	15	25	2250	900
26	39	15 3/5	26	2340	936
27	40.5	16 1/5	27	2430	972
28	42	16 4/5	28	2520	1008
29	43.5	17 2/5	29	2610	1044
30	45	18	30	2700	1080

Figure 3.7 Footage conversion chart

CHAPTER 4

Dailies

"If I'd wanted them at the end of the day, I'd have renamed them nightlies!" stormed the producer, frustrated by the fact that it was nearly 9 a.m. and she had yet to see a minute of the previous day's footage.

During a production, "rushes" or "dailies", as the name implies, are the data or footage that is shot each day and rushed to the postproduction facility for transcoding so that you and your crew can view them after a day's shoot. This is to ensure you've gotten the necessary coverage each day. Today, dailies can be ingested and transcoded on set by the AC or DIT, and can be ready for viewing at the end of the day's shoot.

With film there is a more involved process where dailies are sent to the lab for processing, then scanned to digital files, and those files will usually be ready the next morning. Heaven help the facility with technical difficulties that delay the completion of dailies.

While you should always preplan and plan and plan some more, keep in mind and at heart that no amount of preparation will guarantee that you won't run into issues with your dailies workflow. Should trouble visit itself upon your set or at your transfer facility, try to keep it all in perspective.

Dropping Film at the Post Facility

Whether you will be creating digital dailies or film dailies (or both) from your shoot, or scanning film dailies to digital dailies, someone from the production crew will drop either your raw files at the postproduction facility or your film at the laboratory, each day after shooting. It is important to know ahead of time what time of day the dailies must be dropped at the postproduction facility in order to have them sent to editorial in a timely manner.

Digital raw files will be transcoded and backed up several times. Transcoding involves transferring the raw digital file to a digital file the editor can work with. The high-resolution uncompressed raw digital file is converted to a

lower-resolution compressed digital file for easier access. The sheer volume of capture has impacted the time needed to transcode.

There is an even easier, quicker way to view dailies without your footage leaving set. A DIT can usually ingest your digital dailies at the DIT station, and even do minor color adjustments. This may relieve the stress of quick turnarounds.

If the data capture is a very high volume and the transcoding is done by the DIT or editor, they may decide to compress the files even more than usual to save ingest time. This will result in poor visual quality of the compressed material. The original capture will remain unaffected.

In any case, commit this simple set of facts to memory: No digital processed, no film processed, no film-to-digital transferred; no dailies in the morning, nothing for your assistant editor to do, nothing for the editor to cut, nothing to show the producers; no good for you.

Camera Reports

Most of the time, production and editorial problems are resolved by the production team or the editor. However, there are times that things go wrong and you are looked upon as the one who must solve the mystery. It is best if you know and understand the chain of custody and basic details of data capture. You should know how to read a camera report. One camera report is created for each raw storage card (a set of digital shots, sometimes still referred to as a "roll") or actual physical roll of film that you shoot. The same applies to sound reports. Each production sound card will also have its own report. Each camera and sound report will have multiple copies attached. The original always stays with the respective camera or sound element and goes to the postproduction facility. A copy stays with the production crew, and a third copy is sent to the production office for the editor's reference.

Knowing how to read camera and sound reports will help you better communicate with both production and your postproduction facility. We have provided samples of both camera and sound reports, with a corresponding explanation regarding each section of the reports. (The information on reading a sound report can be found in the production sound section of the sound chapter.) The camera assistant completes this form as a written record of what is photographed or recorded on a particular day of production for each data capture card or SSD media.

Camera Report Breakdown

The report's layout may differ slightly for each facility. (Prior to shooting you can get blank camera reports from the post house – see Figure 4.1.) To further understand the importance of a camera report, it is also helpful to understand

the workflow of production capture. If a project is captured on a digital motion picture camera (Red, ARRI Alexa, Canon, etc.), the AC or DIT checks the raw capture files and makes minor color adjustments or tweaks on set. The digital files are sent to the post house for transcoding. The compressed files are then sent to the editing department, where the assistant editor loads the data into their editing software (Avid, Premiere, Final Cut Pro etc.) and begins assembling the clips on a timeline. A camera report tells the editor or assistant editor what takes are on each data capture card or SSD media, whether the takes were complete, and which ones the director wants to see in the cut. It will also document which camera was used and if it was second unit or principal.

Keeping track of these reports can be time-consuming and at times challenging, but it's absolutely crucial that the notes match the data delivered to your post facility, and it's necessary for a smooth workflow from digital dailies to your off-line edit.

Here is a description of each section of the sample camera report (Figure 4.1):

A. Data capture card number (may still be called a camera roll)
B. If there is sound, is it mono/stereo
C. Date
D. Name of production company
E. Show title
F. Episode (if this is a series, the episode number should be included here)
G. Name of director
H. Name of DP/cinematographer
I. Name of DIT or AC
J. Contact phone number
K. Camera type/camera number (be sure to note if it is A camera, B camera, etc.: it is important to be specific in the data you provide to the post facility or laboratory if there is a dropout, digital hit, artifact or other issue with a clip)
L. Type of recording media, data capture card or SSD media and sound card, etc.
M. Frame rate
N. Shutter speed and angle
O. Light reading from light meter
P. Scene numbers
Q. Take numbers
R. Clip or file number (note that the circle marks the clip selected for use)
S. Remarks

Reports may also include ingest, codec or rendering instructions, and may specify if all or selected takes are to be ingested, transferred or "printed" (as it used to be called). Some directors will still say "print that" as a way of letting the camera department and script supervisor know that it was one of the better takes.

Camera Roll # A			Mono B	Stereo	Date C		
Production Company: Three Girls D							
Title: The Library E				Episode: 3 **F**			
Director: Kumari B. G				DP: Dawn H. **H**			
DIT/Data Molly I				Contact #: 555-1212 **J**			
Format: Arri **K**	Canon	EPIC	ProRes	Red Mix	Other		
Record Media: **L**	Compact Flash		Recorder Mag		SSD	SxS	Other
Frame Rate: **M**	23.98	25	29.97				
Shutter Speed: **N**		Shutter Angle:		ISO/EI			
Kelvin/WB **O**	3200		5400		Other		

Scene **P**	Take **Q**	Clip/File **R**	Comment **S**
301	1	6	NG
301	2	7	Clipped
301	3	8	OK
301	(4)	9	Good

Figure 4.1 Sample digital camera report

Dailies

A	Laboratory Name					
	Laboratory Address					
	Laboratory Phone#					

B Prod. Co. Greenville Productions	C Date: 12/19/01
D Picture Title & Eps#: The Danes #9278	E Loader: Andy H.
F Director: G. Paul	G D.P.: S. Fred

H ROLL# A3 ☐ BLACK & WHITE ☒ COLOR
I EMUL 7245 J MAG# 6
DEVELOP K FOOTAGE_____
☒ NORMAL ☐ PUSH___STOP(S) ☐ PULL___STOP

FILM WORKPRINT L
☐ PRINT ALL ☐ PRINT CIRCLED TAKES

VIDEO TRANSFER L
☐ TRANSFER ALL ☒ TRANSFER CIRCLED TAKES
TRANSFER AT _24_ FPS

M	N	PRINT CIRCLED TAKES				O	
SCENE #	1 6	2 7	3 8	4 9	5 10	REMARKS	
12A	⓴	⓴	⓴			MOS	
12B	10	10	⑮				
	10	10	⑩			Xfr 36fps	
12C	10	20	⓴	20	20		
12D	no roll	15	15	⑮		Transfer warm	
		15	⑮				
		13	⓴	⓴	⓴	no roll	Night Ext.
		20	⓴	20	⓴		
			G.	270	P		
			N.G.	150	Q		
			W.	30	R		
			T.	450	S		

Figure 4.2 Sample film camera report

Figure 4.2 is a sample of a camera report for film capture. These are similar to the camera reports for digital capture. These reports may differ slightly from facility to facility. They can be picked up at the film laboratory in advance of shooting.

A. Laboratory name, address and telephone number are usually preprinted on the camera report
B. Name of production company

C. Shoot date
D. Show title (if there is not a separate space to write in an episode number, then the episode number should be included here)
E. Name of loader/AC
F. Name of director
G. Name of DP/cinematographer
H. Camera roll number (be sure to note if it is A camera, B camera etc.)
I. Emulsion (The lab needs this information for processing)
J. Magazine number (this is very important if you have to track a film problem that occurred during production. Problems such as scratches and fogging sometimes trace back to a camera magazine problem. It is important to be able to isolate which magazine is causing the problem.)
K. Development instructions (if this area is left blank, the lab will assume normal process)
L. Print/transfer instructions (instructs whether *all* or *selected takes* are to be printed or transferred)
M. Scene numbers
N. Take numbers (it would require too much room to provide spaces for all the possible numbers of takes a director may shoot for one scene. It is generally understood that after the take spaces are filled in across the row, the scene number is left blank on the next row, and the takes continue in ascending order. This repeats until all the takes are listed. You know you've moved on to the next scene when it is listed in the "scene" column. In the "take" boxes, the amount of footage shot for that take is usually listed. For circled takes that are to be transferred or printed, the footage number is circled.)
O. Remarks (comments are noted that relate to the takes in that row. This might tell the colorist if it is a night exterior, or to color warm or cool, or if it was shot at an off-speed. The colorist looks here for all subjective guides for the transfer and any special shooting circumstances.)
P. Approximately how many feet shot on the roll are usable
Q. Approximately how many feet on the roll are not usable
R. Amount of waste on the camera roll
S. Approximately how many feet of exposed film (usable or not) are to be processed

Any missing information means your camera assistant has given incomplete information. This should be an immediate discussion with the camera department to ensure all data is being relayed correctly and in a timely way to the post house. Any information left off these reports affects the postproduction team in the dailies process, and could cause unnecessary delays.

Shot Log Sheet

A shot log sheet is created in addition to or sometimes instead of a camera report. Figure 4.3 is an example of what a digital shot log might look like. Shot-logging is capturing metadata during a digital shoot. During production, the second AC logs the start and end timecodes of each shot and data from the day's shoot, which is sent to the editorial department; it includes scene number, camera A or B, take number, and settings. Using this data from shot-logging software synced to a timecode, a shot log is automatically generated in camera. Shot log info is used to reference shots during the editing process and to verify the data for the EDL during postproduction, and would include: Shoot date; page number; project name; production company; clip number; test shots (which should be clearly marked); take number; shot description; and additional comments.

Shot Log Breakdown

- Camera ID: A camera or B camera. A camera is typically your main principal photography camera, and B camera is considered a second unit or additional camera.
- Card ID: This is the raw data storage card the project is recorded to in your camera. These cards should be numbered.
- Project title: Movie title or TV series title, plus episode name and number. Often when shows go to air, the network changes the episode numbers to reflect either their own internal system or maybe air date order – schedules change. Having the episode title and number together also means there will always be a cross-reference should the actual production numbers change during the project.
- Logged by: Name of crewperson who created the log.
- Shoot date: This is the date the video that is being logged was shot.
- Timecode: This is the timecode on the camera, SmartSlate and raw data files that corresponds to the description provided.
- Description: This is data about a particular timecode. It could include scene and take info, describe the scene, highlight certain dialogue or actions etc.

Film-to-Digital Dailies

Film-to-digital dailies are dailies that are shot on film. The negative is processed at the lab, then sent to the digital post house, where the negative is scanned and saved to a hard drive or sent via secure pipeline to the editorial suite. Many large-budget features choose to shoot film for all production or for VFX plates.

Video Dailies Log Sheet	
Tape I.D.	Project Title:
Logged by:_____	Shoot Date:____/____/____
Time code:	Description:
___:___:___:___	
___:___:___:___	
___:___:___:___	
___:___:___:___	
___:___:___:___	
___:___:___:___	
___:___:___:___	
___:___:___:___	
___:___:___:___	
___:___:___:___	
___:___:___:___	
___:___:___:___	
___:___:___:___	
___:___:___:___	
___:___:___:___	
___:___:___:___	
___:___:___:___	
___:___:___:___	
___:___:___:___	
___:___:___:___	
___:___:___:___	
___:___:___:___	
___:___:___:___	
___:___:___:___	
___:___:___:___	
___:___:___:___	
___:___:___:___	
___:___:___:___	
___:___:___:___	
___:___:___:___	
___:___:___:___	
___:___:___:___	

Figure 4.3 Shot log

Whether or not you will be cutting the original negative, it is very important that you capture the edge code during dailies scanning. With this information added to the editor's data, the EDL will have the edge code for each cut, allowing a negative cutter to locate exactly where each shot is on the original negative camera roll. Recording this information during the scanning processes does not cost extra and will ensure that the negative can be assembled at any time that it is necessary.

Digital-to-Digital Dailies

It may be a choice of the production company to transcode dailies from original raw camera uncompressed high-resolution files to compressed, lower-resolution files for off-line editing. This may save memory in the hard drive or time during ingest. You need to remind your director and/or DP when they view the dailies that the color and image may not be a full representation of what they have shot.

The data name, which in turn becomes the source reel (regardless of digital or film) name in your EDL, must provide a logical reference back to the digital master, so that in the on-line it will be easy to determine which timecode is needed for each edit. This becomes especially critical when your sources include reels that carry the same hour code – a phenomenon not uncommon for TV shows, limited series, pay cable, streaming and certainly features.

We suggest as a final safety measure that you make the dailies file name part of the label information on both the editors' dailies and the dailies masters. This will eliminate any doubt the on-line editor may have when pairing source names with source files.

Framing Chart

It is necessary to provide a framing chart (Figure 4.4) to your post facility and your editor, regardless of how you plan to proceed with this image through postproduction. The framing chart will be necessary in conforming in on-line if your image will need to be unsqueezed from a scope image, or if VFX are created. The purpose of the framing chart is to accurately identify the center of the image.

Production Audio Recording Tips

We are going to interject some very important advice concerning the production values practiced when recording production audio in the field. If you happen to be working directly with the production, these are very helpful tips to pass along, as they will save production and postproduction a lot of headaches during the dailies process.

Dailies

Figure 4.4 Framing chart

Some of the following points are discussed in detail in Chapter 7 (the sound chapter). Any of them can adversely impact the postproduction dailies process. The care taken when your sound is originally recorded on the set will directly affect how much money and time it will take for your postproduction facility to render usable dailies.

1. Always shoot sync sound dailies using an electronic slate. Along with the traditional camera digital data card or camera roll, scene and take information, an electronic slate has a red LED readout that gives a visual reference of the production sound timecode. The timecode displayed on this LED readout needs to match the timecode being laid down to your production audio card during recording. The sound editor uses this timecode to physically find the take on the sound element, and it can also be a secondary reference to the off-line editor when verifying the sound EDL.
2. Make sure the slate is in focus. It is very time-consuming for a sound editor, assistant editor or editor to try to decipher the slate to determine the scene and take if the information on the slate is illegible. It is also important that the

visual timecode reference be in focus, so that the production sound timecode is readable and therefore more syncable (we're not sure that's a word, but it says what we mean).

3. Make sure the slate is in the camera frame when the clapper closes. No one will be able to use the clapper to sync your shot if they cannot see the stick when it makes contact with the slate. Don't be offended by this seemingly obvious advice. We see this mistake time and time again by some of the most seasoned professional production crews. Everyone is focusing their attention on the shot, but the person marking the scene and the camera operator(s) must be aware of the position of the clapper in relationship to what the camera is seeing in the frame.

4. If you are rolling multiple cameras, make sure that all cameras see the slate before it closes, so that all cameras see the visible timecode reference. This will also help you ensure that you are giving the ten seconds of audio pre-roll so vital to the editor's and sound editor's ability to sync your sound.

5. Make sure the slate and sticks are readable. If you are shooting a scene that is taking place at the top of a tall building and you are shooting from the ground, don't put the slate at the top of the building where it will be impossible to read! You may need to shoot the slate, clap the sticks to mark the picture and sound, and then leave the shot rolling while you refocus on the building top.

6. Illuminate the slate if you are shooting a dark scene. Be sure to do it so that when the stick makes contact with the slate it is clearly visible in the frame. The timecode numbers need to be electronic and readable in the dark; the close of the clapper is the only way to verify sync at the beginning of the take if the audio timecode fails. Some productions shine a light on the slate, and some apply a glow-in-the-dark substance or tape along the bottom of the stick and the top of the slate so that the clapper closing is visible.

7. Make sure the production sound recordist verbally slates each take. This way, if the timecode on your slate is inaccurate or unreadable, the editor or sound editor has a backup source to find sync and identify the correct takes on the audio card. Syncing sound to picture is a very time-consuming part of dailies ingesting.

8. If the production audio timecode is to become the linear timecode on your dailies, roll the audio card on MOS ("mit out sprechen" i.e. without sound) takes. If you do not, the editor must assemble the shot by jam-syncing the timecode so that it locks and generates, continuing from the previous take. This is time-consuming and probably means these takes will need to go at the end of the dailies. The off-line editor can use this sound for room tones/noise in the cut.

Dailies

Transfer Log

Here is a description of each section of a sample transfer log (Figure 4.5).

A. Edit number: This signifies which edit this is.
B. Scene number: This lists the scene number of that edit.
C. Take number: This lists the take number for the specified scene.
D. Digital data card: This is the digital data card that the scene and take are located on.
E. Sound card number: This is the sound card that the scene and take are located on.
F. Digital master timecode: This is the timecode that exists on the digital master.
G. Audio timecode: This is the timecode that was laid onto the production sound when it was recorded in the field.
H. (If film finish) edge number or Keykode number prefix: The eight letters make up the first characters of the edge numbers on the film. This information is specific to a particular camera roll. Each time a new camera roll is put up and transferred, this prefix changes. The letters represent the film

Slate Date:_____ Title:_____ Transfer Date:_____
Bay:_____ Client:_____ Colorist:_____
Notes:_____

(A) Edit	(B) Scene	(C) Take	(D) Camera Roll	(E) Sound Roll	(F) Record TC	(G) Sound TC	(H) Prefix	(I) Key In
1	86	4	A1	1	01:01:05:05.0	09:36:37:25.0	KQ355030	4169+00
(J) Notes:								
2	87	5	A2	1	01:02:12:20.0	10:42:30:05.0	KQ415166	5146+00
Notes: SLATE TC NG								
3	87	6	A2	1	01:04:46:05.0	10:47:50:28.0	KQ415166	5378+00
Notes: SLATE TC NG								
4	GS		A2		01:07:12:10.0		KQ415166	5599+00
Notes: GRAY SCALE								
5	87A	2	A2	1	01:07:15:05.0	11:17:54:02.0	KQ415166	5665+00
Notes: SLATE TC NG								
6	87A	3	A2	1	01:08:28:15.0	11:20:17:18.0	KQ415166	5778+00
Notes: TAIL STICKS								
7	87B	1	A3	1	01:09:46:20.0	11:33:30:05.0	KQ485066	4947+00
Notes: SLATE TC NG REFLECTIONS ON FACE								
8	87B	3	A3	1	01:10:53:15.0	11:36:00:27.0	KQ485066	5065+00
Notes:								
9	701	1	A3		01:15:46:20.0		KQ485066	5664+00
Notes: MOS								

Figure 4.5 Transfer log

manufacturer and where and when the film was made. These aid the film manufacturer in identifying specific information about a particular roll of film when researching possible film stock problems.

I. Timecode/key in/foot and frames: This locates the timecode or, if working with film, counts the number of feet and frames from the head of the camera roll to the slate of the selected take.

J. Comment line: The colorist is provided with several character spaces in which to make any important notations about that particular take. Items such as MOS takes, tail sticks, camera issues etc. are put here for the editor's reference.

Road Maps and the Multi-Camera Shoot

Road maps are another tool that is very useful for both the transfer house and the client when shooting and transferring multi-camera shows such as sitcoms.

A road map is a spreadsheet that lists what camera rolled for each take. It also lists what camera roll and sound roll each take is on, and each take's duration. Finally, there is a place to note any comments that will help the colorist when transferring that take.

Traditionally used for sitcom transfers, a road map could also be useful for any large production. It provides a guide for the editor to help clarify:

1. which cameras rolled per take
2. the duration of each shot
3. which sound roll each shot is on
4. any comments necessary for each shot, such as "sound didn't roll" or "take no good (NG)".

A road map provides a diagram, creating the layout of the multiple-camera dailies masters to match the multiple cameras.

Figure 4.6 is a sample of a road map. An explanation for each section of the road map follows.

Road Map

The following is a breakdown of the sample road map.

A. Title
B. Episode number and title
C. Shoot date(s)
D. Scenes
E. Takes

Dailies

B
EPS#<u>103</u>
EPS TITLE <u>Trouble Again</u>

A
SHOW <u>Paddy's Wagon</u>
C
SHOOT DATE(S) <u>4/23-4/24</u>

D	E	F				G	H	I	J
		A	B	C	X	SOUND	SOUND		
SC.	TK.	CAMERA	CAMERA	CAMERA	CAMERA	ROLL	TIMECODE	LENGTH	COMMENTS
A	1	1	1	1	1	1	12:14:22	2:42	X Cam aborted take
A	2	1	1	1	1	1	12:35:19	2:39	
A	3	1	1			1	13:01:25	2:54	
B	1	1	2	1	1	1	13:14:21	1:19	
B	2	2	2	2	1	1	13:26:05	1:23	Lens flare
B	3	2	2	2		2	14:01:02	1:07	
B	4	2	2	2	2	2	14:13:09	1:17	
D	1	2	3		2	2	14:20:10	:56	No C scene shot
D	2	2	3	3	2	2	14:23:18	:53	
E	1	3	3	3	3	2	14:33:21	3:06	
PA	1	5	4	4		3	16:22:19	:36	
PB	1	5	5	5	5	4	17:03:21	1:09	

Figure 4.6 Road map

- F. Camera: Put an "X" or camera roll (digital card) number in each camera roll's box if that camera rolled on this take
- G. Sound roll (digital card) number
- H. Audio timecode (timecode recording when take started)
- I. Duration of each take: Either time this yourself with a stopwatch if you are on the set, or ask the sound recordist, camera department or script supervisor to keep track – this information becomes critical during the assembly
- J. Comments: This column is for comments regarding each take that the colorist will need later, such as "take NG" or "sound didn't roll".

Timecode

You probably want to include timecode on your dailies for reference, unless otherwise specified. The visible timecode in the editor's off-line is a visual reference only, but most editors prefer it.

Size Matters

An incident occurred where an editor requested that the visible timecode window be a larger size than the postproduction house traditionally used. This request came because the producer and director liked to look at multiple shots on the off-line system monitors, and the editor was having a hard time reading the timecode in the window. The associate producer agreed, and the visible windows were enlarged on the dailies transfers of their next episode. The associate producer called back several days later. She ordered new editor's files to be struck from all their dailies masters utilizing the smaller visible window size. It turns out the producer and the network executives felt they "could not see enough of the picture" because of the larger-sized timecode windows.

Fortunately, before making the window larger, the dubbing facility had gotten approval for the size change from the production company. Now, in addition to being responsible for the costs incurred in remaking the editor's files, the production company also had to pay someone to reingest the dailies in the off-line system. The production company, not the editor, is really the client; had the postproduction house changed the window size without checking with the production company, the production company could have made a reasonable argument for not having to cover the costs incurred in remaking the files and reingesting the digital files.

Of course, there may be a way to make everyone happy. Read on.

Having "Safe" Picture

A picture has several physical boundaries. The top and bottom of the picture are defined by the vertical blanking intervals (VBlank, if you want to sound hip). The sides of the picture are defined by the horizontal blanking. Blanking refers to the scan lines that make up the image. Some monitors can be adjusted to view several image sizes. Figure 4.7 illustrates image areas affected by the size and type of the monitor on which you are viewing.

Title Safe

- Title-safe area. This is discussed in detail in the credits and titling section of the chapter on completion.

Figure 4.7 16 x 9 action safe/title safe

- Action or picture safe area. Also referred to as overscan, this represents the image area that you can see on a normal TV or monitor. It is the area the viewer will see on the TV set at home – regardless of the size of the set. It is also the area the producer sees on the TV set in the office while watching their dailies, or on the editor's monitor when it is in the normal or overscan mode.
- Underscan or outside-TV-safe area. This represents the area of the image that falls outside the top and bottom of the picture on a consumer TV set. Because many edit system monitors are equipped with the ability to choose between underscan and overscan, you can place visible timecode windows in this area. This allows the editor an increased comfort level by having the visual information available as a reference and double-check, but it allows the executives and network to view the material without a visible window obscuring part of the picture and causing a general distraction.

Some monitors will have a slightly larger viewing area than others and therefore may expose the very edge of a visible window that has been placed in underscan. This is still usually preferable to seeing the entire set of numbers constantly updating on the screen.

Screeners

When a show starts up, whether it be a feature, a limited series or an episodic, the list of people who receive dailies can be quite extensive. And no matter how long the list seems on day one, it is almost guaranteed to be a little longer by day two. Normally, access goes to the executive producers and producers, network executives, the director, the cinematographer, and sometimes even actors' agents. This usually goes on for the first few days of an episode.

The dailies are sometimes distributed via protected Cloud-based file storage or using third-party hosting. Sometimes physical DVD screeners are made by the postproduction facility at the request of the producers. If the director and producers decide they want to view their feature or TV dailies on a larger theatrical screen, the post facility, free of charge, normally provides screening room.

Never Early Enough

It is worth repeating that no matter how early you get dailies to the production office, it will never be early enough. So, know going in that this issue will come up on an almost daily basis. And should you ever be responsible for postproduction on a show where you are told that the dailies can be transferred at the facilities' convenience, and that the production office is not expecting to see dailies early each day, watch out! Someone is lying, or at the very least being naive.

Everyone may be saying this at the beginning, but someone high up is going to start wondering why shooting is going on and no dailies are forthcoming. Just be prepared for a change in the game plan.

Troubleshooting Dailies Problems

Sometimes the cause of a digital or audio problem is not readily apparent. At times the hardest part about troubleshooting is not coming up with a solution, but determining where the problem originated. Hopefully, if there is a digital hit or defect, the camera department, DIT or postproduction team have already done the research on their end to determine if it is a capture problem – or if film, it could be an issue in the gate, dirt, scratches, hairs, or a laboratory problem that occurred somewhere along the developing or cleaning process. It is critical to determine if the problem occurred on the set as quickly as possible, so that you don't have another day of ruined shooting.

After you have determined the cause of the damage, can the take be saved? Can you cut around it? Are there alternative takes? Troubleshooting digital defects can be complicated, because there is always the issue of where the problem originated. Your biggest allies in the quest to research digital camera problems in the field are going to be the camera equipment rental house and the postproduction facility.

If a reshoot is required, the producer may be able to schedule the reshoot before the production crew leaves the location. It is not the most ideal situation, but your producer will be more impressed by this than if you wait several days and *then* determine that a reshoot is necessary and the location is lost. It happened to one of us that a reshoot was necessary and the second unit crew was able to add in this reshoot while they were at the location. It was one of those pat-on-the-back moments that can seem few and far between.

Summary

In summary, remember not to let dailies make you too crazy. As a client, build a good rapport with the postproduction facility; it will help with a smoother workflow throughout the process. However, also keep in mind that your post house should bend over backwards to help you throughout the process; if they don't, seriously consider switching facilities. The facility should strive to meet every need, on schedule, on budget and correctly, so that you will come back again, and so that they can move on to the next job. Remember, it's rough going in the beginning, but by the wrap of principal photography everything runs like a smooth machine.

Remember, of the upmost importance are:

- file naming
- timecode
- coordination with the post facility
- getting a framing chart
- not forgetting to back up!

If your project takes you into uncharted territory, don't let it overwhelm you. Don't feel as if you are alone in all of it. There is *almost* always someone else who has been through it and can help you troubleshoot any issue. The trick is to find that person, that colleague, that confidant. Production revisions happen on the fly, and many times at the last minute. Just remember to remain organized.

CHAPTER 5

Editorial

Why didn't the editor show up to the Adobe protest?
He wasn't an Avid supporter.

Editing is a multilayered creative process. The editor is important in this process, and can be crucial to the outcome of the project. Individual takes are assembled from dailies to create scenes, and scenes are assembled to make acts, and acts are assembled make a show, all according to the blueprint provided by the script.

Many variables are considered when choosing shots. Being familiar with all of the clips or footage, the editor considers the director's notes, the performances, the look of the shots, visual coverage and the pace of storytelling. They choose the better takes of each scene to create the first picture cut, called the editor's cut, creating an EDL and assembling clips together in a sequence on a timeline.

We had a feature film several years ago where the director didn't feel that they had shot enough "coverage" on a particular scene. Coverage is a series of various camera setups, usually mediums to close-ups, on a specific scene, after a wide shot is filmed to establish the action. After watching the rough cut, the director discussed their concern with the editor, who proceeded to dive into the extra footage around the edited clips they had already used in the timeline. They found usable reactions within the unused clips in the project bin and added them to the timeline. Suddenly the film started coming together. Miracles can happen in an editing bay.

Editing begins with the first day of dailies and ends with picture lock. At this point you are ready to go from your nonlinear edit system (e.g. Avid, Final Cut Pro, Premiere etc.) to an on-line facility, or if going out to film, to have your negative cut.

The Editor and Assistant Editor

In the course of a project, editors and assistant editors have countless hours of clips or film footage to review, an impossibly short schedule, and changes to

incorporate at every turn. Working daily with the images, the editor can give the director timely updates on missing shots, digital hits or defects, and if shot on film, scratches or damage that render a take unusable.

Some feature and episodic editors start work the first day of production and are employed until the last day of the mix. However, feature and independent TV producers cut their budgets in editorial by letting the editor go upon picture lock, keeping the lesser-paid assistant through the mix. This is predicated on the budget and the producer's style and experience.

Editors employed on TV or digital series are with the show for the run of the series, though there is normally more than one editor employed. Each editor works on a different episode, and two or more episodes are often in different stages of completion at the same time. Depending on the complexity of the series and the budget, two editors sometimes share one assistant. The assistant editor is on a TV show long enough to ingest the dailies into the off-line system and verify that the data is accurate, but for a feature they may be on the show longer than the editor. The assistant editor may also be responsible for transcoding (converting one digital file to another). Transcoding happens in transferring digital files from camera to dailies, and then again in converting files for an off-line edit (high resolution to low resolution) or converting files for a specific type of exhibition.

Once all of the dailies are shot, delivered to the postproduction facility and down-converted, the off-line editor has ten or more days to present the first rough cut of an independent feature: Typically one to five days for assembly of episodics, five to 15 days for reality TV, and a minimum of six days for limited series or projects that have a run time of more than an hour. These timetables are regulated by the DGA. Any deviation from this schedule will be up to the editor's discretion.

Editors will usually sit in a semidarkened edit bay all day and sometimes all night. Those experienced in the demands of editing come to recognize good editors as talented artists. Paid by the producer and answering to the director (who in turn answers to the producer and studio), editors often find themselves walking a tightrope in many situations, trying to keep everyone in agreement.

Respect your editor. If there is a disagreement between the editor and director or producer, talk and work through the situation until you come to a solid edit. The editor and assistant editor are your communication lines to the production battlefield.

An important note regarding editors: It has been our experience that a demanding or frustrated editor is often acting out of the same passion for the project as the director, reacting to a less than ideal situation and out of desire for the best outcome for the feature or series. It is not always possible, but try to understand where your editor is coming from, and be willing to compromise.

Off-Line Edit Bay Equipment

An edit bay is usually a fairly confined space with a table, a few monitors, an editing keyboard, and editing software such as Avid Media Composer, Adobe Premiere Pro and Apple Final Cut Pro, designed to ingest large data files, interpret the data, assemble the clips, and provide EDLs for use in on-line conform and sound services. The system will also be equipped with additional VFX plug-ins or programs such as Adobe After Effects, Maya, Houdini, Fusion and others that can create minimal effects, color adjustments and titles.

Hardware can be either PC or Mac or custom-built, but it must have enough bandwidth to handle larger gigabyte-size files during ingest, file transfer, and any encoding, transcoding and/or rendering of data. The number of bytes (amount of hard drive storage) you will need for the duration of your project depends on the type of production, the amount of data needing to be stored and the resolution of the image.

Remember when choosing office furniture that at times there will be several visitors in the room at once – director, producers, executive producers – and they will all want a comfortable place to sit. Consult your producer, editor and equipment supplier when making these decisions. Try to be honest and accurate about the amount of storage you'll need, including backups. All versions of the project should be backed up on multiple drives at the various stages. Unexpected delays in production and cut approval can require that several shows stay stored on the off-line system. This may require that you order additional storage space/hard drives so your editors can continue working while you are waiting for shows to be locked.

Regardless of whether you're editing off-line or on film, in addition to editing bay or cutting room equipment, each editor and assistant will need the following:

- time cards, I-9s and any other accounting necessities
- script, plus all revisions
- crew list/cast list
- shooting schedule
- postproduction schedule
- postproduction facility/film laboratory and sound facility contact names and numbers
- delivery requirements (domestic and foreign)
- credits (as soon as available)
- POs (we suggest you set up a procedure that requires POs be issued for all work done through your postproduction facilities)

Film Edit Room Equipment

Film editors need two rooms, Moviolas and flatbeds, sound heads, rewinds, film benches, bench stools, banners, film splicers, take-up reels and film cores, grease pencils, boxes, gloves, cleaner and on and on. The assistant editor may make the list and can help double-check that nothing has been left out.

Viewing Dailies

During a dailies screening session, notes are given by the director and producers, the cinematographer and possibly the postproduction supervisor or other key crew, on everything from defects in camera to color, lighting, continuity, creative or production decisions etc.

It is the responsibility of the associate producer or postproduction supervisor to schedule the screening time. Do this through your post house – they have projection rooms available for viewing dailies. There should be no charge for using these rooms – unless you abuse the service. Scheduling several screenings in a day, or constantly changing screening times, will make it difficult for the facility to service both you and its other clients. The post house may begin to charge you for extra screenings or cancelations. If time does not permit you to screen at the postproduction facility each day, the post house can create screeners for viewing, or your producer or post supervisor can arrange time with the DIT or second AC to screen dailies on set.

Remember, you can now screen dailies in a variety of ways: On phones, tablets and other devices. However, you need to be aware of security issues, and make sure that what you are screening on is calibrated so your final product looks the way the director intended.

Editor's Log and Script Notes

The assistant editor will create an editor's log or script report that organizes scenes shot, footage or clips shot, and number of setups and run time of each take. This is done for each production day, and it may look like Figure 5.1.

The script supervisor's notes are the primary source of information for this log. If these notes aren't available or detailed enough, then you may need to look elsewhere – camera department, sound department and/or continuity – to verify the information. These other sources will include camera and sound reports. The script supervisor holds a very key position on a project, and many aspects of production and postproduction depend on the accurate information contained in the script supervisor's notes.

SCENE	ACTION 9-27-97	LENS	CAM ROLL	SND	TAKE	TIME	COMMENTS
6	Master: sign Will ⟶ Steve joins her 3 shot thru end	32m 4'6'	A2	1	1 ② ③	1:19 1:27 1:35	thru 1B some good
6A	Will ⟶ 2 shot Will: Steve	70m 7'5'	A3	1 1	① 2	:23 1:45	incomp. good
6D	Don's POV of Steve	70m 12'4'	B1	1	1 2 ③	:07 :10 :06	
6F	OS Steve	70m 45'	A4	1	1 ② 3 ④	:18 :34 :21 :35	 *print for snd inc. NGA birds!
6G	OS Will	50m 5'	A4	1	① ②	:33 :35	 great
6H	Don enters w/chef w/pastries	50m 15'	A5	1	1 ② ③	:10 :18 :17	camera *tighter

Figure 5.1 Editor's log

Figure 5.2 shows some sample script supervisor pages that correspond to the editor's log sample chart. The circled scenes and takes from the script supervisor's notes are organized in the same order onto the editor's log. The wavy lines indicate the length of the take and tell the editor if the takes are complete or if they were unusable or NG.

Off-Line Editing

The terms "nonlinear" and "off-line" are used to describe the digital editing process prior to the conform.

All of this is accomplished without any physical alterations to your source material. Off-line has become the new standard over the last several years; most projects are not film-finished, unless they are archiving a print or exhibiting in 35mm film. The flexibility for making changes instantly is very appealing. Scenes can be cut and recut endlessly without worry about film damage, resplicing reels or waiting for reprints.

```
                    5A              5D           5G              5K
        5 Continued: (3)
                                          BUD
                      Sam Smith. Rings a bell?

        Flander shakes his head.

                                 BUD (Con't)
                      She died suddenly. And she was my friend.

                                     FLANDER
                      Drawing a blank.

                                       BUD
                      Well, perhaps will can work this thing.
                               (points at oven)
                      and make some good muffins in Sam's memory.

        6 INT. SCHOOL LUNCHROOM — DAY       6A         6 Master
        A table is set up beneath a sign: "Bake-Off Sign-Up." Will is
        writing or one of the sign up sheets. He looks up to see:
                                          6H       6J
        7 ANGLE: A CAMERA

        Going off in his office. Don is an annoying aggressive chef
        who right now is taking pictures of every pretty cake that passes by.

        He turns the lens on a passing cream puff. Looking it up and down.

                                     DON
                      Look at that whipped cream...
                                     BUD
                      No thank you
                                    WILL
                      Don, knock it off.
```

Figure 5.2 Script supervisor's notes

During principal photography, takes that the director wants to see "printed" are circled on the camera and sound reports. The camera and sound accompany the dailies to the postproduction house or laboratory for processing. Once the raw content from production is ingested and transcoded for the off-line, the various takes – which are noted by the director and camera crew, and determine sequencing order – are assembled on the editor's timeline by the assistant editor. The selected takes are located in the source files by using digital timecode, which is noted along with other data on the electronic slate. If shot on film, the circled takes are physically cut out of the camera negative and scanned to digital files for editing.

Once picture is locked, the editor will drop in the VFX, color timing, placement, opticals, titles and additional media. A visual reference is created, and the metadata and the visual reference are sent to the conform session. (See the digital workflow chapter for more information.)

The production sound is shot digitally, regardless of type of camera. This audio – along with the matching sound reports, which note timecodes from a

SmartSlate, the best takes, any sound issues causing a take to be no good etc. – are delivered on a compact memory card (aka memory sound card) to the appropriate person, usually the editor or sound editor. The circled takes are ingested and assembled in a pro tools session into stems for dialogue or for M&E etc. They are now ready to be edited.

It is now the assistant editor's job to prepare the film or files for dailies viewing, use by the editor, syncing of picture and track, and possibly even screening of screeners. Even if dailies are scanned from film to digital, the assistant editor's daily duties do not vary much. If dailies are screened, they are usually only projected for the first week or so. (See the digital workflow and film laboratory chapter for more detail.)

VFX from Off-Line to On-Line

One of the great advantages of the off-line system is that you can see at any point how the project is coming together, complete with at least rudimentary dissolves, fades, titles, color correction and other effects. This can help the creative team test artistic decisions without getting into expensive on-line and effects bays. As cool and practical as this is, this magic must be accompanied by a word of caution.

The effects you create in your off-line are temp effects and can only be used as a gage. Once created, the on-line effects will look slightly different than the effects you build in your off-line system.

Ultimately, what comes out as dissolves, fades etc. will only be as good as the information going in. Without accurate timecode, those beautiful effects will be useless to you if they do not fit into your timeline perfectly. Any deviation that changes the physical length of the edit will cause sync problems when your track is lined up with your picture. Your editor must provide precise timecode for the post facility to create fades, dissolves and color changes accurately. There are tricks in the digital world if a picture clip is not syncing with audio or effects: You can speed up or slow down a shot to help it fit in its designated place. Is your animation a few frames short? Fix it in post. You don't necessarily have to draw or shoot more frames.

None of these tricks work in the film finish world. And editors who work primarily in the digital realm can quickly forget these limitations. They then become frustrated when their opticals transition too quickly or the color isn't the same as their monitor in the cutting room. But as with most things in life, the harsh realities of the celluloid or digital world come crashing back rather quickly.

It is very rare that you would be cutting film these days, as editing digitally off-line alleviates most of these headaches. But just in case, to try to avoid these frustrations and wasting a bunch of time and money needlessly. If you are cutting film, we recommend a little "better safe than sorry" test. Before creating the final cut list for the negative cutter, pick up the phone. Call your rep at the film laboratory that is going to print your negative and ask a few questions.

You might start with: How short/long can my dissolves be? Can I get a color timer involved before the final film opticals are approved? And here's another favorite: What do I have to know about cutting A and B rolls prior to submitting my negative to the lab? Seeking technical information with opticals and color timing from the start will solve many of your problems before they even happen. More information is available on this in the film lab chapter.

Managing Editorial

Several items are vitally important to the off-line editing room. Someone needs to track the daily amount of footage that was shot, the camera rolls and sound rolls that were turned in to the post facility for transcoding or processing, and any B camera rolls that are due. Traditionally, the associate producer or postproduction supervisor gathers this information, which they receive from production. Someone needs to make sure that all of the dailies masters are accounted for and delivered to the post facility for vaulting until the on-line. Sometimes this tracking falls to the editorial staff. The same person must also make sure that one off-line for each master is delivered to the editing bay. Sometimes, on a low-budget feature or TV show, the producer may even handle this. If these off-line dailies were not recorded simultaneously on the set during shooting, then they have to be created. There is additional information on the creation of these in the dailies chapter.

The assistant editor must have a technical understanding of the dailies information that is provided from the transcode. While dailies colorists are usually accurate in the information they record, they are keeping track of many things at once. Colorists and their assistants constantly monitor their equipment to ensure it is functioning accurately. They check that they have laid down all of the circled takes. They check camera reports against sound reports to verify nothing has been missed. They decipher incorrectly slated takes and incomplete camera reports. There is a window of opportunity for human error in every dailies transfer session. There are, frankly, too many areas to keep track of during the transfer to guarantee that there will be no mistakes.

Because of the human error factor, it is incumbent on the assistant editor to verify the accuracy of the information they receive and load into the off-line system before the editor begins to work with the material. It is also critical that the assistant editor be very organized. An accurate list of shots, circled takes and B roll must always be available and up to date.

Stock Footage

Stock footage is picture that is nonspecific to a particular movie or TV show. It could be a shot of a famous building or skyline used to establish location, or it could be just generic locations, buildings, weather, catastrophic events, large gatherings, wildlife or military shots. If a production company determines that it

is not cost-effective to send out a camera crew to shoot stock footage, they turn to any of the numerous established companies that keep a stock footage library for licensing. Some stock houses specialize in particular types of shots, some have contracts with film studios to buy their clips for relicense, but many stock houses now offer their catalogue of stock footage online, where it is easy to view, purchase licensing rights and download footage.

The ordering of stock footage usually falls on the assistant editor's shoulders. Again, depending on the company structure, it may also be ordered by the apprentice editor, or even by a producer. Regardless of who actually orders the stock footage, it still must be looked at over the internet or via third-party file transfer before determining if it is appropriate and usable.

To order stock footage, determine which stock house you will be dealing with (several stock houses may be used on one show). Then call the stock house and describe what you are looking for. They, in turn, will send out low-resolution digital files of several different shots for evaluation. These shots will be heavily watermarked and not usable in your final picture.

The producer, director and editor will view the shots and decide if any are appropriate. Once a shot is chosen, the stock house will provide a higher-resolution digital file of the shot to be cut into your final picture edit. Part of the licensing paperwork requires an exact footage count or timecode of the amount of the clip used. The associate producer will gather this information from the assistant editor. Detailed information on licensing stock footage is provided in the legal chapter.

Clips

Clips are entire programs, scenes or partial scenes that are particular to a specific movie, newscast or TV production. Clips are used for playback on a set, dream sequences, flashbacks, to establish an event or mood, or to provide information vital to the telling of a story.

There are companies that specialize in licensing vintage, news or public-domain clips. As with stock footage, call the clip house and describe what you are looking for. Once a clip is chosen, the associate producer handles the licensing paperwork. Clips traditionally are licensed without sound, due to complications with music clearances.

Clips from movies still under copyright must be licensed from the copyright holder. This is usually a film or TV studio. Again, more details are available in the legal chapter.

Aspect Ratio – There Is No Stock Answer

If you are working in a format different than your stock footage material, then the short answer is that you have to resize and change the aspect ratio of the

stock footage. You may have to blow it up… not *Die Hard* blow it up. Rather, you'll need to adjust or reposition the image to fit the container.

Editor's Cut

The editor's cut is the result of all of the elements that the assistant editor has gathered in conjunction with script notes and producer and director notes. This longer, looser version is the foundation for, and often closely resembles, the final cut of a show. Scenes are assembled from dailies, using the script notes as a guide. Being familiar with all of the varying takes, the editor chooses the better takes of each scene and orders B roll and re-edits as needed. The DGA agreement specifies the number of days the editor is legally allowed to complete the editor's cut.

Know that there will be editing changes before the show can be called locked. Many times an editor will leave room in scenes for editing changes, pacing and continuity. When the editor signs off on this cut, the director takes over and creates the director's cut.

Director's Cut

Once the editor's cut is complete, the director screens it. All changes made by the director become part of the director's cut. Now the director sets the pace of the show, shortening (tightening) and lengthening scenes as necessary. This cut shows the producers how the director envisioned the movie when it was shot.

Unless the director invites them, it is illegal (per the DGA) for anyone other than the editorial staff to be in the editing bay before the director has finished. Breaking this rule can result in costly fines to the production company. The DGA also sets the rules governing the number of days allowed for the creation of the director's cut. If in doubt about the rules, call the DGA. Some directors are very strict about these rules, so exercise caution.

Sometimes the director will ask for insert shots or second unit shots to enhance the story. The producer and the director will determine feasibility. If additional takes are shot, a smaller second unit crew is assembled and sent out.

Inserts can sometimes be shot on an insert stage. Insert stages vary widely in size, depending on the requirements of the shot(s). Insert shots can run the gamut in terms of difficulty, from something simple like an object falling to the floor or a hand gesturing. They can also be more complicated shots requiring that pieces of the original set be brought in. Because these shots often occur after principal photography, unless they are needed prior to production for playback on set, it is often incumbent on the associate producer or postproduction supervisor to organize the insert shoot. An insert stage will be equipped with camera(s) and operators, lighting, and sometimes even makeup. Insert shots are normally MOS.

If a crew goes out to shoot additional second unit footage, a call sheet and production report will be created. Hopefully, the production manager is still on

the payroll and can handle the DGA paperwork. If not, see your producer for instructions or to handle the details.

The director's cut is formatted to include film slugs (placeholders) identifying act breaks, commercial blacks, missing insert shots, and title cards. It goes to the production company and sometimes to the network executives to view.

In TV, the director's job is officially done when shooting is completed and the director's cut is delivered. Because of TV's fast pace, a new job is often waiting and the director leaves before the picture is locked. However, the director may supervise the ADR or looping session and the second unit shoot, and may also be present at the final audio mix. Even if it is not specified in the contract, it is usually considered good form to invite the director to participate in each of these steps.

Producer's Cut

Following the director, the producer creates the next version of the show. For TV projects, producers usually take two to five days to screen the director's cut and complete their version. Longer periods of time are allotted for features.

As with the director, the producer may feel that insert shots or additional footage is necessary. If approved, the process for arranging inserts shoots and second unit will be identical to the scenario described above for the director's cut. Traditionally, any extra inserts and second unit shoots are coordinated by the director and producer, who together determine what is needed. This way, all of their requests are covered in a single shoot or insert session.

The producer's cut will then go to the production company executives and usually the network for viewing. Even in a half-hour sitcom, several versions (called producer's cuts and labeled PC #1, 2, 3 etc.) may be created for executives and the network to view. We have seen seven and eight producer's cuts go out for a single show before everyone was satisfied. In one instance, four copies of each version were sent to the production company, and seven screener copies were sent to the network executives. The costs of duplicating multiple screeners of each version can really add up. This cost can be minimized with file transfer.

Temporary music and effects may be incorporated into the producer's cut. With film, any special effects not created during production are often too expensive to make just for a screening – in case they are not used in the final version. With digital off-line editing, simple special effects can be created quite easily by your off-line or on-line editor. Simple titles can be added to help round out the effect.

Temporary Dub or Prelay

Depending on your project's budget and the importance attached to the network screening, the producers may decide to create a more completed version. Rather than simply making copies of the off-line screener, they spruce up the

off-line cut a bit with a temporary on-line and temporary dub. These added steps are the exception to the rule and are often saved for use on pilots, streaming, limited series, and cable shows with anticipated foreign theatrical releases.

Producers incorporate temporary music and effects because they want the network and studio executives to visualize the finished product as clearly as possible during the various stages of the cut. This is an added expense that may not have been included in the budget at the start of the process. The money to do this may have to come from somewhere else in your budget. One option when doing a temp audio mix may be to first do a prelay (see the prelay/predub section in the sound chapter) and then do the temp mix. This can limit or even eliminate the need for a prelay session when the final mix is done.

A temp dub or temp mix may be done with your sound services vendor. Here temporary sound effects, mood music and voice-overs can be added prior to sending the picture to the network for their viewing. It is always wise to present the absolute best version of your project to the network or studio executives.

Network/Studio View

In the early days of recorded TV, a producer's cut work print would be viewed with the network executives and legal department in a network screening room, with the director, producer(s) and postproduction supervisor or associate producer present. Later, the network simply had a work print delivered and screened it by themselves, calling afterwards with their comments (referred to as network notes). Today hard drives or screeners are delivered, and everyone waits for the network notes – usually two or more days later.

Picture Lock

As with the completion of principal photography, picture lock is a big step toward the completion of your show. Once all the studio/network notes have been addressed, your picture is considered locked, meaning – in theory – that all of the changes that will be done have been done.

At this stage, the off-line edit is locked (there may still be insert placeholders for VFX or text cards). In a digital show you are now ready to on-line your project. The hard drives containing the locked final picture edit are handed over to the on-line editors at your postproduction facility, along with the EDL and additional notes from the editor, as well as VFX files, credits, titles, and additional elements and metadata.

One very tedious but important job the editor must complete for shows doing a film finish is called balancing the reels. Balancing the reels is required if a scene is split between two reels and a music cue is involved. It is mandatory that the scene be left in its entirety and not split up. It will be difficult or almost impossible for the music supervisor to cut a cue if it has to be split between two reels.

VFX

When the digital VFX are too complicated to be done during an assembly, you can build your VFX before or after your on-line. This VFX reel is now part of your on-line source material. Just make a file for the editor to upload into the off-line system. The shots taken from this file will then be incorporated into the final list of edits. If they are not completed before the on-line, the VFX can be created after the on-line in a separate session and dropped into your master.

Often the effects or music department will have questions and will want access to the editor. If your show is effects-heavy, it would be wise to have the editor oversee the effects and attend any effects sessions at the postproduction house.

If you must create a cut negative to satisfy your delivery requirements, the editor will start ordering your film opticals – which will most likely still be created as digital VFX, at least initially – as soon as possible. Film opticals are created on film at a laboratory or optical house. A copy of the original negative (called an internegative) is made and then altered to create fades, dissolves, scene transitions, titles and other effects.

Negative Cut (for Film Finish Shows)

Negative is never cut before the picture is locked, and the negative cut is never complete until all opticals are approved and have been cut in. Features mostly now edit on-line digitally, but some studios still cut negative.

If your show has film dailies and is finishing on film, the editor will provide the negative cutter with a complete work print. If you have done a digital off-line, the negative cutter will need a negative cut list or negative conform list. This list provides the negative cutter with a list of each shot and its location on the negative, much like an EDL. See the completion chapter for additional information on negative cutting, negative conforming and completion.

On-Line Editing

Lies producers tell editors:

1. It's pretty simple. It should only take an hour.
2. I'm positive we've got this shot from another angle.
3. I've never had this problem at any other facility.
4. I thought you'd be able to just paint it out.

Lies editors tell producers:

1. I'll fill out the paperwork tomorrow.
2. Oh, don't go by *that* monitor.

3. It's on the source file.
4. I think it looks just fine.

On-line editing is the digital equivalent of negative cutting. This process is used if you will not be cutting negative. Sometimes an on-line is necessary to provide the promotional department with advertising material before the show is actually finished and delivered. Very often, due to production schedules, the final version of a TV show (with sweetened audio, visual effects, corrected color and titling) is not available until a day or two before the air date.

In your linear on-line you will use your master materials to carry out all the creative decisions made in the off-line process. All of the various pieces that make up your final version will be assembled together to create your final picture. In this assembly session, you will use the highest-quality materials available to you.

These elements may include dailies, master files, graphics files, main titles, stock footage and any other source material. For example, if you are creating an episode of a one-hour drama TV show, you will have five or more days of dailies, a main title sequence, and maybe one or more effects files. For a biography or clip show, you may have hundreds of source masters coming from many different places, such as movie clips, interviews, graphics etc. Regardless of what type of show you are creating, up to this point your off-line editors have been working with copies of your master materials to cut and recut, getting the show just right. Now you're going to reproduce those final edit decisions with your master materials. Selected shots and sections from your source files will be assembled. A whole new master file will be created. This will be called your final conform. The session in which you string these together is the on-line session (sometimes referred to as an auto assembly or conform).

To summarize, the off-line is the creative process where all available shots are analyzed, and decisions are made as to the shots that will make up your program and the order and way they're put together. Transcoded copies of all those materials are used for this process. This preserves the pristine quality of your master materials. The on-line is the putting together of those shots from your master materials. During the on-line process, the loading of content happens in real time, so ingesting shows – rendering effects etc. that shoot with multiple cameras and produce a high volume of daily footage – is time consuming. The assistant must upload the action and track into the computer in real time. The editing equipment, the daily footage and an assistant editor are monopolized for hours.

When it is time for your on-line, you essentially add a new member to your team: The on-line editor. The on-line editor, sometimes referred to as an assembly editor, becomes an important component in the successful completion of your show.

In an on-line session, the editor is merging your EDL (the list of cuts and effects generated from your off-line) with your dailies masters. An EDL will be a list of your digital cuts with in and out points. The edit system assembles each cut specified in the EDL from the master files, incorporating simple effects such as fades and dissolves along the way. What you end up with is a digital master of your locked picture.

On-Line EDL

The on-line editor needs an EDL generated from your off-line system. The post-production house will provide specifications for the format in which you should deliver your EDL. Don't make assumptions about what they will need: There are several brands of on-line equipment, and it may be difficult for the facility to convert your file to the format they need. On the other hand, most off-line systems can spit out an EDL file in whatever format is requested. "Clean" the list before you deliver it to the facility. Off-line systems contain software bugs that create unwanted anomalies in edit lists. It is incumbent on the off-line edit team to go through their list and text-edit any problems that have been introduced by the off-line system. Naturally, the on-line editor can clean the list, but list management usually bills out at the edit room rate, which can cause unnecessary costs and possible delays in the edit session. A producer supervising a session won't appreciate sitting for an hour while the on-line editor cleans the list. And it makes the off-line edit team look unprofessional. You should also provide a low-resolution file (QuickTime or H.264) of the final output so there is a source to check and refer to. This file is also generated from your off-line system.

To avoid confusion between the way your source files appear in your EDL and the way the actual source files are labeled, send a legend so the on-line editor can match the source names in the EDL with the actual file names/reel labels (for example, MT = main titles).

On-line editors work almost totally at the mercy of the client and the client's editing team. If any of these folks has made an error anywhere along the road to on-line, the on-line editor is going to be very, very unhappy, and possibly deservedly crabby. Because on-line editing is a very data-driven function, there are simple guidelines that, when followed, will pretty much guarantee a smooth and efficient on-line session every time. A smooth on-line makes the on-line editor look good (which they like) and makes you look good (which may help ensure continued employment), all the while creating a really top-notch, professional-looking product. Two items that top this list of guidelines are:

1. clean and check the EDL before delivering to the on-line session
2. make sure there is a clear correlation between the source names in the EDL and the source drive and file labels

If you've sent your on-line editor a problematic EDL, it may cause corruption of data and greatly increase the time required before the actual on-line session can start. It may even cause the session to be aborted, meaning you will have to pay for a session you cannot use.

On-Line Session Requirements

For your on-line session(s) you will need to provide all of your source elements. This will include any dailies masters, logo, main titles, and any stock shots that are available – and of course the EDL, both on a digital file and on paper. You will want to provide an output file specifically for that project to be used as a reference, to be screened against your on-line master at the end of the session. This is done to double-check that the on-line picture and sound edits match your off-line cut. Also bring your delivery timing sheet and title/credit information (if you're planning to format and title during your on-line session).

Traditionally, a half-hour sitcom tries to on-line, create opticals and title all in one session. The speed of some of the current editing systems has cut the actual assembly time so drastically that accomplishing all of the above in a normal on-line session is very doable. You will need to color-correct your show before you can title.

What the On-Line Facility Needs to Know

When you book your on-line time, the facility will have a list of questions you will need to answer regarding the following:

- what type of editing bay you will need
- what editing room equipment you will require
- what types of playback and work monitors you will need access to
- which of their editorial staff will be best suited to your project
- a realistic timetable for the completion of your project

Be prepared when you call to schedule your on-line. If you cover all of the following points, you will have made a giant leap toward making your on-line a successful experience:

- Know what file format your dailies are on.
- Know the audio configuration on your source files.
- Know the timecode on your source files and clips.
- Know what off-line editing system you use.
- Make sure your off-line editor receives any on-line specifications (your post-production house should have these on file and ready to email to you).

Editorial

- Know the amount of time it will take to complete your on-line, based on the number and difficulty of edits (again, the postproduction house will be able to help you estimate the time needed).
- Send a test EDL to the on-line editor.
- Know what format the facility requires your EDL to be in.
- Be aware of any opticals or VFX that aren't complete that still need to be dropped into your on-line.
- Be aware of any other elements needed for your session that are on different formats (e.g. stock shots, motion graphics, VFX etc.).
- Know the location of your source elements and how they are getting to the on-line facility.
- Deliver all the elements for your session in a timely fashion to the on-line facility.
- Provide the facility with an inventory or pull list of the elements for your session so they can confirm that all files and hard drives or data transfers have been received.

You must also have a clear understanding of what you must end up with at the end of your on-line session:

- Know the format you are mastering to and the deliverable requirements.
- Know the timecode you will need on your on-line master.
- Find out whether your on-line editor feels the time booked is sufficient for the number and difficulty of edits. (After starting the session and seeing your material, the editor may feel less or more time will be needed to complete your session.)
- Know what effects or moves that are built into your EDL can be done as part of your assembly session.
- Know if titling will be part of your session.

The above list can also be a helpful guide when choosing your on-line facility and when you actually schedule the session(s). An even better suggestion is to ask the facility if they have a form you can fill out and sent back to them that will outline all of your specifications and requirements.

Your on-line is now complete. The editor may or may not attend the final audio mix. The assistant editor will inventory and pack up the room and confirm delivery of materials to the distributor, per the postproduction supervisor's instructions.

Summary

Off-line and on-line editing are both equally important steps in your quest to meet your distribution delivery requirements. The success of one (off-line) will

dictate the success of the other (on-line). Even though we split dailies and editorial into different chapters, they are in no way independent of one another. We just separated them so the information wouldn't seem so overwhelming and you'd continue reading.

Remember that the best way to help guarantee a successful editorial experience for your project is to be as prepared as possible. Don't leave anything to chance, and choose carefully who you depend on to provide you with accurate and complete information. At each step, double-check what you are asking for and what you are receiving.

Your postproduction facility contacts are a valuable resource for guidance and information. Use them. The more they know about where your project has been and where it is going, the more help and insight they can offer to you.

Don't be shy. We continue to stress that if you don't know something, you should swallow your pride and ask anyway. Your postproduction colleagues can't kill you, but your producers can!

CHAPTER 6

VFX

So, you're ready for the cool stuff!

But what are VFX? FX are visual or sound effects used in film, TV or music. Types vary, in different shapes and sizes. In this chapter we will talk about VFX. VFX are visual effects. Yes, everything gets shortened to an acronym. Important to remember: Know your lingo, and when in doubt, don't hesitate to ask questions.

Even though FX is a very broad department encompassing several types of effects, its main goal is to make things look or sound as if they were governed by real life. Computer VFX can extend your cinematic world, creating extensions of sets, adding assets like people or vehicles, creating characters in 2D or 3D, and sometimes using images that get projected on set while integrating multiple elements with one another.

Today, some simple VFX are available on popular editing packages and as plug-ins. You need to determine if what you need for your production can be handled in this way, or if you need a VFX facility to help. Remember, many productions have 300 or more VFX shots, even when the subject matter isn't something you would expect to be VFX-heavy.

You will most likely be working with one of two different kinds of files, either Open EXR (or just EXR) or DPX. These files are intended to carry picture data: Their developers assumed that sound would be carried in separate formats, e.g. .wav files, and this is the general practice.

Make sure you stay organized in the dailies and editorial. Shot plate numbers, file labels and references will be important later on when you're scrubbing (searching) through footage to find the right clip.

Open EXR

Open EXR stands for Open Source EXtended Range, and it is an image file format. This is a file format that may contain multiple independent images with different sets of parameters, including image channels, resolutions and data

compression methods. These files, along with a set of software tools, were originally created by Industrial Light & Magic under a free software license. The EXR file format is independent of the hardware and operating system. With EXR you can stop and start while you are creating the effect, without loss of precision. These files will have good color resolution, and images will not show noticeable color banding. Color banding is an error that looks like abrupt color changes within the same hue, or inaccurate color. The files are also useful for implementing fast zooming and panning in programs that display images with a large amount of data. These files can store multiview images that show the same scene from different points of view, which can be useful for 3D as well as for creating alternate camera angles and many other effects.

A common application of this file format is 3D stereo imagery, where the left-eye and right-eye view of a scene are stored in a single file. EXR files can be very large with many layers. Because of the flexibility of this file format, it may become an industry standard supported by most high-end 3D animation, VFX and compositing programs. Some of the advantages of this file format are that it maintains quality while saving space; it can be comprised of lossless or lossy compression; it can support multiple layers; it can hold a high luminance range and color; and you can embed multiple render passes into a single image sequence, saving time and money. This format also allows you to see the history of the file and who worked on it. The real benefits can be seen it HDR.

DPX

DPX (Digital Picture Exchange) is the other commonly used file format for DI and VFX work. It is also a Society of Motion Picture and Television Engineers (SMPTE) standard. The DPX format was originally developed by Kodak, but then was enhanced and published by SMPTE, who now maintain the file format.

DPX is a hero file format. It can hold large data files of high-quality motion images. The DPX masters can be used to make the input for film recording (digital images back to film for projection) or D-Cinema digital projection systems for theatrical distribution. Each DPX file represents a single image. DPX images may be produced by scanning film, or by using a camera that produces a DPX output.

Key advantages of DPX:

- It's uncompressed, and you can use the container for standard definition (SD), HD, 2K, 4K or whatever resolution you need.
- It's a universal cross-operating system, so files can be shared between facilities as well as between systems in a single facility.

VFX

- The native frame rate is what your capture frame rate is.
- The header contains metadata, including timecode.
- Timecode is used as the file name.
- The bit depth is smaller, and the color won't be clipped.

Of course, these benefits come with two key caveats: You have to have the bandwidth to move the images, and the storage needed to hold them.

Check with your DI facility about which file format is best for your show. Your budget and the type of production may play a part in which format you choose. This discussion should happen well in advance of production.

Framing Charts

A framing chart must be placed at the head of each timeline or visual reference (Figure 6.1). This gives the VFX facility the framing that was used for the rest of your project. Production shoots a framing chart prior to principal photography. The chart indicates where the center of the frame is located and what area or aspect ratio was used to capture the action. The chart will be sent to the editor with the dailies data, ensuring that shots from camera, editor and VFX are all cropped the same and use the same reference points. See Figure 6.1 for examples of aspect ratios, and compare how the film frame varies in size.

The VFX facility will frame their delivery material per the information and chart you provided and include a buffer called picture safe. The framing chart in Figure 6.2 represents what will be delivered by VFX for mastering.

Figure 6.1 VFX framing chart

Figure 6.2 Aspect ratios

VFX shots should be delivered in the same resolution as the on-line and should include dailies color reference, as the VFX will need to be color-corrected/color-graded to match editorial. For a film finish, VFX is usually done digitally from the digital scanned off-line edit and then transferred back to film. Ask your editor and your post house about best workflow practices or if there are any potential issues before your session starts.

A Note on Color

ACES is the Academy Color Encoding System, a standard for color correction (see the editorial chapter). Some colorists like to work in ACES, others don't. ACES is like a bucket: From the very start of production, your color choices for each clip are saved and added into the bucket. The data can be edited and manipulated in VFX with the color values. Some systems require that the data be transferred to other programs during editorial. However, with ACES it stays in one place throughout the process. When the data is projected or screened, the color choices saved in the bucket are stable and reflect your final data. What ACES does is maintain your color choices across platforms and vendors. Just remember, your final render in ACES needs to be accurately projected or screened on a QC device. Calibration is key here. The monitor or device you are viewing on must be calibrated correctly. If this is the case, your media should look the same regardless of the type of monitor or projection system.

You may not realize that there are alternatives in creating your VFX shots, regardless of your budget. Some shots can be created by forced perspective or other clever tricks in production. VFX can be out of price range for student or independent filmmakers. Take a lesson from the past: Remember, some VFX techniques were developed in the early years of 35mm film and can still be used today. There is off-line editing software that may offer some effects, and image editing software is available as well. If you are creating effects yourself, it is not advantageous to render remotely. Remote renders are very slow and introduce artifacts. Trying to create content with raw MOV files will introduce artifacts and can quickly become a frustrating experience. You will be more satisfied with the end result created in EXR. If you find yourself hiring a VFX company, make sure you know exactly what they will be creating. Nothing can spend your budget dollars more than sitting in an edit bay and hearing, "No, that's not it, I can't describe it, but I'll know it when I see it". Start early, because today VFX happens before, during and after production.

A Note on Dimensions: 2D or 3D

Remember, 2D is only x and y coordinates, so objects move along a plane. 3D is x, y and z coordinates, so you're working along the x, y and z axes. Sometimes you can make 2D look like 3D, and fool the eye. For example, calligraphy type can easily be created in nonlinear editing systems today. By making fonts or objects larger or smaller, you can make them look like they're changing depth through three-dimensional space.

If you are involved in preproduction, you may need to make choices as to the best and most cost-effective way to create the FX you need. When in doubt, ask the experts, and don't hesitate to get multiple quotes.

The VFX Pipeline

Figure 6.3 describes the average VFX workflow. Like all workflows, this can greatly differ from production to production.

VFX are so commonplace these days it's easy to overlook the steps necessary to create every shot. Let's take a high-level look at the steps for creating the magic.

PREPRODUCTION → PREVISUALIZATION OF EFFECTS → PRODUCTION OF LIVE ACTION OR CGI → ANIMATION (IF NEEDED) → COMPOSITING TO EDITORIAL AND DI FACILITY

Figure 6.3 VFX workflow

Preproduction

The first step in any VFX pipeline is usually research and development. During this period, the technical approach to the film's effects is decided, focusing on software preference, technique and facilities. Your choices will depend on what type of VFX you are going to create and your budget. This is where the tools are developed to bring concepts to real life.

Previsualization

The next step is the previsualization stage or previz. It is very important when designing effects. FX sequences should be storyboarded and even made into animatics if possible. This will save you time and money in the long run. Previsualization is the process of converting a storyboard and script into a 3D-animated, low-quality rough draft of each VFX shot. While this does not always accurately reflect the succeeding final result, it allows the director to get an idea of what shots will look like. Previz technology has become extremely sophisticated of late, even overlapping into the production stage by providing live digital environments that can be referenced during the shooting process. There are a few software packages that can create simple effects to help get you started in previz. There are also people and facilities that specialize in making prototypes for your storyboards. Previz is the first step in simulation: The making of a computer rendition of an object or scene which acts as if it were in the real world.

Production

Next comes production. Production includes several categories. One of the most extensive and crucial aspects of computer-generated imagery (CGI) is 3D modeling. This process actually occurs throughout production, with iterations of varying detail being created for varying purposes.

While 3D models make up the bulk of an environment, many backgrounds are still created using matte painting. Matte paintings have been commonly used to create background landscapes since long before the rise of digital effects, but they remain as important as ever. Modeling uses specialized software to mathematically render a 3D model of props or characters. Finally, compositing combines visual elements from various sources to create a single image and the illusion that all the elements are parts of the same scene.

Match-moving allows the insertion of computer graphics into a live-action shot, with the correct position, scale, orientation and motion relative to the photographed objects in the shot. It can also be referred to as motion-tracking or camera-solving. When shooting live action, it can also be referred to as chroma key, blue screen or green screen.

Chroma key compositing, aka blue screen and green screen, is used to position subjects in front of a projected background. Subjects are recorded in front of a large green or blue backdrop, and then the background is added in during postproduction. Blue and green are used because they have the most difference from the color of skin, because the color of the screen cannot be the same as the subject in the shot. Green has become more popular in recent years than blue, for several reasons. Green has the fewest similarities to skin tone. However, if a green prop or piece of clothing is necessary, then blue is used instead. TV weathercasters standing in front of a map are a classic example of green screen.

Front projection effects are an in-camera VFX process in film production, used for combining foreground performance with pre-filmed background footage. In one production, we shot a doorway on location and needed to create fire burning through the doorway in an effects bay. The issue we had was that the shot of the doorway was not a locked shot, and the door was slightly moving. If you were just to see an establishing shot of a doorway and it moved ever so slightly, that might not be noticed; however, when you are trying to fill it with an object, the movement is magnified, because your eye has something to compare it to. Our FX tech ran the door footage through a stabilizer, which minimized the movement, and then he could fill the stable square inside the door with fire. Our lesson on this one was (a) make sure that all plates are locked shots, and (b) send an effects supervisor or post supervisor to the set to make sure the shot is usable.

Rear projection, also known as process photography, is part of many in-camera effects and cinematic techniques in film production for combining foreground performances with pre-filmed backgrounds. It was widely used for many years in driving scenes or to show other forms of distant background motion.

Physical effects are special effects produced physically, without CGI or other postproduction techniques. In some contexts, "special effects" is used as a synonym for practical effects, in contrast to VFX created in postproduction through photographic manipulation or computer generation. Many of the staples of action movies – such as gunfire, bullet wounds, rain, wind, fire and explosions – can all be produced on a movie set by someone skilled in practical effects. Other examples include non-human characters and creatures produced with makeup prosthetics, masks and puppets, in contrast to CGI.

During production, certain members of the VFX team will usually be on set. While they do not have much input into principal photography itself, they will take numerous photos of everything, from the environment to individual, seemingly unimportant props. These photos are used to create textures for 3D models, and to reference the scene's real attributes such as lighting and object size.

Scene preparation covers a number of processes, but they all serve the same purpose: Prepare the provided footage for elements to be inserted. Among these are motion-tracking, rotoscoping, keying and color correction.

Motion-tracking analyzes footage with a moving camera and/or moving object, and tracks the 3D motion of the footage to replicate the camera's movement and place objects into the scene convincingly. Without motion-tracking, VFX could not be inserted into shots with camera movement; nor could they be seemingly attached to moving objects. When analyzing camera movement, this is technically called match-moving, whereas motion-tracking is usually regarding individual object movement.

Rotoscoping and color keying are the techniques used to cut out elements from a live-action shot. Color keying removes a specified color from a scene, as seen with green screens and blue screens. This is different from color correction, which is the process of adjusting the lighting and color profile of each shot to meet a unified, consistent look. It is not to be confused with color-grading, which establishes the creative look of a movie after all of the visual effects are completed. See the mastering chapter for more color correction information.

Rigging is what enables 3D models (such as characters and vehicles) to move. A 3D model of, say, an animal is initially static, but once rigged, its limbs and body can be adjusted and given motion. Realistic movement, especially of existing creatures and machines, is highly dependent on proper rigging.

Animation

Animation is a dynamic visual medium using multiple images sequenced in rapid succession to create the illusion of movement. Once captured, they can be recorded or stored on various equipment in different formats.

CGI is the creation of visual content with imaging software. CGI is used to produce images for many purposes, including visual art, advertising, anatomical modeling, architectural design, engineering, TV shows, video game art and film special effects, as well as AR and VR. CGI is accomplished through various methods. A variety of software can be used to recreate materials and apply them to shots so that elements perform in a similar manner to the real world, such as water or snow. This is called dynamics. Dynamics can also be referred to as FX animation, where objects are animated through controlled forces called fields. Animations take place in the virtual world of computer software. Solvers are mathematical code that tell these forces how to interact with and move objects.

Animators add the movement to rigged models, and are responsible for much of the physical realism of CGI. Animators will often test rigs and attempt to "break" them, sending them back to the rigging department for refinement until perfection.

There are several categories of animation:

- Traditional animation: In the 18th and 19th centuries, pictures were drawn in sequence and flipped to make it looked as if they moved. Motion picture films began using a similar method by creating images on transparent acetate sheets photographed against a still background.
- Stop-motion animation: This involves capturing the physical manipulation of real-world objects to create the illusion of movement. One method used is frame-by-frame photography. Films that use stop-motion include *The Nightmare Before Christmas*, *Coraline*, and the Wallace and Gromit films.
- Computer animation: As the name suggests, these are animations made via the use of computers. Computer animation is divided into two subcategories:
 - 2D animation: The manipulation of images and 2D vector graphics.
 - 3D animation: Three-dimensional graphics utilizing a rigged model to create the illusion of movement.

A landscape representation of a set or location is called matte painting. Matte painting allows filmmakers to create the illusion of an environment that is not present on set. In addition, matte-painted images can be combined with live-action footage. Hopefully the effect is seamless and creates environments that would otherwise be impossible or too expensive to film.

A professional animator must have a thorough understanding of the visual subtleties of physics to accurately portray them in their work. Explosions, water and smoke are all simulation-based effects that come to fruition here. Polishing effects (ranging from lens flares to fake cigarette smoke) are added over the existing scene.

Texturing is the process of adding a surface color and texture to the 3D models, making them recognizable and now near completion. This is where metal objects are given their shine, and humans are given their skin. The level of detail given to an object's texture is dependent on how close the camera gets to the said object, and is therefore usually proportional to the level of detail given to the 3D model itself. One of the most important factors in realistic CGI is the fidelity of its lighting. Good lighting will accurately imitate that of its setting, and due to the sheer difficulty of the process, poor lighting is often one of the first culprits in revealing an element as fake.

Optical flow is another category of computer animation. It deals with the tracking and 3D construction of objects. Today optical flow can be used to solve motion blur, auto roto and dirt removal. It is an area that has seen a lot of growth and application. (Auto roto is where software algorithms paint a source video frame-by-frame automatically.)

Compositing

Compositing is the last stage in the pipeline. Compositing is the step often showcased in VFX reels, where everything comes together to assemble the completed product. The live footage, the scene preparation data, the matte paintings and the various VFX renders are given to a compositor, who then combines and blends them together to create a single, seamless image. The movie will be color-graded after this point, but that is usually out of the hands of the VFX department.

Your VFX editor or VFX editorial department knows which shots are needed and what needs to be added. When picking shots, they should pick clean plates and tiles to send to the DI session. You should always have a VFX vendor representative on set to make sure that what you shoot will work for each VFX shot. Your VFX editor can stand in for smaller companies that don't have the staff to send someone on set.

Summary

In VFX, whether it's a big or small production, it is very important to stay organized. Make sure things are labeled. Different VFX houses will have different naming conventions. Make sure your shot plate numbers and your references are labeled correctly.

Make sure you watch out for things that could delay your schedule or increase your budget:

- Do you have enough storage?
- Have you built in time for file transfers?
- It's always great to test in advance. Send a sample file from one vendor to another to make sure there are no problems.
- Take security measures. Make sure no one can steal your files. You don't want to see your effect on the internet unexpectedly.
- In terms of coverage, do you have everything you need: Raw footage, file requirements, edit lists, a precut reference?
- Keep track of your VFX shots. VFX won't maintain timecode and naming from the original raw. Label manually and keep track.
- It's always the little things.

Remember…
Back it up…
Organize it…
Learning never stops.

CHAPTER

7

Sound

Okay, it's time to talk about sound. Listen up. This is a big topic and an important one. Even in the days of silent pictures, there was sound. Someone played the organ or piano offstage, in the dark, giving life, emotion, energy and flow to quiet images. These folks could be called the first film sound composers.

Audio Sweetening

Taking your production audio and finalizing it with enhancements, looping, music, sound effects and various cleanup procedures is called audio sweetening.

Audio sweetening includes the manipulation of the production sound track on many levels. Extra sound "material" can be added, production tracks cleaned up, existing sound enhanced, music bridged between scenes, M&E added, and ADR or looping combined with production audio.

Your sound is "built" under the supervision of a sound supervisor. This applies to dialogue, effects and music. The person actually responsible for building the tracks will be either the supervisor or – depending on the time constraints and complexity of the project – a specially hired editor.

Sound is as important in TV as it is in film. Some may argue that it is even more important to TV, because the images on the screen don't have the power and size of those on a movie screen.

When done well, TV sound tells the audience when to laugh, when to cry, and when a commercial is coming up so they can get a beer or go to the bathroom. In fact, we owe it to the American viewing public to give them the sound they need and expect. Put an inappropriate sound in the wrong place, and you could have dad getting a beer during the climax of the show. Just something to think about.

Because sound is complex, we have broken our discussion into the following topics:

1. Production sound (raw audio)
2. Temporary mix/temporary dub
3. Predub
4. Sound effects

5. ADR/looping
6. Foley
7. Music/scoring
8. Mix/dub
9. M&E tracks
10. Foreign-language dubbing
11. Foreign-language masters
12. Dubbing materials
13. Anti-piracy issues
14. When do you dub?
15. Foreign laugh pass

And for those of you who prefer a visual reference, we've drawn a nifty diagram to help you (see Figure 7.1).

Production Sound

Production sound is recorded on the set during shooting. It is the raw audio that much of the final audio for your show will spring from. While digital cameras

Figure 7.1 Sound path

record sound as well as picture data, it is best if the actors are miked and dialogue recorded cleanly and independently of ambient sounds.

The Sound Recordist

The sound recordist uses the following equipment and materials: A digital field recorder, along with backup memory sound cards/USB, disk or storage device, batteries, microphones, booms, cables and sound reports. There will also be one or two assistants.

The job done by the sound recordist often determines the amount of additional ADR and looping required later. As an experienced professional, the recordist will notice extraneous noises from planes, cars, wind, actor movement and fluorescent lights that will affect the usability of each take.

The sound recordist can also make or break the dailies data transfer. For instance, if your sound is not captured at the proper speed, you may not be able to sync your dialogue. Sound for SD shows should always be recorded at 24 or 23.98 fps and at 60 Hz (50 Hz for international). Prior to the day's shoot, your recordist will record a sampling rate (known as a bitrate or bits per second) as a frequency baseline. During production, metadata must be recorded along with the audio to ensure a sync point for each take. Date and time of day is the usual preferred calculation for this timecode logging. Off-speed picture captures, of course, cannot have sync sound dialogue. The recordist will also roll sound prior to the slate; this allows the machine to begin recording timecode before the sound is recorded and the editor to have an extra handle for editing. This is called pre-roll, and the standard is three to five seconds.

Sound Report

The sound report is the form that the sound recordist fills in so there is always a written record of what is on an individual sound card and how those sounds were recorded.

One sound report goes with each audio storage device. If there is a primary sound source and a backup sound source also recorded, each format gets its own report. If at the end of your day you've shot three memory sound cards and three backups, then you should have six separate sound reports. Figure 7.2 is a sample sound report.

Sound Report Breakdown

Following is a breakdown and explanation of each section of the sound report and how the information in each section is used. Sound companies may set up their reports with slightly different forms, but all of the information listed here is standard and must be listed on *each* sound report. If any information is missing,

SOUND REPORT

Show Title		Production Company	Date	Page ___ of ___
A		*B*	*C*	*D*
Sound Mixer	**Master Media**	**Recorder**	**Card/Disc #**	**Format:** *I*
E	*F*	*G*	*H*	UDF \| FAT16 \| FAT 32
Phone	**Sample Frequency**		**BITS**	**BWF File Type:** *M* \| **Tone**
J	*K*		*L*	Mono \| Poly \| *N*
				Time Code *Q*
Email	**Director**			**Mono Mix on Ch#**
O	*P*			*R*
Daily Instructions: *S*				

Scene	Take	File #	Notes	1	2	3	4	5	6	7	8	9	10
T	*U*	*V*	*W*	*X*									

Figure 7.2 Production sound report

it means your sound recordist has omitted information that will be necessary to you down the road.

A. Title of project. If a separate line is not included for the episode number, it should be included here.
B. Name of production company.
C. Date the sound was shot.
D. Page number of the report, e.g. 1 of 5
E. Sound recordist and/or company name. This may be preprinted on the sound report.
F. Type of media the sound is recorded to, e.g. flash drive, memory sound card, hard disk.
G. If sound was recorded on multiple devices, indicate which recorder was used for this report.
H. Sound card or storage device number (e.g. memory sound card/flash drive, disk), out of total number of cards for that day. If there are multiple cards, this allows the postproduction facility/editor/digital tech to check that they have received all of the sound cards.

Sound

I. File Allocation Table (FAT) is how the files on the storage card are formatted. Some cards hold more information than others, depending upon what format is used. Universal Disk Format (UDF) is the type of formatting used for disks, which is an alternate storage device.
J. Phone number of mixer or sound recordist.
K. The wavelength at which the head tone was recorded. Tones at the head of the sound storage device help to set sound levels during editing.
L. The audio sampling rate of the recording, known as bitrate. This is the speed at which the data is recorded.
M. Broadcast wave file type. A broadcast wave file allows sound to be shared or read by multiple forms of sound platform. It can be a mono track or multiple tracks.
N. Note here details for the head tone and sync reference so the transcode operator or editor can reference the tone to zero, insuring the playback levels will match the levels at which the audio was recorded.
O. Sound recordist/company email. These are usually preprinted on the report.
P. Name of director.
Q. The start timecode from the record machine for each card: The type of timecode being used, e.g. day and date. It is common for electronic slates not to work properly. This notation of the general beginning timecode of each take gives the editor some clue as to where the take exists on the audio source if there is no electronic slate reference and the operator has to search for and hand-sync the takes.
R. Where the mix of all tracks is located. Mono is used as a guide track.
S. Any special information about this recording, or instructions about the takes.
T. Scene number. This references the script scene number and is included here so the sound can be matched to the proper picture.
U. Take number. This references the number of times a scene is recorded and is included here so the sound can be matched to the proper picture.
V. File number for each take, so that the editor can easily locate each take.
W. Any special notes about that scene and take: Details such as incomplete take, split tracks and interference.
X. Track number.

Any time you find a member of the production crew providing incomplete information and it is information you will need in the postproduction process, correct the problem immediately. Sound reports definitely fall into this category. Any information left off these reports affects you directly in the editorial suite and beyond. There is no reason for any information pertaining to your project to be left off sound reports. It may seem as if we are being repetitious in saying this, but every piece of information is necessary. Ultimately, heeding this warning

will save you valuable time throughout the postproduction process, and time *is* money.

Production Sound Recording Formats

Here are a few rules and some information about the various production sound formats available for recording.

Sound is recorded by both the digital camera and an external recording device. Although it seems simpler to the first-time filmmaker to use the sound from the camera files and forego the extra expense of a sound crew and renders, your sound capture will be made more professional and higher quality by hiring an experienced and knowledgeable sound recordist and crew. Your recordist will record and store production sound on one or more of a variety of digital storage devices. A secured digital high capacity (SDHC) card is the standard device; however, others use flash drives, and some record on hard disk drive. The cards or disks must be formatted prior to use. Formatting for cards is either FAT 16 or FAT 32, depending upon the storage capability of the card. Disks are formatted in UDF. The files are recorded in waveform audio format (.wav), which allows sound to be shared or read by multiple types of sound platforms. It can be a mono track or multiple tracks. The recordist must also note the audio sampling rate or bitrate; 16 or 24 bits is acceptable. Recording standard requires a sample tone at the head of recording (head tone), day and date timecode, metadata, and a sound report as a legend.

Although digital sound is the industry standard, students or low-budget filmmakers may still use digital eight-track tape (DA88). The critical step when using DA88s is that they must be formatted before they are used. Either 44.1 or 48 k sampling rates are usually acceptable. If you need, your sound house can probably format your tapes for you before you use them to record your production audio. Use only Hi-8mm metal particle tape.

If you decide to shoot old-school and want to record sound to a tape format, e.g. ¼ inch, do your homework. Many sound editing and mixing facilities don't have the equipment to transfer or mix to your requirements.

Use a SmartSlate, Dummy

While the electronic slate is not an audio format, we are going to deal with it here because it is so important to the speed and accuracy with which your dailies are transferred – as well as being a visual check/reference for each take you shoot.

A SmartSlate is a clapper with a rectangle in the middle that gives LED readout of the timecode that is being laid down simultaneously on the production audio. *Do not shoot without an electronic slate.* The costs per day for that

Sound

SmartSlate will be money well spent when you get into dailies and off-line. You can read more about the use of the SmartSlate in the dailies chapter. Essentially, it allows the editor or digital technician to type in the LED number and have the audio playback machine physically go to that timecode, giving the editor a very close sync point for the take prior to any manual manipulation.

The Dos and Don'ts of Electronic Slating

Having an electronic slate is not enough. Learn how to use it properly! Your transfer facility may give you some written guidelines, but if not, here are the basics:

- Do not point the electronic slate toward the sun. If you must shoot with the slate facing the sun, then shield it with something so the numbers are readable when photographed. Use the "bright" setting on the slate when shooting outdoors.
- When shooting in the dark, put the brightness switch on "dim". Otherwise, the numbers tend to bleed or blur, making it difficult or impossible to read them.
- Check periodically to make sure the numbers on the electronic slate match the timecode being recorded on the sound source. This is a piece of electronic equipment, and it can be affected by loss of battery power, loose cables and the damnable forces of Murphy's Law. If the readout doesn't reflect the actual timecode being laid onto the audiotape, try jamming the slate to reset it. It's a good idea to jam the slate every couple of hours to make sure the timecode doesn't drift. If you can't get it to work and you can't get a replacement, the transfer house or editor will shower you with unpleasantries under their breath and be very unhappy during your dailies transfer. Not to mention that sync will take much longer to complete. Slate timecode problems will occur in the field. When they do, your sound person can help save money in editorial by noting on the sound report the start timecode at the beginning of each take.
- Make sure the electronic slate is "in the picture frame" so that the editor can see the entire number during the transfer.
- Ask the transfer house or editor if they prefer that the numbers stop when the clapper closes, or if they prefer to continue through the closing of the clapper. Especially in a multi-camera shoot, it is often good to have additional time to grab a timecode – especially if it takes a while for the slate to get around to all the cameras.

And while we're on the subject of the clapper, let us regale you with a few anecdotes to give warning about some easily avoided "gotchas".

Electronic Slate Gotcha 1

Be sure the clapper closes in-frame. It is the only practical visual reference for sync. If the editor cannot see the clapper close, then he or she has to search into the take to find a hard effect on which to sync. That means that it will take much longer to sync and may never be perfectly in sync. This bit of advice may sound really like "duh!" but every show lets this happen, no matter how professional they are. It's sloppy, and it causes unnecessary expenses down the road.

Electronic Slate Gotcha 2

When shooting a scene that starts in the dark, along with using the "dim" setting on the LED display, somehow illuminate the sticks so the editor can see when the clapper closes. This can be accomplished a couple of ways. Some productions simply use a flashlight shining on the slate; some use glow-in-the-dark tape on the bottom of the stick and the top of the slate where they meet. Use whatever method you want. Just use something.

Not Too Bright: Electronic Slate Gotcha 3

During one pilot season, we worked with a company that does lots of TV shows. We won't reveal their identity because we'd like to keep working in this town, but suffice it to say they should have known better. Anyway, the scene starts in a hotel room in the dark. The phone rings. The star reaches up and turns on the light next to the bed by pulling a string. He then watches the phone ring for a second, and then clumsily picks it up and talks into it. You guessed it! The clapper closed with a very loud, firm clap, and not a bit of it was visible in the dark. All there was, was the LED display (blurred because it was on the wrong setting, I might add) and no way to see when the clapper closed. And there wasn't a hard effect to sync to.

We ended up trying to sync to the actor's mouth forming the words. Of course, there were many takes. We got pretty close on some of them – right on for others, even. But it took a very, very long time. The miracle was that the director, the cinematographer, the producer and the associate producer were all in the room during this painstaking process. I'll bet none of them ever lets this happen during a shoot again.

General Slate Loss: Jumped the Gun

Once in a while even experienced filmmakers will jump the gun and begin shooting prior to allowing the sound recordist to establish pre-roll or the AC to slate the take. Having no slate to reference on sync sound can be a nightmare and take hours to rectify. However, a good crew will slate the end of the take, giving the editor something to reference to. Okay, enough with the testimonials, back to the task at hand.

Production Sound (Continued)

Original production sound is either loaded directly into an external hard drive storage (e.g. RAID) or loaded into the editorial hard drive, depending on how much data is captured during production. If the show has multiple cameras and multiple takes, the overabundance of data may warrant an external hard drive storage system. As the editor creates the various cuts, the data will be ingested from the external hard drives and loaded into the editorial system, including the sound data.

The production sound is used as is throughout the postproduction process, until the layback of the final mixed audio. The exception is that when the producer's cut is locked, additional effects and temp music are sometimes added. This is done either in the cutting room by the editor or, budget and time permitting, with a temp mix. Temp mix is explained in detail later in this chapter.

Sometimes it is enough to add a couple of common generic sound effects – such as a car horn, a baby crying or animal noises – to help fill out a joke or storyline until the final effects are mixed. With electronic off-line editing, simple sound effects can be incorporated quite easily by your off-line editor. If the sound is something you don't have in the database, your sound facility can often provide these rather quickly and for a nominal fee.

Temporary Mix/Temporary Dub (Temp Mix/Temp Dub)

Here temporary sound effects, mood music and voice-overs are added prior to sending the picture to the network/studio for their viewing. This is an added expense that may not have been included in the budget at the start of the process. If you decide to go this route, the money to do so may have to come from somewhere else in the budget. You'll have to find a not-so-temporary solution. Note the temp dub is just that – temporary – and is used to demonstrate how it will sound with effects, music or other sounds added. This step is during the editorial process and before picture lock.

Do You Need One?

Planning a temp mix for your project is the exception and not the rule. A temp mix can represent a large additional expense and is usually reserved for use by select producers who anticipate a foreign theatrical market. This would be a presales tool for marketing their program abroad. In another situation, the producers may use this tool for a pilot or feature when the impressions made in early screenings with the network and studio executives are critical.

One of us had the experience of sitting in a screening with some network executives who, after viewing the program, wanted to know why so many of the

sound effects were missing. Here goes… Post 101! This interim sound can be accomplished by creating a temp dub.

Producers want the network and studio executives to visualize as clearly as possible the finished product. One option available to help these executives understand how the finished piece will sound is to schedule a temp dub. A temp dub or temp mix may be done with your sound services vendor.

If the sound effects are indeed simple – a dog barking or bell ringing – your effects company or sound company can provide these to your off-line editor on a format they can load into their off-line editing system. These can usually be had for a minimal cost… sometimes even free of charge. Anything more than this will require going into a dub stage or sound effects room. The costs will rise very quickly. Regardless of the money you do or don't spend on a temp mix, it is still a temp. It all gets thrown out in the end, and you start over.

Temporary Insanity

Beware that the extras can backfire. In another incident, one of us worked on a show in which some temp music was inserted to help set a mood. It was an original score from a popular feature. A network executive fell in love with the piece in the show and demanded that the composer match the music. "Help! We're just a little TV movie!" These "extras" are pretty much saved for use on pilots and big-budget cable movies.

Don't confuse a temp mix with a premix. Premixing is the mixing of minor sound elements prior to the dub to cut down on the need for additional mixing boards or even an extra day in the mix session.

Sound Effects

The addition and creation of sound effects (often written as EFX or SFX) is necessary for two reasons. First, they are added for creative composition. Second, many sound effects are just the replacement of "ambient" effects recorded with the dialogue track. These ambient sounds – such as room noise, doors and windows opening or closing, papers rustling and heavy breathing – are lost when the production audio is looped or separated. If the originally recorded dialogue lines are replaced, then the ambient sounds are lost and must be recreated and put back into the sound mix. In a show that is being dubbed into a foreign language (rather than being subtitled), the originally recorded dialogue track will not be used, and any sound effects recorded as part of that dialogue track will be lost. These effects will have to be recreated as part of a separate audio track called the effects track. These effects tracks are called filled effects, foreign fill or 100% filled effects.

Another sound variation to be aware of is object-based sound. This is three layers of sound from an object or multiple objects that overlap, interact and play

to the surround, overhead and height speakers, giving the listener the illusion of being immersed in the scene. These sounds must be isolated and separated so they can be recorded to the proper sound field during the mix. This is a great tool for creating a sense of suspense, or for a horror movie. It can be time-consuming to prepare and mix for this technique, and is out of budget for most independent filmmakers.

Sound Design Elements

At picture lock, the editor will need to send the composer, sound design and music editors the sound and picture data. Most of the time they will request a visual and audio reference with timecode burned into the picture in the form of compressed data. Some will want to come into the editorial suite and download from the hard drives; others might want an old-fashioned videotape. Track assignments are different for each editor and the programs they will be working in, so be sure to get the exact requirement. H.264 QT is a common request. H.264 is a form of compression that allows large amounts of data to be compressed in order to be stored or sent and then uncompressed upon delivery. QT refers to QuickTime, a format use to deliver, store and play data. This reference would be sent via secure internet pipeline, along with the production audio files in the form of OMF (a platform for the transfer of digital media between different software applications) or AAF (designed for the video postproduction environment). Two secure internet pipeline services commonly used are WeTransfer or Dropbox. Secure pipelines require that users have access via code to upload or download data. If you are delivering to a studio lot, they will have their own secure pipeline within the facility. Often the production audio files are also sent to the mixers, so that if alternate files are needed on the mix stage they are available.

Student filmmakers often don't have access to or requirement for secure pipelines. You will still need to provide all the production audio necessary and a guide for reference. This can be accomplished by delivering a memory sound card or a hard drive to download. It must have timecode and all the necessary metadata. Talk to the composer and M&E supervisors to get the technical requirements for delivering the data. They may have alternate delivery requirements that are easier for students to provide.

If at all possible, have delivery specs submitted to you in writing. If the people you've hired to do this work are seasoned professionals, this will be a common request, and they will be able to email their requirements to you. Get these specs to the editor, and make sure everyone is on the same page. There are other variations that you will see in delivery specifications. That is why it is very important that you get this information directly from the people who will be using the data.

Sound Effects Spotting

Once the picture is locked, it is reviewed with the sound effects editor and the composer in a spotting session. There, the producers, off-line editor, director, sound effects editor and associate producer (or postproduction supervisor) watch the entire show and determine the sound style of the picture. They decide the whens, wheres and hows of all the M&E cues.

The sound effects editor preserves as much of the original sound as possible. New digital technology allows the sound editor to isolate sounds and eliminate background noise, recording problems or other minor quality issues. Any dialogue that has unacceptable audio quality will be added to the list of ADR/looping needed.

Object-based sound needs to be addressed in this meeting. If your delivery requirement is to create Atmos or Auro-3D or DTS:X sound, your effects supervisor will need to know. During spotting, finalize which objects need isolation and exactly where in the scene it will happen. They can then build those cues into the tracks before the mix.

Creating Sound Effects

At this point, the sound supervisor will determine what special sound needs there are. For example, we did a film where a super-rocket car played an important role in the movie; therefore, the sound made by that car was integral to the audience response. The effects company provided several sound samples until they came up with one that was blended and refined and met with the producers' expectations.

After spotting, the sound editor/designer will need as much as three weeks (15 working days) for a 90-minute program to prepare, create and cut the effects, dialogue and loop tracks. Episodics average five to seven days, and a sitcom can average two to three days. Features can easily be more than three weeks, and often months, depending on the complexity of the project.

Sound effects editors are responsible for editing production audio and ambient sounds not recorded in production. The sound designer and the audio mixing facility may be two separate facilities. Therefore, if you have to go back to replace any words or effects in these tracks, or if you need to access the tracks for augmenting foreign M&E tracks, you will go to the sound editorial company for this material. You'll then return to the audio mixing facility to remix the changes and lay the new sounds back to your original elements.

The sound effects editor isolates the audio. This is called building the tracks, and it is done so that on the mix stage there is complete control of each element, and each element can be moved or altered individually as needed. The sound elements are separated as follows:

Sound

- production dialogue
- ADR dialogue
- sound effects
- foley

If you plan to make film prints, now is the time to remind your sound supervisor to create pull-ups for your sound rolls. This is an industrywide practice for overlapping the sound from each reel by two seconds or 20 frames. This will ensure that you have continuous sound from one film reel to the next.

It is important at this point to contact the mixing/dubbing facility to find out:

1. how many pots the mix board handles, and whether an auxiliary board is available, if necessary
2. from what formats they can mix (e.g. compact flash (CF) card, hard drive, disk, DA88 or download via pipeline)

Find out what format the sound effects company prefer, make sure the dubbing facility can handle it, and let everyone know what everyone else is using. All facilities are not created equal, and it's too expensive to wait until you get to the mix to find that the sound effects company is delivering on CF card to a facility that can only handle data from a secure pipeline. Also notify the dubbing/mixing facility if a specific sound format is needed, e.g. Dolby 5.1 or 7.1, Atmos, or another required format.

ADR/Looping

After reviewing the production audio, the sound effects company will provide a chart (see Figure 7.3) of the looping they feel is necessary. You then take this chart and create a budget based on the cost of looping each person, including any group looping. The equation for budgeting how long it will take an actor to loop is not difficult to use.

The master ADR summary (Figure 7.3) lists the number of lines each character needs to rerecord. It also shows the total number of lines or cues for all characters in the show, and an estimate of how long each cue will take. There are several sound editing software programs that will separate the information and create ADR sheets for the actor with their lines, the director with the reason for the rerecord, and the sound editor and mixer with timecode and take numbers. They also have ADR reports to send to the actors' agents without technical information or reason for looping. As soon as the report is created, it can be emailed to the necessary parties. In the ADR character list (Figure 7.4), the exact location of each line is noted in timecode, along with the line itself and what takes are usable. This information can be sent to the dub stage in case an alternate take is needed.

ADR Summary — PIE THROWERS — PILOT/EPISODE 101

CHARACTER	ID	ACTOR	TBW#	REC. MIN	# OF CUES	TOTAL HRS.
Todd	TD	Richard Smith		6	4	0.25
Blair	BL	Martin John		6	4	0.25
Beau	BU	Beau		6	6	0.6
Marcia	MA	Mary Jones	1	6	6	0.6
Group	GP			10	12	1.2
Group	GP			10	14	1.4
PRODUCTION TOTALS			1	44		4.3
*TBW = To be written						

Figure 7.3 ADR summary

ADR Character List — Pie Throwers — Pilot/Episode 101

Studio	Supervising Editor	Version/Date		4	28	18
The Big Tent Studio	Super Ear Bob					
Cue	Character	Line	Takes			
1:37:08:06	Todd - TD	"I'm Serious"	1 / 2 / 3 / 4 / 5 / 6			
1:37:10:05	Reason: Preform		7 / 8 / 9 / 10 / 11 / 12			
1:37:10:05	Todd - TD	(Inhale) "Can't we wait until later?"	1 / 2 / 3 / 4 / 5 / 6			
1:37:12:19	Reason: Background		7 / 8 / 9 / 10 / 11 / 12			
1:37:12:19	Todd - TD	"I can whip you at basketball."	1 / 2 / 3 / 4 / 5 / 6			
1:37:16:08	Reason: Clipped		7 / 8 / 9 / 10 / 11 / 12			
1:37:16:20	Todd - TD	"Oh yeah"	1 / 2 / 3 / 4 / 5 / 6			
1:37:22:07	Reason: Preform		7 / 8 / 9 / 10 / 11 / 12			

Figure 7.4 ADR character cue sheet

Scheduling ADR/Looping

Professional actors can normally loop ten lines an hour. There is also machine time to find the production cue and line it up, and remember your recording crew is probably union and will need appropriate breaks. So, make the ADR list and meet with your producer to decide if there are any changes to the list.

Be One Step Ahead

Because TV has such a short turnaround, it is a wise postproduction supervisor who calls the main actors' managers/agents for their availability before spotting

with the effects company. This way, when you and the producer sit down to make looping decisions, you'll know your main actors' schedules so you can factor time frames into the equation. If you are aware of an actor's scheduling conflict ahead of time, you can avoid last-minute disasters and missed deadlines. Even the most arrogant and hard-to-please producer will be somewhat impressed.

Schedule your actors according to time and availability. Try to work around their schedules as much as your schedule will allow. When they arrive at the session, make sure that they are comfortable and that they immediately receive a list of their loop lines. Traditionally, looping starts with scene one and works through to the end of the show. Actors are normally looped individually, unless it makes more artistic sense to pair two actors for the sake of the scene. Your sound effects supervisor and/or associate producer may need to be on hand to supervise and help if timecodes or references are needed.

A loop group will usually want to view the show prior to the session to get a feel for what is needed. Groups are used to working together as a unit, and if they are well organized, these sessions usually go fairly quickly.

What's It Gonna Cost?

Some cast members (usually the main cast members) will have looping built into their contracts, and therefore will be prepaid and available for one to two days to loop. You can always check with casting: They made the deals and know who has looping built into their contracts, and for how many days. Actors are governed by SAG rules.

Here's a sample of the wording for a looping contract for a two-hour pilot: "Work period for pilot: Four (4) weeks plus two (2) free travel days and two (2) free looping days, which may be noncontiguous and which shall be subject to Player's professional availability". If you are in doubt about the rules, call SAG.

Weekly players will cost either their day rate for a whole day of looping or one half of their day rate for a half-day of looping. Divide the weekly rate on the contract by five days. This gives you the rate for a full day of looping. For half a day, divide the day rate in half.

Day players must be paid a full day rate for a whole day or fraction thereof. Therefore, if you need a day player for only two words of looping, it may or may not be worth it financially to the producer. If you are already hiring a loop group, they may be able to handle the odd couple of lines here and there. Discuss your options with your producer, using the ADR chart and your budget as your guide.

You can't just go off willy-nilly replacing an actor's dialogue with someone else's voice. SAG governs its members well in this area, and a producer is not allowed to indiscriminately revoice (or let a loop group actor add the needed two words) without the actor's consent. Ninety-nine percent of the time, an

actor will want to do their own looping. So, to make this all make sense financially, the sound effects company may have to work a little harder to isolate or enhance the original dialogue track so it can be used.

Sometimes you may have to arrange looping at a distant location. ADR stages and recording cost. They may be in your sound facility package, or sometimes they are separate as needed rentals. These things take time and coordination, so don't cut yourself short. Any early preplanning you can do will make everyone's job easier – especially yours! Plus, once again you've a chance to look good!

Foley

Foley is the addition or replacement of sound effects. This includes such things as footsteps, keys jangling in pockets, doors closing, windows opening, punches and slaps. This must be one of the most creative jobs in the entire postproduction process.

Under normal circumstances, the only people in attendance at these sessions are the foley artists and their recording technicians – and maybe the effects supervisor. Traditionally, the sound effects company is responsible for arranging, scheduling and supervising any necessary foley.

For budgeting purposes, check how many days have been scheduled for the foley, and keep track of any overages. You have usually one to two days for an average 90-minute show, less for an episodic, and in some cases none for a sitcom.

Music/Scoring

Spotting with your composer and music supervisor is done either the same day or the day after your effects spotting, and is attended by the same group of decision makers.

Again, make sure those doing the scoring will deliver a format the dubbing facility can use. If you drop the ball on this, shame on you. We've told you twice now.

Scoring Methods

Composers use various methods to score and record.

Electronic Method

Often this is done in the composer's home or studio. At various intervals prior to the mix date, the producer and director are invited to listen to a semicompleted score while the picture plays on a monitor. There is no scoring stage to book, and there are no musicians to negotiate with. The composer does the entire process as a package.

Orchestral Method

You will need to book a scoring stage, and the scheduler at this facility will need the following information:

1. how many sessions you need
2. what is the picture playback format
3. how many musicians will be attending the sessions
4. the record format

You can usually count on completing 15 minutes of the score in a three-hour session. Remember that your musicians and technicians are probably union. Be sure they get their doughnuts and coffee at the prescribed intervals, or you're looking at penalties. You may have to factor into your budget such things as musician cartage fees (for larger instruments), and the facility will charge you to mix down after the session. A mixdown is when all the instrument tracks are mixed down to six or eight tracks. The music editor will supervise this session and can advise you regarding cost of session and any transfer fees.

Some producers will choose to fly the composer to a scoring facility in another state (such as Utah) where costs are lower. Remember that composers also have a guild (does anyone not have a guild?) that governs details such as conducting – so watch out for them union rules.

Once scoring is complete, the music supervisor has two options. The score can be mixed down and tracks built for the dub; or scores that are recorded in order of use are laid down in stereo pairs, and a mixdown is not required. Stereo pairs refer to like instruments grouped together in stereo.

Music in a Can

Episodic TV doesn't always use a composer. Often, it's up to the editor or music supervisor to buy music from a library. The music is selected and downloaded into the editorial program, and levels are mixed in the dub. The same is true for canned background music for use in restaurant, elevator and grocery store scenes, which are called needle drops. The name harks back to when you could drop the phonograph needle onto a vinyl record and hear a small piece of music. In this case, needle drops are short bits of premade music that are not created by your composer but purchased. There are companies that sell the licenses for this music, just like stock houses sell stock shots. Your music editor will be responsible for finding this music. And if your producers don't like the music the music editor has chosen, there's plenty more to choose from.

These music snippet licenses are relatively inexpensive, and unless you go way overboard in using them, they won't break your budget. It is almost always less expensive to license needle drops than to score bits of original music.

Obtaining Music Clearances

If you are working on a show for a large production company or studio, they will employ a music coordinator to secure bids and finalize licenses. However, if this responsibility falls on you, refer to the music section in the legal chapter. Music licenses take time to secure and research to find the appropriate licensor.

A Word of Advice

Keep in mind that obtaining stock footage and music – especially music – clearances can be very time-consuming and expensive. Make sure before you go through the steps that your producer really wants the quote and that you're not just jumping to the whim of the editor. If you cannot cut around or substitute, and your producer gives the go-ahead, then proceed.

Laydown

Sitcoms and half-hour programs where the tracks are usually added to or enhanced rather than replaced completely often go through a laydown process.

Once your on-line is complete, the sound facility will need the data sent via secure pipeline to their facility. They will download the sound to a priority program and lay the sound across from all audio channels to a multitrack format. This is done at least one to two days prior to the mix. The sound facility can then begin the process of enhancing, correcting and cleaning up the existing production audio. The goal – usually because money and time are very tight – is to minimize the time needed in the foley, prelay and laugh sessions to create final sweetened stereo audio tracks.

Predub/Prelay

If your show includes a lot of effects – for example, explosions, music, sound effects or loud noises over romantic dialogue – then your sound effects supervisor will probably recommend a predub or prelay. Some of the sound effects are mixed prior to the final mix to reduce the number of individual effects the sound mixer has to control. This can be helpful, or even necessary, if there are more sound cues than the mixing board can handle, requiring the use of an auxiliary mixing board, or if there are more cues than the mixer can handle at once. The mixer can only control a certain number of pots. Pots are the individual knobs that control the volume of each effect. Too many cues will be cumbersome and slow down the mix. Premixing them will make the dub go faster. Your sound effects supervisor and one mixer should be able to complete the prelay in one eight-hour day on the dub stage, unless it's a high-budget effects show which will require more time.

Audio Mix

This is one of the most time-consuming and important events in the entire post-production process. The producers, director, associate producer, post supervisor, composer, music supervisor, editor, sound effects supervisor and sound mixer review the show scene by scene. Audio levels are adjusted for all of the sound elements.

The separate edited tracks are played and mixed, isolated, balanced, enhanced and altered to create a composite sound, which is recorded digitally in a multi-track format. These tracks become the master sound track or final mix, which is then laid back to the digital master and becomes the final sound for the project.

If you are making a pilot, short or feature, expect the producer(s), director, composer, music editor, editor, postproduction supervisor, sound effects supervisor, and sound and digital technicians to be present at the mix. The producer(s), director and composer have the creative control and will call upon all the others for advice and technical expertise. This is tantamount to a mini production in itself!

Be Prepared

As noted earlier, arrange in advance to have all the sound properly prepared and delivered to the mix stage prior to the start of the mix. If your sound designer is contracted separately from the facility that will do the final mix, be sure to make arrangements to have all the necessary materials and equipment arrive on time. It is a wise post supervisor that confirms that the mix facility received the audio and visual material needed and that it is "readable". Some facilities require any outside material to be logged and checked prior to use in a secure digital environment. This process of logging and checking for viruses takes time, so start early.

The music supervisor and the sound editor will have entered cues into the editorial software for each audio clip. This continuous timeline plays on a monitor with the audio, and allows the mixers to reference the approximate length or envelope: Which track and where in the timecode any particular effect or sound is located. If they are mixing object-based sound, they will record the sound to the appropriate track to play in the proper spatial field, surround height or overhead. Atmos and DTS:X are the two major players in this field. The sound mixer will use a stylus or mouse to select where the sound is to play on the sound grid. When recorded to the mix, it is encoded to send the sounds to various speakers. When it is played in exhibition, the metadata of the final mix audio sends a signal to the selected speaker(s), allowing the sound to be heard overhead, from behind or across the theater, giving the audience a feeling of immersion. This is referred

to as immersive audio or augmented audio. It is a perfect tool for horror, battlefield or nautical settings. Again, this is a costly technique and usually out of reach for independent filmmaking.

At the beginning of the first day of your dub, take inventory and make sure that all of your elements have arrived and that the crew has everything it needs. Confirm with your facility the format of the final mix and how it is to be laid down.

How Long Should It Take?

The dub for a 90-minute TV project will take up to three days and three mixers (one each for music, dialogue and effects/looping). Schedule an entire day for an episodic. The crew will probably be union and will require the specified breaks/meals.

The producer will give the mixers an overview of the movie and, if it is not painfully obvious, the overall feeling the production company is trying to achieve. Actually, they'll probably get this even if it is painfully obvious.

The show opening usually takes the longest to dub. This is where the feeling and balance of the show are set. Try to complete 20 to 30 minutes of program each day. This will help keep you on schedule.

You will be there, of course, because someone has to watch the "time is money" clock. Of course, it could be a very futile effort on your part. All the guests at this party will want the piece of cake with the flower on it.

If you see your session is going to go over the time allotted, go over and quietly notify the producer. At the appropriate time, someone will need to determine if it is more cost-effective to rack up some overtime (provided that is an option with the facility's schedule) or add another day to the dub. At this juncture, the facility may want a separate PO to cover the additional time. This cost is probably outside any package deal, and while many heads are nodding "yes" in the heat of passion, later they may have a hard time remembering what a good idea they thought this additional time was.

Sometimes when dubbing in Canada, and on some stages in the United States, one mixer mixes each sound source one at a time. This process takes longer – up to five days total (for a 90-minute TV project).

If you are working on a major motion picture for a studio, the delivery requirements might list both a Dolby 5.1 and 7.1 mix, as well as Atmos or DTS:X tracks (object-based sound). Common sense would tell you to mix the 7.1 sound first and just mix down to a 5.1. However, these types of files cannot be automatically mixed down to the next sound version. Sound facilities will recommend that you mix the 5.1, then the 7.1, and finally create your Atmos or DTS:X pass. This is only advantageous to large distributors with markets that can support the higher-budget items.

Getting the Right Mix

After the picture and sound are up on the screen, the mixers will have their run-through of the opening of the show. This is where they determine the starting audio levels. The picture is run again, and it is the creative team's turn to interject their suggestions and comments. They decide the sound level and duration of each sound effect. Once this is completed, the mixers will "make it". This means they run through the scene again with the chosen levels set, and record to the master audio format. Once an entire reel (or act break) has been done, the room is darkened, and everyone watches that section of the picture from beginning to end with the final effects. There will be some small notes and changes. These are made, and then the process starts again until everyone is satisfied with the entire final mix.

Most of the time, digital titles and credits will be completed prior to the mix and included in the digital playback that you are mixing to. However, if the credits/titles are being completed at the same time as the final audio dub is taking place, everyone will want to view the finished product at the dub. The executives will want to verify that their titles look correct and that final sound and picture will match in length. Be prepared to provide this final element to the mix stage at the last minute, which may take planning to transfer the data or hand-carry data to the stage.

Final Sound Masters

So, the party – which you call your sound mix – is over, and your final sound track master has been made. The executives have gone home, and now it's time for you to create the sound elements for delivery and lay back your audio master to your picture master.

What do you have, and what do you need? With all the mix days and sound data flying around secure pipelines, it's hard to keep track of what the elements are. You will have a digital record of music, dialogue and effects, all on separate tracks and mixed to the final specifications. The first thing after the mix you need is to make a new element. The sound editor will use the final mix to create stems of audio effects for foreign distribution. These are sound effects that may have originated in the original production audio, like footsteps and keys jangling, that will disappear when the dialogue track is replaced by another language. The foreign distributor will need the effects to be continuous on the effects track, with no dropouts or dead sound. With the audio stems complete, the mix facility will create the sound materials needed for delivery. The following is a list of standard audio delivery requirements delivered via hard drive or secure transfer. These split tracks will be audio files that will be saved as 24 bit/48 k .wav or

AIFF files. Once these are mastered to a DCP or interoperable master format (IMF), sound and picture data files are referred to as "essence".

Sample Sound Masters

Two-track print master:
Two-track mix of audio left and right

Six-track print master with Dolby 5.1
Track 1: Left
Track 2: Left surround
Track 3: Center
Track 4: Right surround
Track 5: Right
Track 6: Sub (this is a low-frequency channel for subwoofer)

SRD stereo mix masters for:
Dialogue
Music
Effects (that include stems)
All three separately delivered in the same channel assignments as above

Eight-track M&E masters (aka multitrack M&E)
Track 1: Left
Track 2: Left surround
Track 3: Center
Track 4: Right surround
Track 5: Right
Track 6: Sub (this is a low-frequency channel for subwoofer)
Track 7: Optional (used to separate sounds that are overlapping, e.g. English-language loop group)
Track 8: English dialogue guide track

With these standard delivery requirements, the distributor can make any element needed for multiple digital markets. The digital facility where your picture masters are made will need one or more of these sound masters to lay back the digital version.

M&E Tracks for Animation

Although there are separate M&E tracks on your multitrack, you will still need to create what are called foreign fill or fully filled music and effects tracks. This

is normally done right after the domestic mix is completed. One exception to the rule is animation. With animated shows, the fully filled M&E is sometimes created simultaneously with the domestic mix. Dialogue is all looped, and there are no ambient affects – no on-camera action to get mixed into the dialogue track.

Layback

Once you have a final sound element, you are ready to lay it back to your digital master(s). This is called the layback. It is simply the process of recording that final sound onto your digital picture master. This will be done at the digital facility. Be sure to check your delivery specifications for the proper sound format for each delivery element. Samples of the various sound requirements are shown above.

Once approved and completed, the original sound data and dubbing cue sheet files need to be sent to the distributor via a secure pipeline. This releases the sound facility's archive for the next load of data on a new show. Students and low-budget filmmakers will have the sound facility transfer the data to their own hard drives, allowing the student to archive or access as needed. Be advised: As technology changes a digital archive (store of data) will need to be upgraded or "migrated" every few years to the newest digital element, so that you will be able to access the material as needed.

If you are creating a composite print, at this point the sound facility will use the final sound master to create an optical track.

Film Prints with Sound

Although some filmmakers both big and small choose to shoot on film, 95% of the time it is exhibited digitally. However, the studios take the needs of those small markets very seriously. We doubt you will be required to ever make composite film prints, but in the event you do, here is an outline of what sound track formats are printed on film.

When making film prints, the sound format that will be printed onto the film needs to be determined in advance. There are several reasons for this. First, the sound facility needs to know what format to record the final mix to. They'll need to know what types of tracks will be printed onto your film (e.g. Dolby Digital, stereo (SR) etc.). This will tell them what license fees you will need to pay for the right to use specific recording formats.

There are several sound formats for film. However, only two are widely used: Dolby Digital and Dolby's SR/SRD. Sony no longer manufacture SDDS decoding equipment, although they continue to service equipment in the field.

See Figure 4.4 in the film lab chapter for a visual reference of where on the film frame these formats are printed.

Each one consists of several channels of sound, which are matrix-encoded. Matrix is a term used to describe an encoding device that can mix four sound channels into two stereo channels, which will then be restored to four channels upon playback. The four channels are left, center, right and mono surround (LCRS).

Dolby Digital has several formats to choose from:

- Dolby Surround: This is licensed from Dolby Labs for a fee, and Dolby will physically inspect your sound setup before granting the license. The sound is a four-channel digital encoded format. The Dolby logo must appear in your end credits as part of the license agreement.
- Dolby 5.1: This format consists of five discrete channels (left, center, right, left and right surround) and a low-frequency effects channel (which plays back on a subwoofer).
- Dolby 7.1: This format consists of seven discrete channels. It mirrors the 5.1, with the addition of two channels that play to the special field.
- DTS: This surround format has six channels of audio. The encoded sound is on a CD-ROM. The final film print will have timecode information in the DTS track area that drives a CD-ROM player connected to a projector.
- SDDS: This surround format is six channels of matrix sound. A license and license fee are also required, along with the logo appearing in the end credits of your project.
- SR: This is a mono optical track, split with one left and one right channel.

Once you have reviewed your delivery requirements and decided what sound format to use, it's almost time to have the sound facility shoot the optical sound track negative. We have cautioned you before, but it's worth mentioning again: Do not shoot your optical sound track negative unless you have made a print before first trial or have mixed to a work print. These are the only elements that when played with your new sound master will ensure that you will be in sync. With that said, please note that the laboratory will process an optical track – but note that they do not shoot tracks. See the section on adding sound in the film lab chapter for more information on optical sound track negatives.

Sound Quality and Sibilance

The biggest sound roadblocks student and independent filmmakers run into is sync and poor-quality end result. Mixing your final sound track will be one of the most expensive line items in your entire postproduction budget. And of course, the final mix comes at the end of the process – at a time when the

money has usually run very low. Cutting corners and scrimping will be very tempting at this juncture. You might, for example, choose a sound facility solely based on a low bid, and not on whether it is the proper sound house for your particular project. Or you might decide to do all your sound editing and save money. Should you yield to this temptation, it will almost certainly lead to bigger headaches down the road. Inferior production sound, a poor mix and sloppy audio work add up to possible disaster, which could find the project rejected. QC reports can be devastating and the fixes costly. A poor mix and sloppy audio work don't allow enough leeway in optical printing tolerances. These are the gauges used to measure the density of your optical sound track. Laboratory tolerances vary, depending upon the temperature and age of their chemical baths. All prints and tracks are expected to pass QC inspection within several points of density. If your track is already on the edge of tolerance, and is not printed *exactly* to the proper density, you will hear a distortion called sibilance. This is a "shhh" sound that can be very problematic and maybe even unacceptable to distributors. If you suspect that your print has this problem, ask the film lab to inspect and QC a print. If they determine that it is sibilance caused by a poorly exposed track, the only recourse you have is to return to the sound facility and have them inspect their records for density and exposure. Remember that the film lab does not shoot optical tracks; they just process and print them. The sound facility will not want to reshoot a track at their expense because of a bad mix. Sync is also problematic when you are cutting digitally and printing film. As we mentioned, film needs extra sound to make reel changes, and digital elements and film run at different speeds. If you are unfamiliar with the challenges, you will be out of sync. If you find yourself here, you are in a bad way. So don't be a knucklehead: Take our advice (it's what you bought the book for, remember?), save yourself from trouble so close to the end of your project, and do it right the first time.

Laugh Tracks

Not to disillusion anyone, but all the chuckles and belly laughs you hear nightly while watching your favorite sitcom were probably not all generated by the live audience at the taping of the show. After the fact, someone went in and beefed up the audience laughs. This beefed-up audience reaction track, the laugh track, was then mixed into the final sound track for domestic airing. We prefer the word "augment" to "embellish", but essentially we're speaking of the same thing.

Laugh tracks are either enhanced or created entirely in the mix. There are a handful of "laugh people" in the world today. They operate a piece of equipment designed to create or enhance a laugh track for your show. If your show is going to have a laugh track – as it always will if you're doing a sitcom – be sure to

schedule your laugh session as early as possible. These folks are busy, and they don't come cheap. They usually work on a two- or four-hour minimum. You can approach your laugh tracks in two ways. The way you choose depends on how your show is shot, and how much time and money your producers want to budget for this step.

If you are creating a sitcom and it shoots in front of a live audience, you will already have a laugh track as part of your original production audio. That laugh track, usually labeled "audience", is recorded on your production audio master.

From here you can elect to hire a laugh person to come in and bridge and enhance the existing laugh track. "Bridging" means that any laughs that are cut off by editing are extended. Laughs can be filled in if you need more than the audience provided, or inserted if no laughter exists and you think it is needed.

Bridging and enhancing an existing laugh track for a half-hour sitcom should take about two hours, and it can be done either during the mix or after you've made a dialogue/effects pass in the mix and you've spotted the areas that need "laugh help".

Some sitcoms do not shoot in front of a live audience or choose for some reason not to use the live laughter, instead having a laugh person completely replace the laugh track. Again, this can be done during the mix from the beginning, or you can make a dialogue/effects pass in your mix, spot the laughs and then bring in a laugh person to create the laugh tracks. This method should take about four hours for a half-hour sitcom.

Foreign-Language Dubbing

Foreign-language dubbing is the replacement of the language that the actors are speaking in a show with a language different than the one spoken in the original dialogue track.

The trick is to match the translations, and the timing of the way the actors recording the replacement dialogue are speaking, with the mouths of the original actors as closely as possible. In addition to matching the mouth movements, it is also important to recreate the mood of the speech to carry the proper message about what is going on with the characters and the movie itself. If the actors' emotions are not also captured in the dubbing process, then the movie will not carry the same impact, and maybe not the same message, as the original dialogue track that was recorded on the set.

Foreign-language dubbing may bring to mind visions of the old English-dubbed Japanese Godzilla movies. The English words were so poorly matched to the mouth movements of the Japanese actors that sometimes whole sentences were spoken and no one's lips moved.

The translation itself is also an important part of the process. Going back to the Godzilla movies, sometimes the phrasing was so outrageous that a serious exchange between actors became downright comedic. Fortunately, foreign-language dubbing has come a long way. Even the worst dubbing is generally not too bad.

When you sell your movie, TV show, commercial etc. to a foreign market, you may need to be involved in the foreign-language dubbing process as part of the terms of the sale. In this case, you'll either be providing the elements necessary for a dubber in the foreign country to do the dubbing and possibly mix the new dialogue track with the M&E track, or you will actually be responsible for getting the dubbing done.

In either scenario, you'll need to provide the dubber with a picture reference of the program. You'll have to provide a script, a picture element with a guide track, timecode that matches the master, and a sound element that contains the fully filled M&E track.

The foreign dubber will use the script to do the foreign translation. Then the picture source will be used as a playback reference when the dialogue is rerecorded – matching the mouths of the actors as closely as possible.

The new foreign-language dialogue track is then mixed with the foreign M&E track, making a new composite track to marry to picture.

Localization

It sounds like staying local and getting to know your local culture and language. But what does that have to do with dubbing? It's much more than translation: It's how a show is accepted or understood in other countries. Foreign distribution used to be a simple process of translation and subtitling. Having to read the subtitles made the experience less enjoyable than it could have been. Foreign dubbing took over the market, making the movie easier to understand, but often the dubbing would be of the aforementioned Godzilla variety. In addition to the inadequate translations and sync, distributors found that cultural differences, local humor and etiquette played a large part in the audience's understanding of the story. With this awareness, distributors began to tailor the content in addition to the translation: For example, finding slang words in the foreign language that would give the same meaning as the original, or changing the color of an object based on cultural differences, or integrating folklore into the story. Put these changes together with a voice-over actor in the appropriate language, and the program is received in a more positive and successful light. To put it simply, it's not just translation, it's about meaning. Most distributors now dub for localization in the largest markets. Like captions and subtitling, localization is a specialty and takes time to create. Often the actors hired are in the country of the language required, and the

work is done long-distance via secure internet connection. The localization service will help with the translations and have staff to help with the cultural and linguistic needs. The technical specs are similar to those for captioning. As an independent filmmaker, you won't be required to provide this as a delivery item unless you sell to a single market or a very small distributor in a specialized market.

Localization File Specifications Sample

SD/HD work files in order of preference:

- AV1
- MPEG-1 (SD only)
- MPEG-2
- QuickTime
- WMV

Delivery specs:

- frame size: 320 x 240
- frames per second:
 - 24 fps, 25 fps (PAL), 30 fps (29.97) drop frame or non-drop
 - audio codec: PCM, ADPCM or MP3
- audio must match the audio on the final master
- on-screen timecode matching the timecode on the final master to appear in the upper-right corner
- do not deliver audio and visual streams as separate files, or use embedded audio in a video file
- HD/SD work files are also accepted, and the specs are similar

As with captioning (see the mastering chapter), make sure you send your contact the title of the project, your company name, your name and contact information, and the run time and format. Again, paperwork and setting up an account takes time so make sure you think in advance.

Most post facilities will be able to send your file data via a secure pipeline to the caption company, and the data will come back the same way. To send and receive this data, each facility will share a secure source code to download the data. The post facility will then add the captioning to the IMF or DCP as a separate file. This file is also known as a side car.

Foreign-Language Digital Masters

Depending on your requirements and resources, you may:

- have the foreign dubber actually mix the foreign-language track with the M&E track and lay back to a digital format, creating a foreign-language master
- have the dubber send the separate tracks to you, and you have them mixed locally and do a layback
- have the dubber return the mixed dialogue/music/effects (DME) tracks, and you do the layback only

Foreign Dubbing in the United States

If you are considering dubbing your foreign track in the United States for a movie or TV show originally shot with union actors, check with the SAG before you actually do the dubbing. You may have union residual issues to deal with. These could be costly and create a sizeable impact on your postproduction budget.

Once you have decided to do your dubbing in the United States with a company that specializes in the language(s) you require, try to work with a company that is recommended by someone you know or trust. If that is not possible, then you may want to consider doing a test with one or more companies, and having the tests viewed by either the potential client or some other representative the distributor chooses to ensure that the dubbed track will be acceptable to your client(s).

During our careers, one of us had to supervise a library of foreign dubs. About a quarter of the way through this particular library, we noticed that something was a little off with the sound. Upon further investigation we found that the dubber wanted to save money and didn't put in the proper sound. The language was subpar, and barking dogs were added to the track to cover it up. The problem was the "dogs" were just people mimicking barking dogs and not dogs at all. Needless to say, the work was pulled from the dubber.

So, whether you are using a dubber that was recommended or just picking one at random, always get a credit list. You'll want to know what specific programs this dubber has done, to get a feel for how often the dubber dubs in the language(s) you need, and to be sure the dubber you are hiring has experience dubbing movies in the genre of your movie. Dubbing a drama is much different than dubbing a comedy – whether you are referring to theatrical releases or network TV series.

Also, dubbing is costly, and you certainly don't want to finish it only to discover that the work you've paid for is not usable – and, worse yet, that the dubbing has to be created again.

Dubbing is not new or "foreign" to our industry (no pun intended… okay, maybe a little pun). Don't make yourself crazy reinventing the wheel here. There are plenty of other things that will come along to legitimately make you crazy – you don't need to invent things. So, ask for help; seek out those who have done

this before. Make the dubbing facility sell you on their abilities by showing you what they have done. Don't just listen to them telling you what they can do. If they're good, they should have plenty of material in the appropriate genre to show you.

Many movie studios require that foreign languages be dubbed in the country of that language (i.e. Latin Spanish dubbed in Mexico, French dubbed in France etc.). This is certainly something to consider, especially if you find yourself in the position of having to create foreign-language tracks and you haven't yet made a foreign sale, so you can't know for sure who the licensee will be and what their requirements will entail.

Foreign-Language Film Prints

Foreign film prints are not widely requested in delivery requirements. However, the major studios still service a few small markets. For theatrical use, the foreign-language DME track will be used to shoot an optical sound track so that composite theatrical release prints (picture with sound) can be struck. These will be shipped to foreign markets for viewing in a theater. See the section on adding sound to picture in the film lab chapter for information on creating composite film prints.

Foreign Dubbing Materials

Dubbing for Theatrical and Digital Use

What materials the dubber requires will depend on how much of the work the dubber is going to be doing for you. Let's work from our three possible scenarios listed earlier in the chapter.

Scenario 1. The foreign dubber mixes the foreign-language track with the M&E track. You will use this mix or "comp track" to create an optical sound track negative (OSTN) if you are making a foreign film print. The dubber possibly lays this mixed track to a digital element, thus creating a foreign-language master.

In this instance, the dubber is going to be responsible for all of the work involved in creating the foreign-language track and subsequent master. The dubber will not, in most cases, be creating the OSTN.

To accomplish this task, the dubber will need several items from you. If your masters are still at the post facility, you can have them send the digital material via secure pipeline. You will provide:

- a dialogue script of the program
- a picture reference of the entire show with timecode to match the master
- an English track to use as a guide
- a high-quality sound element of the fully filled M&E track

- a copy of the show on a digital format with at least two open channels, to allow the stereo mix of the foreign-language track to be attached as a separate file within the master (if a final master is to be created with the dubber; if it will be created by your facility, the data will be sent back via the same secure internet pipeline, with a code for access)

Scenario 2. You may have the dubber send the separate foreign- language dialogue track to you so you can have it mixed locally with the M&E track (and do a layback, if you're also creating a digital master).

In this instance, the dubber will require the same set of delivery materials, minus the M&E sound source and the digital master.

The dubber will take the script and create the word translations to the appropriate language. Once that is completed, using the picture reference as playback the foreign-language track will be recorded as a "dialogue-only" track. At this point, the track is truly dialogue only: No effects or music have been added. This dialogue track is then sent back to you. You take this track along with the fully filled M&E element and mix the two to create a fully mixed or "composite" track. Your foreign-language track is now complete, and with the exception of a different language being spoken it should match your original movie track almost perfectly.

Once mixed, this track can be used to generate an optical sound track to be married with a film print, or laid back directly to an existing digital picture element.

Tip: Here's a suggestion born from experience. Even if you do have the dubber mix the tracks as part of the service they provide for you, insist that you receive a clean dialogue-only track anyway. There are three very good reasons for this.

First, should you ever need to remix the composite track, you will already have all of the necessary elements. It is often impossible years down the road to locate a foreign-language track with a dubber in a foreign country.

Second, should there be problems with the mix done by the dubber, you have the option of simply redoing the mix yourself locally. This can be especially critical if you are on a very short turnaround… and, let's face it, when aren't you on a very short turnaround? I'm not sure I've ever received or made the call that starts with "there is no rush on this so take your time".

And third, having the separate dialogue track adds longevity to your track, future-proofing it against legal issues such as music clearances. Should you someday lose a music license in your project (and it happens more than you may think, especially with popular hit music recorded by the original artist), you can now very simply and inexpensively go into your M&E track, replace the offending music tracks, and remix your composite track. And *voilà*! You

can continue to license your product. If you do not hold the separate dialogue tracks, you will have to cease selling this product until you can either find the separate dialogue track (which will take time, if nothing else) or redub the entire track again (an expensive solution to a problem you created yourself). Scenario 3: The dubber returns the mixed DME tracks, and you do the layback to the digital picture master. The dubber will require all of the dubbing elements listed above, minus the master.

Anti-Piracy Issues

Digital materials can be encoded with metadata and other secret tags, which are almost or entirely imperceptible security measures. Or the picture can be marked up, with several large-text words such as "Property of…" or large windows of timecode within the picture. When ordered, this is usually called "with burn-in" or "spoiled". At least one movie studio places a text-code visible window in the picture of all copies of movies they send to dubbers. Each set carries its own unique code. Therefore, if a copy is pirated, the visible window of text will identify from which tapes the pirated copies were made.

It is nearly impossible to prevent piracy. However, it can be discouraged by marring the picture with large areas of numbers or text within the picture area.

Another option is to encode the material with an anti-piracy encoding that will prevent copies being made from those elements. The anti-piracy encoding will prevent the signal of the master from being successfully duplicated onto another source. This is a costly procedure and not very practical for the odd copy that is sent out (such as dubbing materials). Therefore, most people just rely on the obstruction of large portions of the picture with visible information windows containing alpha or numeric characters.

Some copies are sent out without any chroma in the picture when the dub is made, so the dubbers receive a black-and-white picture. This certainly makes piracy less desirable.

As a reality check, keep in mind that too much obstruction is going to make it difficult, if not impossible, in some scenes to see the actor's lips moving in order to sync the foreign dialogue properly. So, as you can see, you just have to use some common sense and strike a balance.

When Do You Dub?

The dubbing materials for a foreign-language theatrical release often need to be provided to the dubber before the actual digital mastering is completed – or even started, in many cases. This allows the foreign-language version(s) to be released at (about) the same time as the domestic release.

Sound

Piracy in this instance is at its highest potential. Some precautions must be taken in this situation over all others to protect materials.

Foreign Laugh Pass

Just as with the domestic laugh tracks built or augmented for domestic release, for foreign release you will need to use a laugh company that will come in and generate appropriate laughs to fill your foreign track. As with other ambient effects (i.e. effects recorded while dialogue is being spoken so they are married), you have to replace the laughs and audience reactions that are lost when the original dialogue track is removed to create your foreign track. Remember, there are a limited number of laugh people, and they are in great demand. Plan ahead so you can schedule your laugh session when you need it.

Foreign effects are created to replace the ambient sounds that are married to the dialogue track and are lost when the dialogue is replaced by a foreign-language track.

For sitcoms recorded in front of a live audience, the audience reactions will be recorded on the set as the show itself is being filmed. The audience is miked separately (left and right, to be used later to create a stereo audience track). Because the audience is right there in front of the actors, there is no way to prevent their applause and laughter (hopefully, there is applause and laughter) from spilling over into the actors' microphones.

Now it is easy to understand that just as with any ambient effect recorded on the set as dialogue is being spoken, when the original dialogue track is removed, some of your laugh track will be removed along with it. The laughs will also be lost when the dialogue is replaced. Therefore, if your show has audience laughs, then you will need to include a "foreign laugh pass" as part of rebuilding your effects for foreign dubbing.

Okay, so you've come to grips with the fact that you are working on a sitcom being recorded in front of a live audience – and all of the special problems that situation brings to the table. And, you've accepted the fact that you will now need to add this little additional step, fondly referred to as the laugh track, into your postproduction process. It seems like such a small thing, you think to yourself, but aha, there's more. There's always more.

You have to think ahead about how you are going to build your audio tracks with respect to this laugh track. Don't worry, we're now going to give you some options, reasons and arguments, hopefully to make this all easy as pie for you. As with many steps discussed in this book, you do have choices when it comes to your laugh track and preparing for your foreign delivery (because that's really the meat of what we're talking about here).

First, there is your foreign fully filled M&E track. Do you mix the laughs as part of this M&E track, or do you keep it separate?

As always, if you have delivery requirements, check them. If this is not specified in your delivery requirements, call and ask the question. Ask your distributor specifically if they want the laugh tracks mixed in with the foreign M&Es or kept separate. Should you have no distributor, and therefore no delivery requirements and no one to ask, here's our suggestion: Keep them separate.

The client that will use the foreign M&E track will be the client that is rerecording the dialogue into another language and completely remixing that new dialogue track with the M&E. It is no harder at that point to also mix in the laughs, should they want them. Because not all foreign clients want laughs in their broadcast, this gives them the option, without you having to redeliver – or worse, remix – your M&E.

The next question is: How do you deliver? What will your delivery elements be? Working on the assumption that you don't yet know how you will be required to deliver for foreign markets, we recommend that you definitely maintain a separate mix. In other words, you may decide to create an audio element where the foreign effects and laughs are mixed together. We suggest that you also maintain an audio element that keeps the foreign effects track separate from the foreign laugh track.

A simple solution could be audio channels, with the following configuration:

Channel (CH) 1: Dialogue stereo left
CH 2: Dialogue stereo right
CH 3: Music stereo left
CH 4: Music stereo right
CH 5: Fully filled effects stereo left (without laughs)
CH 6: Fully filled effects stereo right (without laughs)
CH 7: Fully filled laughs stereo left
CH 8: Fully filled laughs stereo right

The above scenario preserves all of your tracks separately, allowing you to deliver any configuration any client may request.

For your own convenience, you may want to create a backup element that will serve as your primary delivery playback source and not require mixing every time you use it to make a copy for someone:

CH 1: Comp stereo left
CH 2: Comp stereo right
CH 3: Fully filled M&E stereo left (without laughs)
CH 4: Fully filled M&E stereo right (without laughs)
CH 5: Fully filled laughs stereo left
CH 6: Fully filled laughs stereo right

In summary, and at the risk of beating this dead horse, whenever you pay extra to create something, consider always keeping a clean, pristine copy of that thing you created… just in case.

Sound Advice

These 15 areas of postproduction sound will make the difference between a really impressive show and one that's just there. Record the cleanest and technically best production sound possible, and log the metadata with meticulous detail. Hire an experienced sound editor/designer, and pay close attention to the details of your mix. Make sure you are creating sound masters that will provide track assignments necessary to your delivery or anticipated delivery. Often independent filmmakers have to remix because the music license isn't within the distributor's budget; having a six- or eight-track master helps to make the music swap easier. Our advice: Check and double-check what you are asking for, what you need, and what you are getting.

CHAPTER

8

Mastering for Digital Cinema and Film Completion

The creation of theatrical picture and sound masters has become a world of acronyms, bitrates and data files. It can be confusing, and at some point you will feel like a technical dweeb. Don't become "compressed", we will help you "extract" the data and create a duplication "master".

The steps to create a conformed and color-corrected element are explained in the digital workflow chapter. That element is a digital intermediate (DI). Mastering is the process of converting that DI into a package ready for distribution to theaters. The DI contains a large amount of data; to move this data into distribution, the picture data is compressed (made smaller) and encrypted for security. The sound files do not use as much data and are left uncompressed. For foreign distribution, subtitle data is also needed. All of these files, along with timecode to keep them running in sync, are combined into an element called a DCP. In this chapter we will take a closer look at the steps it takes to create the DCP including compression, encryption, QC, theatrical distribution operations, replication and validation.

A note on film: 35mm film is an extremely robust medium. The amount of data contained in a 35mm film image is greater than the amount of data displayed in any type of digital playback system used in cinema today. In film, every frame consists of emulsion layers that respond differently to light. Film can contain five times more data than its digital format counterparts. So it's important to keep your deliverables in mind and create a package with the highest quality possible (this may mean the largest amount of data possible), while controlling your costs. Remember, in many cases, the more data, the more expensive.

To help understand why it's needed to shrink and expand the movie data, it is helpful to know how it gets distributed. An example is taking a photo and emailing it to a friend. Your friend can't open the photo because his or her computer can't process that much information all in one file. Most of the time we "format" our photos when sending them via email. We make them smaller so they can travel faster and display on all computers. This is the same principle used to send programming to foreign markets. Once the masters of the movie

are complete, and you have all the captioning and subtitles, textless, and all the bits and pieces needed to make almost every conceivable version of a movie, that information – that data – needs to move from the post facility to a place where the distributor can access these materials as they need them. They can pull the textless material and insert it, add the foreign localization sound, and send that data to their foreign markets across the globe. This is done digitally. I like to think of it as a virtual delivery, because until it's uncompressed and projected, it is only ones and zeros. Your virtual movie contains a lot of data that has to play in any configuration programmed, and to travel digitally across data lines and in and out of the secret Cloud, or sometimes saved to hard drives and shipped to its destination. In order to service worldwide markets at the speed it needs to be sent, the data is compressed to travel and uncompressed to play.

What Is a DCP?

A digital cinema package (DCP) is a globally standardized delivery format used to play content. It is not a single file, but a collection of digital files. Think of it as a file box: In this box, you will add sound and picture files, textless and captioning, and in addition you will add instructions on what order these files are to be activated and played. This "box" is saved to a hard drive and either sent to a location to play or pushed (sent) via secure internet to its destination. You are probably wondering if a small independent filmmaker needs to go through this complex process to exhibit their content. The short answer is yes. By creating a DCP, you can show your movie at cinemas and film festivals, and submit it for Academy Award consideration. The more complex answer is: There are alternatives.

DCP Is Easy as One, Two, Three Steps

Compression

This is the step where data is squeezed into smaller bytes. Therefore, we squeeze the data into smaller files by compression to fit it in our "file box". The DI is loaded into a special computer, which scans the image data and uses an algorithm to remove redundant or imperceptible information – thus extracting a 2K image from a 4K image. The algorithm is engineered to compress with very little loss of visual integrity and less likelihood of bit errors. Did we mention errors? Sometimes when files are compressed or "down-converted", errors do occur. If you have very dark scenes, rapid pans and tilts or movement, the pixels will create what is called blocking. You will see little blocks where there should be pixel information, or you might see a dithering effect which may make you notice a visual noise or softness. These can be fixed, but usually go by so fast you can't detect them. Distribution QC will pick up on them, which means having

them fixed or a new DCP made. As the name "digital cinema package" implies, the standards and requirements are different than for TV, streaming or other video formats. Digital audio files are so small relative to digital video files that compression is not used. Many movies are shot in 4K, and when the DI is created it is 4K, which as we said is a very large file to store and move around. Many digital projectors in commercial theaters today only project a 2K image, so you need to decide if 4K is worth it for your production. This may depend on if you are planning to sell your content to the theatrical or home entertainment space. Check your delivery requirements or your venue.

Encryption

Piracy is one of the biggest issues in the distribution of motion picture content. To protect studio assets, DCPs are encrypted (encoded) to prevent films from unauthorized screenings, theft and/or duplication without the owner/filmmaker's consent. All the data in our "file box" is protected by an encryption code. Encryption is a two-step process. While the compressed files are still in the computer, they are encrypted. How they are coded, and how the encryption code is chosen, is secret business. If we told you, well, you know how that story goes… In order to play the content, the theater must have a "decoder ring" or digital key. In order to add an additional layer of security, the theater will receive a "key" or KDM via email, separately from the DCP. Your key is programed for a specific piece of content, a specific server (not just an auditorium), and a specific time and date range for a key to work. If you are missing one of these three parameters, your key will not play back the content. And there is yet another layer, the trusted device list (TDL), which is a list of verified devices allowed to play back content. The device is acknowledged with the correct KDM, and several other layers of security are built into the system.

Packaging

We are not talking about Bubble Wrap and peanuts here. Your DCP has compressed picture files and uncompressed sound files and a special decoder key. Just like 35mm film, digital cinema packaging is based upon reels. These reels can be electronically spliced together to create a "composition" (i.e. content: a trailer, the feature, or the sound that matches it). Reels include parallel track files of picture, sound, subtitles etc. Track files are tied together by the composition playlist (CPL). Packaging is the process of assembling together all of the encoded and encrypted files and wrapping them up into a complete package for shipment.

With the key, you might think that the projector will play back the content. However, the computer connected to the projector will not know what sound to play with which picture and in what order. What the server needs is a show playlist – but wait, there's more. First, the CPL must be made (Figure 8.1).

Figure 8.1 Composition playlist for digital cinema

Figure 8.2 Show playlist

Once the sound and picture are matched up with each other, the show playlist can be made to list in what order and when that content is played (Figure 8.2). A supplemental package can be used to create another alternative version of an existing DCP. The supplemental package has a different CPL and may have different audio tracks, different subtitle tracks, and sometimes even different picture tracks. The supplemental package will use other content assets of an existing DCP to complete its package. For example, your OV or original version of your

DCP may have a supplemental package with the Spanish-language track. When this supplemental package and the new CPL are played, you will see the original version of the picture while hearing the audio in Spanish. A great advantage to this system is that you can now send three languages with one picture file and use a CPL to tell the server which language to play back.

Don't panic and start making lists. Encoding, compression and encryption can be done all in the same facility. You are now ready to package your DCP.

Packaging is the process of assembling together all of the encoded and encrypted files and wrapping them up into a complete package for exhibition. Your DCP is now complete.

Some Technical Specs for the Techies

The digital cinema distribution master (DCDM) is the uncompressed master files for picture, sound and subtitling. The image DCDM is color-corrected for digital cinema projection and will be used to create the compressed files for digital cinema distribution. Video source files for your DCDM or digital source master (DSM) can be your DI or tape (HDCAM/HDCAM SR/D5), or ProRes or uncompressed QuickTime files. The DCDM is often a 16-bit TIFF file or DPX file.

Audio source files are uncompressed linear PCM (digital audio files) at a 48 kHz sample rate running at 24 fps. Audio commonly delivered as 48 kHz at 23.98 fps requires a sample rate conversion to stay in sync at 24 fps.

Typically, in digital cinema movies are played back in 2K or 4K packages. 2K is an abbreviation for 2048. 2K normally refers to a count of 2048 horizontal and 1556 vertical pixels in the DI world, but for digital cinema 2K means a scope picture represented by 2048 x 858 pixels, and a flat picture represented by 1998 x 1080 pixels. 4K is an abbreviation for 4096. 4K normally refers to the count of 4096 horizontal and 3112 vertical pixels in the DI world, but for digital cinema, 4K means a scope picture represented by 4096 x 1714 pixels, and a flat picture represented by 3996 x 2160 pixels. You should always confirm that your aspect ratios are correct for your delivery requirements or venue.

QC

You breezed through making a DCP and you thought you were done and out the door to the theater, but there is a very important last review that has to be done: Take a look at the content and make sure it plays correctly and that it has no visible or audio errors. This is called quality control or QC. QC should be done by a person, not just a computer, so you can verify that the package contains

what you think it has, and that it is indeed *what* you have; and also that picture and sound are in sync and work correctly. If movie A is mislabeled as movie B, you can go through this entire process with the wrong movie. Since DCP files are digital, they can also be checked by a computer. This process ensures that the files in the original copy match all the other copies of your DCP. It is *very* important to QC. This is where you notice mix-ups, subtitle mistakes or things added at the end that aren't supposed to be there, end credits that are incorrect, reels out of order, reels for the wrong show etc. There was a movie theater that mistakenly played an R-rated program to a "G" audience of children. As you can image, parents and children were surprised, and not in a good way. Mistakes happen more often than you think, and you don't want to be the person they happen to. We cannot overemphasize the importance of QC.

Choosing a Facility, or Not

If you have the budget, you will go to a postproduction or mastering facility to have your DCP created. The session is not a client-supervised one, and the process can be completed within a day. The DCP can be saved to a hard drive, or if you are connected to a distributor the DCP data can be electronically pushed to them.

Students and independents don't always have the budgets to complete a project like the pros, and sometimes budgets are so minimal by this time in the schedule the project has almost run out of funds. Don't despair: There are several options, including companies that can create and QC DCPs for you and work within your budget. Yes, there are software programs that can automatically create DCPs for you – however, you are taking a big risk that you may run into problems. You are in the driver's seat, so it's important to make sure the parameters of your DCP are correct. Do your own QC to make sure it plays properly before you send it off, especially to a film festival.

Gotchas

What are the most common issues when trying to play back a DCP? There are many, but here's a list of the most common:

- Encryption: If not done correctly, KDMs can have trouble with playback in the field.
- Subtitles and projector incompatibility: If your subtitles were not created correctly, or are incompatible with your projector, you may have problems. Make sure you QC the DCP and ask your facility or post supervisor to check them. Subtitle and caption source files should be CineCanvas XML

timed text with an associated font file (e.g. Arial.ttf), or timed subtitle spots with associated png images (sometimes used for Japanese, Chinese and Hebrew)
- Hard drive formatting: Hard drives must be formatted in EXT2 for theatrical distribution. This is not how common hard drives are formatted.
- Having audio workflow problems? Is your audio workflow in stereo? Could it be at the wrong sample rate? The wrong bit depth or file type? Is it 5.1 or 7.1 or mono .wav files? Audio should be 24 bit, 48 kHz at 24 fps, or 5.1 or 7.1 interleaved files.

The bottom line on sound is to have an allocated budget to finish at an audio facility. And if you plan to have the film distributed on Blu-ray, it will require that the mix be Dolby 5.1-certified, and an additional licensing fee will be incurred.

Common DCP issues can include:

- non-cinema frame rate
- wrong aspect ratios
- misidentified color space or dynamic range
- highly compressed video source
- color graded on uncalibrated monitors (a cinema projector is best)
- missing sync details (no 2-pop, no countdown leader)
- sound mixed in an uncalibrated room (way too loud or way too quiet)
- mislabeled audio channels
- invalid subtitle XMLs
- mistimed subtitle XMLs
- a missing font file

You can also have lost shipments, damaged hard drives, misplaced hard drives at the theater, server upgrades, or changes or swap-outs of servers where new KDMs are needed.

Other Mediums

There are other projection and broadcasting methods. Although you may not encounter these formats, as a filmmaker you should be aware of how your product may be exhibited and how it will affect the look of the content.

MXF

Other venues such as TV, streaming and in-flight entertainment are starting to use a file-based structure called MXF, which is very similar to a DCP. MXF is a format that holds files combined with metadata. The metadata describes the

files. MXF is intended to be a standardized way to move video and audio files between systems regardless of operating system and/or hardware.

What Is E-Cinema?

E-Cinema is a lower grade of projection currently used for advertisements and pre-show advertising prior to the feature presentation.

E-Cinema includes:

- pre-show advertising
- alternative content
- live TV and opera broadcasts to theaters
- lower-end projection systems (not HD)
- very low security measures for piracy

There are a few foreign markets that project via E-Cinema. If you sell to a distributor and they sell to these markets, your content may be projected via this method.

3D Projection

3D popularity comes and goes. It can be a headache if you haven't worked in this medium. It can also be costly. Movies can be shot in 3D, or converted to 3D in the DI process. Here is where QC becomes incredibly important. We urge you to preview your movie in a 3D venue. 3D can be very dark: The glasses that help create the 3D effect limit the amount of light received to the eye, and thus the overall project can be darker than expected.

There are several 3D projection systems, and they all work differently. We mention this here in the mastering chapter because a DCP with 3D content can play on different types of 3D systems. Depending upon the show, you might be very particular about the look, color and lumens. If this is the case, make sure to preview it in the theater you're projecting in.

How Does DLP Work?

There are several manufacturers that use digital light processing (DLP) technology: NEC, Barco and Christie, to name a few. These projectors use digital micromirror devices (DMDs), a computer chip etched with thousands of tiny mirrors which switch on and off to project light. Sony's DLP uses a proprietary system. At the time of publication, LED monitors are just being introduced into movie theaters. They use a different type of display technology that may or may not require another color correction pass. See the chapter on the future for more information on LEDs.

In case you need to know more about theater exhibitions: Digital Cinema Initiatives LLC, also known as DCI, is a consortium of the major movie studios and various technology experts, formed in 2002 to establish voluntary standards pertaining to the industry of digital cinema. The goal was to find common standards (of the highest possible quality) for exhibition, distribution, filmmaking, mastering, encryption etc. of digital theatrical content. They released their final report in 2005 (although it is continually being updated), and it is available for download at www.dcimovies.com

Color Correction

Once the conform is complete, you may begin the color correction process; however, it should be done prior to adding credits. We have seen strangely tinted credits due to color correction being done after the credits are laid over live action. Don't let it happen to you. Color correction is the process by which the current colors and density in a show are adjusted, enhanced or changed completely to bring the piece to the look you, the client, are striving to achieve. The colorist (known as a "timer" in the film world) makes the adjustments according to the specifications you have given regarding how you want your show to look on a scene-by-scene basis.

Why Color Correction Is Necessary

There is often confusion regarding the need for color correction. It is a necessary step in any project created with multiple light sources, whether on film or digitally. A film-based project or a multilocation or multi-camera digital project that is not subjected to color correction will be unacceptable to any distributor. TV sitcoms or talk shows which shoot in controlled lighting and on an indoor set will generally not color-correct their footage. We have done a quick one-light pass on these shows; however, the cameras are calibrated, and the lighting and capture are controlled, making it even in most scenes.

Who, What, When

Color correction and/or color-grading is a process in workflow that occurs after the conform is complete. The digital file, DSM, DCDM or other conformed element will be accessed by a colorist, who will review and adjust the color and density of each cut and scene throughout the show. If your DP or director are available, they will want to be involved in this process. As a post supervisor you will need to be present to represent the production company and make sure all things go as planned. There will be special scenes that require more attention, e.g. day for night, a pan that starts in front of a bright window and

ends in a dark interior, or outside scenes where the light has changed during setups.

How

Your colorist will start with the provided LUTs and suggestions from the DP, director or post supervisor, and will rely on the scopes to keep levels within spec. The scopes measure the waveforms of exposure or luminance; the chroma – red, green, blue, cyan, magenta and yellow values; and saturation or hue. During the process the colorist will adjust these levels to smooth out the cuts and scenes, making them appear seamless. Once a scene is balanced, the colorist can begin to add refined corrections. This secondary color correction step is called color-grading, and this is where you will be able to add a special mood or tone to enhance the movie's theme or feel: For example, dark and moody for horror, or bright and saturated for present day.

What Can Go Wrong

If the chroma, saturation or luminance are taken beyond their limit, you will crush the blacks or blow the out whites. Crushed blacks occur when the saturation is increased beyond the acceptable limit, and blown-out whites are also beyond the technically acceptable limit of luminance. Extremes in color or density can cause color shifts scene to scene, and this is a cause for rejection by a network or distributor. Color corrections that are incorrectly cued, occurring early or late at a scene change, will cause incorrect color shifts within the scene. Those are also cause for rejection, but can be remedied.

How Long

This is a time-consuming task, and it's important to your overall look of the project. We have been in sessions where things have gone wrong, data is missing, or someone with authority takes the color in a "new" direction. All of these surprises can cost the schedule dearly. Barring any real issues, a two-hour feature might take two weeks in the color correction suite. Some very big-budget effects features may take more time. A 90-minute TV program may take three days. A short will take less than a day, depending upon your budget.

What Happens Next

The color choices and any additional digital fixes will be saved to your DSM, DCDM or other master element. This will become your master to make other materials, e.g. DCP, mezzanine files or consumer material, as discussed above. In case we haven't stressed it enough: Any new materials must be QC'd, because anything can go wrong.

Can I Do It at Home?

Students and low-budget filmmakers may try to do minimal color correction with available software. For short projects that have been captured reasonably well, it may be successful. Be aware that simple things like changing the lighting, or turning off or on a lamp in the room where you are working, will affect your outcome. Changing computers or monitors mid-correction will interrupt the consistency in how you make your changes, even if they are the same brand. Monitors are not all calibrated the same, and using multiple screens will create frustration.

For projects that are longer than a few minutes, it is wise to have the guidance of a professional colorist. You might be able to get a discount or student rate during off-hours or off-season.

Film

While film can give remarkable reproduction of the image it has photographed, it is not always a consistent medium. Color balance variations can occur between different types of film stock, and even within different batches of the same film stock. Other variables such as exposure, temperature, age and lighting all work to affect color balance. Therefore, to maintain a smooth visual finish, exposure and color correction adjustments are necessary.

Color correction can also be used to achieve color effects scheduled to be done in postproduction, rather than on the set.

To create a color-corrected print, you will view a print with a color timer. The director or cinematographer attends these screenings, and you may have to coordinate screening dates with the lab and the director/DP. Your timer will make color and density adjustments, and two or more prints before you strike your final answer print or IP. (For more details, see the section on creating other negatives and prints in the film lab chapter.)

The Color-Blind Producer

Once, during a very busy period, one of us was unable to supervise the color correction session for a 90-minute TV program she was working on. One of the show's executive producers offered to go in her place. It must have seemed unimportant to him at the time that he didn't know exactly what a color correction session was, because he neglected to inquire. Off he went to his session.

After the session, someone at the office asked this executive producer how the session had gone. He said he was surprised at how difficult it had been to match all the gray values. Turned out the gentleman was color-blind. Yikes! Makes you wonder what the colorist must have thought. Anyway, the facility's colorist was very good, the show aired, and it looked alright.

Summary

Color correction sessions are long and necessary. We have found them to be fun and a chance to put the final touches on our projects. Before you turn over any masters or data, make sure you have the elements QC'd for any one-frame errors or other glitches that can be fixed before they are cause for rejection. For more on QC and common causes for rejection, see the section on common causes for rejection in the acquisitions chapter.

Credits and Titling

Creating credits and titles is a step that occurs during the mastering process for all media. We have therefore added it here between digital and film. Credits are the actual listings acknowledging who did what in a program. They include everyone who is getting a screen acknowledgment for the part they played in making your show.

In episodics and sitcoms, the names that are built as part of the main title and that stay the same from week to week are referred to as the main title credits. Credits displayed over the show opening are called opening credits, and those shown at the end of the show are called the end credits. The text that is used throughout the show to identify a place or date is called the locale.

Credits

When you work for a large studio, the credits will usually be provided to you. If you are working for an independent, you may have to figure them out for yourself. This is a very important task. If they are incorrect or incomplete, you or the producer can be held legally responsible and may be fined. These guidelines are helpful no matter what your capture or delivery formats are.

Tips for Creating Credits

Creating credits for a show can be tedious and even nerve-rattling, with the potential for expensive legal ramifications if it is not done properly. Here are a few tips to help you through the process:

1. Always get a copy of the signed contract of every actor and crew member. The producer or production manager will have the contracts. Read the contracts and highlight the credit provisions.
2. Request a credit list and order of credits from the casting company. The deals were made through them, and they will know the legal agreements.
3. Ask the production manager for any company deals that require credits, and ask the producer if there are any extra or nonstandard credit deals.

4. Secure legal verbiage from your lawyers regarding copyright and fictitious-persons wording.
5. If the show is for a studio or network, there will be a list of credit guidelines in their delivery packet (see the delivery chapter).

Put all of these together, and then pull out the "credit section" located in your distributor's delivery requirements.

Sometimes distributors do not allow certain departments in the main title, or they won't acknowledge these departments at all. After going over the credits and making your adjustments, give the first draft to your producer. After the producer's adjustments are completed, recheck all the spellings against the contracts, and then distribute the credit list for approval to casting, legal, the producer, the director and the editor. After the credits have been approved internally, send them to the distributor for approval.

The delivery package usually includes a list of those who need to sign off on credits before they can be considered approved. You will probably end up creating more than one draft of credits before they are finally approved. Be sure to date and number each page (1 of 13, 2 of 13, etc.) of each version of the credits, so you always know you have the complete and final version when you go in for titling.

When all the adjustments have been made, confirm the number of main title cards with the editor, and submit the approved final copy to the lab for opticals, or to the titling person at the postproduction facility to pre-enter your copy.

Credits for Features

Feature productions are generally larger than TV productions. They shoot longer, have larger crews and larger budgets, and even shoot a larger aspect ratio than most programs created for TV. Keeping in line with these "larger" items, feature films usually have much larger, more elaborate main title treatments, and much longer end credits. Some movie title treatments are being worked on before production even starts. The elaborate and distinctive titles from the James Bond movie series come to mind.

We're seeing a trend with some filmmakers who feel that a grand artistic title display detracts from the tone or introduction to a film's beginning. They have begun to downplay all the credits in the interest of directing your complete attention to the movie itself. These filmmakers save all the credits, and sometimes even the main title of the movie, for the very end of the movie. This is the opposite of some early filmmaking where all of the credits are seen in the movie's opening titles and the end of the movie is simply followed by a card that reads "The End".

Regardless where your movie titles appear, the order in which the individual credits can appear is predetermined. As in TV, the unions rule how and when

their members are acknowledged, and their rules must be adhered to. The guidelines for features and TV shows are very similar in the order, wording and on-screen duration of the credits. The end credits for features, however, will be much more extensive, and every crewmember for every shooting location will be listed. All music and clip licenses will be listed, as well as company logos and legal, copyright and ownership information. Compiling the list of credits for a feature can be an enormous undertaking. Your first hope is that a studio legal person will take on most of the legwork and supply you with an already-approved list. Anyone who has ever worked on a low-budget film knows that many times credits are extended in lieu of payment, or in exchange for reduced payment. These credit lists can be seemingly unending, and there probably won't be any studio person to help you. Be sure executives and legal people sign off on a hard copy and that all the appropriate guilds give their approval as well. Every guild has a website that lists the credit provisions and provides forms and procedures for your convenience. Ignorance is not bliss, and in this case it can be costly.

Credits for TV 90-Minute Programs/Pilots

When making a 90-minute program or pilot, the credit order is fairly standard. Some contracts will require certain actor credits to appear on the screen before the show's main title card is shown. These are called "above-the-title" credits. A traditional credit lineup will look like this:

Opening credits
 Actors (above the main title by special contractual obligation only)
 Main title
 Actors
 Composer
 Editor
 Art director
 Director of photography
 Producer(s)
 Executive producer(s)
 Writer(s)
 Director

Instead of being included in the opening credits, the executive producer(s) may elect to take the coveted last fade at the end of the show before the final commercial break position. Only the director or the executive producer(s) can use this credit position. In rare instances, a short credit roll is approved that includes producers and associate producers.

End credits
 Unit production manager
 First assistant director
 Second assistant director
 Actors and roles played (lead players usually appear first)
 Crew members (job performed, then name)
 Service providers (lab, sound house, prop providers etc.)
 Legal disclaimer (get the verbiage from your lawyer)
 Copyright notice (get the verbiage from your lawyer)
 Logos

Later in this chapter we list some additional guidelines and union rules for dealing with credits and union members.

Credits for Episodics

A permanent main title sequence is created that includes the regular actors, the main title and sometimes the creator. This main title sequence is used for each episode. Each episode will have new opening credits listing guest stars, writer and director. A traditional credit lineup will look like this:

Opening credits
 Actors (above the main title by special contractual obligation only)
 Main title
 Actors
 Composer
 Editor
 Art director
 Director of photography
 Producer(s)
 Executive producer(s)
 Writer(s)
 Director

The executive producer'(s') election to take the last fade at the end of the show before final commercial break position is also applicable to episodics as well.

New end credits will also be created each week to include new actors and crew members.

End credits
 Unit production manager
 First assistant director

Second assistant director
Actors and roles played (lead players usually appear first)
Crew members (job performed, then name)
Service providers (lab, sound house, prop providers etc.)
Legal disclaimer (get the verbiage from your lawyer)
Copyright notice (get the verbiage from your lawyer)
Logos

Many end credits are contractually regulated by the following:

- contract requirements
- casting company deals
- producer requirements
- production manager deals/requirements
- legal jargon
- production company logo requirements
- network/foreign logo requirements

Union Rules Regarding Credits

The blanket rule for all of the above procedures is that regardless of what is negotiated, the unions –SAG, DGA, Writers Guild of America (WGA) etc. – rule. All of their guidelines are written in their basic agreements and are traditionally not negotiable. For detailed explanations of each union's guidelines, check their websites. Each union provides an outline of the credit requirements, some downloadable in PDF form.

For convenience, here are some simple guidelines outlined by these organizations:

The director can be either the last card in the main title or the last card before the final commercial break. If the director is the last card in the main title, then the writer is the second-to-last card in the main title. If the director is the last card before the final commercial break, then the writer is the next card, which is the first card in the end credits. The writer's card must be on screen a minimum of two seconds, or the same length of time as the producer's or director's card – whichever is longer. The unit production manager and the first and second assistant directors share a card. This card is placed in the most prominent technical position in the end credits. The production executives are considered technical and should appear after the unit production manager/first and second assistant director card. A major TV producer tested this rule and lost. This was very expensive for the production company. So putting the unit production manager/first and second assistant director card first in the end

credits will guarantee you've fulfilled this critical requirement. Of course, the exception to the rule is that the DP (cinematographer), the art director and the editor credits can be placed ahead of the unit production manager in the technical (end) credits.

The rules for actors, on the other hand, are less mandated. SAG has very few rules for actor credit placement; therefore, the actor has to make their deal up front in their contract. Any contractual obligations that follow the rules must, of course, be honored. There can be no more than six actor credits per card in the end credits, and the screen time for each card can be no less than two and a half seconds. After successfully obtaining all of your in-house and network credit approvals, you must submit them to the WGA and DGA for approval.

WGA

Get a tentative writer's credit form from the WGA (see Figure 8.3). Fill it out and make two copies. File one copy, and have the original *hand-delivered* to the WGA with a cover letter. Be sure to get a signed receipt from the WGA that they have received the form. The WGA website states: "The NTWC (notice of tentative writer's credits) must be sent via Certified Mail/Return Receipt Requested, messenger, or some other independently verifiable means. Email is not considered an independently verifiable means". Also, the WGA requires that you send the writer two final drafts of the script and a copy of the tentative writer's credit form with a cover letter.

The WGA and the writer have seven business days to respond. If you have not heard from either in this time period, you may assume you have fulfilled your legal obligations and are free to proceed. The WGA does not send written approval.

Should there be a dispute before the seven business days have expired, the WGA will arbitrate between the producer and the writer. If the writer is a producer on the project, the WGA considers this an automatic arbitration. If there should be an arbitration, you will need to immediately send the WGA another copy of the tentative writer's credit form, the original script, the final script, and any written information required by the arbitrator.

This can be a time-consuming process and underlines how important it is to do the credit approvals early on.

DGA

The DGA will accept an email of your credits with a cover letter requesting approval. If the credits are approved, you'll receive a return email with the approval.

```
Date_____

TO: Writers Guild of America, West, Inc. 7000 West Third Street, Los Angeles, CA 90048, or to
    Writers Guild of America, East, Inc. 555 West 57th St., New York, NY 10019
    AND
    Participating Writers

NAMES OF PARTICIPATING WRITERS          ADDRESSES_____

_____         _____
_____         _____
_____         _____
_____         _____

Title of Episode_____Production #_____
(If pilot or MOW or other special or unit program, indicate network and length)

Series Title_____

Producing Company_____

Executive Producer_____

Producer_____   Associate Producer_____

Director_____   Story Editor_____
                                          (or Consultant)
Other Production Executives, if Participating Writers_____

Writing Credits on this episode are tentatively determined as follows:

ON SCREEN:

Source material credit ON THIS EPISODE (on separate card, unless otherwise indicated) if any:

Continuing source material or Created By credit APPEARING ON ALL EPISODES OR SERIES
(on separate card):

Revised final script was sent to participating writers on_____

The above tentative credits will become final unless a protest is communicated to the undersigned
no later than 6:00 p.m. on    _____    _____
                                                 (Company)
                                                 By_____
```

Figure 8.3 Notice of tentative writer's credits

SAG

To date, SAG does not require prior credit approval. It is considered a courtesy, however, to also send a copy of the credits to SAG for their approval. The SAG website does give guidelines for the length of time names should be placed on screen. It reads in part: "Credits shall be considered to be at a 'readily readable' speed if the card on which they appear is shown for not less than the applicable time period indicated below (or the equivalent thereof in a 'crawl')":

Number of names on card	Minimum time period card must be shown
1 name	1.0 second
2 names	1.5 seconds
3 names	2.0 seconds
4–5 names	2.5 seconds
6 names	3.0 seconds

Armed with your officially approved, technically correct credits, go ahead and calculate the duration of each card in the end credits. (Actual placement of the opening credits sometimes falls to the editor or the producer, although often the associate producer has this responsibility.) The network and other distributors will have predetermined the run time of the show's end credits. Remember not to violate the predetermined lengths discussed above. If you find, when calculating credits, that you are over the time allotted, you may want to call your distribution contact to see if they will allow any exceptions. If there's a good argument for bending the rules, it may be allowed. This doesn't happen often, so don't try their patience by trying this every week. Usually, by doing your job and being prepared, you can avoid this situation.

Choosing a Font

Okay, now here's the fun part! Well, it's more fun than sending credit copies to the DGA and SAG, or begging producers to sign off on credits so you can deliver on time. Sometimes in this business you have to broaden your definition of fun.

If you are working on a very low-budget project, there is software you can use that will create a digital end title roll-up in the editing suite, which can then be filmed out. If you have a little money, your post facility will be able to create your main and ends and locals (these are titles in the lower third of the screen that designate a date or location of the action). If you have a large budget, you have the luxury to be able to hire a main title artist. They all design digitally, and for a film finish you will need to have your post facility film out or record out to film to create a negative. Most of the time you will be working with a post facility that will create the main title and end credit roll-up. Ask the titling facility to provide samples of the available font types, and submit these to your producer. If asked, most facilities are happy to provide an opening title and an opening and end credit in several fonts for the executives to view. This may help them visualize how their copy will look in the different fonts. It is sometimes easier to choose when you see your actual titles on the screen. Put forth the effort to have the producers narrow down the font types before making a sample. Most facilities will work with you as much as possible in choosing a font style, but try not to take advantage of the situation. Of course, as an associate producer you may not

have any control over the actions (or inactions) of the producer and the production company executives. But the facility will appreciate your efforts in any case.

Once the type style has been chosen, let the facility or title artist know, and schedule your session.

The graphics person assigned to create the opticals or type the titles will need to know which size to make the credits. Generally, the opening credits are all 100% of title. The end credits vary, with the more prominent cards being 100% of title and multiple cards being 80%. The legal disclaimer is as large as needed to fit in the space allowed. In the case of film titles, you will make them digitally and film them out, then have the negative cutter cut them into the negative after — and only after — you have seen a print from the negative that was filmed out.

Mine Is Bigger

A trick for deciding the size of the main title is to take the longest name in the opening credits and use this as the size for the rest of the opening credits. There are rules to follow that determine the relative size of titles and credits. Be sure to check your contracts for size guidelines. Traditionally, no credit can be larger than the main title. Other limitations will be stated in the contracts.

A final note on credits: Even though everyone and their brother (industry nepotism gives a scary reality to this cliché) has approved these credits, try to find the time to personally check each one for spelling. A good trick is to use the actor's signature on the contract. A further check is to count all the speaking parts and make sure you have a credit for each. Ninety-nine percent of the time, speaking parts get a credit.

Red Alert

Please take the following as a warning and not as a hard-and-fast rule. We recommend that when choosing a color for your digital titles or drop shadows, you avoid the color red. It does not generally reproduce as well as other colors, and it sometimes shifts or may appear to be smeared. A very popular cable series used red letters on their main title very successfully. If you have the time and budget, don't be afraid to experiment; just be aware that this particular color can be troublesome.

Titling

In film, this is when you order your opticals and have them cut into your negative. Film opticals, which include fades, dissolves, scene transitions, titles and other effects, are created digitally and filmed out to a new negative stock. This then becomes part of your cut negative.

Graphics technology is one of the most rapidly changing aspects of postproduction. Graphics equipment has become much more affordable and flexible, so some

facilities now use equipment that makes titling much easier, less time-consuming, more creative and more accurate. Fancy movements can often be accomplished on the same equipment that you use to create your simple text credits.

You can email the postproduction house or title designer a copy of the original credit list. This copy must have been signed off and approved by all, with spelling checked. The list will include the size of title as compared to the main title font size, indicate how long the card is on the screen, and be in order of how the credits will show on screen. This eliminates the need for them to retype the information, thus avoiding names being misspelled or left off completely due to human error.

Title Parts

Your titles are made up of the following components, although not necessarily in this order:

- main title
- actors
- executives
- service providers
- disclaimers
- copyright notice

To create the credits that make up your titles, see the credits section in this chapter.

Titling Requirements

For your titling session you will need to have done the following:

1. approved title copy
2. chosen a font style, color and size
3. spotted the place where each title will appear on the screen, and determined how long it will be on the screen and whether it will fade or cut on and off
4. designed a main title (for a series, this is usually a prebuilt separate element that includes your regular stars and is inserted into your show each week; this main title sets the tone for the show and becomes the show's signature)

Textless – It's Not a State

Check your delivery requirements to see if you need to deliver textless material. These are the backgrounds that your titles will be placed over.

If your main title has backgrounds, you may be required to make a clean version without backgrounds. For film, you will need to make an IP or dupe to fulfill this requirement. The same may be true if your show has many locales throughout, and thus a lot of textless footage.

For a program that has more than one part (a special program may have two or more parts), be sure the material is labeled as to which part the textless belongs to, e.g. "Part 1 Textless Main and Ends".

Some shows might have a lot of locals, i.e. the text at the bottom of the screen that indicates a location and/or a date. Some distributors will ask that you leave these with text and all other texted backgrounds be supplied textless. This is called semi-textless.

Digital in, Film out

As you know, there are several ways to approach the making of a film or TV project. Most films begin as a digital signal and remain digital through exhibition. There are filmmakers who prefer to shoot film and then finish digitally, and a few shoot film and finish film. If your project has a distribution agreement, the studio may require a film negative as a delivery requirement. Let's pretend you survived shooting your movie and the postproduction process. A studio, desperate for a big hit to drag its stock out of the toilet, sees your movie and makes you an offer you can't refuse. (Good place to start, huh?) How do you provide this element when no film has been shot?

So, What Is This Film-Out Thing?

If you shot on film and finished your project on a digital format, you may only need to deliver the original negative and a final cut list with the Keykode information (please tell us you generated a negative cut list). These elements will be stored by the studio/distributor, and can be accessed if necessary to resurrect the project on film or retransfer up to 500 years from now. That is what you call asset protection. There are still certain territories and small markets that require film prints. Perhaps 20 or so prints will be sent from venue to venue to service these contracts. Studios will sometimes, on very big titles, make 35mm prints. If you captured digitally, you have one option: "Output to film". Other terms used to identify this process are "laser recording", "film recording", "record out to film" or "film-out". Once the film-out is complete, the new negative is called a digital intermediate. While we are taking about the process we're going to use "film-out", because it is so many fewer words to type, and when you're writing a book, this becomes important. (Sorry, we digress.) Any HD format of your final project is your best choice. You'll take all the regular steps to master your project, color-correct, title, QC. Then you'll take your final master or data files to your film-out facility. There are a couple to choose from.

Most film-out facilities can output from several different data formats. However, each facility may differ in what type of data files they can read, so do your homework.

Understanding Data Resolution

When you enter the world of film-out, everyone is going to start talking to you in terms like 4K, 8K, 307,200 pixels etc. It is important for you to know what they are talking about so you can order exactly what you need and only have to go through this really expensive process just once.

To reproduce the quality of a 35mm film frame, you need an image with 5000 x 3760 pixels. Film frames stored as computer image files come in three common pixel dimensions: 2K, 3K or 4K. A 2K image has 2000 pixels, a 3K image has 3000 pixels, and so on. Working in 3K or 4K most closely matches the human visual threshold of about 2500 x 2500 pixels (in a square picture). Your scanning might be done at 4K. However, most film-outs are done at 2K because of reduced costs and data requirements at half the output time. Many would argue this makes financial sense, because there is little visual difference for most people between 2K and 4K. Some would counterargue that once again money wins out over art.

Film-Out Specifications

There are a few details the facility will need from you when you are ordering your film-out:

- What is the original format you will be delivering?
- If it's a data file, what is the size?
- What is the run time of your project, so they know how much storage space you will need?
- If you are not outputting an entire feature from beginning to end, but only outputting negative pieces, have you added the additional frames you'll need for negative assembly?
- What aspect ratio is going in, and what aspect ratio needs to come out?
- Do you have a separate sound element that will need to be married to the print you receive? And who will be responsible for syncing that sound?

We have provided a sample specification sheet (Figure 8.4) to help you gather the necessary information before speaking with the film-out lab.

Prior to outputting your project, the facility will do a test to make sure the output will meet your expectations and that you have done everything right technically with your source material. Depending on their schedule and your needs, the test could take from overnight to several days.

There are several variables that might affect the look of your film-out project. First of all, the equipment and lighting used in production will have an effect.

Film-Out Specifications

Date_____ **Project Title**_____

Production Company_____ **Contact**_____

 Ph _____ **Alternate Ph#**_____

Source Material:
___ 1 Gig Jazz ___2 Gig Jazz ___Zip ____CD-ROM ___Floppy ___Other
___ DLT 4000 (UNIX-based) Retrieval Command _____
___ Exabyte (UNIX-based) Retrieval Command _____
___ DTF 1 (UNIX-based) Retrieval Command _____

File Type:
___ Cineon ___ SGI.rgb (16 bit) ___ SGI.rgb (8 bit) ___ Targa ___ Tiff ___ Call regarding others

File Size:
___ 2K (2048x1536) ___ 2K (2048x1556) ___ 1.85 2K (2048x1107)
___ 4K (4096x3072) ___ 4K (4096x3112) ___ 1.85 (1828x988)
___ 5 perf 65mm 4k (4096x1796) ___8 perf 65mm 4k (4096x2930) ___15 perf 65mm (4096x3002)
Other: _____Horizontal _____Vertical

Image Alignment: **Scope:**
___ Centered ___Academy Centered ___Anamorphic ___Anamorphic (unsqueezed)

Comments:

Record Format

35mm Academy center: ___ 1:33 ___ 1:66 ___ 1:85 ___Scope

35mm Full aperture center: ___ full ____ 1:78 ___Super 35 common center ___Super 35 common top

___ 65mm 5 perf ___ 65mm 8 perf ___ 65mm 15 perf

Negative Film Stock

___ 5245 ___5244 ___5369

Laboratory Instructions

___Daylight Rush ___Develop Only _____# of Positive prints ordered

___Interpositive ___Registered I.P. ___Schmitzer I.P.

Special Notes or Requests:

Figure 8.4 Film-out specification form

Pans and camera moves may look different once transferred to a different frame rate. Once it is determined the outcome will be acceptable, the facility will then output the entire project to a negative film stock. Be sure to find out if the price you have been quoted includes the negative film stock. Some facilities only quote prices for prints.

The film-out negative is simply exposed negative and will need to be processed and printed. The first print will be a check print to check for overall quality. Then you will need to go through at least some color adjustment per roll. The process will not be as extensive as when you timed your original cut negative, because the digital master has color correction built in, and during the testing phase the facility should have also made some adjustments. Once color balance has been finalized, the sound track needs be lined up, and a final answer print will be made. We recommend that when you shoot your movie, you should record your sound to a separate audio element, as you would in a normal film shoot. Then you can go through regular audio postproduction and produce a higher-quality audio track than if you just used the audio recorded to your camera source tracks. You are now ready to make your IP, dupes and theatrical prints.

The Film Recorder

The film recorders that reproduce the highest resolution (6K) offer two basic technologies. There are the film cameras that shoot high-resolution black-and-white video screens through red, green and blue filters; and there are red, green and blue microlasers that scan an image on the film's surface. The facility takes your final picture master and digitizes it into their computer. The images are then fed a frame at a time into the film-recording machine. The recorder captures each frame and creates a film negative. The output ratio (2K, 4K) determines how long it takes to produce the new negative (called a digital intermediate).

This process is not too widely used, but can be more cost-effective if you stay in the SD format.

Sound for Film-Out

Whether you shoot your project on film or digitally, there are a few things you need to straighten out before you say goodbye to your sound facility. Once the project goes through the "magic film-out" and becomes a film element, it might not sync up unless a few precautions are taken. Your sound facility will need to know some basics:

- What format will you be delivering to the sound facility?
- How is the sound master configured – what audio is on which channels?
- How will the film-out be formatted –1000-foot or 2000-foot reels?

- How was the film/sound originally recorded and at what speed?
- Who is going to sync the tracks?

2-Pop

It is imperative that the sound facility adds what is called a 2-pop at the head of the track. This is a tone that corresponds to the visual countdown on your film leader on the number "two" (counting backward from ten). The 2-pop will sound, confirming your track is in sync with your picture. Without a 2-pop, it is nearly impossible to sync your project.

Finally, we strongly suggest that you take the check print of the film-out and project it against your sound master before making any optical tracks. This seemingly small last-minute double-check will save you money and embarrassment. Otherwise, you may find out in the screening room with the executives that your track is out of sync.

Film Completion

Completing your project on film may be a creative choice; however, delivering a film negative may be a requirement, depending upon the elements in your delivery requirement instructions. There are still projects shot on film that cut negative, and after meeting with a major film laboratory we felt it was important to retain the steps of film completion. Film does after all have a special magic that is hard to match electronically. Having shot on film, you will most likely be required to deliver one of the following: An uncut negative and digital element finish (this is the most common requirement) or a cut negative and digital finish. For digital capture, you may be required to deliver a film-out digital intermediate and digital finish. Be aware of your post schedule, and that delivering your show finished both on film and digitally does not mean that each version will necessarily be completed at the same time.

The following film completion components will be discussed in this section:

- film finish
- opticals
- negative cut/negative conform

Film Finish

A film finish means that all of your work toward delivery will be done on film. This does not preclude making a digital master. The digital master can be created from daily film scans or a transfer from an IP.

The negative is cut once the show has been locked and opticals are complete, regardless of whether or not dailies are digitally transferred.

Film Opticals vs. A/B Cutting

Prior to cutting your negative and preparing for your film finish, you will have to make yet another important decision. This one covers how to complete your film opticals. Fades and dissolves, which are two types of film opticals, can be created in a couple of different ways, either as a single strand or as A/B rolls.

Single-Strand Opticals: Fades, Dissolves and Effects

Single-strand opticals take time. Be sure to check with the digital facility prior to shooting to gage how long they will take to create. The digital facility will need the visual background where the optical occurs. This may be a transfer of your digital dailies or a high-resolution scan of your negative. The optical is then built, manipulated, layered, and output to a digital file which then needs to be filmed out to a new piece of negative. A check print is made to ensure the quality of the new negative section. Once approved, these new opticals are cut into your original negative in a single strand. This method represents an industry standard and results in excellent-quality opticals. Time can be a factor, though, as each stage takes at least a day or more, depending upon the complexity of the optical.

A/B Opticals: Fades and Dissolves Only

The A/B method for making fades and dissolves requires the creation of a checkerboard of negative and leader on alternate rolls. The A roll begins with action, followed by black opaque leader where the optical will be. The B roll begins with black opaque leader. At the footage where the first optical occurs, the action negative of the next scene that fades or dissolves in is cut into the B roll. This continues throughout each roll, thus creating a checkerboard of action and leader between the two rolls. No separate opticals are created then cut into your negative; your original negative is simply cut this way. The dissolves are created when the rolls are run together for printing.

Choosing the Right Method

On the surface, the A/B method can seem to be less costly. However, you have to do your homework to do a complete assessment of the pros and cons of each method. The single-strand method is a slower process to render the effect on a computer. Depending on the complexity of the optical, rendering could take several hours to several days. There are also slight visual differences between the two methods. Your DP will probably have an opinion on which one is best suited to your particular project.

With the A/B method, both the negative cutter and the laboratory will charge an additional fee for a B roll.

Negative Cut/Negative Conform

Negative cutting is a concern only if negative is going to be cut – either for a film finish, or later to satisfy delivery requirements.

If you are making a true film finish show complete with film print dailies, the negative cutting requirements are pretty basic. If any of the postproduction process is being done electronically, you will need to remember that film information (edge numbers/foot and frames) must come from the film during dailies transfer. One reason you may need the original Keykode is a delivery requirement. Some studios don't require a cut negative but do require a negative cut list to be stored with the negative for future reference. If you do a film dailies transfer without gathering this information at the time of the transfer, the only way to recapture this information after the fact is to retransfer the film. This will add an additional expense that will be difficult to hide! This mistake is huge. It will not impress your producer, and is definitely one of those "oops!" situations that could be a career-breaker.

It's only fair to mention that there is technically one other way to retrieve key numbers if this is not done at the time of the dailies transfer. This is a very time-consuming process whereby the film is put back up on the telecine and the key numbers are recorded at each clap of the slate for the takes used in the final locked picture. The timecode on your original dailies is converted, and feet and frames can be calculated.

Once your picture has been locked, the negative is physically cut and assembled according to your EDL (also called the negative cut list). Some negative cutters use a pair of scissors to cut the negative, and then tape the splices together. This cut negative is then sent to a film laboratory with a negative assembly department to be hot-spliced together. Hot splicing creates a permanent bond that will pass through the film printing machines or telecine transfer without breaking apart.

This process matches back (conforms) your original negative to your final version of the show (either digital or work print). The original negative contains numbers along one edge that serve as a reference for the negative cutter. These edge or key numbers are either originally gathered as part of the dailies film-to-tape transfer or printed through onto the work print stock from the negative. The negative cutter matches the edge numbers in the cut list to the original negative.

When you know you are going to need a negative cutter, it is best to choose one as early as possible – preferably before you start shooting. All the information the negative cutter will need comes from film, so it is helpful if you can include your negative cutter's requirements from the beginning of the postproduction process. Negative cutting begins as soon as the editor sends the cut list to the negative cutter. The opticals or titles may not be complete at this time; however, there is plenty of work to do before they are turned over to the cutter.

After the picture negative has been cut, a negative of the credits is made and cut into the original negative (see the credits and titling section earlier in this chapter).

Accessibility

In response to a Federal law that went into effect in 1993, mandating captioning decoder chips in all new TV sets that are 13 inches or larger, modern-day TV sets come standard with the ability to read captions. In 2010, to ensure these laws were updated to include current technology and to increase access, President Obama signed the Twenty-First Century Communications and Video Accessibility Act (CVAA) into law. Notice that the CVAA has the word "accessibility" in it? It is no mystery why delivery requirements have a section entitled "accessibility" to outline the captioning and video description requirements.

Generally, a student or independent filmmaker is not required to caption their project. However, if it is broadcast on TV or distributed to theaters, you may be required to have it captioned. And think about it: You want as large an audience as possible to be able to see and hear your project. According to figures from the Federal Communication Commission (FCC) and the American Foundation for the Blind, there are nearly 56 million blind, deaf or hard-of-hearing possible audience members (extra tickets) that want to and could enjoy your project. There are "closed captions", which must be decoded or turned on to view, and "open cations" that appear at the bottom of the screen and cannot be turned off. Closed-captioning (for the hearing-impaired) and video descriptions (for the blind) are a delivery requirement for exhibitors, all networks and cable stations, home video and most foreign distributors. Distributors to Brazil require closed captions and descriptions in Portuguese as well as sign language. There are several types of captions (closed and open), subtitles and video descriptions, and various methods by which theaters provide this technology. As a filmmaker, there are also on-screen considerations that you need to be aware of.

Closed-Captioning

Technically speaking, captioning is the recreation of the words, lyrics and effects on a program's audio track, along with action description typed out and then encoded into the picture's master file. This is done at a captioning agency.

The actual captioning is a signal that contains text information. It is incorporated into program data which is broadcast to your TV; the decoder in your TV will then decode the signal and display the text.

It's Not Just for the Hearing-Challenged

Originally, programs were closed-captioned solely for the deaf and hard-of-hearing. Persons with these disabilities could purchase a signal decoder. The

picture signal ran through this device, which decoded certain lines in the vertical interval of the video, making the information on the audio track visible as written words on the screen. Today this technology is also widely used by the hearing public. You see it in sports bars, restaurants, nail salons, lobbies… almost every public venue that has a TV turns off the sound and displays the captioning. It has become completely integrated into our society.

The production company is expected to pay all costs for captioning, although in some instances the network does help cover costs. This may be especially true if the network requests last-minute changes after the captioning has already been completed. In your distribution delivery requirements, the captioning deliverables may be listed as "HI/VI", i.e. hearing impaired/visually impaired. This is a phrase that is most often used during post to describe caption requirements.

Captioning Needs

To caption your show, the captioning company will require a script, and almost any format of your finished picture with timecode matching your master. Therefore, try not to deliver material to the closed-captioning company before final assembly.

The exception to the above statement, of course, is if the show is very dialogue-heavy and there is an unusually short turnaround between mastering and delivery. The captioning agency will need to make last-minute adjustments to the captioning, but at least they will have a head start on entering the information.

Be sure to provide the captioning company with your postproduction schedule as early as possible so they can add you to their schedule. And if your schedule changes or episodes air out of numerical sequence, please remember to let the captioning company know. This is especially true of sitcoms and episodics, which generally deliver weekly and are on a very tight schedule. It takes three to five days to caption a 90-minute show. Fees are charged by the run time length of the show. They will also want you to fill out credit forms and general information about the project, and confirm your requirements.

The captioning company will provide you with specifications that include visual as well as audio specs.

When sending material to the caption company, include the following information:

- project title
- client name
- total run time
- audio language
- timecode type

- speed: 24 fps, 25 fps (PAL), 30 fps (29.97) drop frame or non-drop
- screen format and aspect ratio: 16 x 9 1:78:1 etc.
- HD format: 1280 x 720 progressive, 1920 x 1080 progressive, 1920 x 1080 interlaced, 1920 x 1080 progressive

Sample Caption Work File Specifications

Written out, closed caption file specifications look something like this (although with enough notice they can handle almost any format):

- SD/HD work files in order of preference:
 - AV1
 - MPEG-1 (SD only)
 - MPEG-2
 - QuickTime
 - .wav
- delivery specs:
 - frame size: 320 x 240
 - frames per second: 24 fps, 25 fps (PAL), 30 fps (29.97) drop frame or non-drop
 - audio codec: PCM, ADPCM or MP3
 - audio must match the audio on the final master
 - on-screen timecode matching the timecode on the final master to appear in the upper-right corner
 - do not deliver audio and visual streams as separate files or use embedded audio in a video file

HD/SD work cassettes are also accepted, and the specs are similar.

Understanding Closed-Captioning in Theaters

Since the Americans with Disabilities Act was enacted in 1990, theaters with 50 seats or more are required to provide assisted listening devices. There are several methods theaters are able to use to provide this service. They are not all available in every theater, but one of these is available just by asking.

- **FM radio** frequencies transmit amplified sound through a special receiver that viewers wear.
- **Infrared light** is transmitted to sound from an emitter to a special receiver that is worn and can be adjusted to the desired volume.
- **Induction loop systems** receive a sound signal through the T-coil in hearing aids or cochlear implants. The viewer switches the hearing instrument to T-coil and can then enjoy the show.

- **Entertainment Access Glasses** created by Sony, and a more recent version, **Open Access Smart Capture** glasses, project captions in the air in front of the viewer. The text can only be seen by the user. Access glasses are used instead of reading captions on the screen, and they are large enough to fit over conventional eyeglasses.
- **Rear-window captioning** enables viewers to read text on a personal panel which displays captioning reflected from an LED screen at the back of the theater. The panel is mounted on a flexible plastic stalk that fits into the seat's cup holder.
- **Subtitles Viewer!** is a free application for the iPhone. The app provides subtitles from a library of titles new and old, in 20 languages. There are additional apps for this technology. The drawback is of course the no-cell policy in most theaters.

Three of these methods rely on having the DCP captioned. All of them, with the exception of the apps, broadcast captions or sound from the data streaming in from the projection booth.

Captioning Your Master

Once captioning is completed, the captioning company will send the data via a secure internet connection to the postproduction facility scheduled to do the actual transcoding. The post facility will record the data and necessary timecode to a side car of the IMF and DCP. Transcoding is the process of laying the captions onto a separate track of the DCP. If programmed to play, the captioning locks to the timecode, and the system does the rest.

Captioning vs. Titling

People don't often think about the relationship between titling and closed-captioning. The two don't interfere with each other. But when "open" captions are decoded, they appear as text across the lower third of the screen. This is also where opening credits are often placed. This means the captions appear over the credits, and neither will be readable on the screen.

If you provide the captioning company with the timecodes of the start and end of your opening credits and where on the screen they appear, they will place the captioning higher on the screen during these times. This way the credits and decoded captions will be clearly readable.

Better yet, if time permits, have the work cassette that goes to the captioning company made after you title your show. They will then have a visual reference of your title placement and can place their captions so that when decoded they will not overlap with the credits. The drawback is that TV delivery schedules don't always allow enough time for this method. If a tight delivery prevents you

from providing a captioning work copy with titles, give the caption company approximate timecodes where you expect to place your credits, and tell them where on the screen the credits will appear (e.g. upper third, center, lower third). They will do their best to avoid overlapping.

Nearly all domestic and some foreign distributors require programs to be delivered with encoded captions. Planning ahead will help ensure that everyone who sees your show is able to read the credits and the accompanying captioning.

Captioning companies archive each show's captioning information for an extended period of time. Therefore, should you need to make changes that affect the captioning, or should you have to remake your delivery master for some reason, the captioning company can resend the information to the postproduction house.

Subtitles

Most of us are familiar with what subtitles look like. They are used when a foreign language is being spoken on screen to tell the viewer what is being said in their language. They manifest as one or more lines across the bottom of the screen, and are timed with the actor speaking.

Subtitles are usually done with white letters, but sometimes they are done in yellow letters. White letters can be hard to read if the visual behind them is very light.

Film subtitles used to be created one of two ways. They were shot on high-contrast film stock and were married to picture negative in the printing process on what was called a traveling matte. In the other method, the text is literally etched onto the print's emulsion side. The emulsion is scraped away in these areas, and the subtitles appear when light goes through from the projector. Today subtitles are generated electronically, like titles. They are inserted into the picture at predetermined timecodes. This can either be done in an edit bay, or more commonly are created and encoded just like captions. In fact, subtitles are often referred to as "open captions".

There is an art to creating subtitles. There are rules as to how many words are in a line, how many lines appear on the screen at once, the duration, and the punctuation used. Be sure to have your subtitled movie done by an experienced professional subtitling company. Be mindful about the differences in subtitle placements between full frame and 1:78 images. If you are subtitling both, you'll have to have the subtitles reformatted for one or the other. If you use full-frame subtitling for a 1:78 movie, the subtitles will appear somewhere in the letterbox. If you use 1:78 subtitles for a full-frame movie, the subtitles will appear high up into the picture. For more information on subtitles, dubbing and localization, see the sound chapter.

Video Descriptions

In 2002 the FCC ruled that video descriptions are a broadcast requirement. Video descriptions are to the visually impaired what closed captions are to the hard-of-hearing. They are spoken descriptions of things going on in the picture that may not be readily apparent from the dialogue or music but are important to the story's plot, such as the setting, costumes and facial expressions. The descriptions are inserted into pauses within a program's dialogue.

Special writers are hired to write the descriptions and actors to record them. The descriptions are placed in the natural pauses in dialogue, and do not get recorded over any dialogue or the opening of any song lyrics. It takes two days to write the descriptions, one day for review, and one day to record. The fees, as with captioning, are charged per screen minute. And just as with captions, the data is sent to your post facility and saved as a separate file in the DCP. This is a specialty, and only a few places do this type of work. This translates to: Make sure you get scheduled as soon as you confirm your mastering date. The description service will need the same materials as the caption company: As-broadcast script, media with timecode that matches the master, run time, show name, and all the required paperwork.

As-Broadcast Scripts

An as-broadcast script is a transcription of a program exactly as it aired on TV or was shown in a theater. And you are probably asking why not use the production script. Production scripts are often close approximations to what really ends up in the final mix. The reason for this is that dialogue lines and even songs or song lyrics can change once a program is locked and goes into ADR – and maybe even after the final mix has already started.

This happens because once a show is put together, complete with the "final" audio track, the producers or executives may feel or realize that some dialogue, for example, doesn't work as well as originally thought. Or maybe they realize that more exposition or explanation is required for the audience to understand a plot point or character's action. Sometimes audience testing will show an unfavorable reaction to a scene, and the producers make a change to correct that reaction.

There may be a song mixed in, and the last-minute clearance cannot be obtained and another song must be substituted. This may happen so close to air or release that the change is made on the fly, quickly mixed in to meet the delivery deadline, and not incorporated into the script. These kinds of last-minute changes are especially common in TV series.

Another example of a time when the script is incorrect is when movies are then cut down or re-edited for TV viewing. There are rules each network, cable channel and airline has for words and actions that cannot be shown on TV. These are called standards and practices (S&Ps). To conform to S&P guidelines,

language, violence or sexual content may be edited out. Then the script needs to be redone to accurately reflect those changes.

When a program is cut down to make its run time shorter for syndication, a new script may need to be created so the captioning can be updated. These are all the as-broadcast scripts. These final scripts are used to create foreign-language subtitling, and by the caption companies to create the closed captions.

Should your job include providing these accurate revised transcriptions for any of these purposes, you will need to plan for the creation of these scripts. They take time (often several days), which will need to be added to your delivery schedule and will cost additional dollars, which will have to be factored into your postproduction budget. There are script creation companies, or transcription companies, that specialize in this service.

Summary

Captioning is a required delivery element for broadcast TV and theatrical exhibition. Make sure your schedule and budget make room to create the as-broadcast script, the visual reference and finally the captions themselves. Be aware of how subtitles and captioning may collide. Student filmmakers aren't required to go the extra mile; however, it might provide you with an additional audience, not to mention the respect of inclusion.

Wrap-Up

As you can now appreciate, because you made it to the end of this very long and information-intensive chapter, a lot goes into completing your film or digital project. Don't be intimidated by the number of steps covered in this chapter: Our advice is consistent. Read your delivery requirements early, question anything you do not understand, and constantly update your postproduction schedule so you can keep track of where you are. As technology changes almost faster than we can keep up with from project to project, your film laboratory, sound house and postproduction facilities will play a bigger and bigger role in helping you successfully finish your show. They won't be able to do that, however, if you don't ask them for help when you need it. They often have more up-to-date knowledge and experience, because they are completing many different types of show on a daily basis. That hands-on type of experience can be invaluable when trying to understand *how* and *why* things work. And they have continual access to the equipment manufacturers who are creating this technology.

CHAPTER 9

Deliverables

Contrary to what we may wish to happen, when it is time to deliver your project, the great antennaed stork does not swoop down, gather up all the precious elements you've nurtured through the postproduction process, and magically deliver them into the distributor's crib. *You* must get them there.

A Long Labor

Delivery begins with dailies (usually in the form of off-line proxies) and progresses in stages throughout the completion of your show. Delivery is completed only when you have fulfilled all of the delivery requirements and the distributor has accepted the elements. Make sure you get signed confirmation that the appropriate persons have received all the items listed in your delivery requirements. This is an important suggestion, as items have a way of getting lost, and if you cannot produce a signed receipt for all of the elements you delivered and things come up missing later, the onus will be on you to track them down. This advice comes from one who has had to track down "lost" material more than once.

Get the Delivery Agreement

At the start of your work on a picture, make sure you get a copy of the agreement that clearly outlines the delivery requirements for each of your distributors. These requirements tell you exactly which steps in the postproduction process you must complete.

To your producers, successful delivery is the most critical step in the postproduction process. Each day that passes beyond the delivery due date can translate into dollars lost by the production company. Distributors will not make the final payment until all of their delivery requirements have been met.

Makin' a List and Checkin' It Twice

In general, TV shows are delivered to a network or cable company, one or more foreign distributors, and the production company. Read through your individual network/domestic, foreign and production company delivery requirements, and make yourself one big checklist. The items on your checklist will vary depending on which distributors you are responsible to. It could be a lengthy list, and unlike the list St. Nick makes, naughty or nice, they will get what they want.

Large-budget features are delivered to studios who are the international and home video distributors. Other producers will have made distribution deals and deliver to multiple distributors, both foreign and domestic. Independent movies without a distributor will need to anticipate delivery requirements for theatrical release, digital mastering etc. Part of that will include dealing with contracts outlining the legal rights and requirements related to the project. If your project gets picked up for distribution after it's made, confer with your attorney. Remember that teammate that has your back?

Combining all the material requirements serves two purposes. First, it keeps you organized, and let's face it, if you are not organized, the show is in lots of trouble. Second, you will find that some of these requirements overlap, allowing you to plan ahead and meet some of the criteria in more cost-effective ways. In fact, if your domestic and foreign distributors are one and the same, you may find that many items do overlap, helping you see that this part of your job may be less daunting than you originally thought. Later in this chapter, you will find that each set of delivery requirements – network/domestic, foreign and production company – is covered in detail.

Know Who Gets What

Delivery, of course, does not count if you do not deliver to the correct person in the correct department. Make sure you know who is expecting your materials. Neither your daily contact nor the person who sent the requirements may be the same person who gets the final product. For example, your network contact will not be the person that receives the 35mm negative. Negative is delivered to the vault. In addition to being delivered to a specific place, ask how it is to be packaged. Negative must be inventoried and packaged in certain sized boxes to fit in the storage racks. You can probably guess how we became so knowledgeable about box sizes. Therefore, when you determine who the appropriate persons are to receive the materials, call prior to the delivery date and introduce yourself. Confirm the delivery date with them. Let them know how you plan to get the materials to them, and determine if there are any special instructions.

For example, will your delivery person need a drive-on (permission to enter the property)? Do their offices close at a certain time?

Accompany any materials with two copies of the delivery letter, and have the appropriate person sign one of the copies upon receipt. Make sure the delivery company returns the signed delivery letter to you so you can add it to your files. We have found that wording the delivery letter as closely as possible to the wording of the delivery requirements helps avoid confusion.

Figure 9.1 shows a sample delivery letter.

The sample delivery letter in Figure 9.1 does not cover all of the items on our sample delivery list, just those that Mr. Rooty is scheduled to receive. If there is a point person you have been working with at the distributor regarding the general delivery of elements, make sure that person also receives a copy of this letter.

Network/Domestic Delivery

Each distributor, studio, network and cable station has a pre-established set of delivery requirements. These requirements are usually part of a "delivery packet". Make sure the distributor sends this packet of information to you at the start of production. If you do not receive it, call your contact, who will put you in touch with the appropriate department.

Hopefully you have read the network delivery list prior to setting up the dailies transcoding and final mastering, and will be able to deliver all the appropriate masters required (see the dailies chapter for more details).

A specialized department at the distribution company handles each step of the postproduction process. The number of different departments/people you will need to interface with usually depends on the size of the distributor. Creating a road map of who's who and what each person receives will help you.

Network Resources

Networks have more in-house resources than some smaller cable stations and other distributors. Production stills are a good example. Networks will sometimes provide their own photographer on a shared-cost arrangement with the production company. The network therefore provides its own stills, and you have access to all of the photographs, including gallery shots, for your foreign distribution requirement.

Even if the network retains the foreign distribution rights, it may be to your benefit to use the network's photographer. It ensures that they will accept the quality and content of the stills. In addition, you won't have to hire a photographer.

Other packages available from a network/studio may include duplication, formatting and closed-captioning work. This may save you money in the long

Four Girls Production Company
2222 2nd St. 2nd Floor
Hollywood, CA 90000
213-555-1212

September 27, 2020

Mr. Nick Rooty
Foreign Distributor Grande
5000 Galaxy Dr.
Galaxy, CA 90002

RE: The Four Girls "Kiss 'N Tell"/Delivery

Dear Nick:
Per the Foreign Distributor Grande's delivery requirements, dated 1/1/19, for the above named 90-minute program, please find accompanying this letter the following materials:

 1 – Editor's Lined Script
 1 – Camera and Sound Reports for Dailies
 1 – Editors Code Book
 1 – Footage Worksheet
 All dubbing cue sheets for dialogue, music, sound effects and foley
 1 – Dialogue and cutting continuity script
 1 – 35mm silent timed answer print
 1 – 35mm DI Negative

Also delivered on this date via Aspera and confirmed by email:
 Closed Captioning with matching timecode to the original DCDM
 1 – 6-track of the mixed music, dialogue and effects
 1 – 4-track of the mixed music, dialogue and effects
 1 – 4-track of the original score
 1 – DI with Textless and 7.1 fully mixed tracks
 1 – DCP with 7.1 fully mixed tracks

If you have any questions or need any additional information, please don't hesitate to give me a call at the number listed above.

Sincerely,

One of Four Girls
FG/og

Cc: Producer
Accounting
Legal

Figure 9.1 Sample delivery letter

run, and if they do the work, they generally have to accept it or make it right at their own expense.

These resources are not always available from a small distributor. For example, photographs: You may still be required to deliver publicity stills, but you must provide them at your own expense and using your own personnel. Don't hire your brother-in-law to take pictures unless he is a professional photographer. Professional stills are required. You will need to budget for the photographer's fees for several days of work.

Network Meetings

Some of the networks hold meetings prior to the start of production. In attendance will be the producer(s), postproduction supervisor, promotion department, publicity department, delivery folks, attorneys, photo department and network executives. These meetings can be useful for several reasons. You have a chance to meet the people you are going to be dealing with for the next several months. A timetable is established for each phase of the project. All expectations and no-nos are established up front. Any special needs, such as on-set interviews and specific promotional elements, can be arranged at this initial meeting.

One of the first departments you will work with is the promotions department. Sometimes this is combined with the publicity department, sometimes not. They will need materials to work with early on. Then there is the publicity department, which may have separate requirements. It sort of snowballs from there. Various executives will want copies of the show through its different stages of completion – dailies, producer's cut, rough cut, on-line, color correction and titling etc.

Feeding the Promotions Department

The promotions department will want the cleanest copy of the rough cut or an LTO as soon as it is available for release. They will require split tracks (preferably separate dialogue, music and effects tracks). After it is complete, they will also want a hard drive with the score.

In situations where an episodic or sitcom is not going to be completed in time for the promotions department to get their advertising on the air, they may elect to come in on their own dime and edit together some promotional material to broadcast. To promote TV long form with a tight postproduction schedule, they may ask for a partial or temp copy of the off-line of the show, go into the postproduction facility and cut something together from the masters, and pull something from that to air.

Network Delivery Packet

At the beginning of production, you will receive a delivery packet from the studio/network. This packet will include:

- a cover sheet
- a rate card
- a format sheet
- delivery requirements
- credit guidelines
- S&P guidelines
- music cue sheet instructions
- broadcast technical specifications
- film and TV diagrams

Cover Sheet

The cover sheet will welcome you to the network folds, wish you the best of luck on the project, and offer assistance should you need it along the way.

Rate Card

If the network offers duplication as a service, a rate card will be included in their packet. These rates will cover multiple copies in various formats. Prices will vary by program length and number of copies ordered. They may also offer closed caption encoding services. You will never be required by the network to utilize any of their duplication services. On the other hand, the prices may be very attractive, and it can be a convenient option.

Format Sheet

The format sheet will have the network IDs, commercials etc. already filled in. There will be blank spaces wherever the information is to be completed by you. This sheet outlines exactly how your show is to be laid out for network delivery. It tells you where to put the commercial blacks when you format. It also gives a space to fill in the run time of each act. You will be required to provide timings for each section of program and commercial blacks at specified lengths and intervals. There will also be a requirement regarding program run time and main title and credit lengths. This is the length the show must be when you deliver.

The format sheet the network provides in your delivery packet will be appropriate to the show you are delivering. If yours is a half-hour sitcom, your format sheet will be specifically for a half-hour sitcom. If you are delivering a two-hour show, then the format sheet will reflect that. Figures 9.2 and 9.3 are sample

Deliverables

NETWORK:	
PROGRAM/TITLE:	
EPISODE #: _____	EPISODE TITLE: _____
DIRECTOR: _____	EDITOR: _____
AIR DATE: _____	

FORMAT ITEM	IN	OUT	LENGTH
MAIN TITLE W/CREDITS (MAX :30)	01:00:00:00	01:00:31:00	00:00:31:00
ACT I	01:00:31:00	01:05:40:15	00:05:09:15
BLACK	01:05:40:15	01:05:50:15	00:00:10:00
ACT II	01:05:50:15	01:10:36:06	00:04:45:21
BUMPER (MAX :03)	01:10:36:06	01:10:39:03	00:00:02:27
BLACK	01:10:39:03	01:10:49:03	00:00:10:00
ACT III	01:10:49:03	01:22:04:15	00:11:15:10
BLACK	01:22:04:15	01:22:14:15	00:00:10:00
TAG/CREDITS	01:22:14:15	01:22:35:00	00:00:20:15
EXECUTIVE PRODUCER LOGO	01:22:35:00	01:22:38:00	00:00:03:00
NETWORK LOGO	01:22:38:00	01:22:41:00	00:00:03:00

FORMAT ITEM	LENGTH
SHOW TIME (INCL. COLD OPEN, MAIN TITLE, ACT I, II, III, BUMPER TAG, CREDITS, and LOGOS)	00:22:11:00
SHOW TIME PER NETWORK	00:22:11:00
FORMAT BLACKS	00:00:30:00
TOTAL RUNNING TIME	00:22:41:00

TEXTLESS STARTS AT ____	INT'L TEXTLESS MATERIAL	TIMECODE
	MAIN TITLE	01:25:00:00
	ACT I	01:25:31:00
	ACT II	
	END CREDITS	01:26:40:00

COMPLETED BY _____ DATE ____ DELIVERY DATE ____

Figure 9.2 Sample format sheet for half-hour program

format sheets for a half-hour sitcom and a two-hour show. Basically, the format sheet should be a paper account of the layout of your entire program, including cold open, main title, each act and commercial blacks.

The run times you will need to complete this sheet can be calculated during your format session. If you off-line with the appropriate blacks built into your show, then you can also get this information from your assistant editor. Be sure to keep a copy of this format sheet in your paperwork and box it up with your other important papers. Sometimes you can procure a small variance in the required run time of the program you deliver. The networks have a little wiggle

NETWORK:	AIR DATE:	
PROGRAM /TITLE		
EPISODE #:	**EPISODE TITLE:**	
DIRECTOR:	**EDITOR:**	
Network ID/Movie Opening		:35
Act I (incl. Main Title)		18:25
1st Commercial Position (1)		2:34
Corporate Promo		:45
Act II		9:52
2nd Commercial Position (2)		2:34
Network Title Card (w/Announce)		:05
Promo (Promo Swap)		:31
First Station Break		2:04
Network ID/Movie Opening		:05
Act III		10:14
3rd Commercial Position (3)		2:04
Network Title Card (w/Announce)		:05
Local Affiliate Swap Position		:31
Second Station Break		1:34
Network ID		:05
--END OF REEL 1--		
Act IV		19:05
4th Commmercial Position (4)		3:05
In-Show Promo		:41
Act V		7:06
5th Commercial Position (5)		2:35
Network Title Card (w/Announce)		:05
Promo		:41
Third Station Break		1:49
Network ID		:05
Act VI		15:29
6th Commercial Position (6)		2:34
In-Show Promo		:41
Station Break		1:34
Act VII		10:14
In-Show Promo		:11
7th Commercial Position (7)		:31
Movie Trailer		:31
Credits		:60
	Network Elements	**28:35**
	Program Content Time (91:25)	**1:31:25**
		2:00:00

Figure 9.3 Sample format sheet for 90-minute program

room to work with. If the show runs too long, you will have to trim here and there (what we used to call "nickel and dime it") to deliver at the required length. What foreign distributors won't accept is programs that are too short. But do not change the delivery run time without talking with your network contact. This must be approved prior to final delivery.

Delivery Requirements

The delivery requirements will come next. (Promotional and publicity requirements may also be listed here, or they may come as a separate section in the delivery packet.) You will find listed here dailies requirements, digital master format, rough-cut materials, credits, timing sheets, music cue sheet requirements, and the names and telephone numbers of all the people who are to receive these materials. Confused by any of the items listed in this portion of your delivery packet? For crying out loud, call somebody! Make sure you understand each item completely.

Network delivery requirements outline the final delivery format (DCDM, IMF) along with the audio and DI technical specifications. Even though these technical broadcast specifications are used industrywide, provide them to the facility doing your on-line, color correction and delivery dubs, to avoid misunderstandings down the road. The delivery requirements will also outline any other special requirements (closed-captioning, video descriptions etc.).

Along with masters and format sheets, delivery will include most if not all of the items on the checklist below. In this checklist, we have endeavored to include anything you might have to account for to satisfy your distributors' particular requirements. Remember that your list may be shorter than our list. If you are delivering both film elements and DCDM or IMF, your delivery list will be longer than if your program was shot digitally.

The Network/Studio Delivery Checklist

This checklist is an example derived from items in actual network delivery packets. Dailies and rough-cut materials are not included here, as they have been handled earlier in the process. This list covers only those items included in the final delivery requirements, and remember, your list may differ from this list, depending on your distributor.

Delivery elements:

HD 1080p HDCAM SR pay TV broadcast master:

1080p/23.98sf 16 x 9 original aspect ratio (OAR) 1920 x 1080 HDCAM SR master made from the DSM. HDSR master will retain 4:4:4 chroma sampling, but dubs and any conversions must be 4:2:2. HDSR master will be 100% QC'd.

Textless materials must be placed at the end of program and labeled as such. Audio configuration:

 CH 1: English left
 CH 2: English right
 CH 3: English center
 CH 4: Low-frequency effects
 CH 5: English left surround
 CH 6: English right surround
 CH 7: English left
 CH 8: English right
 CH 9: FF (fully filled) M&E forced options left
 CH 10: FF M&E forced options right
 CH 11 & 12: FF M&E left/right (traditional M&E)

DVDR NTSC pay TV master screeners:

Ten clean NTSC 16 x 9 OAR DFTC DVDR of the pay TV (PTV) version. Audio configuration:
 CH 1&2: English left/right

Four timecoded NTSC 4 x 3 letterbox DFTC DVDR of the PTV version with visible 29.97 drop frame (DF) and 23.98 burn-ins, stacked in upper left, with DF text identifying the 29.97 time code. Audio configuration:
 CH 1&2: English left/right

Digital video files:

ProRes 4444 23.98p broadcast PTV file:

Original resolution 16 x 9 OAR 23.98p ProRes 4444 file created from the DSM. File will be 100% QC'd. ITU-R BT. 709 color space; variable bitrate (VBR). Audio profile 5.1 Surround + left/right Eng and left/right FF M&E: PCM, 24-bit, 48 kHz. Include slate and textless materials. Audio configuration:

 CH 1: English left
 CH 2: English right
 CH 3: English center
 CH 4: Low-frequency effects
 CH 5: English left surround
 CH 6: English right surround
 CH 7: English left
 CH 8: English right

CH 9: Forced options FF M&E left
CH 10: Forced options FF M&E right
CH 11&12: FF M&E left/right (traditional M&E)

ProRes 422 HQ 23.98p broadcast PTV file:

1920 x 1080 16 x 9 OAR 23.98p ProRes 422 HQ files created from the QC'd 23.98p ProRes 4444 broadcast file. ITU-R BT. 709 color space; VBR. Audio profile 5.1 Surround + left/right Eng and left/right FF M&E: PCM, 24-bit, 48 kHz. Include slate and textless materials. Audio configuration:

CH 1: English left
CH 2: English right
CH 3: English center
CH 4: Low-frequency effects
CH 5: English left surround
CH 6: English right surround
CH 7: English left
CH 8: English right
CH 9: FF M&E forced options left
CH 10: FF M&E forced options right

Feature delivery will require DCDM, DCP with six-track master, textless and closed-captioning.

Other stuff:
- act-by-act timing sheet
- six music cue sheets (also send a copy to BMI and the American Society of Composers, Authors and Publishers (ASCAP))
- one printout of the final main and end credits

In addition, your production company will have a series of DVDs they will require when the network delivery is completed.

Credit Guidelines

If your cover letter does not specify the run time your show must be when delivered, you will find this information in a footnote or rule sheet. The rule sheet tells you to the second how long your program must run and where the act breaks must occur. You will also be told who is and who is not allowed to have screen credits and the person(s) at the network who must have final credit approval. Logo rules and screen placement will also be spelled out.

A special rule sheet on credits may be included. This will contain more detailed information on credit trade-outs (companies' compensation for allowing their products to be shot), length and legal limitations. Remember that this is just the network/studio requirements and limitations. See the film completion chapter for details on union and guild guidelines.

S&P Guidelines

Some networks will include an S&P rule sheet from their legal department. This will outline the rules regarding profanity, nudity, product placement and credit trade-outs. These guides follow FCC regulations and help the network establish, prior to delivery, responsibility for any editing required after delivery to meet these guidelines. Some producers will still keep a certain amount of profanity, violence and nudity in a program and leave the onus with the network to demand they be removed.

It is not your job to determine what does or does not stay in a project – only to make sure your producer receives the guidelines.

Music Cue Sheet Instructions

Next may come the music cue sheet examples (see Figure 9.4). Give a copy to your music supervisor. These are standard forms, and your music supervisor will know how to fill them in for you. You are responsible for sending the final copies to ASCAP and BMI, the network, and any other entity that requires them. Take time to look over the forms to make sure all of the blanks are filled in.

Technical Broadcast Specifications

The network's technical broadcast specifications will come next. This is a rather large text of technical and engineering requirements. The technical specs are consistent between networks or streaming venues. To cover yourself, be sure to pass along a copy to your postproduction facility as soon as you receive them. If you look carefully, you will see that these also specify timecode requirements, blanking placements, audio and video levels, formatting etc.

Sometimes the networks will include information vital to you. So try to read these specs carefully, questioning any item you think may apply to what you are doing.

Framing Guidelines

Finally, there will be film aperture and TV safe area diagrams, or at least aspect ratio requirements. These are standard TV measurements. Postproduction houses have the ability to call up a prebuilt safe area template on screen for you to use when titling, adding locals or dates, confirming if something in the picture will be picture safe or outside the normal viewing area.

Deliverables

MUSIC CUE SHEET

Title of Film: The Usual
Year of Production: 2016 (completed)
Production Company: Morning Person Pictures
Country of Origin: USA
Total Music Duration: 9:30 mins.
Total Film Duration: 9:30 mins.

*Codes:
VV = Visual Vocal; T = Theme; BI = Background Instrumental; MT = Main Title
BV = Background Vocal; ET = End Title

Cue #	Music Title	Composer	Arranger	Performers	Publisher (if any)	Label & Number	Performing Rights Society, if applicable or if public domain or owned by Producer, please indicate	SOURCE TYPE, ie – specifically composed or produce cleared, library or unpublished	USE*	Duration	Time in/ Time out
1	Welcome Open		n/a	n/a	Good Morning Pic.		Public Domain / Archival Footage / Cleared by Archival Place USA	Library / Archival Ftge. Cleared by Archival Place USA	MT	Approx 33 seconds	:12 to :45
2	Composition Music By Composer		Ralph Tone		Publisher Good Morning Pic.	Record Label 123	Mechanical sync & Performance License worldwide, all media	Non-exclusively licensed / cleared for The Usual	BI	Approx. 26 seconds	:46 to 1:12
3	"B&Y"				Publisher Good Morning Pic. With Sunny		Mechanical sync & Performance License worldwide, all media	Non-exclusively licensed / cleared for The Usual	BI	Approx. 2 mins. Total	1:38 to 1:50 (muffled thru door) 1:51 to 3:40
4	"LL"			Gaucho	Publisher 3		Mechanical sync & Performance License worldwide, all media	Non-exclusively licensed / cleared for The Usual	BI	Approx. 1 min. 15 seconds	3:40 to 4:55
5	Sunset						Public Domain / Archival Footage / Cleared by Archival Place USA	Library / Archival Ftge. Cleared by Archival Place USA	BI	Approx. 30 seconds	4:59 to 5:29
6	Composition Music By Composer				Publisher 4	Record Label 123	Music Composing Publishing / Usage Agreement / License worldwide, all media	Non-exclusive rights to use composition for The Usual	BI / ET	Approx. 1 minute 42 seconds	6:27 to 8:09

Figure 9.4 Music cue sheet

Making Use of the Delivery Packet

As soon as you get your delivery packet, make a copy of the delivery materials list. Use it as your master delivery list, noting in the margins when each element is delivered and to whom. Create a giant delivery list combining all departments' delivery requirement lists to catch any overlaps and economize your ordering of elements and work. This eliminates having to spend money to go back and create forgotten or missed elements because another pass is required. You can also consolidate or even speed up delivery by creating your various elements in an orderly and economical fashion. This may mean earlier payment for your producer.

Combining all of the requirements of the delivery packet for domestic, foreign and producer's material, the following is a comprehensive list incorporating all the distributor's requirements. Again, this list will vary based on what your individual distributors demand.

Sample Delivery Duplication List

- HDCAM SR (4:4:4) color-corrected telecine transfer master 1078, made from the DI files with textless :60 after program, timecode for textless matching the corresponding background in the program. Tracks to be configured as follows:
 CH 1&2: English left/right + 14 decibels (dB)
 CH 3&4: Stereo M&E
 CH 5: Left front
 CH 6: Right front
 CH 7: Center
 CH 8: Low frequency effects (LFE)
 CH 9: Left surround
 CH 10: Right surround
 CH 11&12: Stereo English left/right + 18 dB
- HDCAM SR (4:4:4) color-corrected telecine transfer masters, two air masters with sweetened stereo audio, one promotional copy with dialogue only, one foreign master with separate stereo composite and M&E tracks.
- Twelve viewing DVDs: five network, one production company library copy, five production company executives, one actor (if contractual), all made with shortened blacks.

As with network delivery, the foreign distributor will provide a detailed set of delivery requirements. See the foreign delivery checklist later in this chapter.

Granting Access

If the foreign distributor has purchased all the rights to your show, your delivery materials list will be quite extensive. We culled the following list from a very large and very active distributor. If, however, the distributor purchased rights for only a specified length of time, the original negative, digital intermediate, LTOs, DCDM, six-track masters, dailies trims and outs, and other elements will remain the property of the executive producers. These materials will be sent to a vault or other holding area and must be inventoried and cataloged for the owner's files. An access letter (see Figure 9.5) will be sent to the company that is holding the materials specifying who may access them and under what conditions. Be sure it is typed on the appropriate letterhead.

Deliverables

December 3, 2001

Hollywood Film Laboratory
2222 Hireme Lane
Hollywood, CA 90027
RE: "Charging at Windmills"

Dear Ladies/Gentlemen:

You have previously received from us, as a bailment, the following material (collectively "Materials") relating to the above entitled motion picture.

Ten (10) reels of 35 mm negative action
Ten (10) reels of 35 mm optical sound track negative

This letter will serve as authorization for you to grant full and complete access to any and all of the Materials to Laughing Pictures Entertainment, Inc., or any of its representatives or designees.

This authority will remain in effect unless revoked in writing by the undersigned.

<u>Cora L. Filter</u>
Cora L. Filter
President

cc: John Flush/HFL
 Horace Wrangler/LPE
 Jean Pocket/The Lawyers

Figure 9.5 Sample access letter

Foreign Delivery Checklist

The following checklist will assist the distributor in securing or defending the rights to the picture and marketing the picture, as well as outlining his or her financial obligations to the picture's participants, crew and other licensees.

- Eight cast and crew lists. The production coordinator can help you obtain these at the end of production.
- Nineteen paper copies of the final main and end credits, and a drive with those credits.
- Eight copies of the final script. This will also come from the production coordinator.
- Four sets of all the production reports. These, again, will come from the production coordinator. It may seem a lot to ask of one person, but if you arrange this with them ahead of time, they will be glad to run extra copies of whatever you need.

- One editor's lined script. The foreign distributor will use this to find trims and outs. Often the foreign distributor will use this to re-edit for length, foreign content or even promotions.
- One set of dailies camera and sound reports – also used for tracking trims and re-editing.
- One footage worksheet or timing sheet, or an act-by-act footage count if negative was cut.
- One set of dubbing cue sheets covering music, dialogue, effects and foley. These are road maps for all of the individual sound locations on the original sound files.
- One dialogue continuity script. This is a list of all of the dialogue in the final version and the timecode at which it starts. It may also contain small descriptions of selected scenes and a footage count to locate these. Viewing a DVD with visible timecode creates the continuity, and a script comes back to you as a typed report. The continuity person usually charges by the picture length. Foreign utilizes this for looping.
- All editor logs and cuts on LTO, logos and EDLs. Get the EDL from your editor.
- One copy of all literary material acquired or written for the picture, which includes one copy of each script draft (each draft version is identified by a change in paper color, and the version number will be on the cover page), labeled with the writer's name and the date. A list of all of the public-domain materials used in the picture, including literary, dramatic and musical, and those that provided the services to clear the rights to use the public-domain material, must be provided. This will help the distributor's legal department in securing or defending the rights of the picture.
- One copy of each contract and/or license for the use of screen credits in print advertising and paid advertising obligations. These contracts detail who gets credit and under what circumstances. If you have the contracts, you can supply this information. If not, get the information from your legal department.
- All writing credit documentation. This includes the notice of tentative writing credit, any arbitration material, and final received-by signatures. These will be in your files.
- The chain of title documents.
- A schedule or report for payment of residuals, including the following information on an external drive, to be used to compute residual payments when the picture is replayed, shown in foreign theaters or sold in the home video market, or if the musical sound track is sold. All of these details come from your accounting department or your legal department. The accounting department may use software that will generate this for them. Traditionally,

the accounting department has the information, so start there. This information must include:

- production dates and locations (these can also be obtained from the production coordinator's call sheets or production reports)
- a list of all actors, including loop group players – make sure the social security number, guaranteed days, days actually worked, salary, loan out or gross participation, and SAG status are included for each person affected
- names of director, first and second assistant directors, and the unit production manager, along with their social security numbers, guaranteed days, days worked etc.
- a list of the writers and all of their pertinent information
- total dollar amount for salaries below the line and any International Alliance of Theatrical Stage Employees labor
- a list of any other individuals entitled to gross or participation moneys
- a list of all individuals or companies that require credit in paid advertisements

- Six copies of the music cue sheets and the cover sheet indicating who else you provided with cue sheets.
- All composer agreements, sync licenses, master record licenses and artists' licenses (singers). Any music licenses you have, including needle drop licenses. These can all come from the legal department.
- The original written score. This will come from your music supervisor. If there is no written score, a memo to this effect from the music composer will suffice.
- If musicians were hired, include a copy of the American Federation of Musicians (AFM) report, social security numbers for the musicians, and their salaries and AFM status. Your accounting department will have this information. If you did not use AFM musicians, a memo to this effect from the composer will suffice.
- All accounting records, including checks, vendor files, bank reconciliations and payroll records, from preproduction through postproduction. Your accounting department will provide these materials. Also have them prepare an inventory and include a copy inside the boxes with the records, and a copy taped to the outside.
- Twenty black-and-white still photographs titled and captioned with each actor's real and character names. If the main actors retain still photography approval, begin early so that their approval does not hold up this process. The stills come from your photographer, and it is your responsibility to label each shot.
- One hundred color transparencies labeled as copy information. Transparencies, also known as slides, come from your photographer.

- One 8 x 10 main art color transparency. This will be made from your main title card, and it can be purchased from the optical house or department.
- One billing block outlining credit requirements, paid advertisement requirements and photo approval. Obtain this from the legal department.
- Biographies on actors, director, producers and writers. These come from the manager or agents, and sometimes, in the case of producers, directly from the person. Start early and have them emailed to you. It will take some time to collect all of these. Requesting them at the time your looping session starts usually works. This material helps the distributor market the picture.
- A one- to three-page synopsis of the picture. This is a marketing tool. Often the promotional departments will have something you can use. Or you may have to write something yourself and get producer approval for publication.
- Reviews – you can try to collect these yourself, or get them from the network. Often the picture is delivered in such a rush that these are not available.
- One cast and crew list, with the names of the characters and the actors' real names, and the crew members' titles next to their names. This comes from your production coordinator.

Film and/or digital materials

- All production audio. You will retrieve these from the sound effects company. Your distributor may have a vault, or they may be vaulted with the company that did the audio transfers. An access letter to that facility may be all that is required.
- One original multitrack on hard drive of the entire score. This can be made by your dubbing facility when you are finished mixing.
- One original multitrack audio master on hard drive of your sound, music, dialogue, effects and foley.
- One six-track and one four-track print master on hard drive. Foreign uses this to create masters with whatever audio configurations they need. Be certain that the effects and music tracks are a "full foreign fill". This means that all the sound effects originally part of the dialogue are on the M&E tracks. This way no effects are lost when a foreign language is substituted for the current dialogue track. Your foreign fill should be created as soon after the domestic mix is completed as possible – preferably the next day. (See the sound chapter for more detail.) Your sound facility can complete the foreign fill for a 90-minute program in about one day.
- One DCDM with sound and picture essence.
- One DCP with full mixed six-track audio, textless and captioning.
- 35mm original cut or uncut negative, if shot on film. The distributor will use this for archiving. Some distributors will have vaults to store this film in.

Others will just want access letters sent to the facility storing the negative. This will be determined by who has final ownership of the picture.
- DI fully color-corrected master, with mixed six-track audio.
- Fully timed interpositive (if made).
- One-light internegative if shot on film, or digital intermediate made from the final DI. This will be used to make a small number of prints for the foreign market. (See film completion in the mastering chapter.)
- Composite check from the above DI print mounted on reels and packed for shipping.
- Closed-captioning data (if available).
- Alternative version of writing credit in the DCDM as a side car (when you are providing both a TV and a feature version). If the credit reads "teleplay", this refers to the TV version. The feature version should read "screenplay by". If the credit reads "written by", no separate element is required.
- One DSM (2K or 4K, depending upon aspect ratio) and count sheets for title cards, mattes, overlays, opticals for titles, bumpers and opticals. Used for generating any new title treatments and restoring opticals.
- DSM of all textless backgrounds, including titles, credits, bumpers, subtitles etc.
- All trims and outs, opticals, title tests and trims, including those trims and outs used for a foreign version, on LTO. These can be used for recuts and sometimes for promotions. Get these from your editor. In the case of *Star Wars*, George Lucas kept all the optical elements in his personal vault, and 20 years later he used them to restore the film to its original condition.

Remember that the number of delivery items you will be required to provide depends on who has picture ownership. If the producers sold the picture outright to the foreign distributor, the distributor will want every element and legal document made. If the ownership remains with the producers, only access to the DCDM and DCP, delivery of an internegative and check print, and the usual legal paperwork and photographs will be required. These will be outlined in the distributor's obligations and materials for promotional use.

Foreign Formatting

Again, whether foreign distribution formatting will need to be done in an edit bay will be determined by the individual specifications. If you made an episodic, and the delivery requirements call for blacks to be pulled up to exactly ten frames, you should do this in an edit bay, rather than relying on someone in your duplication department to do this machine-to-machine. Again, be careful not to up-cut the music. Make sure to start counting the ten frames after the music ring-out is completed.

You must also include textless material at the tail of your foreign delivery master. Occasionally a company will require that the textless materials are provided on a separate hard drive, but usually they want it to start 30 or 60 seconds after the end of program. Textless material must be provided for all parts of the program that have text. This includes the main title, opening credits, end credits, bumpers, and any parts in the body of the show that have text, such as locales and legends. Textless material is formatted in the titling session. For more information on textless material, see the titling section in the mastering chapter.

Foreign distributors will also require separate M&E audio channels. All current delivery formats have more than four channels of audio, so the M&E tracks can be included on the delivery master in stereo without losing the English composite track.

Remember that there may be additional delivery elements for foreign distribution that are not required by the networks. As noted earlier, these can include trailers, slides, music cue sheets, continuity scripts and separate audio elements. Don't wait until you are ready to deliver to compile your foreign delivery requirements. Your company won't be paid until they deliver all of the required elements. Going back to recreate elements can be expensive and hold up delivery and incoming moneys.

Details that seemed so minor compared to all the postproduction emergencies you were handling with levelheaded authority can surface at the 11th hour and catch you. Most vaults have specific box size (the size of the box you pack their elements in for delivery) and box-labeling requirements. Check these out ahead of time. If possible, get them in writing so you can pass the information on if someone else will be physically packing the materials into boxes.

Production Company Delivery

Compared to the networks and foreign distributors, the production company delivery requirements will seem like a walk in the park. The production company's delivery requirements will depend primarily on whether the producers retain the rights or the rights are sold to another distributor.

Most production companies will have very simple requirements. Often it will be all of your notes and files documenting delivery, files of contracts, and DVDs for the producers'/executives' personal use or for a contractual obligation. If the picture is sold in total to the distributor, there will be very little film or digital material to retain, as the producer will not have the right to reproduce the picture for anything other than a record of the accomplishment.

If, however, the producer retains ownership of the project, you must make a road map listing where all the remaining materials live. There may be negative at the lab, sound at the transfer house, and negative trims, outs, and vaulted and master

digital materials in storage. Some producers keep very little of the trims or digital material, so confer with them and find out their requirements. This list may be even more important if your job ends with delivery. You don't want to get a call six months later from a frustrated producer asking where the material is vaulted.

Cast/Crew Copies

Regardless of who retains the rights, the production executives, and possibly the cinematographer, the director and some of the cast, are going to want copies for their personal libraries and reels. Often cast and crew members will approach you asking for DVD copies of the show. Sometimes there is a contractual obligation to provide these. You should have a list of these obligations when you make all of the final materials. However, if this is not a contractual requirement, check with your producer before allowing a copy of the show to be borrowed or made. Unauthorized copies could cause a legal problem, and the producer could be sued. Ask the legal department to make a one-page agreement for the requesting party to sign before receiving a DVD. Usually they just want the footage to add to their work reel.

Technical Requirements for DVDs

Production companies don't usually care to have their library and DVDs closed-captioned (but be sure to double-check this... there's always an exception to every rule). If your show was formatted with long commercial breaks, you may want to make these DVDs with the blacks shortened. This means that the formatting and blacks between acts that were put in for the air master delivery are taken out. Executives are notorious for not having the patience to sit through a ten-second black between acts. They will usually want the blacks no more than five seconds or even two seconds in length.

This can be done machine-to-machine instead of in an edit bay. The charge should be your regular duplication cost plus a small machine-edit charge. If you are going to need a lot of pulled-blacks copies, it may help to create a pulled-blacks submaster to avoid picture or sound issues. Your post facility will most likely make you a deal. Another consideration is adding a "do not duplicate" banner and/or a watermark with the name of the person receiving the DVD. The watermark and banner are anti-piracy measures. Watermarks are traceable to the original recipient. Depending upon the program, this may be a requirement for all production obligation DVDs.

Production Company Delivery Checklist

The relative simplicity of production company delivery expectations, compared to the rigmarole that domestic and foreign distributors put you through, should

not negate the value of a checklist. In the heat of the delivery moment, things can get harried, and a forgotten executive could hurt your reputation on the job.

Here is a sample list of items/elements you need to document in your list of lists:

- what format the elements are in
- address and phone number where they are located
- the title they are stored as

Elements to be included include (but are not limited to):

- negative, DCDM/IMF masters, DCP etc., six-track sound master, trailer masters, textless
- editorial paperwork
- daily elements or prints
- final film answer prints

List all the people you made DVDs for and when they received them. Make sure the producer(s) get a copy of this list for their reference, and put a copy in your notes and legends that you turn over.

When the Producer Sells the Rights

When the producer has relinquished all rights to the picture, the production company delivery list will be very short. This order will consist of one or more DVDs. Be sure to poll everyone before you put this order in with the duplication facility. Check into any possible contractual agreements with stars or crew members who have been promised copies. Some companies split up who makes these copies. The more prominent members of the production company may get DVDs made by the duplication facility, because the quality is usually better.

The DVDs made at a professional duplication house will be of a higher quality, because they will be able to author them with chapters or additional information and titles if necessary. However, the DVDs made in your office can be made virtually for the cost of the stock, thus lessening the burden on your probably already overburdened budget.

If the production company wants copies made for their executives and staff, or if they request a playback source for making their own copies, they will want these to have shortened or pulled blacks.

It Rings True

A word of caution when making a pulled-blacks element: Be very careful that the facility does not up-cut (cut off) any music ring-out. If an executive screens a

DVD you've made for their library and the music is cut off, you will have a really hard time convincing that person that it is not that way the streaming version was sent. You'll probably have to order a new DVD (at the facility's expense, of course).

When the Producer Retains the Rights

Low-budget independent features are often complete and have screened around the globe before the executive producer has realized one penny of profit. They may have screened in film festivals and film markets for months looking for a suitable buyer. Many important details can be forgotten due to the extended amount of time that may elapse between the completion of an indie project and its purchase. For example, a distributor may want to add or change a title over action, which means you will have to find all the textless and texted materials needed to create the original titles in a timely manner. The elements might be at the EFX house where the titles were made, they may be at the post facility, or they may be in storage. An hour of phone calls later you will realize how important it is to keep track of your elements.

Try to keep all of your masters together. Keep the negative at the film lab and digital masters at the post facility if you do not have access to an appropriate centralized vault. It will also help to make textless backgrounds and other material required by distributors. Keeping your paperwork organized, and in legal and accounting order, will save you from scrambling when the big sale hits. Be aware that sometimes distributors will want creative changes. It may be due to bad language; reference to a product, person or thing; or just to tailor the project to their audience. If you have made all your delivery masters prior to the sale, you will now have to edit those masters. Choose carefully which materials get made, and only make the elements you need as sales tools prior to that big sale.

When the producer retains ownership of the negative, your production company checklist will look something like the following:

- One cut or uncut negative of the entire show. This is usually stored at a vaulting facility.
- One DCP with 5.1 and two-track stereo sound track and subtitles at tail.
- All backgrounds or original material and count sheets for title cards, mattes, overlays, titles, bumpers and opticals; and any HD-generated material used to create the above on hard drive. These are used for generating any new title treatments and restoring opticals.
- One multitrack audio master of the entire show on hard drive, including any filled M&E tracks. This is usually stored at a vaulting facility.

- One HDSR 444 master with textless at the tail, dialogue, music and effects split out onto separate tracks. Delivered 1078. This is usually stored at a vaulting facility or with a duplication facility.
- Editorial LTO, stored at a vaulting facility. These boxes should be inventoried and numbered. One copy of the inventory should be inside the box, and one should be taped on the outside of the box.
- All editorial paperwork, boxed and labeled, with an inventory inside and one on the outside. Included in this material will be a lined script, act-by-act timing sheets, opticals orders, negative cut list, EDLs, Advanced Authoring Format (AFF) files etc.
- The postproduction supervisor or associate producer's paperwork, boxed and labeled with an inventory inside and one on the outside.

The above material will allow your show to be formatted to meet future needs. If the producer is retaining all rights, there may be additional items on the delivery requirements. In fact, these delivery requirements could follow the foreign checklist very closely.

Taking Stock

Some production companies that produce several shows a year choose to make or save a little money by bartering or selling their trims and outs to stock houses. Establishing shots and crowd scenes, and any potential stock location shots or specialty shots, may be of interest to a stock house. If the producer retains the rights to the show, there may be an arrangement that can be worked out with a stock house. The stock house receives a DVD of the show and all the trims and outs on LTO. They pull out shots they want, and the rest goes into storage with the rest of the program elements. Then, whenever the stock house rents or sells any of the shots, the production company will receive a percentage of the fee. In addition, should the producer want to use any of these shots again, they will be available at a discount, or possibly at no charge. This is a way for the producer to receive extra income from the production.

Executive Quality

Most importantly (after meeting the delivery deadline, that is), the production company executives are going to want high-quality DVD copies from the final, color-corrected, sweetened (stereo) digital master. Determine how many you need and whether you should have individual names typed on the labels. You also need to know when they expect to receive their copies. If you deliver to the network on Friday night, you may need to messenger DVDs to the production company executives' homes, or they may be willing to wait until Monday morning to receive their copies.

Delivering

Once you have created all of the required elements and gathered all necessary paperwork, you are ready to deliver your "hard" delivery items. Make sure you double-check everything, label each item as instructed, and box and inventory as required. Proper labeling may save your neck and will certainly make it easier to distinguish what is what if you have multiple versions of your project. Element master labels need to include:

- production company name
- final title of the show (and aka if needed)
- date the element was made
- run time
- whether a subtitled or captioned file is included
- if the tape contains textless title backgrounds and where they begin
- a note if the element is one of multiples, e.g. LTO 2 of 2
- aspect ratio
- PO number
- channel/track configuration
- language

When boxing up elements, be sure to include the following on the outside of the box and on the inventory inside the box (this sounds redundant, but the outside list sometimes gets torn off and then it's anybody's guess what's inside):

- production company name
- final show title (and aka if needed)
- box label including box number, e.g. box 26 of 50 – all boxes must be labeled and inventoried

With this done, your office will begin to resemble a warehouse, with boxes stacked high. Get rid of everything as soon as you can. When all the items are delivered and have been accepted at their respective destinations, you are no longer responsible for their safety. Accompany elements with a detailed delivery letter stating what materials are being delivered, when and where. Again, utilize the wording from the delivery requirements. This makes the distributor more comfortable that what is delivered matches what was requested. Be sure to send your foreign or network point person a copy of this letter if their material is being delivered somewhere else.

Put your delivery instructions in writing for those responsible for the actual delivery. Also, require that a signature be obtained (written and legibly printed)

whenever any element is delivered. Make sure you retain all of these "received-by" signatures in your files. These will prove that the materials were delivered, and will put the onus on someone else for locating lost or misplaced items. As an extra precaution, take time to call the receiving facility or contact person to let them know what materials are coming and when.

It might seem like you are finished and ready to turn out the lights, but there are virtual master elements that still need to be moved. I call them virtual because they are not tangible until downloaded on to a hard drive or element. These are the DCPs DCDMs and IMFs, all the captioning and subtitles, textless, and all the bits and pieces needed to make almost every conceivable version of a movie. That information – that data – needs to move from the post facility archive computer to a place where the distributor can access these materials as they need it. The studio/network or distributors will provide the post facility with a KDM to push the files to their Cloud. Once it arrives, the post executive at the studio/network and the facility will get an automatic email or text that the material has been received, and you will get a confirmation on your end as well. If there is a problem in transmission, that too will alert everyone so that it can be resent.

Delivery is a great relief. It's the reward for all the work you've done to get your show on the air. Don't botch the moment with some careless *faux pas*. And remember, get all the appropriate signatures and delivery notifications as you move along the postproduction path.

CHAPTER 10

Piracy

Arrr, mateys! Arrr… let's talk about piracy, ya landlubbers. While the romance of pirates on the high seas may be captivating in novels, it is not so romantic when it robs our hardworking production teams, postproduction teams and distributors. The act of piracy is felt by all aspects of the filmmaking community, big and small. It directly affects theater attendance, VOD, streaming, cable providers, and Blu-ray/DVD and other sales, and it represents a major financial threat to the movie industry. It is incredibly costly to protect against its damaging effects, and it has become the focus of digital security measures.

The US Federal government lists the following laws prohibiting movie piracy:

- US Copyright Act
- Digital Millennium Copyright Act
- Family Entertainment and Copyright Act
- No Electronic Theft Act

In 2005 the Motion Picture Association of America (MPAA) examined the effects of file-sharing on entertainment industry profitability. The study concluded that the industry lost $6.1 billion per year to piracy.

The Big Picture

If you find yourself working on a big studio project, you will immediately encounter serious security measures. Putting aside ID tracking and ID verification of employees, assets of the show will be given the highest security even before shooting begins. The plot for some motion pictures and TV shows is so sought-after, producers have resorted to extreme measures. A very large and popular feature series recently issued scripts printed on red paper so that it could not be photocopied. Another counted the number of scripts each day and required cast and crew to turn them in each night; after verification that every script was accounted for, they were shredded, and new scripts were issued the next morning. Some companies issue iPads loaded with the day's shooting

script: The data expires after a certain time frame, locking out the reader. Companies may also intentionally leak fake scripts or filmed content in order to keep the public from seeing the actual "to be aired" content. Hackers may not just be pirating the script or the show itself. They may be data-mining for internal data: Anything from IT to contracts, salaries, marketing, publicity, and/or exclusive show information – internal emails with information that can be leveraged against an employee or to exploit a show. Hence the measures of high data security on the lot.

Dailies

Studio/network dailies are also protected, stored on an encrypted RAID, hard drive or tower which is only accessible via company servers with the correct code. Projects often film in many locations across the globe, and dailies must be quickly sent to the studio or network executives daily. Many studios/networks use secure high-speed internet services that require security measures to both upload and download any data sent. These are not your regular six-digit password internet pipelines, but services that are tailored to the sending and receiving of large amounts of data in the highest form of security. Aspera, GlobalData and SmartJog are three that are widely used. Still, some store data on encrypted drives, and transport those drives with a security escort to secure locations. More than one studio is scanning and verifying files coming onto the lot before they can be uploaded onto sound, editorial or other local drives. This takes time, so be aware if you are bringing data from outside it will have to be inspected prior to use.

Editorial

Digital/video facilities and VFX houses have historically been the target of content piracy. In addition to signing a non-disclosure agreement, employees and guests are watched via cameras placed in entrances, exits and elevators. Almost all studios, VFX facilities and post houses use passcode entry. Only employees working in high-security areas are allowed on that floor or section of the building, limiting the chances of unauthorized on-site duplication. Be careful when you are a guest in a facility; we have been locked out once or twice. To limit access, editorial computers and data storage banks are not connected to the internet but are on internal servers in a secret location. Employees who have to download material from outside have separate computers for that use, and their software is designed to download data only. Uploads are for encrypted servers and high-security pipelines only.

Screeners

Various cuts of a movie are made and distributed to various departments prior to release: Editor's cut, director's cut, final cuts and others are used in the post process, and sent to various decision makers as well as test audiences and other venues. These screeners, whether they are burned to DVD, electronically sent or loaded to a hard drive, are encoded for identification; in the event it is pirated, the source can be traced. For screening at a theater for a test audience, an encrypted DCP may be created for a specific theater, set date and time range. Screeners may also be created for and distributed to industry insiders during awards voting season.

In almost all cases there will be some sort of warning ahead of the program, or burned-in text intermittently throughout the film or TV screener, to discourage pirating of the content. You probably recall seeing the added obtrusive visual text "screener copy only, property of [production company or studio name]" or "unauthorized duplication of this promotional or preview screening copy is punishable by law" across your screen.

In the Theater

Feature film print and theater piracy has actually declined over the past few years, but there is still work to be done. For years feature film distribution has used cap-coding to ensure tracking of prints. These are barely visible dots placed in a particular pattern in a particular scene on roll of film print. This method has become more sophisticated over time and watermarking is still used for prints.

Studios view security of digital projection very seriously, and it has become quite complex. All of us writing this book worked at one time on a particular high-profile show together. The security of the digital data was so stringent that a security guard, a postproduction encryption key handler and a projectionist were present in the projection booth for each screening in each theater for the entire run of the show. This was a few years ago and security has evolved, although there are times both security personnel and a key handler are required. More commonly today studios use a two-step encryption process. The DCP files are encrypted: How it is done, and how the code is chosen, is secret business. In order to play content, the theater must have a digital key or KDM. The key is programmed for a specific piece of content (movie), a specific server (not just an auditorium), and a specific time and date range. If you are missing one of these three parameters, your key will not play back the content. And there is yet another layer: The KDM has a built-in trusted device list, which includes digital cinema server and projectors. The server and projector must be on the trusted

list to play. There are several other layers of security built into the system, but again they are secret or the system wouldn't be secure.

Software is not the only defense. Studios have changed their release strategies to reduce or eliminate time gaps between movie openings in different countries. They are opening worldwide, across multiple platforms, in what is called "day and date", thus eliminating pirated presales.

Several companies are working on visual encoding. One is a patented method preventing "through-the-air capture of projected movies", aka smartphone or digital recorder piracy. It works by superimposing infrared images on the visual image. According to the maker, these images are not detectable to the theater audience but show up on video captured by most cameras. Another company is developing a digital movie encode designed to confuse cameras without being detectable by theater viewers.

Broadcast TV and Streaming

In TV, one may think that the issues may not be as severe; but with music a close second, TV appears to be the top affected media for illegal downloading globally. TV and streaming companies strive to find new security methods to protect crucial data and plot points, including cast and crew's personal information. Third-party plug-ins facilitating unauthorized access to copyrighted streaming media and peer-to-peer downloads are the biggest source of losses. We haven't even mentioned gaming and publishing, which is a separate subject. There is an effort to get content out to consumers more quickly, and to make it more accessible and secure, in order to discourage consumers from going to sites promoting piracy.

The Little Guy

Independent, ultra-low-budget filmmakers are especially vulnerable to stolen content. They don't have the budget to hire teams of security staff, or may not even know about the need to secure their content. Many times, for these filmmakers or independent companies it's about getting the content made and out there, but piracy can be especially devastating to these shows. Indie filmmakers are getting creative in their own battles against piracy, with some opting to self-distribute and to control their own content (which also carries many risks), and to plead with moviegoers directly to support indie filmmakers by buying and/ or streaming their films instead of illegally downloading. Pirates use hackers to exploit FTP networks. Filmmaker clients and postproduction facilities may use third-party file transfer vendors to send and receive sensitive data for convenience purposes, which can leave them vulnerable to hackers.

During one of our very own productions, we had an encounter with these scallywags. A feature film that one of us produced was picked up for distribution: We won't name names to protect the innocent (us). It was exciting to see the DVD box at the local Blockbuster. (Some of you may be old enough to remember Blockbusters. Those of you who do will recall a time when we had to actually get in our car and drive to a store and rent a physical movie, then get in the car the next day to drive it back to the store to return it. Hooray for modern science.) The film was renting in stores and digitally via streaming platforms, and suddenly we began finding our film on unauthorized sites. The first call was to the distributor; the second call went to the authorities to track down the source of the unauthorized distributing of our content. While no one was imprisoned or burned at the stake (i.e. brought to justice), the sites were forced to remove the content. Soon after, it just ended up popping up on other unauthorized sites, and the process would start all over again, until it became a kind of Whac-a-Mole scenario where each time we would shut down one site, another would just take its place elsewhere in the world. It's difficult enough to locate these pirates, even harder to really stop their operations. And this was for a tiny little no-budget feature film; we're not even talking a Hollywood blockbuster.

How to Protect Your Content

Security is always key, from production to distribution, and being aware of the issues with piracy will better help you protect your project. Even if you don't have the backing of a big-budget show, there are some logical steps you can take.

The MPAA has created a Content Security Program. Its membership and participation include most of the major studios, and the purpose is to strengthen the process by which its members' content is protected during production, post-production, marketing and distribution. After extensive research and coordination with postproduction facilities and internet providers, they published a set of best practices. The program assesses, evaluates and outlines security at third-party vendors. This is good news and helpful to all filmmakers. If you use the same facilities, you are assured that while your project is at that facility, or if you use the same secure network, it will be protected by the same standards as the studios.

If your budget or schedule doesn't allow you to use these facilities, it might be tempting to use a fast third-party internet provider to move your data around, or a small facility that can do your post inexpensively. This is a risk that you need to investigate. Heavily vet that vendor or service provider. Make sure when transferring or storing your data via the Cloud or third-party transfer it's in a secure pipeline.

When preparing your content for theatrical, festivals or other exhibition, check with the film festival/venue to confirm what format they can exhibit. The most secure way to protect your content is to create a DCP with encryption;

however, there are alternatives. One of the best advantages to creating a DCP is that if your hard drive is stolen, your content can't be accessed without a key. As noted in our budgeting chapter, this comes with additional costs, complexity, timing and coordination, but is well worth it for the security it creates.

If you find that your theatrical exhibition venues cannot play a DCP, there are still secure choices. Do a little research, and consult with your post facility to see what is best for you and the venue.

Several methods of security are:

- Forensic watermarking: Carries forward and is present in any duplicated screeners, including pirated versions, allowing a hack or illegal duplication to be traced back to where it originated.
- KDMs: Encrypted DCPs require a key, which would limit access to the content.
- Encryption: Content is encrypted and can only be viewed by persons given instructions on how to decrypt the content.

Some Things to Think About Regarding Piracy

- Employees – crew members – may need to sign a non-disclosure agreement.
- Who else is going to see this footage, and how is it getting to them?
- Which secure internet provider is available?
- With authoring/post houses, there may additional costs for encryption and anti-piracy measures.
- Remember to add banners and burn-ins when you show your content, especially if you're screening your final product.
- There may be plug-ins in the editorial software you're using to combat piracy.
- Be cautious when you put your work up on the internet.
 - Use passwords and change them often.
 - Adjust settings appropriately for more confidential content to prevent sharing and downloading.
 - Heavily vet vendors, internet service providers and Cloud storage services.
 - Make an encrypted DCP if possible.

Remember: There are options available. Don't let paranoia set in.

It's a Global Issue

While criminals will always find a way, and piracy cannot altogether be eliminated, it can be limited and minimized. This involves many organizations as well as

consumers working together. The MPAA has discouraged advertising companies from placing ads on sites that promote piracy, and has encouraged finance companies away from working with these sites, which cuts off the money flow. Congress introduced the Stop Online Piracy Act and the Protect Intellectual Property Act. Federal authorities are pursuing larger-scale production warehouses and making examples of smaller independent thieves.

Other countries are lending support against copyright infringements. Some countries are acting against the pirating of movies, TV, sports and games. They are primarily targeting illicit streaming device (ISD) sellers, and blocking these devices from being sold. ISDs are little black boxes, which when loaded with specific software allow people to illegally watch content across all media platforms without paying for it.

Studios, networks and production companies created the Coalition Against Piracy, and more recently in 2017 a worldwide coalition of major entertainment companies called the Alliance for Creativity and Entertainment was formed to combat illegal content downloads and to reduce and discourage piracy.

Summary

Piracy comes in all kinds of flavors and targets all kinds of content. It affects everyone employed in entertainment: Studios, networks, independent filmmakers, theater chains, companies that provide services to studios/networks, everyone above the line and all those below the line. The entertainment industry, studios, distributors and the government are all working to protect this valuable asset. If you take measured precautions and are aware of your chain of custody, you can be assured to sleep at night.

CHAPTER 11

Acquisitions

Acquisition: The act of acquiring or gaining something.

What Is an Acquisition Title?

An acquisition title is a feature film, TV show, documentary etc. that is purchased by a studio, network or distribution company for the purpose of distribution. This may be brand new product or even an older library of movies or TV series. Sometimes this is referred to as the "back-end" (the product is being "picked up" for distribution after it has been created). Often the license fees paid for the distribution rights represent a sizeable amount of money for the producer, so it is very important that all delivery requirements are met. This can get complicated, because there will probably be multiple distributors for product, and there will be differences in their delivery requirements.

There are many outlets for distribution of entertainment product, and within those areas there are varying degrees of license rights. These include domestic free TV, international free TV, domestic pay TV (cable or satellite, pay-per-view channels), international pay TV, VOD (hotels/airlines) and home video/DVD. There are also others, such as the military, internet, streaming video etc.

Within these categories, you may have wide-ranging rights or very limited rights regarding the territories to which you can distribute and for how long. For example, "all media, worldwide, in perpetuity" means the distributor has full rights to distribute the acquired title anywhere in the world. The title can be distributed via any medium from the date of the contract until the end of time. Buying only free TV in France and Germany implies a very different thing. Because these two scenarios are so different, the materials needed to service all media worldwide and free TV in France and Germany can vary a lot.

With all of the variable markets and legal limitations, it is important to create product of the highest technical quality that will be acceptable in all distribution scenarios. We're going to help you do just that.

What If You're Just a Little Guy?

So, you are an independent filmmaker making a movie, and you hope to sell the distribution rights to a major motion picture studio. The rights you sell will determine the materials you will need to provide. If you are lucky enough to know who the distributor is before you complete work on your project, your job is easier. You can request a list of delivery requirements and technical specifications up front. This makes it possible to prepare the necessary materials as you go, which will be more efficient and cost-effective for you.

However, this is not always the situation. There is a good chance that you will make your independent film, then shop it at festivals and distribution conventions, looking for a company or companies to pick up the distribution. This means you may have to recreate material if you didn't make masters with options: Audio masters with dialogue, music and effects on separate tracks, with sound effects fully filled (see the sound chapter). You may have to change music if the distributor feels the rights aren't secure or are too expensive. Make textless backgrounds so that foreign titles can be inserted. QC your masters for conversion problems. Two issues I encountered was music that had to be changed, and the addition of the distributors' logos and other credits resulted in main and end remakes. This is usually done at the filmmaker's expense.

Determining Delivery Elements

When you can't get specific delivery requirements and technical specifications ahead of time, you'll have to do your homework to determine what is normally expected. Be aware that in addition to the picture elements, there are legal documents the licensor will need before final payment is made.

In the delivery chapter of this book, we have provided a very comprehensive list of delivery elements that you may be required to provide as part of your distribution contract. You may also be able to get various studios or distribution companies to give you sample delivery requirements to use as a guide. Also, if you are working with a production company that has made other projects sold as acquisitions, they may have old delivery requirements in their files that you can reference. If there are elements listed and you don't know what they are, ask. If they are not explained in this book and they are film-related, call a film lab. If they are not explained in this book and they are video-related, call a postproduction facility. If they are contracts or legal documents, call your attorney.

Some simple questions should help you at least weed out the items you won't need to deliver. For example:

- Did you shoot digitally or film?
- Are you planning on doing a theatrical exhibition?

- Is there a large amount of subtitling that would cause you to create both a texted and textless version?
- Did you mix to a six-track master or make a separate M&E track?
- What audio format are you mixing to?
- Did you shoot 2K?

If you shot digitally, you won't have any of the film items to deliver, such as a negative. However, if you did shoot digitally and plan to do a film-out, then there are film elements in the list that you can make.

Technical Acceptance

So now you've determined what physical elements you are going to create. Of course, just delivery of physical elements and legal documents does not mean your work is done. You need to know that your product is "technically" acceptable. If you are not savvy technically, you will need to rely on someone else to help you know that your product will pass a technical inspection. Hopefully, your film laboratory or post facility has had experience with the type of project you are doing, so they will be able to offer dependable and accurate technical guidance.

As an independent filmmaker or even a small production company, you may not have a lot of experience working with various facilities on a variety of projects. Therefore, when you are looking for a postproduction facility, film laboratory or sound house, there are some basic questions you should ask before placing your work in their hands. And while money drives many of our decisions in this business, it is also important to pick the appropriate facility for your work. It doesn't help you if you go with the cheapest facility and then have to go back and spend money fixing items or trying to make elements after the fact.

You need to question facilities about the types of work they specialize in:

- Are they a feature house specializing in film finish projects?
- Do they focus primarily on longform TV?
- Do they focus on sitcoms and reality TV?
- What type of clients do they have? Are they large studios, or does the facility cater to the smaller independents?
- Are their shows mostly for domestic delivery, or are they experienced in deliveries to international markets?
- Do they have an in-house QC department?
- Can they provide multiple services, or will you need to move your materials to another facility during the process?
- How many other projects will your facility rep be handling besides yours?

It is important to choose a facility that specializes in your type of project. This is especially important if you are going to need help from your facility to guide your show through the process. You don't want to find yourself trying to get a short completed among a bunch of TV series trying to meet harried air dates. In this situation you simply won't find yourself a priority.

It is nice to work at a facility with clients who are working on projects similar to yours. It is a good networking opportunity for you, and a great way to get advice and suggestions from those working on similar shows. An important tool for learning, aside from doing something yourself, is to learn from others. We always recommend not reinventing the wheel if you don't have to.

Sometimes facilities get so wrapped up in servicing their large studio clients that the smaller client can get a bit lost. Smaller facilities with a more independent client base are usually poised to provide a more personalized service, as they have to rely more heavily on repeat business than some of the larger facilities that have a much bigger client pool to draw from.

Postproduction facilities that specialize in TV sitcoms and other TV programming with weekly air dates always work on a very tight schedule. Usually the shows have preferred editors, colorists etc. and have booked them well in advance of the season. These clients pay top dollar to ensure that they will be able to complete their shows in time for delivery and air – no matter what delays they run into. That means bumping other sessions and possibly working a lot of overtime well into the night. If you are trying to complete a show that is not working against looming broadcast dates, at a facility that is on this schedule, good luck. You might very well find yourself bumped or delayed or moved to another colorist or editor. The other issue with TV-oriented facilities is they often don't have QC departments, or ones that are geared to recognize issues that are common problems for foreign clients. In a situation where you are depending on the facility to know what problems to look for in your materials, this will be disastrous for you. If they don't have a formal QC department at all, then you are faced with moving your materials elsewhere for the QC check. This is inconvenient on two fronts. First, moving your materials around is never convenient: It makes tracking more difficult, and the possibility for damage or loss is greater. Second, it can result in finger-pointing. If facilities disagree on the severity of problems and where/how they occurred, you'll have to play referee and make some unpleasant decisions. When one facility does the work and then QCs the work, it makes them responsible for the entire project. Then, if you have any rejections from clients down the road, you have a place to go to air your grievances and one place to go for restitution.

The same argument applies to moving your materials from facility to facility to have different steps completed. There is always the danger that a problem will be introduced, and it might be difficult to ascertain where the problem originated. Also, facilities don't like to work on other houses' masters, for just this reason. They might be blamed for something that was done prior to them receiving the materials, but that may be hard to prove.

You also want to be careful about going with a facility where each rep handles a heavy workload. In this situation, the fires will get the most attention, because the person is juggling multiple projects and cannot possibly focus on every detail of each. For a seasoned client, this may not be such an issue. But if you are new and not aware of all of the potential areas of trouble, you could get lost in the shuffle, and important issues may not be addressed until they too become fires.

The bottom line is that you need to do some research when choosing a facility. Don't only request a bid on a project, but ask some of the tough questions. Try to make sure you will receive the service and attention you are going to need to get through your project properly.

If you don't have technical specifications from your distributor at the time you are posting your project, a good rule is to follow SMPTE broadcast specifications. The absolute rule of thumb is: Do not post your project without any technical guidelines. This SMPTE guide will provide you with industry-acceptable technical specifications with regard to video and sound record levels and record parameters —whether you are creating a project for theatrical release, US or foreign TV broadcast, DVD release etc. SMPTE information is available for both HD and SD. SMPTE can be contacted through their website, www.SMPTE.com. Also, most facilities follow SMPTE specifications already.

This is another good point we should talk about. When you're creating a show for TV broadcast, one of the responsibilities of your telecine colorist, conform editor, colorist etc. is to ensure that your program does not exceed acceptable video (brightness) and chrominance (color) level limits. While editing or color-correcting, the operator should be watching the various scopes and alert you to any problems you may be causing.

So if in the color correction session your colorist tells you that you are exceeding those limits, heed this warning and back off. You will save yourself many headaches down the road. Delivering a program well out of legally acceptable limits will certainly result in rejection by one or more of your distributors.

Other Common Causes for Rejection

There are also items that are common causes for rejection that are often the result of small-budget projects trying to cut costs and save money. The phrase "penny wise, pound foolish" comes to mind. Be careful when cutting corners not to cut quality. Below are several common reasons for rejection:

- missing sound effects
- production sound problems
- film dirt/damage problems
- artifacting/dithering/digital blocking/dark scenes
- low-quality master/conversion issues

Missing Sound Effects

We'll discuss two sound effects problems. The first concerns the effects that are mixed with the dialogue track to create composite (dialogue/music/effects) stereo tracks. Second are the effects that need to be recreated to create your separate fully filled foreign M&E track.

Distributors intending to sell your film in the same language in which the film was originally shot (e.g. US distribution for an English-language film) may or may not be concerned about how complete your separate M&E track is. This is because they shouldn't need to do any audio remixing. Don't, however, rule out the possibility that they might still require this element as part of delivery. They could, for example, use the M&E track for cutting promos or creating trailers or TV spots.

Chances are you already plan to sell your show internationally and have already created a foreign M&E track. If, however, you only think you'll have a domestic sale, don't rule out the possibility that you might still need to fill your M&Es for a domestic delivery.

In either case, don't scrimp on the effects. Missing effects, whether they are mixed with the original language track or generated for a separate M&E track, will be flagged. It is a whole lot easier and more cost-effective to only mix once. Going back in to add effects and then remix and relay your sound track(s) is both time-consuming and costly, and can eat into the producer's profits significantly.

Production Sound Problems

Production sound problems can be a heartbreaker for a producer. No one wants to hear that dialogue shot on location that should be fine is not. Do be aware that if there are audio problems on the set, the producer will have to confer with the sound mixer to make a judgment call about how much dialogue replacement and/or cleanup work will be done. Once mixed with your M&E, any production audio problems not fixed are then married to your track, and it will be much costlier to go back after the fact to do fixes. There is software that will help isolate sounds such as dialogue, but if the sound isn't clear or consistent enough it can't be fixed. Therefore, depending on the severity of the problems, they can be cause for rejection.

Film Dirt/Film Damage

While international clients may be more lenient with this issue than some domestic distributors, you have to fix any major or distracting dirt and damage. Many distributors are sophisticated enough to know what tools are available to do this work. Just realize that if you decide not to do fixes but the clients then

insist they be done once you've delivered, any costs incurred for this work will probably be deducted from the license fee you are to be paid.

Electronic Cleanup and Fixes

Often fixing something – removing or replacing a pixel, smoothing out color – may cause dithering, pixel blocking or other anomalies. Artifacts that can be introduced from these processes, as well as compression, may be the most common reason for rejection of digital delivery materials. One must be very careful when utilizing the tools available for cleanup, damage and conversion. If careful, the operator should be able to insert these fixes into your master materials without introducing any new problems or side effects.

However, as we keep warning, you may want to go ahead and make a duplicate of your master and introduce any fixes into the copy – preserving for yourself a pristine master.

Digital video noise reduction (DVNR) can be another matter. The operator cleaning up your picture with DVNR is utilizing an electronic process to cover up or mask small imperfections in your picture (such as film dirt, simple scratches, film damage or marks etc.) overall. This process can be very useful as a preliminary cleanup tool to get rid of the small particles of dirt and damage before going into a more expensive and time-consuming session.

This overall dirt cleanup is not a substitute for going in and doing effects work, if needed. As we describe earlier in this book, in the completion chapter, inappropriate use of this process can easily cause problems more severe than the ones you are trying to fix. This phenomenon is referred to as an "artifact".

The very best advice we can offer in this area is to *always* keep a clean master. If you are mastering film to digital, clean your film and then have it transcoded. Then, in the digital realm, do the dirt cleanup or other processes you feel the movie needs. You'll have a small additional charge for this method. But you will always have a clean master to deliver, if you need it. We can't tell you just how many movies we've rejected over the years for unacceptable artifacting that was caused by these processes. And in so many of those cases, the licensor did not have a clean master to send us. In each of those cases, either the deal was canceled or a retransfer took place at the licensor's expense.

Textless

Textless material is an important delivery element and an item best planned for early on in postproduction, rather than addressed at the last minute.

You already know that textless is the picture material background over which text is placed. Main and end credit textless is pretty standard, but don't forget about text within your show. All locales, legends, subtitling etc. will need to be

accounted for in your textless materials. Also, do you have graphics with text built in? Often, that will have to be built with and without the text.

Other Delivery Items

There are many paperwork items and legal documents that will have to be delivered. Many of these will be prepared by others in the company, or by a service outside the company that is contracted to do so. You should be aware of what these documents are and if they've been created and/or delivered already. Production companies have a bad habit of disbanding once a project is completed and most everyone is off the payroll. Don't get stuck with last-minute items that you didn't anticipate. Items such as chain of title, errors and omissions (E&O) insurance, a script, music cue sheets, marketing and publicity materials will all be on the list.

Be sure you know what is delivered to whom. The same person receiving the videotape or film elements may not be the same person receiving the E&O insurance documents. For more tips on successful and proper delivery, turn to the delivery chapter in this book.

Rejected Delivery Materials

Realize that rejections are not abnormal in the acquisition world. We have seen only a handful of titles delivered without rejection. The reasons for rejection range from the small (e.g. missing textless background) to the much bigger (e.g. having to remaster your movie). If your project is rejected, be sure to get the following information from the licensee making the rejection:

1. the specific written rejection(s), with exact locations of the problems on your material
2. a letter stating that the materials will be accepted once the fixes are completed to the licensee's satisfaction
3. a written acceptance by the licensee once the fixes are completed

Written Rejection Report

For discussion, let's say you delivered a DCP of a feature to a licensee. The licensee performs a technical evaluation of the material you have delivered. Upon inspection, it is determined that the material is not acceptable as delivered and fixes will need to be made (see Figure 11.1).

The first thing you're going to ask for when the licensee informs you of the rejection is a written rejection report. This report should detail very specifically what the problems are, and the exact location (this means the exact timecodes of the problems).

		Final Rating:	*Fail*	

Title & AKA:	**Three Girls Production Company**		Date:	9/18/19
Version/Episode:	3 -		Account Code:	1007
Resolution:	2K		WO#:	
Aspect Ratio:	scope		PO#:	149
Format:	DPX		Standard:	HD
Subtitle Language:	Spanish		Timecode:	
Textless @ Tail:	No		Data Rate:	
Texted Version:	Yes		Data Size:	
Closed Captions:	No		QC Type:	Supervised
QC Operator:	Joe	Client Rep. Sydney	Source L#:	
QC Time:	12:pm	Revised By:	Source Format:	
QC Machine:	11	Revised Date:	Source Standard:	
Program Start :00:00:30	Program End 08:41:30:00	Program Length 8:40	Textless Length 1:30	TRT 1:45
CH	Audio Configuration:	Audio Language:	Bit Rate/kilohertz	
1&2	L/R Stereo	English	24-bit/48.000kHz	
3&4	L/R Stereo	Spanish	24-bit/48.000kHz	
			24-bit/48.000kHz	
		Overall Quality Comments:		
Picture:	Animation rendering errors			
Video:	Video levels are in spec			
Audio:	Drop Outs and Audio Tick			
Other:				
		Severity Rating Codes		
1=Minor	Not Objectionable			
2= Moderate	Noticeable, Does Not Necessarily Interfere with Program Viewing			
3=Severe	Will Interfere with Program Viewing or Technically Unacceptable			
TC:	Type	Description	Severity	Review
00:34:4:15	V	Jump cut	3	
00:40:24:25	V	Freeze Frame	3	
00:41:10:28	V	Heavy Aliasing (center building)	2	
00:45:16:00	V	Digital Artifact Just right of Ctr	3	
00:45:25:22	P	Digital Artifact lower left	3	
00:51:52:05	V	Animation Error - shading vibrates	3	
00:52:40:03	P	4 Frame Flash Cut	2	
00:54:53:12	V	Animation Error - black shape appears	2	
01:02:10:23	V	Flash Frame	3	
01:02:12:09	V	Heavy Moire on Floor	3	
01:07:26:18	P	Moire on Bricks	3	
01:08:01:05	P	Layering Error - face sinks	3	
01:11:37:17	P	Animation Error 1 frame red block	3	
01:11:41:21	P	Density Shift 1 frame flash	2	
01:17:13:17	V	Audio Tick 5.1 chs. 7&8	3	

Figure 11.1 Sample QC report

This is the only way you are going to know that you and the licensee are talking about exactly the same spot on the DCP. Once armed with this information, you will move to the next step.

Common Artifacts That Cause Rejection

A pixel is just a tiny part of the big picture. The higher the definition, the smaller the pixel: The finer the edges, the more resolution, and thus the more defined the image. Digital quality depends on a number of factors that generally occur as the result of compression. During compression, redundant data is reduced as much as possible to save space. For example, if three pixels are the same, compression will reduce them to two. This in general will not cause artifacts. However, the data transfer speed or sampling rate, data size, metadata and video processing can each contribute to a breakdown in the encoding chain, resulting in artifacts.

Aliasing

The visual appearance of aliasing depends on the nature of the source, but one of its most common manifestations looks like what is commonly referred to as a moiré pattern. This might appear as misaligned columns or wheels rotating in reverse. It is also described as shapes that have no relation to the original image in orientation or size. It is often caused by a low scan resolution or sampling rate. There is an anti-aliasing algorithm; however, sometimes these fixes cause additional issues.

Macroblock or Blocking

As the data is encoded into various formats, e.g. MPEG-2 or H.264, the images are quantized. If the data transfer speed is too low, the signal is interrupted or there is a video processing error, blocking will occur. If the image contains fast pans and tilts or dark scenes, this may also contribute to the blocking image. The image will look like groups of pixels boxed together like odd puzzle pieces.

Dithering

This is the process of juxtaposing pixels of two colors to create the illusion that a third color is present. It can be introduced to soften the visual image, or it can occur if the compression or conversion is not at the proper sample rate.

Rendering Errors

Rendering errors are a common occurrence in creating VFX. They are especially common in CGI and the creation of animation. Generally, these defects will be corrected by the VFX facility prior to the export, but sometimes they sneak by. They might look like colored blocks traveling through an animated character's body, or in a fight scene an arm will be detached or fists might actually smash

through another character's chest as if they were a ghost. Often tight schedules will be the cause for oversight of these issues. The VFX company will be responsible for fixing any errors.

Dither

This describes an audio issue. It sounds like a low-volume noise, and occurs when converting from a high bit resolution to a lower bit resolution. The process of reducing bit resolution causes truncation distortion, which can sound very unpleasant. Dither is not related to dithering.

These are just a few of the most common artifacts that cause rejection. The very nature of rectifying compression, formats, multiple codecs and data size with additional data quality factors lends itself to the probability of quality loss. The question is: Is the quality loss too much to ignore, and if so, how is it resolved?

Other Reasons for Rejection

More often than not, a project is rejected because someone didn't notice very basic mistakes. Recently one of our vendors received a rejection because the client didn't spellcheck their titles/credits. An actor's name was misspelled; the distributor caught it and sent it back for a fix. This cost would be on the client for not doing a good job. Other simple mistakes are mike booms or camera dollies in frame, audio or frame dropouts, or simply not mixing to a Dolby track as stated in the delivery requirements. As a postproduction supervisor, your job is to pay attention to the details, and hopefully the fixes required will be minimal.

Conditions of Acceptance

Before sinking a lot of money into meeting the licensee's demands regarding fixes, be sure you know that doing these fixes to the licensee's satisfaction will guarantee acceptance. When they send you the rejection report in writing, there should be a sentence that states the materials will be accepted once the fixes are satisfactorily completed. Otherwise, you could end up going back and forth with the client as they find new problems each time you redeliver.

Fixing Rejections

The first thing you'll do is confirm that the problems really do exist as claimed by the licensee. Some aspects of evaluations are subjective and prone to human interpretation. For example, someone might hear footsteps on gravel off-camera and mistake them for an audio distortion. You always have to have the rejected areas checked by a technical person that you trust. This may be someone on staff who is familiar with the show, or maybe a facility you've worked with. The best

scenario might be to go back to the facility that did the work and see what they say. Others might think you won't get an honest answer and a neutral third party is a better choice. You will need to make that decision.

So, you've taken the material and your written rejection report somewhere and confirmed the problem exists. Now what? Now you need to determine the following:

1. Is the problem bad enough to require a fix?
2. What is the cost for the fix, and is the cost justified?
3. How much time will be needed to make the fix? Is there a contractual due time by which fixes must be completed?
4. When fixes are completed, do you need to deliver a whole new element, fix the originally delivered materials, or just provide short pieces with the fix that the licensee can insert into the existing materials?

Is a Fix Required?

Take your master and the written rejection report, and go to your facility to look at the problem. This accomplishes two things: First, you will start to understand what certain problems look like, how to fix them, and how they are caused; and second, you can determine with the facility if the complaint is legitimate and how to proceed with fixes.

Should you determine the complaint is not valid, send a written response to the licensee explaining what you found. Hopefully, that will end the issue and the materials will be accepted. If the complaint is legitimate, you need to start fixes.

How Much Will the Fix Cost?

The best scenario when doing fixes is to discover the problem is the facility's fault and the fix is done at no expense to you. Barring that good fortune, you will need to negotiate the cost of the fix with your lab. If this is going to be very expensive, like a new DI, you might speak with the licensee. If they are a studio or large distribution company, they may be able to get better pricing. If so, they may agree to do the work and just deduct the cost from the license fee. Be sure to get a copy of the invoice for your records.

How Long Will the Fix Take to Complete?

If the fix will happen relatively quickly, just get it done and redeliver. If the fix is more complicated, let the licensee know when it will be completed. Again, it is always best to communicate in writing, as there are legal contracts in place regarding payment upon acceptance.

You also need to check the license agreement to see if there are time constraints as to how long you have to deliver acceptable materials, and if there are time limits for doing fixes. Often, if the license period is short, these timetables will be a part of the agreement, so the licensor can ensure proper time to exploit the product before the license period ends.

What Needs to Be Redelivered?

Ascertain how to do the fix, and determine if it is something you are going to take on. Then you can figure out, first, if the elements need to be completely redelivered; second, if you can just fix the material you originally delivered and redeliver that; or third, if you can deliver the fix on a separate element.

Redelivering all the elements again can be costly. If you did fixes that were extensive and throughout most of the show, you probably cannot avoid this. But if you just fixed a spot or two, maybe the licensee will return the materials and allow you to insert your fixes and redeliver, since this often benefits both parties. It is more cost-effective for you, and it means the distributor doesn't have to reevaluate all the materials again – which will be costly for the distributor. This way, they can just spot-check and sign off on the fixed area.

Often, if the rejection is a result of a missing element – such as textless materials – the licensee will be happy to take this material on a separate short element. Then they just have to add that material to the tail of the originally delivered materials and check to make sure everything is complete. As with the previous scenario, this saves you and the licensee money.

Once the licensee has approved the materials and delivery is considered complete, the producer can collect the final funds owed.

Acceptance

Once your materials have been accepted, you should receive notification of such from the licensee's legal department, with a note as to when final payment will be made.

Acquired Libraries

If your company is acquiring the library from another company, ensuring that all materials are accounted for and acceptable can be a very tricky and time-consuming proposition. This is especially true if the library is large, old or made up of multiple items, such as many years of a TV series.

Hopefully, the selling company has good records of what is being purchased. In this scenario, you may just be faced with spot-checking appropriate samples of the product to ensure that what was promised is what was delivered. Unfortunately,

too often this is not the case, and then things become complicated. You will have to pull together the materials and organize them to ascertain what you have. Then you will have to start the technical evaluation process. Usually the best way to do this – as it can take a very long time to complete this project – is to try to figure out which titles have the best chance of being distributed first. This might go faster if you include the head of your sales force in this project. They should have a pretty good feel for what titles will be most desirable to your clients, so start there. Generate an inventory as you go along, so that you can account for the materials and document the work you've done as it is completed.

Summary

Burgeoning distribution opportunities with the increase in theater screens and the growth of cable, satellite and foreign markets have generated an opportunity for product. Distribution is a very good business to be in if you can offer product that is desirable and in acceptable shape. The key to this is to do things right when you are creating or cleaning up your content. You would expect this large increase in sales would result in nearly limitless budgets. However, this is not the case, so you will need to be savvy about negotiating with facilities to do the work necessary. You have an advantage if you are creating something from scratch. You can do things right from the start and not have to try to fix the mistakes of others. If you don't have the funds to complete your new project properly, then think about a cost-effective way to have product to shop around to those who do have the money to complete the project properly. And as we always stress, pick a facility that can show they know what they are doing, and then listen to their advice.

CHAPTER

12

Archiving

In this harrowing, hero-making department, you may find yourself in need of a bullwhip, a shoulder bag and a fedora, or opening up dangerous ancient face-melting artifacts, or being chased across the globe by evil villains... ohhh, you mean arch*iving*...

Since celluloid began, Hollywood has always searched for a way to preserve itself. The more things change...

Do you ever wonder what happens to the master source file of movies or shows? What happens to the raw uncompressed data that has been shot? Sound files? How are they securely stored away, but accessible in the future for that special 20th-anniversary screening years from now? If a DSM or a digital master is stored on a hard drive, how do you know in 20, 30, 90 years it will still be accessible or compatible with the software and hardware of the future? With the ever-changing technology (encoding, hardware and software updates), how can you verify that you'll be able to unencrypt a hard drive that was built in the 2010s and now has to somehow be compatible with a computer in the 2090s? Will a hard drive hold up over the years or will it wear out? More importantly, why do I need to worry about this *right now*? I'm just trying to finish my movie.

Reasons to Archive

For both a studio with a huge library and the small independent filmmaker, the answer is money. A finished project ready to sell is your biggest asset. The project has the potential to be sold in multiple markets: Theatrical, TV, streaming, DVD/Blu-ray, domestic, foreign, and other markets not invented yet. Even if it has been licensed, there may be other markets to tap.

It is in your best interests to keep your masters stored in a safe environment. If your project has not been picked up for distribution and you're not entirely sure which assets will be needed for deliverables, it is best to keep your materials in great condition for that scenario, whenever it may come. It may take months or years to sell a project, but as soon as it is licensed, the distributor will ask for additions to the

credits and changes in the titles adding the distribution company logo, ratings cards, and they may even ask for content changes. You will need to have a master that can be revised with additional sound or action in case a cut needs to be lengthened or shortened. Once the changes are made and the project is sold into distribution, it is then up to the distributor to vault or archive the material.

What to Archive

Even the studios are having a hard time with an answer. The quantity of content is enormous. With an estimated 7000 new movies released worldwide annually, it's a hard question to answer. Due to the sheer volume and work hours, not all content will make the migration. The studios have opted to save all content in vaults, and they migrate what they can, as they can. Some companies are deciding what data to migrate to the next generation and what data will remain in the original format. For an independent filmmaker, there is a long list of materials to "save", and they are the same materials that the distributor will want to acquire:

- raw camera capture files/dailies
- director's cut
- final locked picture/final conform
- DI with color correction, and before color correction
- DCDM in P3, J2K
- DCP in P3, J2K
- DSM in ProRes, Rec. 709
- VFX (if required)
- captions, titles, subtitles and textless backgrounds
- sound for each element, as well as stems, final mix and foreign-language masters in .wav/AIFF files
- behind-the-scenes (e.g. gag reels, "making of", director interviews, bloopers etc. in MOV, set stills, gallery shoots, artwork, and any additional material needed)

Make sure you check with your distributor and post house on what elements and in what formats they suggest you archive. As technology changes, the files and formats may also change.

A colleague was working as a set photographer on a show. They wrapped the show, edited the gallery, touched up the photos, the usual… They sent the final file of photos to the production company, and moved on to several other projects. Nearly a year later, the production reached out to the set photographer and explained that they had had an incident with their storage and had lost all of their photos. They wanted to know if by any miracle the set photographer might

still have any of the photos on file. Good thing for that production this photographer made it a habit of keeping separate media files for each project, and had saved all of their final photos. Back up! Back up! Back up!

How to Archive

Digital archiving has a long way to go to match the shelf life of 35mm film. It's been noted that the digital format is growing and temperamental, and not as suitable for archiving elements. Drives can deteriorate quickly. There is concern that more modern films from the newer digital era may be vulnerable to being lost if new practices and standards are not developed. Of course, there is always cost involved to secure and maintain a controlled environment. It takes employees and time to initiate the migration of files to the next generation of archival storage.

With the long list of necessary materials that need to be stored, there are a few simple ways you can protect your assets:

- Output your files to the original capture resolution. This ensures that you retain as much digital information as possible. To preserve the value of your asset, you will want to do your best to maintain the resolution, color choices and overall quality.
- Consider using ACES. This fairly new color logarithmic encoding initiates in-content capture and allows transfer of color information throughout postproduction. Not all digital facilities are able to read and manipulate the encoding, so do your research before you begin:
 - GAMs is a color-grading archival master (working in LUT, ACES or Output Transform) and should be included in an archival package.
 - NAMs would be the non-color-graded archival master, which you should also consider including in your archival package.
- Experts recommend that you keep an uncompressed version for long storage at the highest resolution, and a compressed version for duplication and general use.
- Store your editorial files on the most reliable storage element. New versions of LTO can store up to six terabytes of data. It's a studio standard because it's a widely used source that can store a large volume of data for over 30 years without degradation.
- Make several backup copies. This is your hard-earned project. If the house or facility catches fire or floods etc., it might be lost.
- Migrate your data. Studios upgrade the storage formats to the newest format approximately every seven years. Even though current LTO tapes have a long storage capability, hard drives may become incompatible, file formats may become outdated, and copy and playback hardware may become obsolete.

- Finally, think about a film finish: Turning your DI into actual film negative. Film is still the most proven method for storing, preserving and archiving movies. It seems to be good enough for the major motion picture studios, who preserve their blockbusters and priceless treasures on film negatives not only because of the long-lasting nature of film – over 400 years – but also because 35mm holds more data than any digital master.
- YCM color separations on film can be more color-accurate than making a digital negative. There are a couple of processes to create them. One is to create them photochemically; the other is digital output, combining the three separations and making a check print. See the film lab chapter for more information.

Animation and VFX

Animation contains many layers of images, creating large amounts of data. You may be asked to archive some final versions. This requires more storage space than an LTO. There are algorithms and digital tools created specifically for animation and VFX, allowing it to be stored in proprietary software. The animation or VFX facility will have its own set of tools for storage. These elements need to be in the migration schedule as well.

Where to Archive

Now that you have made all of your archival materials, where do you store them? Certainly there isn't enough room under the bed.

Digital materials, data capture cards, SSD media and LTO tapes are easy to duplicate. Make several copies of your elements, safely stored in multiple geographic locations. The storage area needs to be clean, dry, dust-free and out of sunlight, with low humidity. A fireproof vault is a good suggestion for home or office storage. Consider making multiple formats, e.g. DI, DCDM and DSM.

There are several large organizations that will help independent filmmakers archive their materials. The Sundance Institute Collection at the University of California, Los Angeles Film and Television Archive will store your film for free if your film played Sundance or was supported by any of its artist development programs. If you didn't play Sundance, www.Indiecollect.org are an organization dedicated to archiving independent American cinema, and they will help you locate long-term storage for your film.

Cloud Storage

It sounds easy: Just upload your files to a secure Cloud storage service and *voilà* – you don't have to worry about fire or flood. There is a lot of "fake news" about Cloud services, and research can be daunting. Many filmmakers are

using Cloud-based services such as Amazon's AWS or Glacier, and these types of Cloud storage service are bound to expand in the near future. Research all options and costs first: The storage charges are usually per upload and download. If you access your material often, it might be a costly proposition. In addition to costs, there is the chance of piracy. Even major studios have been affected by this, and it's something the Cloud services and the studios are working independently to prevent. Encryption is literally the key to this well-publicized theft. Access to data requires multiple layers of secret encrypted passwords. The Cloud service you choose should provide backup to your data in three locations on their servers, providing a better chance that if one gets corrupted, you have others to access. Servers can go down, data can be deleted by the user – yes, you could make a mistake – data can be lost by software error, or a storage bank can just freeze. Again, always have a backup saved or stored in another location.

Film Vaults

Film elements, YCMs, negatives and optical sound tracks are stored in climate-controlled vaults. Film needs to be in a similar environment as LTO tape: Clean, out of sunlight and humidity-controlled. Your closet is not suitable for long term. There are professional film vaults who will safely store your materials for a fee.

Summary

The finished project you create is your most valuable asset. It has cost a great deal of money and effort. Make sure that it is stored for future access and sales. We recommend the following:

- store copies of your master elements in different physical locations
- transfer to a variety of different formats
- consider what to archive, depending on your project

If you are operating on a very restrictive budget, do more research, and find someone or an organization to help you.

Store it like the pros. Keep it up to date and ready for a distributor. Make sure you have all the elements you need to recreate a master or make adjustments that will be necessary to the buyer, including the raw, editorial and metadata listed at the top of this chapter.

Filmmakers, directors, producers and cinematographers have an obligation to ensure that their projects will be played into the future and not lost to a format that is obsolete. Don't forget your backups!

CHAPTER 13

Legal

Lawyers are our friends, and they are here to protect us and look out for our best interest (and we have some swampland to sell you…). No, seriously, attorneys are an important part of any movie or TV project. And it is important to know when they need to be consulted and the most cost-effective way to work with them. We are going to guide you in this area.

Some of the suggestions in this chapter may save you from expensive and embarrassing legal hassles. Some are just common sense and "cover yourself" kinds of stuff. But it's good sometimes to be reminded about the legal ramifications and the responsibilities that go with the job.

Sooner or later, one or more lawyers will be involved in some phase of your project's postproduction process. These lawyers will have the power to second-guess each decision you make, to your personal frustration and possible embarrassment. Their involvement will either help you or slow down the process to a crawl. Because of this, it is important to understand how to work with attorneys and get the most out of what they can do to help you. It is our experience that trying to work around the attorneys often backfires. And if it comes down to them or you… guess who almost always has the last say.

Worthwhile Advice

When you have access to an attorney, consult with that attorney for approval on all contracts and license agreements. This is particularly important whenever there is unclear language in contracts, licenses or delivery requirements. As our consulting attorney reminded us, your attorney is your partner and teammate. This relationship can only exist where you've informed them of any informal concessions or demands you have made prior to legal or contractual involvement. If you have given permission or made an agreement on the fly, make sure that when it comes time to create a binding legal document those items are honored and are entered into the final contract. This means jotting the agreement down and making sure your legal representative is informed. Think of them as your partner. They have your back, but only if you keep them in the loop.

As you go through the various steps in the postproduction process, protect yourself by getting everything you can in writing – especially regarding services performed. Then back yourself with a memo, in case there is any question on anything you or someone else agreed to. Whenever appropriate – or maybe whenever you can – get all signed agreements and releases messengered, emailed or mailed back to you.

While some of what is in access letters and laboratory agreements is considered "technical information" about which most lawyers are ignorant, these documents have serious legal ramifications. It is important to have someone in your legal department look over the wording of these documents before they are signed. For many documents, it may also be appropriate that they be signed by someone with "ultimate authority".

To achieve timely and worthwhile results, agreements must be reviewed legally early in the process. After you have committed to using certain stock footage, for example, or awarded work to a particular facility, you or your attorneys will have little leverage to change what you do not like. And if you really do not like what can no longer be changed, you may be faced with expensive and embarrassing replacement costs.

Know what's required if you are selling your project into distribution. Low-budget and independent filmmakers need to take note here. With all the waivers from guilds and unions and contracts for locations and other services that are required, it's easy to forget about one detail necessary for distribution. One of us had this experience, and it was a rude awakening. Independent filmmakers pour their hearts, knowledge and existence into making a film. The end goal, of course, is to use it as a resumé, a selling tool to make a longer project or sell it into distribution. The project we are referring to was complete and made to sell. Beyond expectations, it quickly sold to a distributor, and now not only did logos have to be inserted – at the cost of the filmmaker, who had not budgeted for this expense – but the buyer required E&O insurance. The filmmaker was surprised, and caught off guard *and* out of budget. E&O is a liability insurance that protects the production, its employees and the distributor from claims of negligent actions, e.g. story theft, copyright infringements, plagiarism, screen credit omissions and other possible lawsuits. Almost all distributors require E&O insurance. Most mainstream producers know they have to purchase E&O before production, and it's a budget item just like cast or film insurance. Before purchasing, you need to consider saving the policy fee until you have sold the project. The project may take months or years to sell, and the policy can cost thousands of dollars and may take weeks to process. Prior to entering a distribution deal or purchasing costly policies, you may want to check with an attorney to make sure the deal is right for you.

And a final note: It is a good idea to check with your attorneys before making payments on deals that remain "in negotiation".

Five Reasons to Check with the Lawyers

To help you determine which steps of postproduction may have legal ramifications, we've broken this section down into five easy pieces.

Stock Footage

Stock footage is usually an establishing shot of a location – a beauty shot, usually static. Most of the stock footage houses and music libraries provide basic information on their websites, with types of footage, costs and contacts. Some websites even have a search section. (See the editorial chapter for more detail on clips and how to insert them.) Before you get too attached to a stock shot (or music, for that matter), get a blank contract from the vendor(s) with whom you are negotiating. If you have a legal department at your disposal, send a copy of the blank contract for their review. Chances are they will want to change some of the wording. There is one word that is most often disputed or added: "Indemnify". Your attorney will want the contract to indemnify the production company against any legal action (clearances) arising from the use of the purchased visual or audio clip. Often, standard agreements do not grant the rights they purport to. You will need to ask the vendor to approve the new language and have it *incorporated into* your license agreement before the deal is signed. This saves you the difficulty of having to go back after the fact to try to rearrange the rules.

Although many of the details of stock footage are taken care of in postproduction, the availability of such footage can be a determining factor in planning the shooting schedule and budgeting. Therefore, sometimes research on available stock footage is done during preproduction. The production executives will need to decide if there is suitable footage available for a certain location or action that can be incorporated into their story. If not, they will need to shoot at the location or action to get exactly the footage they need.

There are many stock footage houses around. Prices are pretty consistent from house to house. Final costs will depend on the extent of the rights that are granted. Here are some examples:

- Media: Theatrical, TV, student, home video, streaming, all media
- Region: Domestic, foreign, worldwide
- Duration: One time, three years, perpetuity

Based on your descriptions, stock houses will provide access to view various shots available. This may be an access pass. Look at the clips with your editors and producers, and determine which ones you will purchase the rights to.

Music

If you are working on a show for a large production company or studio, they will employ a music coordinator to secure bids and finalize licenses. We strongly recommend this whenever possible. The best coordinators are typically more knowledgeable than attorneys about this area.

The decision about which rights to clear, and questions regarding financing, licensing and insurance, are beyond the authority of the postproduction supervisor, at least in part. Direct these questions to a higher authority. Do not take the risk that a unilateral decision on your part will put your production company in breach of contract with its distributors.

Even though you may not be making the final decision, there is groundwork you will need to complete before the producers will have enough information to make an educated decision:

1. Determine the foreign distributor's requirements regarding music rights and clearances.
2. Determine the producer's expectations regarding the feel and length of the piece, along with cost limitations.
3. Determine if you need the rights to the lyrics (sync) or the recording (master). If your actor is going to sing the song, you want the sync. If you are going to hear the original recording of the song from a jukebox, you want the master.

To receive a bid on licensing a piece of music, you must know who owns the license. The websites for BMI and ASCAP are helpful, and their search bar on the front page will help you find the appropriate license holder. These are not unions, but rather watchdog societies that track all music used or played in all media. They also track royalties. You may find that several publishers own the rights, or that a publisher holds the rights in the United States but not in other countries. You will probably need to obtain the rights for worldwide distribution, so be thorough. Call whoever the copyright holder is and ask for a cost. Most likely, you'll need to submit your request in writing and include the following:

1. what the music will be used for (feature, commercial etc.)
2. how much of the music you are planning to use (the entire piece, a certain number of bars etc.)
3. the scene in which the music will be used

Email the request. It may take several days or more to get the quote back. Not all music can be purchased for perpetuity, world distribution or all media (many have five-year options). Let an attorney guide you on this; it can get complicated. The publisher may inquire regarding video buy-outs and whether the show will

Legal

appear on TV or as a feature. Music clearances are not something you can learn in a day. With the help of an attorney, sometimes deals can be structured in such a way that someone other than the producer, such as the distributor, bears part of the costs.

The actual music license may take weeks to finish and execute. You may end up using the song long before all of the paperwork has been completed. That is why it is crucial to have legal or music coordinator assistance. In lieu of an attorney, a music coordinator may be willing to assure you and your insurers that the music has been "cleared" pending completion of the paperwork.

Copyright protection laws used to be very complicated and vary widely from country to country. In the past few decades, the basics have become standardized as a result of international copyright treaties. Our attorneys recommend that your legal department handle all copyright issues, and be involved in all discussion regarding copyrights and chain of title. Chain of title refers to the history of title transfers and rights for a property. This is one of the first things a distributor will ask for, even before they purchase your content.

Products

Products are physical items for which use must be licensed that are featured in a show. Some examples would be a Smashing Pumpkins T-shirt, a Gorman painting, a name brand on a food label, or an actual magazine cover. One of the most unusual items that required a license was a very famous tattoo. The case of the tattoo is well documented, and since the initial lawsuit new tattoo copyright questions for other media uses have arisen. Just be aware that any work of art could have a copyright. As an example, an attorney we know was representing a reality TV show. It shot in a real home that had paintings on every wall. Some paintings were famous or known; some were not. The paintings appeared so often and prominently that our friend was asked to clear and identify any potential copyright issues. With so much of the footage shot in front of the art, the attorney had to view dailies every day to identify and head off any infringement. Copyright infringement is a strict liability claim. The law states if you reproduce it, you are in violation. Just when you thought it was safe to shoot in the grocery store. To obtain a license to lawfully use these items, you will need to find out the product owner, then:

1. call the company and determine who negotiates the use of their product in a TV/feature/student show
2. explain how you to plan to use the product (cable, broadcast series, feature etc.)
3. find out how to get permission to use the product (not all companies charge a fee)
4. provide them with a scene description and the scheduled air date

They will want this information in writing. Usually you can email the information with a cover letter. When the copyright holder grants permission, whether or not there is a fee involved, be sure the response is in writing and includes the rights you need, e.g. all media, worldwide rights and perpetuity.

If a fee is involved, present the quote to the producer(s). If they agree on the fee and the terms of the license, confirm this with the copyright holder. Make sure you receive the copyright holder's signature of agreement before sending payment. Have an attorney review the agreement before it is signed.

Some companies may request screen credit in lieu of payment or for a reduced fee. This decision is for the network/studio and the producer(s) to make. Do not agree to any screen credit without prior approval. Be aware that Federal regulations and network broadcast S&Ps require the disclosure of any deals in which a producer accepts "consideration" (e.g. a product discount, free airfare or free product use) in return for inclusion of a product in a production. The disclosure rules are complicated; to cover yourself, it is best to disclose everything to the person you report to or the network, and let them decide how to handle the situation.

An item containing a photograph of a person, such as a movie poster or magazine cover, will generally require permission from the person in the picture as well as the photographer and/or the copyright holder. If the photograph is of an actor, he or she will usually want payment for use. Be sure you have obtained the rights of all parties involved, or have received legal assurance that such rights need not be obtained.

There is a case of an independent filmmaker using a doll in a derogatory manner to demonstrate the vulgarity of the casting couch in a film. The filmmaker did not clear the use of the copyrighted doll, and submitted the short program to a well-known film festival. After screening the submission, the festival lawyers inquired about the rights to use the name and image of the doll. When the filmmaker could not produce indemnity or legal permission, the film was denied entry in the festival. With so much at stake, it's best to ask for clearance or check with an attorney before you shoot.

References

This involves any mention of a person, place or thing in the body of a show. If the reference is casual, nonderogatory and not a featured story point, you are clear to use the reference in dialogue. However, if the reference shows a person or product in a derogatory way, you could be looking at a lawsuit. Furthermore, even if something is legally okay, it may violate S&Ps, embarrass a network, or lead to a series of letters from the named person's or element's representatives. Be careful – when in doubt, let someone higher up make the call.

References can get tricky when you're talking about inferences. Say you have a scene in a bar, and the bartender is making references to how great Elvis songs are.

Legal

In the background Elvis-style music is playing, but it is not actually Elvis Presley singing. This may mislead the audience to believe that it is Elvis music they are hearing: Therefore, permission from his estate may be required. When you think you are in a potentially gray area, it is always best to consult your attorney.

Film Clips

Film clips are different from general stock footage in that they are moving pictures, not static establishing shots, lifted from an existing program. There are two ways to approach obtaining film clips. First, there are several firms that will grant rights to films, sporting events, newsreels, cartoons and old TV shows for a set fee. The licensing will be similar to that of a stock shot. The film libraries will have catalogues for you to choose from.

Second, if you are looking for a certain film, such as *Star Wars*, you must contact the copyright holder and go through the channels outlined above to obtain the rights. Normally the costs are extreme. Part of this cost is to cover the actors, who must be paid a residual every time the clip is seen. Another part of the cost goes to pay the composer for any music included in the clip. There may also be other fees attached to the use of a clip. The person providing the license will also provide a list of those who must be compensated, and this compensation is usually included in the cost of the license.

Use of a film clip for playback on the set for a TV, or in a movie theater, requires special handling. Talk to your DP and find out what he or she needs. There are a couple of ways to play back material. Ultimately you want the playback and the speed of the camera to match. First, you will need to secure the rights to use the clip; second, you will need to do a transfer, and then rent special equipment to link the playback to the camera. If the clip plays full frame within the film and no playback is required, a license and a transfer – with or without sound, depending upon the request – are needed to add the clip to your final master.

As with music and stock footage, begin the clip licensing process as early on as possible. All the same rights apply, and as with music it may take time to find the proper licensee. Determine costs and legalities, and then discuss them with your producer.

Disclaimers

A disclaimer is another legal tool that affects all TV and feature programs. Disclaimers are pretty standard, and your company should have one already created for you to use.

The disclaimer usually goes at the very end of the end credits, just before the logos appear. There is no hard-and-fast rule about how long the disclaimer must

remain on the screen. Below is a sample of a disclaimer used in a TV program. Occasionally the foreign distributor will have some input into the wording of your disclaimer. It is best to always have your legal department determine the wording.

Sample Disclaimer

The characters and events depicted in this motion picture are fictional. Any similarities to actual persons, living or dead, are purely coincidental.

This motion picture is protected by the copyright laws of the United States of America and other countries. Any unauthorized duplication, copying, or use of all or part of this motion picture may result in civil liabilities and/or criminal prosecution in accordance with applicable laws.

© 2019 (place company name here)

All Rights Reserved. Country of first publication: United States of America.

(Place company name here) is the author of this motion picture for purposes of the Berne Convention and all national laws giving effect thereto.

Disclaimers like the one above are designed to protect the show's copyright holder or distributor from legal action charging that a person has been defamed by the program. The copyright statement is to protect the copyright holder from infringement and other legal battles stemming from any misuse of this protected material, both domestically and in foreign release.

Is It Clear?

Keep in mind that obtaining stock footage and music – especially music – clearances can be very time-consuming and costly. Before you go through the steps, make sure that your producer really wants to pursue use of the material and that you're not jumping to the whim of the editor. If you cannot cut around or substitute and your producer gives the go-ahead, then proceed.

Stock footage clearances, music clearances, product use and placement, references or inferences, and film clip clearances are the primary areas in which you will find you need legal advice. Other areas covered in previous chapters, such as finalizing titles and credits and obtaining main title use clearance, will also require input from your legal department.

Often, common sense will be your best defense against legal trouble. If there is any doubt about anything you are doing, consult your legal department.

Remember to get signatures on all agreements and releases, and keep hard copies in your files.

Just remember that anytime a decision is being made that involves signing a contract or agreement, it is probably a good idea to run it by your legal staff. Contracts are binding, and it is important to ensure that what is being agreed to will not be a decision that could turn costly or result in some type of legal action down the road. Long after you complete a project and move on, the details of that project will live on.

CHAPTER

14

The Future

> We cannot predict the future, but we can invent it.
>
> Dennis Gabor

What is the next big thing?

Ah, that is the question. There are trends and obvious technologies that are expanding. Digital standards, software and media storage will continue to rapidly evolve. While streaming may not have reached its peak, broadcast TV is floundering and trying to find new ground. Features, on the other hand, are reinventing themselves as the premiere movie experience, offering up comfortable and relaxing seats, gourmet food, immersive visual and sound experiences that reward you for that two-hour time-out from your phone, computer and social media.

As a post supervisor you will encounter new formats, containers and codecs, resulting in new acronyms, faster ways to send and receive data, brighter theater screens, higher capture rates and tighter delivery schedules.

Film will continue to linger in the background, especially for capture and the use of large format. There is a rumor that Kodak may be interested in manufacturing negative film stock again in the near future. At this time, it remains the highest-resolution and most robust archival medium.

As we take a look into our crystal ball, the following subjects seemed to float above the mist.

The Cloud: Storage and Beyond

With Amazon and other companies offering a substantial set of Cloud services, this may be the first technology discussed in the future chapter that actually becomes part of the present. Cloud-based companies have created entertainment industry-specific services beyond long- and short-term storage. Data-sharing for collaboration with VFX, editorial, studios or any other vendor creates the ability to augment or share your media between parties anywhere in the world with internet access. Currently remote VFX renders can be expensive, and slow to

move the terabytes of data needed when creating the many layers required. It remains to be seen if the pipeline will change, or if compression methods will change. Remote QC may speed up the approval process for TV and streaming where schedules are already tight. Music and sound design use less data and may take advantage of the storage-sharing capability more quickly. Sometimes these services are only available to (a) dedicated computer station(s). Remote access and access to tablets and laptops have not necessarily been completely worked out.

Experts explain that the Cloud could be expensive, and even more so with security, not due to the amount of storage, but for downloading or uploading your data. The costs involved to access your media may be prohibitive for independents or small companies. However, many services have structured their products for movie production, with long- and short-term subscriptions taking costs and post schedules into consideration.

Physical File Storage

File storage in a single container is increasing. LTO tape is the standard editorial delivery format. LTO 8 is the latest version, holding up to 12 terabytes of uncompressed data and 30 terabytes of compressed data. LTO 9–10 will be released in 2018 or 2019, with uncompressed storage of 24 to 48 terabytes; and eventually there will be LTO 11–12, which will hold up to 192 terabytes of uncompressed data. Thunderbolt is a widely used external hard drive. The current version, Thunderbolt 3, allows data transfer speeds at 40 gigabits per second (two times faster than the previous version) and boosts signal reception and HD quality in VR headsets, potentially making for a better experience.

Premium Large-Format Exhibition

Along with the popularity of IMAX, premium large-format (PLF) theaters are cinemas with giant screens, premium sound systems, and enhanced customer offerings like reclining seats and table service. These special premium theaters are gaining widespread popularity, enticing audiences to pay a little more for a heightened experience. Look for this luxury venue to enlarge and increase in numbers.

Camera Technologies

Camera technology is also expected to increase. Ultra HD is on the way, along with cameras that will allow you to choose different points of focus in post. Right now many productions use 4K, but 8K is right around the corner.

There are also large-format cameras, such as:

- Monstro 8K Vista Vision or Alexa 65 IMAX: The Alexa shoots vistas with incredible detail, for customized use on IMAX productions. It's a complete large-format solution for major theatrical motion pictures, with 65mm digital cinema camera, custom-designed prime and zoom lenses, and fast, efficient workflow tools.
- Sony VENICE 6K 35mm full frame: With maximum resolution of 6048 x 4032, it allows extra-shallow depth of field, super-wide shooting and other creative effects. It also shoots Super35 anamorphic 4K.
- Alexa full frame: It has an enlarged sensor compatible with upcoming and existing lenses and workflows, wide color gamut, and records in a broader range of resolution flavors – 4K, ProRes and ARRIRAW up to 150 fps.

New higher-resolution cameras will generate larger amounts of data, and you will need larger storage capability, depth of field and frame.

There has also been discussion around a light field camera, also called a plenoptic camera. This imaging device creates images that can be readjusted after the picture has been taken – for example, to alter the focus, lighting or depth of field.

Drones

Drones are currently used for location scouting, but in the future they may be used for much more. We heard a story about a drone that accidently crashed into a body of water; all the footage, the camera and the drone were lost.

LED Monitors

An LED (short for light-emitting diode) monitor or LED display is a flat-screen, flat-panel computer monitor or TV. Samsung recently debuted its first-ever LED cinema screen in the US at Pacific Theaters' Winnetka in Chatsworth, California, pitching the new technology as a money saver for exhibitors. Essentially a massive TV screen that can display content in much greater detail with its HDR, it does not require a projector, eliminating the need for a projection booth. These screens boast that they can display true black and are unaffected by ambient lighting. Sony is developing a developing a Crystal LED cinema screen that may be seen in theaters soon. LED cinema screens could replace conventional cinema projection with what are effectively LED video walls. Some seasoned filmmakers, including the biggest directing names in Hollywood, have expressed serious concerns about the technology. This could be a major change for the exhibition industry. Enhanced color and different frame rates would be more accessible, not

to mention the potential for video game-playing and the streaming of live events in movie theaters.

Speaking of streaming and live events in cinemas, while there have been several attempts at concerts and live sports events – the most notable draw being the Metropolitan Opera in theaters – alternative content hasn't really taken off. That doesn't mean that someone won't find the right content to lure customers into movie theaters for live events.

Sound Improvements: Object-Oriented Sound

Dolby Atmos is an audio format that takes sound accuracy to an unprecedented degree. With its object-oriented audio engineering and its up-or-down-firing speakers, Atmos is changing the way audio in theaters is set up, and more importantly, how sound is distributed in the room. There are several other companies following in their footsteps with like-minded products.

With Atmos, a sound designer can point to any spot inside a three-dimensional cube and send a sound to a precise location. For example, when a helicopter pans around or from side to side, that path is fully plotted out in 3D. Like Atmos, DTS:X uses heightened speakers and object-based surround. There are currently industry standards being created so that more companies can take in one audio data stream, and multiple equipment manufacturers can use that one input interpreted by their proprietary sound systems.

Accessibility

Brazil has recently required video of a person performing in the Brazilian sign language embedded in the picture at public showings in movie theaters. There is a consideration being discussed by many governments to make sign language mandatory. As we mentioned in our discussion of accessibility, there is a potentially huge audience out there that with the right technology could increase movie theater attendance.

More Data

Everything is heading toward 4K acquisition – 100% file-based, no tape (with the exception of LTOs) – but with that should come 4K exhibition and streaming. Currently most theaters in the US can only project 2K, which would mean a lot of equipment (digital servers and digital projectors) would have to be swapped out in movie theaters. Who's going to pay for that? The studios? Exhibition? The answer remains to be seen.

VR

VR (virtual reality) is the computer-generated simulation of a three-dimensional image or environment that can be interacted with in a seemingly real or physical way by a person using special electronic equipment, such as a helmet with a screen inside and gloves fitted with sensors.

VR content can be created through your VFX house in some cases, or your final color-timed master. However, very few companies have been able to monetize this experience. Today it is still used mostly for marketing purposes.

AR

AR (augmented reality) is a technology that superimposes a computer-generated image on a user's view of the real world, thus providing a composite view, using a phone, tablet or other device.

As with 3D, the popularity and longevity of these formats remains to be seen. There are certain venues that lend themselves to this technology, and it will likely grow into a popular activity. There are several kits available online that are helpful when creating in these formats. There are production companies that are developing programs that could contain VR or AR segments within a show. This is for special venues and is still in the developing stages. In addition, production may change to account for the 360-degree view needed for VR and AR.

4D

4D (four-dimensional) film is an entertainment presentation system combining a 2D or 3D movie with special physical effects that occur in the theater in synchronization with the content. Effects simulated in a 4D film may include rain, wind, temperature changes, strobe lights and vibration. Seats in 4D venues may vibrate or move during the presentations. Other common chair effects include air jets, water sprays, and leg and back ticklers. Auditorium effects may include smoke, rain, lightning, bubbles and smell. Because physical effects can be expensive to install, in the past 4D films were most often presented in custom-built theaters at special venues, such as theme parks and amusement parks. However, more and more often these days, movie theaters have the ability to present 4D versions of wide-release films. There are also mobile 4D theaters, which are mounted inside vehicles such as enclosed trailers, buses and trucks. This type of presentation is gaining in popularity, especially with younger audiences.

Multiscreen Formats

ScreenX provides moviegoers with a 270-degree viewing experience by expanding the scene onto the side walls. The three-screen configuration puts the images on the front and sides of special screen-like material on the walls of a theater. The image is projected across the side walls, using multiple projectors per wall and stitching the images together. It's similar to the old Cinerama theaters, but more of a box than the old circular presentation.

The multiprojection system can be installed in existing theaters, because it works by extending the movie off of the main screen and onto the theater's side walls.

Barco Escape is another multiscreen video format similar to Cinerama, introduced in 2015. The format combines Barco technologies such as Auro 11.1 (object-based sound) with three multiprojection screens in order to create a panoramic experience. Although Barco has put its multiscreen format on hold, these technologies – and there may be more on the horizon – are expected to expand, competing with IMAX and Dolby Cinema, so stay tuned for more of these formats.

Studios' Technical Standards

In the past you knew you could deliver to every studio as long as you were DCI-compliant. These recommendations ensured security, quality and interoperability. However, this only pertains to the theatrical window. Now similar but studio-specific standards may apply to streaming and the home entertainment space. A new program has been developed by Netflix to verify postproduction products and systems – and their vendors – meet its technical and delivery specs.

The Netflix Post Technology Alliance logo program certifies that a product has been vetted for delivery to Netflix, and that the manufacturer is committed to ongoing support of the streamer's technology. The program covers four different product categories: Cameras, color-grading, editorial (video editors), and IMF and media encoding. It remains to be seen how these standards and recommendations will develop.

Conclusion

Cinema has survived the advent of many competing technologies. There were prophecies of the demise of cinema during the early days of TV, VHS, Cable, Blu-ray, video games and many more. Each time cinema has survived, if a little battered and torn. Today, people have more choices than ever on what to do to entertain themselves during their free time that compete with the entertainment

industry, including smartphones, tablets and social media. We thought we'd take a little time to look at some of the technologies newly on the horizon for the cinematic arts and the entertainment industry.

These improvements and many more are on the horizon of the cinematic experience. It remains to be seen what will happen, but experimentation always brings lessons.

Part of the excitement of cinema is the fact that no one knows how it will develop, or where it will lead. The only constant is change. Since prehistoric days around campfires, people have felt the need to tell collective stories. From those first stories and plays through cinema today and beyond, people will find new and exciting ways to tell stories and share their adventures. We hope that you too will be a part of the storytelling process.

Glossary

If you don't have access to Wi-Fi at the moment, here are a few definitions that might help.

2D Animation	Animation using the manipulation of images and 2D vector graphics.
2-Pop	Tone that corresponds to the visual countdown on film leader on the number two (counting backward from ten).
3D Animation	Animation with three-dimensional graphics utilizing a rigged model to create the illusion of movement.
4:2:2	Original digital picture standard.
4:4:4	Twice as much color resolution as 4:2:2, resulting in sharper images and superior multilayering.
4D (Four-Dimensional Film)	Marketing term for an entertainment presentation system combining a 2D or 3D film with physical effects that occur in the theater in synchronization with the movie, such as motion seats, fog, wind and lighting effects.
4-Perf	Motion picture film that has four perforations or sprockets per film frame.
16:9	Widescreen TV format in which the image is long and narrow compared to today's nearly square TV image. The ratio is 16 units wide by nine units high.
16mm Optical Track	Mono only. Read by a light on a projector or telecine. Contains sprocket holes, so there is no need for timecode for editing. For playback only.
35mm Optical Track	Two-track (mono or stereo) audio format. Contains sprocket holes, so there is no need for timecode for editing.
720p	720 lines progressive scanning. High-definition TV format. Displayed in the 16:9 aspect ratio.

Glossary

1080i	1080 lines interlaced scanning. High-definition TV format. About twice the vertical resolution and more than twice the horizontal resolution of standard TV. Displayed in the 16:9 format.
1080p	1080 lines progressive scanning. High-definition TV format. About twice the vertical resolution and more than twice the horizontal resolution of standard TV. Displayed in the 16:9 format.
A/B Roll	Technique of placing alternating scenes on two rolls of film and then playing them together to build fades and dissolves.
Acquisition	Feature film, TV show or documentary created by one company (or in joint production with a set of companies) that is purchased by a studio, network or combination of companies, who thereby become the distributor.
Action Safe Area	Area of a TV picture that is visible on consumer TV sets. It is also called the "picture safe area".
ADR (Automatic Dialogue Replacement)	Recording new dialogue, or rerecording dialogue where the production sound is unusable or obscured. It is also called "looping".
AIFF (Audio Interchange File Format)	Audio file format standard, used for storing uncompressed sound data.
Air Date	Date on which a recorded program is to be broadcast.
Aliasing	Visual effect lacking picture detail/resolution, caused by an ineffective sampling technique.
Ambient Sounds/Effects	Sounds recorded as part of the dialogue track.
Anamorphic Scope	Cinema photography technique of shooting a widescreen picture on standard 35mm film, or other media with a non-widescreen aspect ratio.
Answer Print	First print struck from a finished cut negative.
AR (Augmented Reality)	Technology that superimposes a computer-generated image on a user's view of the real world, thus providing a composite view.
Archiving	Preservation and/or restoration of media for future use.
Artifacts	Video blemishes, noise, trails etc. Any physical interruption of the video image is called an artifact, and is usually introduced electronically.
Aspect Ratio	Ratio of picture width to picture height, commonly expressed by two numbers separated by a colon, as in 16:9.

Glossary

Asset Map — List of all files. Provided in XML format on a digital cinema package.

ATSC (Advanced Television Systems Committee) — Group formed to study and make recommendations to the Federal Communication Commission regarding digital TV.

Audio Hiss — Overaccentuated high-frequency noise heard in audio.

Audio Hum — Low-frequency noise heard in audio.

Audio Stems — Dialogue, music and effects sound that may have originated in the original production audio, such as footsteps and jangling keys, and that will disappear when the dialogue track is replaced by another language.

Authoring — Process of organizing materials and putting them into computer language for use with an interactive disk (such as DVD).

Baking In — Using a custom camera setting to record a particular look.

Balancing Reels — Building reels to assure that music cues don't overlap reel changes. It is done by the film editor or assistant editor.

Banding — Visual artifact whereby brightness or color gradients appear to be made up of bands of brightness or color. It is often the result of insufficient bits to represent each sample of a picture.

Bearding — Highlights on one side which are obviously not part of background.

Bitrate — Number of bits per second that can be transmitted along a digital network.

Black Level — Level of TV picture signal corresponding to the maximum limit of black peaks.

Black Track Prints — Prints made from finalized negative prior to completing the sound.

Blanking — Point in the video signal where a horizontal scan line or vertical field that makes up one-half of a video picture is completed and another one starts. There is no picture information at this point in this signal.

B Negative — Film takes not originally slated to be printed from dailies but later called for to be printed. Originally a film term, it has carried over into videotape and refers to non-circled takes that are later transferred as alternative takes.

Camera Report — Form filled in for every camera roll exposed, to explain what is on the roll and any special printing or transfer instructions.

Glossary

CDL	Format for the exchange of basic primary color-grading information between equipment and software from different manufacturers. This information is used by the DIT.
CGI	Creation of still or moving images using computer software.
Chapter Stop	Code embedded in a video disk which identifies each new chapter or section beginning. This speeds up the process of locating specific segments on a disk.
Check Print	First film print used to check color corrections. The print can be from the dupe or a digital original.
Chroma Key	Superimposition or combination of two video images to create one composite effect. One of the video sources must be a saturated color, such as blue or green.
Chrominance	Color portion of a video signal, also called chroma.
Chyron	Company that manufactures special effects and titling equipment used in on-line edit suites. The term is also used as a common name for this type of equipment.
Clipping	When a signal is stronger than the circuits can handle, the excess is clipped off. In video this can cause a milky appearance, while in audio the sound can become distorted.
Cloud	Storage data bank in an undisclosed location used to store large amounts of data. Space on the Cloud can be leased or owned.
Closed-Captioning	Signal that contains text information incorporated into video that can be viewed on your TV when run through a decoder.
Codec	Generic term to describe the type of compression, e.g. JPEG 2000, MPEG-2.
Color Bars	Test pattern used to determine if a signal is calibrated correctly.
Color Correction	Color-grading process that adjusts the picture color, tint, hue etc. on either film or digital. It is also referred to as color balance from scene to scene.
Colorist	Telecine operator who corrects the color and light balance while transferring film to videotape, or videotape to videotape.
Color Keying	Removes a specified color from a scene, such as scenes with green screen and blue screen.

Color Space	Abstract mathematical model which describes the range of colors as tuples of numbers, typically as three or four values or color components, e.g. RGB (red, green, blue). It is also called a color model or color system.
Composite Audio	Fully mixed audio track with dialogue, music and effects married together. It may be stereo or mono.
Composite Film Print	16mm or 35mm film print that contains a sound track on the film element.
Compositing	Combining visual elements from various sources to create a single image and the illusion that all the elements are part of the same scene.
Compression	Process for squeezing digital data into a smaller space than it would normally fit. A 2:1 compression makes the data half its original size. It can be lossy or lossless.
Computer Animation	Animations created digitally. This can be 2D or 3D animation.
Conforming	First step of the on-line editing process, using an editor's decision list as a guide to record the full resolution of raw data, fades and dissolves.
Continuity Script/ Dialogue Continuity Script	Actual dialogue from the final version of a project.
Contrast	Range between light and dark values in a video signal.
Conversion Lag	Error as a result of standards conversion. It is most noticeable in horizontal movement or image "trails".
Converter	Electronic device which translates one frequency into another. It is also called a decoder device.
CPL (Composition Play List)	A text file that includes all the information on how the files on a specific composition should be played back, including how audio and subtitles are synchronized with picture.
Credits	Titles in a program naming the stars and others involved in creating a project.
Crosstalk	Bleeding of sound from one channel or track to another.
Crushed Blacks	Lack of detail in the black areas in picture. This is caused in either photography or transfer. If a result of photography style, it cannot be fixed.
Cue Sheets	Spreadsheets or road maps of audio cues so that sound recordists can locate specific tracks.
Cuing	Scribing and removing the emulsion at the tail of film.

Glossary

Cyan Sound Track	Track used for making sounded prints that utilizes the cyan layer of the film.
DA88 Audiotape	Audio recorded on Hi-8mm metal particle tape stock that provides up to eight channels of audio recording.
Dailies	Footage that is shot in a day (called "rushes" in the UK).
DAW	Digital audio workstation.
Day and Date	Release of content around the globe on the same day and date.
Daylight Developing	Rushing film processing through a lab within a few hours instead of overnight.
dB (Decibel)	A unit of measurement indicating ratios of currents, voltages or power, and used to represent audio transmission levels, gains and losses. A decibel describes the smallest perceptible change in audio level.
D-Cinema (Digital cinema)	Projection of content through a computerized electronic projection system, utilizing data or video elements. It is also known as E-Cinema.
DCDM (Digital Cinema Distribution Master)	Master file that contains both picture and sound essence.
DCP (Digital Cinema Package)	Collection of digital files, both picture and sound, equivalent to a film print.
Decoding	Reprocessing of a signal to get the desired part. In audio, a signal is encoded when recorded, and in playback it is decoded so that it sounds normal but the noise is reduced.
DI (Digital Intermediate)	Intermediate film element made from a digital image.
Digital	Signal made of two discrete levels – on and off – as opposed to signals that vary continuously between high, medium and low levels.
Digital Blocking	Artifact in digital picture that appears as tiny blocks. It can be caused by dark scenes, or during compression.
Digital Cinema	Digital distribution or projection of motion picture content.
Digital Master Image	Digital recording or other digital asset preserved as the original for archival storage.
Digital Micromirrors	Computer chip etched with mirrors that passes light and allows digital cinema to project an image.
Director's Cut	Rough cut created by the director once the editor's cut is completed. Usually followed by the producer's cut and picture lock.

Glossary

Dissolve	When picture or audio melds into another picture or audio. In film these are opticals. In on-line they are created electronically.
Distortion	Poor-quality sound, often caused by an audio signal that is too strong.
(DIT) Digital Imaging Technician	Crew member who works in collaboration with the cinematographer on digital workflow
Dither	Low-volume noise introduced into digital audio when converting from a higher bit resolution to a lower bit resolution. The process of reducing bit resolution causes quantization errors, also known as truncation distortion, which if not prevented can sound very unpleasant.
Dithering	Process of juxtaposing pixels of two colors to create the illusion that a third color is present.
Dolby 5.1	Digital sound format that is separated into five discrete channels – left, center, right, left surround and right surround – and a low-frequency effects channel which plays back on a subwoofer.
DPX (Digital Picture Exchange)	A now common file format used for digital intermediate and visual effects work. It is most commonly used to represent the density of each color channel. DPX provides a great deal of flexibility in storing color and other information for exchange between production facilities.
Drift	When an element does not keep a steady speed during playback. This is usually caused when there is no timecode to lock to, or when the record machine power source was faulty, causing the recording to vary in speed.
Dropout	Temporary signal loss. It shows up randomly as image loss or silence on audio.
DSM (Digital Source Master)	Generic term for sound and picture data.
DTV	Digital television.
Dubbing (Audio)	Combining all sound tracks (dialogue, music and effects) onto a single master source. It is also known as mixing.
Duplicate Negative (Dupe Neg)	Backup or safety copy of a cut negative. It is used for creating prints, thus preserving your original negative.
Dynamic Range	Range between the lowest level of sound and the highest level without distortion.

Glossary

E&O (Errors and Omissions) Insurance	Liability insurance that protects the production, its employees and the distributor from claims of negligent actions, e.g. story theft, copyright infringements, plagiarism, screen credit omissions and other possible lawsuits.
EBU (European Broadcast Union)	PAL timecode. It's non-drop frame.
Edge Damage	Physical damage on one or both edges of videotape. It usually affects audio tracks, but severe damage will also cause picture breakup.
Edge Numbers	Numbers printed on one edge of motion picture film, allowing frames to be easily identified in an edit list. It is human- and machine-readable. Keykode is the trademark name for Kodak edge numbers. The combination of letters and numbers identifies specific information about a particular roll of film, such as place of manufacture.
Editing	Assembling a program by combining sound and images from various master sources, either film or tape.
Editor's Cut	First cut of a picture. It is usually followed by the director's cut.
EDL (Edit Decision List)	List of edits created during off-line or film editorial.
EFX (Effects)	When working with picture, this refers to visual effects. In audio it refers to sound effects.
Encode	Convert data into a coded form to prevent data duplication.
Encoder	Circuit that combines separate component signals into a composite video signal.
Encryption	Random string of bits created explicitly for scrambling and unscrambling data in order to protect it from unauthorized use.
Encryption Key	Special data used to encode or decode video.
Episodic	A TV show with multiple episodes. The term is often used to refer to a one-hour program, but technically applies to half-hour programs such as talk shows and sitcoms.
Essence	Recorded picture and sound stored as data in track files.
EXR	High dynamic range file used to create effects.
Fades	When picture or audio slowly disappears. In film these are created as opticals. In on-line they are done electronically.

Glossary

FAT (File Allocation Table)	Computer file system. Storage cards are formatted to FAT 16 or FAT 32, depending upon the storage capability of the card.
Film Bounce	Unnatural variation in the brightness of a picture.
Film Finish	To complete film editorial by cutting film negative.
Film-Out (Film Output)	Process of creating a film interpositive or dupe from a digital image. It is also called scanning or recording.
Film Perforations (Perfs)	Sprocket holes along the edge(s) of film.
Film Preservation	Film restoration – the ongoing effort to rescue film stock and the images that it contains.
Film Processing	Treating and stabilizing exposed negative so that it can be exposed to light without damage to the images on the film.
Film Scanning	Scanning original negative to high-resolution uncompressed digital format.
Film Splice	Place where two pieces of film are joined by either glue or tape.
Final Mix	Final sound mix, made to synchronize perfectly with the locked picture.
Final Script	Final version of the script as it was produced at picture lock. It is used to make foreign-language and subtitled versions. It is also called "as-produced script".
Flash Frames	In a film element, these are white frames between frames with image on them. In video, these are mistimings in the editor's decision list or editing that leave empty frames between cuts.
Flat	1:85 aspect ratio.
Flutter	Rapid fluctuations in the pitch of recorded sound. It is also called "wow".
Foley	Sounds added during audio sweetening to enhance ambient sounds, such as footsteps, doors closing and breathing.
Font	Lettering style used in character generators.
fps (Frames per Second)	The frequency (rate) at which frames appear on a display.
Frame	Action safe area as defined by the aspect ratio. The term can also refer to a single film frame.
Front Projection Effects	In-camera visual effects process in film production, used for combining foreground performance with pre-filmed background footage.
FX	Visual or sound effects used in film or TV.

Gain	Amplification of a signal to increase its output.
GAM	Graded archival master, in 16-bit uncompressed EXR in ACES linear color space, or ten- or 16-bit DPX in camera's log color space.
Gigabit	Unit of computer memory equal to one billion bits of data speed.
Gigabyte	Unit of computer memory equal to one billion bytes of storage space.
Grain	Digital effect used to make the digital image look more like film. The term can also refer to the grain structure of film.
Gray Scale (Chip Chart)	Standard graphic made up of two opposed horizontal nine-step tonal monotone scales (from 3% to 60% reflectance).
HD (High Definition)	Video of higher resolution and quality than standard definition. While there is no standardized meaning for high definition, generally any video image with considerably more vertical lines than standard definition is considered high definition.
HDR (High Dynamic Range)	Technology that improves the range of color and contrast in a digital image.
Heads Out	When the beginning of the material is left on the outside of the reel (as opposed to tails out).
HI/VI	Hearing impaired/visually impaired.
Image Enhancement	Digital manipulation of an image using software.
IMF (Interoperable Master Format)	Provides a framework for creating a true file-based final master. It is a SMPTE-based compressed storage format. Alternatively, it may mean Impossible Mission Force.
IN (Internegative)	Duplicating film stock that turns into a negative when printed from a positive print. It is used to make opticals and titles, and as a source for making interpositive prints. It can be cut into the original cut negative. It is also called "dupe negative".
IND (Digital Internegatives)	Internegatives created by film-out rather than in the lab.
Ingest	Import of data to a database for storage or use. Dailies are ingested into the daily computer.
Insert Shots	Additional footage, often shot during postproduction, to create an effect or cutaway shot, or to add information.
Interlace Method	Making a TV picture by filling in all the odd lines from top to bottom, and then going back and filling in all of

Glossary

	the even lines. The process is repeated about every 1/30 second.
Interlock	To project picture and sound track elements together.
IP (Interpositive)	Positive print made from an internegative on special film stock. It is often preferred for telecine mastering, and as a protection element so original negatives can be stored and not used.
ISO	Measurement of the sensitivity of the light sensor in cameras. When you double your ISO speed, you will double the brightness of the picture.
Jam (Jam Sync)	To reading existing timecode and then generate a new element with timecode matching exactly to the original element's timecode.
Jitter	Momentary loss of synchronization of a video signal. It can affect an individual line of picture or the whole picture.
JPEG 2000	Standard format for compressing image essence files. It is used in making digital cinema packages.
K (as in 2K, 4K etc.)	Short for kilo, meaning 1000. It comes from the international system of units.
KDM (Key Delivery Message)	Contains all the keys necessary to allow the playback of content in a digital cinema package on a specific server at a designated time.
Keykode	Trademark of Kodak edge numbers.
Keykode Reader	Device that reads the barcode along the edge of motion picture film. It attaches to either the telecine or a bench logger. The edge numbers are logged automatically, without human error, in about 10% of the time it would take for manual entry.
Kilobit	Unit of data speed equal to 1024 bits of data speed.
Kilobyte	Unit of computer memory equal to 1024 bytes of storage space.
Lab Roll	Roll of motion picture film made up of more than one camera roll spliced together. Labs create these rolls for film that will go through telecine so that the operator is not constantly changing reels. These rolls are usually built in either 1000-foot or 2000-foot lengths for 35mm film, and 1200-foot lengths for 16mm film.
Laugh Tracks	Audience reactions. These are added or enhanced during the dubbing stage. They are primarily used for sitcoms.
Layback	Laying the completed sweetened audio back to a digital master.

Laydown	Recording sound from an audio source or digital element to another audio element. During this process, timecode can be added or altered, channel configurations rearranged, or audio levels compressed.
Leader	Opaque or clear film attached to the head and tail of film rolls.
LED	Light-emitting diode. Often refers to a flat-panel display which uses an array of light-emitting diodes as pixels for video.
Lexicon	Electronic pitch stabilizer used when speeding up or slowing down sound that you want to sound "normal".
Linear Audio Track	Audio recorded along the edge of a videotape.
Localization	Adapting content to a specific market. It refers to dubbing in foreign languages with local meanings.
Locked Cut/ Locked Picture	Final version of a show after all the changes have been incorporated.
Looping	Recording new dialogue, or rerecording dialogue where the production sound is unusable or obscured. It is also called "automatic dialogue replacement" or ADR.
LTO (Linear Tape-Open)	Industry standard for the master archive of digital materials.
Luminance	Brightness or contrast of the video signal.
LUT (Lookup Table)	Table for a color transformation chart.
(M&E) Music and Effects	Sound track that contains just music, and/or sound but no speech or dialogue. Foreign fill or augmentation is when the music and effects from the domestic stereo track are supplemented to create a track that can be used without the domestic dialogue track.
Magenta Track	Sound track that utilizes the magenta layer on the film print and redevelopment process. It is used for making composite sound prints.
Match-Moving	Allows the insertion of computer graphics into a live-action shot.
Matrix	Encoding device that can mix four sound channels into two stereo channels, which will then be restored to four channels upon playback. The four channels are left, center, right and mono surround (LCRS).
Matte	Black bars found at the top and bottom of the picture when a widescreen format is projected on a TV set. The term is also used to refer to blocking out or cutting around an image in visual effects and graphics.

Glossary

Matte Painting	Landscape representation of a set or location, allowing filmmakers to create the illusion of an environment that is not present on the live-action set.
Megabit	Unit of data speed equal to one million bits.
Megabytes	Unit of storage space or size equal to one million bytes.
Megahertz (MHz)	One million cycles per second.
Metadata	Data information about a file including its size and details about its contents.
Migration	No, not birds. When content is saved from one format to another.
Mixer	Sound recordist on a dub or mix stage.
Mixing	Combining all sound tracks (dialogue, music and effects) onto a single master source. It is also known as audio dubbing.
Moiré	Video artifact seen in NTSC pictures along the edges of brightly colored objects, patterns and graphics. It looks like colored dots or saw teeth.
MOS	Picture without sound. The acronym represents the pseudo-German slang term "mit out sprechen".
MOV	File extension for the QuickTime multimedia file format.
Moviola	American-made film editing machine.
Music Cue Sheet	List of all the music used within a movie, including the publishing and mastering rights for each cue.
Music License	License for a musical work that ensures that the copyright holder is compensated.
MXF	Format that holds essence files with metadata. It is a standardized way to move video and audio files between systems, regardless of operating system or hardware.
NAMS	Non-color-corrected archival master.
Negative	Original motion picture film that is bought raw, exposed during shooting and then processed at a film laboratory. It is also referred to as "original color negative" (OCN).
Negative Assembly	When film is spliced to create lab rolls, or negative is spliced to create a cut picture. It is also referred to as "negative cutting".
Negative Dirt	Dirt on the film negative element. It can appear white. In some cases it will appear as sparkles across the screen caused by negative dust. Because the film emulsion is very soft, dirt can become embedded into the film stock, and can only be removed by being washed by the laboratory (this is called a "rewash").

Glossary

Negative Scratch — Scratch in the camera negative or dupe negative. It usually appears white, unless it has penetrated through the yellow, cyan or magenta layers, in which case it may appear to have a slight tint of color.

Noise — Interference in audio or digital signals. Audio noise might be a hum or hiss. Digital noise might be snow or streaks in the picture.

Noise Reduction — Electronic reduction of observable grain in the picture. While noise reduction devices can provide a method for minimizing the discernible grain structure of film, extreme caution should be observed when using them. Unwanted side effects can include strobing and trailing images, reduction in picture resolution, and ringing effects.

Nonlinear Editing — Assembling video sequences in random order. Shots can be moved, deleted, copied or changed electronically before being copied to videotape.

NTSC (National Television Standards Committee) — Committee that established the color transmission system used in the United States, Canada, Mexico and Japan. The term also refers to the system of 525 lines of information scanned at approximately 30 frames per second. This is the broadcast standard for North America.

Off-Line Editing — Editing done prior to on-line to create an edit decision list to be used in the final assembly of a program. It applies to video only, and can be done electronically or manually.

ON — Original cut film negative.

OND — Digital original negative, filmed out from data.

On-Line Editing — Final assembly or editing utilizing master tape sources. It is usually done on a high-quality computer editing system, with computer-generated effects.

Open Captions — Spoken dialogue seen as text on the lower third of the screen.

Opticals — Film effects, film titles, and film dissolves and fades. The term has carried over into digital and is sometimes used to indicate special effects.

OSTN (Optical Sound Track Negative) — Used to make sounded film prints.

Overscan — Image outside the normal TV viewing area.

Glossary

Packing List	Packaging list in XLM format that stores the hashed files in the composition. This file is generally used during ingestion in a digital cinema server to verify if the data has been corrupted.
PAL (Phase Alternating Line)	625 lines of information, 25 frames per second. This is the broadcast standard for many countries throughout the world.
PAL-M	A version of PAL that is 525 lines, 30 frames per second. It is used only in Latin America.
Physical Effects	Special effect created physically, without computer-generated imagery.
Picture Negative	Action negative, rather than sound.
Picture Safe Area	Area of a TV picture that is visible on consumer TV sets. It is also called the "action safe area".
Pickup	Small, relatively minor shot recorded after principal photography to augment footage already shot.
Piracy	Unauthorized use or reproduction of another's work. This could be costly.
Pixels	Tiny dots that make up a picture.
PLF (Premium Large Format)	Cinemas with giant screens, premium sound systems and enhanced services, like reclining seats and table service.
Positive Dirt	Often built in during printing, this appears black on the screen.
Positive Scratch	Scratch in a film print element. It usually appears black on the screen.
Posterization	Reduced picture brightness levels, giving a flat poster or cartoon-like look.
Postproduction	Completing a project after production. It encompasses all phases of assembly through delivery.
Postproduction Supervisor (Post Supervisor)	Person responsible for all phases of postproduction including cutting, editing, dubbing duplication, and all steps leading to exhibition of a project.
Principal Photography	First-unit phase of production, in which the movie is shot with actors on set and cameras rolling.
Printmaster	Stereo mix master audio element consisting of two or four channels of audio.
Producer's Cut	Often the final cut prior to picture lock.
Production Sound	Audio recorded during principal photography on location.
Progressive Scan	Making a computer or TV picture by filling in all of the scan lines sequentially from top to bottom.

Glossary

Publishing Rights	Rights to the composition – both lyrics and melody – written by the composer and songwriter of a work of music.
Push Notification	Notification sent to a mobile device or computer to alert the recipient to a message. It is used to signal that data has been sent or received, for example when sending delivery materials via secure internet services.
QC (Quality Control)	Scrutiny of audio, digital or film elements for technical specifications and visual/audio defects.
RAID (Redundant Array of Independent Disks)	Data storage used for raw materials, both picture and sound.
Raw Stock	Unexposed film or audio stock.
Release Print	Composite theatrical print.
Rendering	Filling-in of a computer graphic frame.
Reshoots	Necessary for visual, audio or plot discrepancies.
Resolution	Picture sharpness, usually measured in lines. The greater the number of lines, the sharper the image. Vertical resolution is basically limited by the number of horizontal scanning lines per frame.
RGB (Red, Green, Blue)	Primary television colors.
Room Tone	"Sound" of a particular room, caused by echoes and background noises in the room.
Rough Cut	Assembly of edited shots prior to picture lock.
Safe Title Area	Center area of a TV screen or monitor that can be seen on any size of monitor. Titles are placed there because you know they should show on all monitors.
Sample Rate	Number of samples per second of sound essence.
SAP (Supplemental Audio Program)	Method for broadcasting a third audio channel along with the stereo channels. It is often used for Spanish-language or video descriptions.
Saturation	Vividness of the color.
Scoring	Session in which live music is performed and recorded to match an existing picture.
Script Notes	Copy of the shooting script prepared by the script supervisor, noting camera angles, what lines were recorded by which camera, and the shooting order. It also notes shot lengths and circled takes.
SD	Standard definition.

SDHC (Secured Digital High Capacity) Card	Standard device for digital or audio storage.
SDTV	Standard definition television.
Simulation	Making a computer rendition of an object or scene act as if it were in the real world.
Sitcom (Situation Comedy)	Slang that describes a half-hour TV comedy.
SmartSlate	Production clapper that includes a lighted readout of the timecode being recorded onto the production sound audiotape.
SMPTE (Society of Motion Picture and Television Engineers)	Committee that set the rules for use of timecode and other technical procedures in the United States and various other countries.
Sound Design	Art of augmenting production sound and creating sound effects for the final sound mix.
Sound Mix	Process of mixing all the sounds that will go into the final form of a movie or other project.
Sound-Only Print	Print that is made with sound but no picture, to check the audio quality.
Sound Report	Form filled in for each audiotape recorded that describes what is on the tape and any technical instructions for proper playback.
Sound Sync Check Prints	If a new track is submitted, a print will be made to check sync.
Specifications	(Specs) Complete list of all the technical and layperson instructions for creating an element.
SPL (Show Playlist)	Order in which the compositions on the digital cinema package should play back. It is typically created by exhibition and transferred to the equipment controlling the particular screen.
Splice	Joining of two film or audio pieces. It is usually done with splicing tape, but can also be "hot-spliced".
Spotting	Determining where either visual effects or sound and music effects are to be placed.
SRD	Digital sound format developed by Dolby.
SSD (Solid State Drive) Media	Storage device in lieu of a storage hard drive. Some SSDs are built into a box of the same size as a hard drive. Some are on a card similar to a graphics card.

Standards Converter	Device that coverts one standard of video into another (for example, NTSC to PAL).
Steady Gate	Transfer of film through a PIN-registered device to provide a more stable image. It is used for green-screen and blue-screen transfers where the separate elements must be steady for accurate compositing. It does not happen in real time.
Stereo	Playing or recording two separate audio channels at once. One channel represents what the left ear would hear, the other represents what the right ear would hear. It requires two audio channels.
Stock Footage	Establishing shots, playback or action footage that would otherwise be difficult or unaffordable to capture, purchased from a stock footage library.
Streaming	When a user watches digital video content or listens to digital audio content on a computer screen and speakers over the internet.
Streaming Media	Multimedia that is constantly received by and presented to an end user while being delivered by a provider.
Sweetening	Enhancing sound or video that already exists. Video sweetening is also referred to as "color correction".
Syncing (Synchronizing)	Lining up proper picture with its matching sound. In dailies, when you hear the clapper close and see it at the same moment, it is considered "in sync".
Sync Rights	Rights allowing the licensee or purchaser to use the original musical recording of a song in a visual piece.
Sync Sound	Sound recorded with the intention of being married to a picture at an exact point.
Tails Out	When the end of the material is left on the outside of the reel.
TDL (Trusted Device List)	Database of trusted devices from theaters and manufactures to ensure content security.
Teammate	Your attorney, the person watching your back.
Tearing	Displacement of a group of horizontal video lines from their normal position.
Temp Dub	Temporary music and effects added to a rough-cut version of a project for network or studio screening.
Terabit	Unit of computer memory equal to trillion bits of data speed.
Terabyte	Unit of computer memory to a trillion bytes of data.
Texturing	Process of adding color and texture to 3D models.

Glossary

Three-Perf	Motion picture film that has three perforations or sprocket holes per film frame. It allows one to photograph 25% more image than the same amount of four-perf film. It requires a special telecine gate and edge code-reading software.
TIFF (Tagged Image File Format)	File format to store uncompressed images.
Timecode	Numbering system adopted by the Society of Motion Picture and Television Engineers that assigns a number to each video frame indicating hours, minutes, seconds and frames.
Timecode Generator	Electronic device that outputs timecode.
TMS (Theater Management Server)	Server within a theater complex that will direct the content to a particular playback server.
Transcode	Direct digital-to-digital conversion of one encoding to another.
Transfer	General term for recording from one source to another element.
UDF (Universal Disk Format)	Format for a storage device used to store digital data.
Underscanning	Altering the height and width of the image on a video monitor so the edges of the signal and blanking can be seen.
User Bits	Areas in the vertical interval where various information, such as Keykode and timecodes, can be recorded. User bits have eight digits.
Variable Bitrate (VBR)	Type of encoding where the bits per second vary depending on the complexity of the content.
VDM	Video display master.
Vertical Blanking	Blanking signal which occurs at the end of each field.
VFX (Visual Effects)	Process by which imagery is created or manipulated outside the context of a live-action shot in filmmaking.
Visible Timecode	Timecode burned into a video picture so that it can be seen when viewing the picture.
VO (Voice-Over)	Ancillary dialogue, separate from the dialogue track and recorded separately on a sound stage.
VOD (Video on Demand)	Programming system which allows users to select and watch/listen to video or audio content, such as movies and TV shows, whenever they choose, rather than at a scheduled broadcast time.

Volume Index (Volindex)	XML file used to identify the volume order in a series on a single digital cinema package.
VR (Virtual Reality)	Computer-generated simulation of a three-dimensional image.
VU Meter	Measures the strength of a video signal. A zero VU level is considered the optimum sound level and is usually used as tone reference.
.wav	Sound file format. The digital cinema distribution master sound essence will be stored as a file.
Wetgate Print	Print created using a chemical process that coats the print, hopefully filling in digs and scratches or imperfections that occur in the negative to help restore the image.
White Balance	Mix of primary colors that equal pure white light. It is an adjustment in a camera that assures no color overpowers the others and the whites are not tinted.
Wild Sound	Audio recorded without a sync relationship to specific picture.
Workflow	Schedule of postproduction stages leading to delivery.
Work Print	Positive print of original negative used in a film cutting room. Print dailies are called workprint.
XML	Interchange file format that is used to define the data storage for both the hardware and the operator.
YCM (Yellow, Cyan, Magenta)	Creation of color separations of each dye layer of film. This allows the film to be stored for 100 years or more and later recombined into one print in perfect color condition.

Index

2-pop 175, 194
2-perf film *see* two-perf film
2D 128
2D animation 132
2K 170, 173, 191, 193, 222, 268
3-perf film *see* three-perf film
3D 124, 128, 176
3D animation 132
3D models 129
3D projection systems 176
4-perf film *see* 4-perf film
4:2:2 definition 212
4:4:4 definition 212, 217
4D 269
4K 268

A/B cutting vs. film opticals 195
A/B roll definition 195
Academy Color Encoding System (ACES) 36, 127, 253
accessibility 197, 268; FCC regulations 197, 202
acetate vs. estar 80
ACES *see* Academy Color Encoding System
acquisition: acquired libraries 249–250; definition 237; rejection causes 241–244; technical acceptance 239
act by act timings 227

action safe area 102; framing chart 96; picture safe area 103
ADR *see* automatic dialogue replacement
air masters 25
airdate scheduling 28, 29
Alexa 89, 267
aliasing definition 246
ambient sounds/effects: definition 136, 143; foreign effects and 166; recreating 145–156
animation 131; budgeting 43; scheduling 21
answer print: composite 179, 193; formatted dupes process and 79; scheduling 22
anti-piracy issues 165, 224, 234–235
application definition 81
AR *see* augmented reality
archiving 59, 251–255
artifacts definition 24, 128, 243, 246, 247
as-broadcast scripts 202, 203
aspect ratio 62–63, 126–127; title safe/action safe 101–103; framing 95–97, 215; stock footage 114
audio mix/dub 152–153; audio recording tips 95; audio sweetening 134; getting the right mix 154; laugh tracks 158–159; sibilance 157–158; source files 173

Index

augmented reality 269
automatic dialogue replacement (ADR) 145–149; budgeting 41, 47; costs 148–149; definition 146; looping 146–149; scheduling 19, 23, 27, 28, 147

bleach bypass *see* skip bleach
blue screen 129–131; budget 36
breathing definition 74–75
budgeting 30–52; areas to budget 34; computer software and 35; cost of accounting 33, 41–42; editorial and projection 33, 35–36, 38, 40–41, 43–45, 47, 49–51; fringe benefits 40, 42, 47, 51; music 36, 40–41, 45–46, 48, 50–51; negotiating rates 32–33, 43, 51; photographic effects and inserts 43; postproduction sound 36, 40–43, 46–49, 52, 146, 149; purchase orders 38–39; sample 33, 37, 39–40; second unit 40, 42; starting 32–33; summary 51, 52; titles and opticals 35, 48–49; understanding costs and bids 30, 32, 33, 37–38

camera and makeup tests 42, 68
camera problems 104
camera report(s) 62, 69; breakdown 88; sample 91
camera running off-speed 73
camera scratches 69, 71–72
captions and titles: accessibility 197, 200–203
CDL *see* color decision list
CGI *see* computer-generated imagery
check print 22, 79, 80, 193, 195, 222; YCM 254
chroma key 129; compositing 130

chrominance 241
clips: dailies 89; stock footage 114, 119, 258, 262
closed-captioning 170, 200–203; master 197–198; in theaters 199
Cloud: archiving 56–57, 59; dailies 18, 103; delivery via 25, 229; future 266; storage 254–255, 266
codec 55
color correction 22, 177–179; ACES 127; answer print and 179; budgeting 34–36, 38, 41, 48–50; dailies 69; film-out 193; schedule 27; VFX 112
color decision list (CDL) 57–58
color key 131
color space 56–57
colorist: dailies 69, 113; ACES 127; definition 177; DSM 177–179
completion 169, 194–203; as-broadcast scripts 202–203; closed-captioning 25; color correction 177; credits and titling 180; film finish 194; negative cut/negative conform 196; quality control 245; video descriptions 202; video in/film out 190
composite print 61, 156
composite track 61, 152, 160, 164, 242
compositing 36, 129, 133
composition playlist (CPL) 171, 172
compression 144, 170, 246
computer animation 132
computer generated imagery (CGI) 129–132; errors 246; VFX workflow 128
conform 169
container 55

293

Index

continuity script *see* as-broadcast scripts
cost of accounting form sample 41, 42
CPL *see* composition playlist
credits 180; 90-minute 182; creating tips 180; episodics 183; features 181–182; font choosing 187; union rules regarding 184–186
crushed blacks 178
crystal LED 267
cut negative 118, 196; damage 71, 80
cyan sound track 81

D-Cinema *see* digital cinema
DA88 audiotape 135, 139, 146
dailies 87, 93–104; audio recording tips 95–97; budgeting 34–35, 40–43, 104; camera reports 69, 88–92; color-correcting 69, 92; completion timetable 17, 65, 107; data capture 88, 89; definition 18; deliverables 202, 204; film lab 65–69; footage calculations 86; framing 95–96, 101–103; processing 63–66, 87–88; Keycode 196; proxies 204; scheduling 16, 18–19, 34–35, 63–66; screening 109; solid state drive (SSD) 34; special handling 66–68; summary and troubleshooting problems 104–105; transcoding 107, 113; transfer to hard drive 43, 50–51
data capture card 16, 54, 56, 88–89; budgeting 34–35, 40, 42–43, 51
data resolution understanding 191
daylight develop definition 63

DCDM *see* digital cinema distribution master
DCI *see* Digital Cinema Initiatives LLC
DCI-P3 57
DCP *see* digital cinema package
decode definition 171
delivery 204–229; acquisition 237–244; agreement obtaining 204, 216, 220, 225–226; dubs 25; foreign checklist 218–222; labeling 228; network/domestic 205–206, 217; network resources 206, 208; production company 223; requirements list 212–214; sample letter 207; scheduling 33
density shift/breathing and HMIs 70, 74–75, 178
DF *see* drop frame
DGA *see* Director's Guild of America
DI *see* digital intermediate
dialogue continuity script *see* continuity script
digital cinema (D-Cinema); anti-piracy 165, 234–235; color correction 24, 177–180; delivery 212–215; future and 176, 267–268; preparing for transfer 234
digital cinema distribution master (DCDM) 48, 173; color correction 177–178; deliverables 225, 229
Digital Cinema Initiatives LLC (DCI) 57, 177, 270
digital cinema package (DCP) 135, 155, 169; budgeting 37–38, 50; definition 170, 161; mastering 169–174; piracy 233
digital electronic film transfer 196, 243

digital imaging technician (DIT) 56, 87, 88, 104
digital intermediate (DI) 169, 190, 193–194
digital light processing (DLP) 176
digital micromirror devices (DMDs) 176
Digital Picture Exchange (DPX) 55, 58, 59, 124–125, 173
digital projection and future 125, 173, 176, 232, 267
digital source master (DSM) 59, 173, 177
digital television: accessibility 197–198; deliverables 212–215; FCC regulations 215
digital workflow 53–60; archive 56; chart 55; mastering 58
director of photography (DP) 24, 56–57, 67–70
director's cut: archive 252; DGA 19, 27, 107; editorial 115–116; scheduling 19–20, 27, 29
Director's Guild of America (DGA): credit rules 184–185; second unit and 42
dirt fixes 71, 74, 77
disclaimers 189, 262–263
dissolve definition 21, 29, 195
distortion definition 158, 247
DIT *see* digital imaging technician
DLP *see* digital light processing
DMDs *see* digital micromirror devices
Dolby 81, 146, 153, 155–157, 175, 247; Atmos 145, 146, 152, 268, 270; surround 157
double exposure 70, 73
DP *see* director of photography
DPX *see* Digital Picture Exchange

drift 73, 140; definition 278
drones 267
drop frame (DF) 161, 199, 213
dropout 34, 89, 154, 247
DSM *see* digital source master
DTS:X 81–82, 145, 152–153, 157, 268
dubbing (audio): budgeting 41, 47–49; Canada 153; cue sheets samples 156, 207, 219, 284; foreign language 159–160, 166; localization 49; materials 163–165, 221; scheduling 24–25, 153; theatrical use 48, 162–163, 165; *see also* audio mix/dub
duplicate negative (dupe neg) definition 76, 79, 80
dynamic range definition 34, 175
dynamics 131

E&O *see* errors and omissions insurance
E-Cinema 176
edge numbers 98, 196
edit decision list (EDL) 93, 95, 96, 106, 108, 112, 117, 118, 120–121, 133, 219, 227
edit room and equipment 44, 109
editing 110; on-line editing 118–120; on-line EDL 120–121; on-line facility need-to-knows 121–122; on-line session requirements 121; picture lock 117; producer's cut 116; stock footage 113–115; summary 122–123; temporary on-line/ temporary dub 116–117; VFX 118, 279
editor's cut 19, 106, 115, 232
editor's log 109–110
EDL *see* edit decision list

Index

electronic slate 96, 111, 138, 139, 140, 141
encoder 44
encryption 171, 232, 234–235
episodics 19, 22, 33, 44, 49, 145, 180, 183, 198
equipment rental, budgeting for 41, 44–45
errors and omissions insurance (E&O) 244
executive producer 8, 10, 103, 108, 110, 183
EXR *see* Open EXtended Range
extensions: VFX 124

fades 21, 112, 118, 120, 188, 195
FAT *see* file allocation table
FCC *see* Federal Communication Commission
feature postproduction sample schedule 27
Federal Communication Commission (FCC) 202, 215, 197
file allocation table (FAT) 138–139
file names 56, 58, 95, 120, 126
film and laboratory production budget 35–36, 40, 42–43, 49–50
film cans, bags, cores, and blank camera reports 69
film clips and legal advice 114, 119, 121, 258, 262
film damage 69–70; density shifts/breathing and HMIs 74–75; double exposure 73; film loaded in reverse 72–73; film weave 78; fogging/light leaks 72; foreign delivery 242; laboratory errors 76–77; perforation/edge tears 70; scratches 71–72; short ends 78; skiving 73–74; stock damage 77–78; water damage 74; x-ray damage 75–76
film editing: editor's log and script notes 110–111; equipment 108–109; off-line editing 110–111; viewing film dailies 63–65, 109
film editor 11, 106–107, 113; credits 181–182
film finish: A/B cutting vs. film opticals 195; adding sound 81–82; application splash 81; color correcting 177; creating formatted dupes 79, 122; flowchart of film shoot to 64; single strand opticals 195; sound applications methods 80–81; for telecine transfer 75, 93, 196; theatrical 50, 116–117, 203
film footage calculations 86
film laboratory 53–60; aspect ratio 62; budgeting for postproduction 33, 35–37, 40–52; camera and makeup tests 68–69; creating other negatives and prints 63, 79, 81, 83–84, 195; damage to film 69–79, 242; errors by 76; footage conversions 85–86; motion picture formats 62, 127; negative processing path 62; processing dailies 63; telecine print creation 65–66, 196; three- and four-perf film 61–62; shipping exposed negatives 84; YCM creation 81–84
film magazine (gate) 71, 92
film-out (film output) 190–193
film shipment, budgeting for 50
film shoot flowchart 7
foley 135, 149; budgeting 41, 47; scheduling 27

Index

font 175, 187, 189
foreign delivery 134–135, 159–166; checklist 217–222; scheduling and budgeting 25, 48–49
foreign language dubbing 135, 159
foreign laugh pass 135, 166
formatting 25, 31, 138, 139, 175, 206, 215, 222, 223, 224
four-perf film 61
fps *see* frames-per-second
frame rates 60, 267
frames-per-second (fps) 60
framing charts 126
fringe benefits, budgeting for 51
front projection 130
future 265–271
FX (effects) 124

green screen 129–131

hard drives 31, 35, 43, 44, 50, 56, 108, 117, 122, 142, 144, 156, 170, 175, 253
hazeltine 22
HDR *see* high dynamic range
high-definition TV 272, 273, 281
high dynamic range (HDR) 34, 35, 36, 50, 55, 58, 60, 125, 267
high magenta sound tracks 81
horizontal blanking 101

IMF *see* interoperable master format
IN *see* internegative
insert shots 115
insurance 40, 42, 49, 51, 70, 74, 76, 78, 79, 244
international or foreign delivery *see* foreign delivery
internegative (IN) 68, 79, 83, 118, 222

interoperable master format (IMF) 161, 200, 212, 225, 229, 270
interpositive 68, 77, 79, 192, 222

jam sync 97, 140

KDM *see* key delivery message
key delivery message (KDM) 171
Keykode 66, 190

lab roll (daily roll) 62, 66
laugh tracks 158–159, 166
layback 29, 36, 47, 156
laydown 151
leader 35, 62, 66, 81, 194–195
LED *see* light emitting diode
legal advice on 256–257, 263
letterbox 201, 213
light emitting diode (LED) 267
line producer 8, 30–31, 52
Linear Tape-Open (LTO) 18, 50, 54, 56–57, 59, 266
localization 49, 160–161
locked cut/locked picture 22–23, 117–118, 196, 252
lookup table (LUT) 57–58, 178, 253
looping *see* automatic dialogue replacement
LTO *see* Linear Tape-Open
luminance 125, 178
LUT *see* lookup table

M&E *see* music and effects track
magenta track 81–82
management and crew flowchart 8–9
mastering 41, 48, 58–59, 169–170
match moving 129, 131
matrix 157
matte 58, 78, 222, 226

Index

matte painting 129, 132–133
mixer 47, 151–154, 242
moiré 246
monitor for viewing 101, 103
Monstro 8K 267
MOS (without sound) 18, 91, 97, 115
motion tracking 129, 131
MPEG-2 36, 49, 59, 161, 199, 246
multi-camera shoot and road maps 16–17, 56, 99–100
multiscreen formats 62, 270
music: budgeting 40–41, 45–48; cue sheet instructions 215; legal 151, 182, 259–260; rights and licenses 46, 216, 237, 259–262
music and effects track (M&E) 23–24, 45, 155–156, 163–164, 166–167; acquisitions 242; deliverables 213–214, 217
music coordinator 13, 259–260
music editor 13, 20–24, 45, 150; budgeting for 36, 40–41, 45
music/scoring 135, 149–150; budgeting 45–46
music supervisor 13, 24, 45, 150, 215
MXF 36, 55, 57, 59, 175–176

narration budgeting 33
needle drops 150, 220
negative 22, 60–62, 64–65, 118–119, 191–196; damage 69–78; special handling 66–68
negative assembly 22, 62, 64
negative cut 22, 118, 196
negative fog 72
negative processing path 62–63
negative scratch 71–72
negotiating rates 32–33
Netflix 59, 270

network resources 206, 208
noise reduction 243
nonlinear editing 35, 106, 110, 128
NTSC 213

object-oriented sound 6, 268
Open EXtended Range (EXR) 3, 55, 57–59, 124–125
optical flow 132
optical sound track negative (OSTN) 79–81
opticals 79, 111–113, 118, 194–195, 222
original version (OV) 172–173
OSTN *see* optical sound track negative
OTTs *see* over-the-top content
OV *see* original version
overnight ratings 26
overscan 103
over-the-top content (OTTs) 7, 50, 59

packaging 171–173
PAL *see* phase alternating line
perforation/edge tears 69, 70–71
phase alternating line (PAL) 161, 199
photographic effects and inserts 43, 130
physical effects 130, 269
physical file storage 266
picture lock 17, 20–21, 27
picture safe area 101–103, 126, 215
piracy 165–166, 171, 230, 234–236
pixels 173, 191, 246
plenoptic camera 267
PLF *see* premium large format
PO *see* purchase orders
postproduction assistant 8–9, 11
postproduction coordinator 8–9, 11

Index

postproduction supervisor 8–12, 39, 60
premium large format (PLF) 266
previsualization (pre-viz) 36, 128–129
principal photography 27
print master 155
producer's cut 17, 19–20, 29, 116
production audio recording tips 95–97
production company delivery 205
production sound 96–98, 111–112, 134–136; slating 139–141; sound report 136–138
production staff 10–11, 40
proxies see dailies
purchase orders (PO) 38–39

QC see quality control
quality control (QC) 173–174

RAID see redundant array of independent disks
raw stock 42, 61–62, 67–68, 77–78
rear projection 130
Rec. 709 56–57, 60, 252
redundant array of independent disks (RAID) 18, 43–44, 56–57
rejection causes 180, 241, 247–248
release print(s) 60–61, 79–80, 163
rendering 44, 89, 108, 119, 195, 246–247
resolution 95, 120, 124
road maps and the multi-camera shoot 99–100
room tone 97
rotoscope 36, 131
rough cut 27, 106–107, 208, 212

safe title area 101–103
SAG see Screen Actor's Guild
saturation definition 178
scheduling 15; ADR/looping 147; creating schedules 15–16; dailies 109; elements of 16–17; film processing 65; getting started 32–33; samples 27–29
scoring 135, 149–150; budgeting 36, 46; methods 149; scheduling 23, 27
scratches on film 69, 71–72
Screen Actor's Guild (SAG) 186; credit rules 184, 186–187; on actor's dialogue replacement 148
script continuity 219, 223; budgeting for 49
script notes 109, 111, 115
SDDS 81–82, 156–157
second unit 18, 115, 116; budgeting 40, 42
SFX see sound effects
shipping exposed negatives 61, 84
short ends 72, 78
show play list 171–172
sibilance 157–158
situation comedy (sitcom) 16–17, 99, 151; captioning 198–199; credits 180; format 210; laugh tracks 158–159; network delivery 209–214
skip bleach (bleach-by-pass) 68
skiving 70, 73–74
SmartSlate 93, 112, 139–141; dos and don'ts 140
SMPTE see Society of Motion Picture and Television Engineers
sneak previews see theatrical test screenings 21–22
Society of Motion Picture and Television Engineers (SMPTE) 125, 241
solid state disk (SSD) 34–35, 43, 56, 89–90

299

Index

Sony Venice 6K 267
sound 134; adding 80–81; ADR/looping 23, 47, 146–147; advice 151, 168; anti-piracy issues 135, 165; audio mix/dub 24, 135; audio sweetening 134; budgeting 36, 43, 47; dubbing budget 48; foley 149; for film-out 191–192, 221; foreign language digital masters 161–163; foreign language dubbing 135, 159–160; foreign language dubbing materials 163–164; foreign language film prints 163; foreign laugh pass 166; layback 156; laydown 151; looping and narration 135, 146–148; music and effects tracks 23, 45, 145, 155–156, 160, 163–164, 167, 213–214; music/scoring 135, 149–150; path flowchart 135; predub/prelay 151; production 135–138; temporary mix/temporary dub 142
sound design supervisor 12, 13
sound editor 12, 13, 135, 145–146, 152, 168
sound effects (SFX) 23, 143–145; ambient 143, 145, 166; creating 145; missing 241–242; spotting 23, 145
sound mix 21, 143, 154
sound recordist 97, 100, 136, 137, 139, 141
sound report 88, 138, 140; breakdown 136
sound tracks, budget 48; cyan and high magenta 80–81; optical storage 255
splice 171; hot splice 196
spotting 147; music 17, 23, 149

SSD media *see* solid state disk
standards and practices (S&P) 202, 215
stock damage 70, 77
stock footage 256, 262; budgeting 41, 50–51; editorial 113–114; legal advice on 257–258; selling 257
stop-motion animation 132
studio/network viewing 17, 20, 27, 117
subtitles 201–203; gotcha 174
supplemental package 172–173
sweetening definition 134; budget 46, 48
sync license 46, 259
sync sound 96; film-out 193; sync license 259
syncing 97, 112, 191

TDL *see* trusted device list
tails-out 72, 76
technical acceptance 239
telecine 62, 63, 65, 69, 72–76, 80, 85, 196, 241
temporary (temp) dub 20, 116, 117, 134, 141, 142
temporary (temp) mix 117, 142–143
test audiences/screenings *see* theatrical test screenings
textless material 169, 170, 189, 213, 214, 223, 244, 249
texturing 132
theatrical print *see* release print
theatrical test screenings 20
three-perf film 61–62
timecode 22, 23
titling 30, 31, 49, 101, 118, 121, 122, 173, 180, 187, 188–196
traditional animation 132

transcode 35, 54, 56, 87, 95, 99, 111, 113, 243
transfer 196, 217, 223, 234, 254
trusted device list (TDL) 171, 232
two-perf film 61–62

ultra HD 34, 266
underscan 103

vertical blanking 101
vertical interval 198
VFX *see* visual effects
virtual reality (VR) 40, 42, 131, 266, 269
visible timecode 49, 97, 101, 103, 219
visual effects (VFX) 11, 13, 17, 22–29, 30, 33, 36, 42–49, 53, 54–55, 57–60, 95, 108, 111, 112, 117, 118, 122, 124–133, 231, 246, 247, 252, 265

VO *see* voice-over
voice-over (VO) 33, 117, 142, 160
VR *see* virtual reality

water damage 70, 74
wet wrap 77
wetgate print 71, 80
WGA *see* Writer's Guild of America
wild sound 18
work print 117, 118, 157, 196
wrapper 55
Writers Guild of America (WGA) 184, 185

x-ray 70, 74, 75, 76, 78, 84–85

YCM *see* yellow/cyan/magenta
yellow/cyan/magenta (YCM) 81, 82–84, 254

Lightning Source UK Ltd.
Milton Keynes UK
UKHW050716050920
369353UK00005BA/273